An American Sampler
Folk Art from the Shelburne Museum

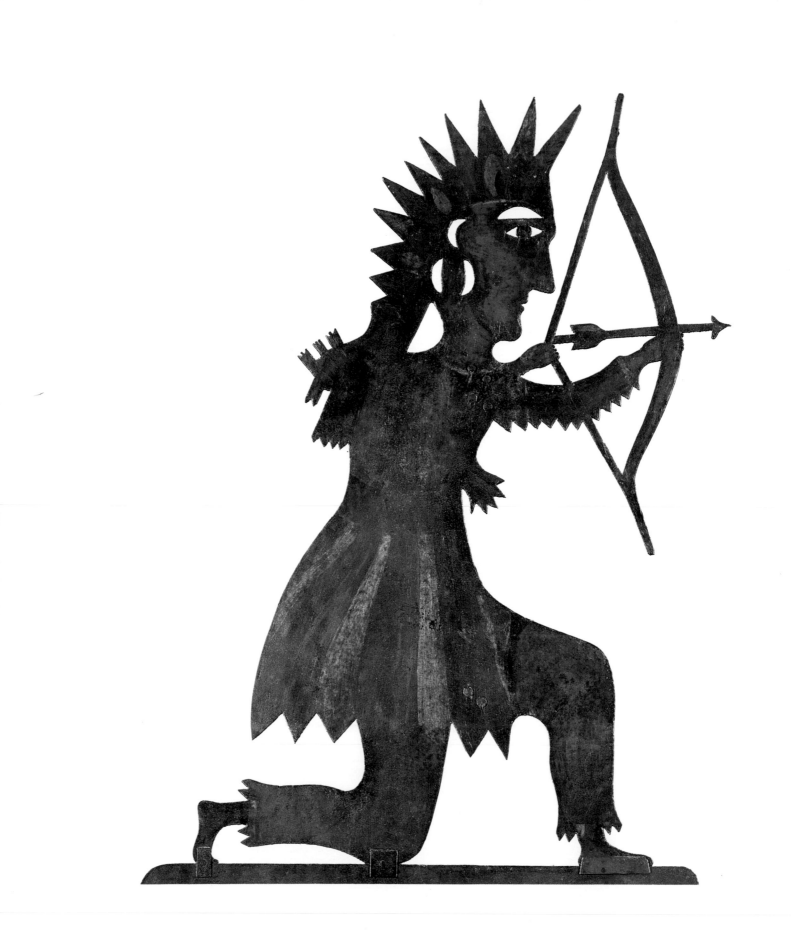

An American Sampler

Folk Art from the Shelburne Museum

National Gallery of Art
Washington

The exhibition is made possible by a generous grant from

The New England

Exhibition dates

National Gallery of Art, Washington
15 November 1987–14 April 1988

Amon Carter Museum, Fort Worth
7 May–4 September 1988

Denver Art Museum
15 October 1988–8 January 1989

Los Angeles County Museum of Art
16 February–30 April 1989

The Wadsworth Atheneum, Hartford
4 June–3 September 1989

The New-York Historical Society
3 October 1989–7 January 1990

Worcester Art Museum
15 April–5 August 1990

Library of Congress Cataloging-in-Publication Data

An American sampler.

"Exhibition dates: National Gallery of Art, Washington, 15 November 1987–14 April 1988, Amon Carter Museum, Fort Worth, 7 May–4 September 1988, Denver Art Museum, 15 October 1988–8 January 1989, Los Angeles County Museum of Art, 16 February–30 April 1989, The Wadsworth Atheneum, Hartford, 4 June–3 September 1989, The New-York Historical Society, 3 October 1989–7 January 1990, Worcester Art Museum, 15 April–5 August 1990"—T.p. verso.
 Bibliography: p.
 1. Folk art—United States—Exhibitions. 2. Shelburne Museum—Exhibitions. I. Shelburne Museum.
II. National Gallery of Art (U.S.)

NK805.A687 1987 745'.0974'074013
87-24676
ISBN 0-89468-104-4

Produced by the editors office, National Gallery of Art, Washington
Editor-in-chief, Frances P. Smyth
Edited by Mary Yakush
Typeset in Caledonia
by BG Composition, Inc.,
Baltimore, Maryland
Printed by Princeton Polychrome Press, Princeton, New Jersey
Designed by Frances P. Smyth

Back cover: cat. 89 (detail)
Front cover: cat. 67
Illustration on this page: cat. 7

Color photography by Ken Burris, Burlington, Vermont

Contents

Foreword

ALTHOUGH THE HAVEMEYER FAMILY is perhaps best known for its associations with New York, and especially the magnanimous gift of impressionist and old master pictures to The Metropolitan Museum of Art, the name of Electra Havemeyer Webb also holds special resonance for the National Gallery of Art. Since the Gallery's opening in 1941 a number of very important works have come as gifts to the nation from the several children and in-laws of Henry O. Havemeyer and Louisine Elder Havemeyer: first in 1942 a pair of portraits by Goya; then in 1956 Manet's luminous image of the *Gare Saint-Lazare;* in 1962 Vermeer's exquisite portrait of *A Lady Writing;* and most recently, in 1982, another major Manet, his *Masked Ball at the Opera.* In addition, other works once owned by the Havemeyers, including two splendid paintings by Mary Cassatt, *Mother Wearing a Sunflower* and *Girl Arranging Her Hair,* came to the Gallery in the early 1960s. And shortly after the Gallery's founding, Mrs. Webb, herself, along with her husband, J. Watson Webb, gave to the Gallery in memory of her parents a Dürer engraving of Saint Jerome and two sets of Whistler etchings, totaling several dozen pieces devoted to Venetian subjects.

During these very same decades Mrs. Webb was pursuing a parallel vision in the collecting of all manner of American folk art. Her interests, first piqued in childhood, led to a lifelong passion of gathering native handmade objects, often in striking colors and expressive designs, which culminated in 1947 with her founding of the Shelburne Museum in Shelburne, Vermont. The exhibition of key selections from the museum, celebrated in this publication, marks the fortieth anniversary of the Shelburne Museum. The idea of the National Gallery inaugurating this exhibition came from John Wilmerding, who for this enterprise wears at least a tricorn hat: as vice president of Shelburne's board of trustees, deputy director of the Gallery, and grandson of Electra Webb.

At Shelburne itself is assembled what Mrs. Webb called a "collection of collections," one of the great combined repositories of American arts, architecture, and artifacts. Unable adequately to suggest the whole in any logical exhibition, we chose to concentrate on two broad groups of objects, recognized as among Shelburne's greatest strengths: textiles, including hooked rugs, coverlets, and especially quilts; and second, sculpture, notably weather vanes, decoys, cigar-store Indians, carousel animals, and shop signs. These were seen by Mrs. Webb, and can be viewed by our visitors, on two levels—as aesthetically pleasing works in their own right and as wonderful reminders of American life and culture.

J. Watson Webb, Jr., and Samuel B. Webb, Jr., generously shared their enthusiasm, energy, and apparently boundless knowledge of Shelburne's history. The introductory essay has greatly benefited from the many photographs selected by J. Watson Webb, Jr., from his vast personal archive. The able staff of the Shelburne Museum, in particular Gisèle B. Folsom and curators Celia Oliver and Robert Shaw, made available to us their considerable knowledge and obvious love of these objects; chief conservator Richard Kershner's care made it possible for a number of fragile pieces to travel safely, and Kenneth Burris expertly photographed the collection.

At the National Gallery we are especially indebted to Deborah Chotner, coordinator for the exhibition and assistant curator of American art. From the outset she has participated helpfully in the selection of objects, negotiations with contributing authors, arrangements with other colleagues at our partner museums, and general oversight of the complex discussions giving shape and focus to the show. The American department's secretary, Rosemary O'Reilly, capably handled the preparation of copious lists and labels. As always, we have relied on the efficient behind-the-scenes management of our exhibitions and registrar's offices, in particular the work of Dodge Thomp-

son, Ann Bigley, and Mary Suzor. Other important contributions to the installation design and to this accompanying catalogue came respectively from our chief of design, Gaillard Ravenel, and assistant chief, Mark Leithauser, and our editor-in-chief, Frances Smyth, who designed this book, as well as our editor, Mary Yakush. Thanks are also due to Laura Luckey, director of the Bennington Museum, and Linda Ayres, curator of paintings and sculpture at the Amon Carter Museum, who assisted us in the early stages of planning for the exhibition.

This publication largely owes its substance and character to the distinguished catalogue essayists David Curry, Benjamin L. Mason, and Jane Nylander, whose joint expertise in the broad fields of Shelburne's collections is amply evident in the thorough and stimulating words herein. Their writing provides not only relevant historical information, but also fresh views on folk art and its relationships to American culture as well as to modern taste.

We take special pride and pleasure in sharing this exhibition across the country, as it travels from Washington to the Amon Carter Museum in Fort Worth, the Denver Museum, the Los Angeles County Museum of Art, the Wadsworth Atheneum in Hartford, the New-York Historical Society, and the Worcester Art Museum. For their generous support of this national tour we want to express our sincere appreciation to *The New England*. A special debt of gratitude is due Edward E. Phillips, their chairman and chief executive officer, and to John A. Fibiger, president and chief operating officer.

Not only do we believe there will be a broad public discovery of a relatively unfamiliar treasury of Americana located in the green mountains of Vermont, but that in this discovery of our national heritage viewers will find both delight and insight.

J. Carter Brown
DIRECTOR

A "Simple" Vision

BENJAMIN L. MASON

JOHN WALKER ONCE REMARKED that he knew of only three American families that had produced second generation collectors . . . the Mellons, the Wideners, and the Havemeyers. This essay concerns Electra Havemeyer Webb, an extraordinary personality, a seminal collector, and a pioneering institution builder. The youngest daughter of the Metropolitan Museum's great benefactors, her life began in 1888 in New York City, at the pinnacle of the opulent American Renaissance,[1] and ended in 1960 in the remote beauty of northwestern Vermont, near her beloved Shelburne Museum. The exhibition of folk art from her collection only begins to suggest the range of her tastes and collecting passions; this brief summary of her life provides but a glimpse of a multi-talented, often contradictory woman who, twenty-seven years after her death, is at last becoming recognized as one of the major cultural forces of her generation.

Electra, like her museum, had a personality that tolerated glaring inconsistencies. She was enormously wealthy and could be appropriately grand when an occasion demanded. Yet she will always be remembered in Vermont as a warm, kind, and generous person in a house dress and pearls who developed lasting friendships with local residents. A Park Avenue dweller who, as head of the New York City Red Cross blood

bank during the Second World War, stood on a box in Pershing Square exhorting longshoremen to follow her example and give blood, she also saw no incongruities when, ten years later, she berthed a 900-ton paddle-wheel steamboat on a manicured museum lawn two miles from Lake Champlain. Although deeply committed to "beauty," her generic description of tastefulness, she was by her own admission "a killer" who enjoyed the excitement and challenge of blood sport in all its forms. The museum she founded is filled with the results of her enthusiasms; its special character is as pronounced and ornately figured as was that of its patroness.

Like its founder, the Shelburne Museum never stopped growing and developing. Consistently passionate about early Americana, Electra began to acquire twentieth-century American sculpture and painting just before her death in 1960. She had never had a formal plan for her museum, and who today can guess where her eclectic tastes might eventually have led her acquisitive spirit? She founded her museum in 1947 to house the overflow of her own vast collections and to prevent the dispersal of her husband's family's carriage collection. Unlike other founders of restoration villages, to which Shelburne Museum is sometimes compared, Electra had never intended

to represent an historical period or place; her museum was conceived as a living thing.

Today, however, Shelburne is usually considered—along with Colonial Williamsburg, Old Deerfield Village, Greenfield Village, Old Sturbridge Village, and Mystic Seaport—under the generic heading, "outdoor museums."[2] While not an American invention (the first was established in Denmark in 1879), the form took strong root in this country immediately after the First World War. The outdoor museums' most active decades of development were the thirty-odd years between the Armistice and the Korean conflict. The opening of the period rooms in the American wing of the Metropolitan in 1924 and the watershed Girl Scouts 1929 loan exhibition of American furniture roughly coincide with the establishment of Henry Ford's museum in Dearborn (1929) and John D. Rockefeller's slightly earlier collaboration with the purposeful Reverend Goodwin in Colonial Williamsburg. New outdoor museums still occasionally start up, but for reasons unimagined in the 1920s.

America's first outdoor museums were established by a socially and philosophically homogeneous group of wealthy individuals who were concerned about this nation's welfare and direction. The First World War had thrust America into a position of inter-

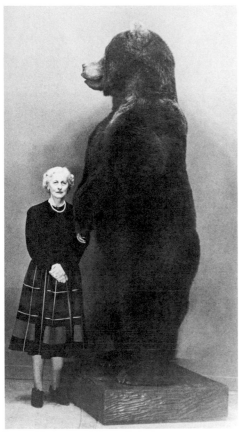

fig. 2. Mrs. Webb with Kodiak bear she shot in Alaska [J. Watson Webb, Jr.]

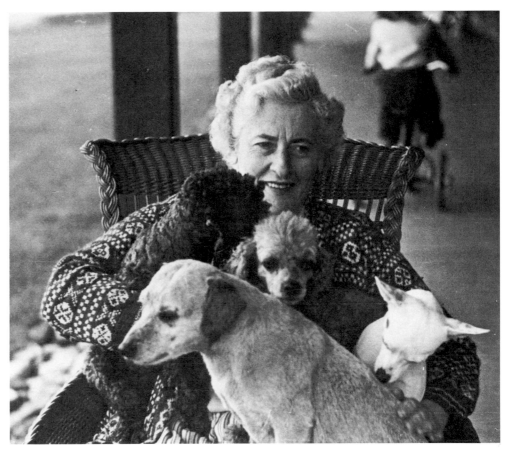

fig. 1. Mrs. Webb with her dogs, 1948 [J. Watson Webb, Jr.]

national preeminence, and native taste-makers were eager to find ways to reflect this new geopolitical reality. Whereas previous generations of leadership extending back to the post-Civil War era had sought European antecedents, forms, inspiration, and models to help pattern polite society and to guide its leaders—those were the salad days of "New" England boarding schools, the Episcopal Church, the Grand Tour, castles on the Hudson, and "Mrs. Jack" (Isabella Stewart Gardner)—the new cultural chauvinism strove to discover "the genius of our forebears." Whereas Henry Adams' contemporaries had earlier seen themselves as "impoverished Europeans," the creative elite in the postwar period sought out the bedrock of native American values and tradi-

tions, which surely were to be found under "the fog of unenlightenment."

To speed the search, a hardy few of these primarily eastern leaders decided to outdo the proponents of historic rooms in art museums. They tried to revive or fabricate historical communities or neighborhoods in which their unenlightened, often recently arrived, fellow citizens could immerse themselves. The founders were largely concerned with imparting to those who visited their campuslike museums a basic message about the essential nature, principles, character, and spirit that had guided the development of this now greatest of world powers. Their period-rooms-writ-large were polemics to advance a particular vision of a new national self-consciousness. The out-

door museums made manifest an important shift in the history of the development of American public thought.

Today, despite their common heritage, these institutions bear very little resemblance to their founders' notions of what they would become, or to each other. Most have been "improved" or "edited" by successive generations of museum professionals. Not so Electra Webb's highly idiosyncratic and unself-conscious museum at Shelburne. Less change, for better or worse, has come to it than to any of its sister institutions; the spirit of its founder is almost as palpable in 1987 as it was when she was assembling history there more than twenty-five years ago.

Electra Webb's parents were power-

ful and extraordinarily interesting personalities. Her father, Henry O. Havemeyer (1847–1907), created the Sugar Trust[6] in 1887 and briefly operated on the same economic level as John D. Rockefeller, J. Pierpont Morgan, and Henry Clay Frick. The success of "Harry" Havemeyer's American Sugar Refining Company was overshadowed by a string of highly publicized lawsuits that continued to plague his heirs even after his death, and earned him considerable notoriety as a combative witness in the courts. His business acumen was also legendary, and permitted him and his wife, Louisine Elder Havemeyer (1855–1929), to amass vast collections of art, and eventually to indulge in lavish cultural patronage. Although the pressure of running the sugar empire was Harry's most consuming reality, he still found time for an hour of practice on his Stradivarius each morning before going to work; he was an early, caring, and active member of the Grolier Club; he maintained a close watch on the New York, London, and Paris art markets; and he traveled extensively abroad with his family and artist friends. A very private man, at age thirty-five Havemeyer had forsaken strenuous socializing outside his immediate family as a precondition to his engagement to Louisine Elder, who became his second wife in 1883.

Louisine, too, was atypical of the era. By the time she married Havemeyer at the almost overripe (by Victorian standards) age of twenty-eight, she was a dedicated and knowledgeable collector. Her fiancé's taste still ran to old masters and to acquiring job lots of exotic oriental decorative wares (textiles, lacquer, metalwork, and ceramics), which had, since the Centennial Exposition, also so enthralled the painter Samuel Colman and the designer Louis Comfort Tiffany. By

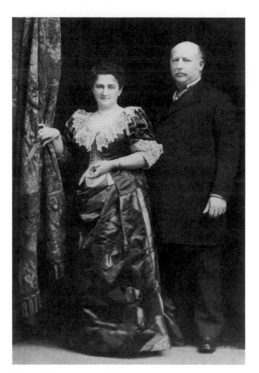

fig. 3. Louisine and Henry O. Havemeyer in Paris, 1889 [J. Watson Webb, Jr.]

contrast, Mrs. Havemeyer's regular girlhood trips to Europe already had set her on quite a different collecting course. At nineteen, while living with her mother and sisters in Paris, she had met the expatriate Philadelphian Mary Cassatt, herself recently established in France. Although Mary was eleven years older than Louisine, the young women began a friendship that would last fifty-two years, from 1874 until the artist's death in 1926. Louisine became the first American known to have bought a Degas when, at Miss Cassatt's urging, she pooled her own and her sisters' allowances to acquire a ballet pastel early in 1875. By the time she married Harry Havemeyer, Louisine was familiar with, or owned works by, Courbet, Whistler, Pissaro, Manet, Monet, and Degas.

The Havemeyers were an odd couple by most of their Gilded Age contemporaries' standards. Industrious, strongwilled, and daring in the best robber-

baron image, Harry also often performed with the musicians hired for the Sunday afternoon concerts in the music room of the family's lavish new home on the corner of 66th Street and Fifth Avenue. While his peers were engaging in extravagant consumption and furious social competition, Harry chose the opposite and spent his limited spare time in the bosom of his immediate family or with the artists and bookish men whose associations he seemed to crave.

The Havemeyers' residence at 1 East 66th Street, built in 1890 and since destroyed, was an extraordinary creation resulting from a collaboration between the architect Charles Coolidge Haight and Havemeyer's old friends Samuel Colman and Louis Comfort Tiffany. This neo-Romanesque, artencrusted house became a haven and inspiration for scholars, diplomats, the aesthetic and literary avant-garde, and the Havemeyers' very few close personal friends. Their winter Sunday afternoon musicales attracted a frothy mix of the leading cultural people of the day. Homer Saint-Gaudens, often taken as a boy by his parents, later lamented: "There was a mingling of artists and men of both means and understanding of the aesthetics that I fail to come across these days. There were painters like Thomas Dewing, architects like Stanford White, sculptors like Frederick MacMonnies, and editors like Richard Watson Gilder."[7] Mrs. Havemeyer later wrote, "Our collection as well as our house had a far greater reputation abroad than here, and strangers were deeply impressed by the work of Mr. Colman and Mr. Tiffany."[8] The Havemeyers were classic collectors: they were wealthy, aware, acquisitive, and very sure of their taste. They passed this cluster of characteristics on to at least one of their children.

Electra was the third and youngest Havemeyer child. Said by many to be her father's favorite, she was tutored not in the prim domestic arts of the high Victorian era, but in turn-of-the-century business skills. She went to commercial college rather than to a young ladies' finishing school and in later life noted that her brother and sister always called her a "dumb bunny." She learned from her father to ride, fish, shoot, and compete at sports like a man. She was equally at home in a counting house, a duck blind, or her mother-in-law's box in the Diamond Circle at the Metropolitan Opera; later, she also would be completely at ease sitting at the scrubbed kitchen tables of the small-town Yankee antique dealers who helped her build the Shelburne Museum. She was an active, highly organized, competitive, involved, and caring person who did not subscribe to the old aristocratic notion of genteel restraint.

Thorsten Veblen was not referring to Electra or her parents in his *Theory of the Leisure Class* (1899), but he certainly did describe the people, man and family, whose name she took in marriage in 1910. In December 1881, William Seward Webb (1851–1926), Electra's future father-in-law, married Lila (Eliza Osgood) Vanderbilt (1861–1936), the youngest of William H. Vanderbilt's four daughters. An entrepreneur who, in the great American tradition, had ambitions that eventually exceeded available resources, Webb was a New Yorker from a deeply rooted pre-Revolutionary family and was trained as a physician. He left his practice in the then-unfashionable medical field and worked on Wall Street at Worden and Co., later W. S. Webb and Co. After his engagement to Lila Vanderbilt, he joined her family's business, the New York Central Railroad.

fig. 4. Mrs. Webb on hunting expedition in Alaska, 1939 [J. Watson Webb, Jr.]

fig. 5. Dr. William Seward Webb, 1910 [J. Watson Webb, Jr.]

One of the prospective son-in-law's first assignments was to scout the terrain north of Albany to find a rail route to Montreal. The company already dominated the New York–Albany, Boston–Albany, and Buffalo–Albany railroad freight and passenger businesses, and a northern tie to Montreal would give the Vanderbilts near-total control of the principal rail markets of the Northeast. While in northern Vermont to investigate the Rutland/St. Albans right-of-way, Webb was struck by the awesome beauty of the Green

Mountains and Lake Champlain. There, a long, narrow arm of rolling, farm-dotted land reached north from Shelburne to embrace Shelburne Bay and to draw out the peninsula that protects the port city of Burlington from the violent southerly storms that are a feature of the lake in summer. Webb advised Mr. Vanderbilt not to buy the Rutland Railroad, but he rented a large home in Burlington and in 1882 began construction of a residence in South Burlington.

While their "cottage" was being built, William Seward Webb and his new bride explored the countryside. A favorite drive took them out around the bay and through the small farms to Shelburne Point, from which place they could look east back across the bay to Burlington and Oakledge, or, more spectacularly, west, north, and south, up, down, and four miles across Lake Champlain to the splendid sunsets and thrusting jumble of the Adirondack Range. These views still are among the world's scenic miracles.

Despite the fact that Lila's father was building a string of would-be chateaux for his daughters and their families on Fifth Avenue's "Vanderbilt row," the young couple already had decided to spend most of their time in Vermont. Their eldest son, J. Watson, was born in Burlington in 1884. When Lila's father, "the richest man in America," died in 1885, leaving his daughter a $10-million legacy (at the time more than the annual budget of the state of New York), Lila and her husband realized financial independence and decided to live year-round in Vermont.

The Vanderbilts, like many other members of the new industrial meritocracy, seem to have been passionately concerned with publicly demonstrating their prominence in the emerging hierarchies of American social life. Their

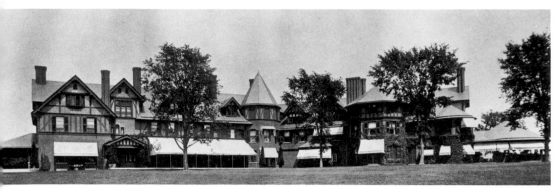

fig. 6. Shelburne House, 1903 [J. Watson Webb, Jr.]

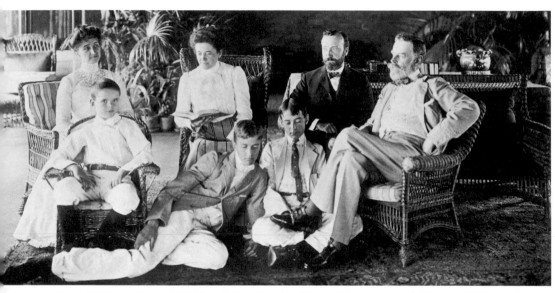

fig. 7. William Seward Webb and family at Shelburne House, 1902 [J. Watson Webb, Jr.]

Webb built tenant houses and a Catholic church for the servants. He retained the New York architect Robert Henderson Robertson (1849–1919) to oversee the master plan and to create a temporary residence on the western, or lake, shore of the peninsula. Webb's intention was to move his growing family to this shingle-style home for a few years while the major farm buildings were being built and then to install them in far grander circumstances high on the hill that commands the lake and overlooks the domain.

What in the end was a relatively fleeting, if stupendous, tableau at Shelburne Farms was guided by an early organizing principle of magnitude. In its heyday the farm comprised almost 3,800 acres, an unmanageable tract in the pre-mechanized era. The horse barns were set up to handle several hundred draft and pleasure animals, an inconceivable number in then-depressed, turn-of-the-century Vermont. At Shelburne Farms Dr. Webb hoped to achieve on-site production and storage of essential forage, grain, vegetable, fruit, and animal crops. Hundreds of laborers and managers were required to build and operate the farm and to maintain the estate; a large and complex staff also was needed to run the big house and to support the family and its endless stream of guests.

The ostensible business of the enterprise was the breeding of English hackney horses for the carriage trade. In an 1893 publication, Dr. Webb stated, "what I desire to do at Shelburne Farms is to bring back to the State of Vermont the old type of draught-horse, with this difference, that with the use of the English Hackney he will be a little finer."[10] Hindsight and the development of the motor car by Henry Ford certainly buttress the view that this ven-

mores and philosophies derived from English social Darwinism, as did their games. They imported the manners, trappings, attitudes, and rituals of the English gentry. Most spectacular among these were the architectural notions they set down in the American countryside. What better way to proclaim one's worth and recently acquired status than to build, equip, staff, and live in a castle, palace, or manor house? This may have been Dr. Webb's motivation when he decided to compete residentially with his Vanderbilt in-laws. Webb chose a spot on the eastern shore of Lake Champlain, slightly to the south of Burlington, as the site of his

country estate. It would rival his Vanderbilt brothers-in-law's castles in Newport, New York City, the Berkshires, Asheville, and along the Hudson.[9]

In 1885, with his wife's blessing, Webb set out to acquire all of the Shelburne peninsula. He used a straw man, Arthur Taylor of Burlington, through the winter of 1886–1887, and eventually bought up nearly thirty farms. The development of the estate began in earnest in the spring of 1887. The plan called for a central manor house that was never built, though work was completed on an array of complementary structures to shelter the agricultural and service dependencies.

ture proved to be little more than a deficit-expanding diversion from the real purpose of Webb's estate: splendid living. It is true that the lifestyle at Shelburne was but an up-country variant of the flamboyant themes being played out in New York and Newport. Work, as defined commonly today, was not routine for this class; their days were filled with lavish entertainments, brief accomplishments, and expensive distractions. Extended house parties were commonplace, with a variety of related activities for those who had the strength: cruising the lake in the family's steam yacht, the *Elfrieda*; playing golf on the farm's eighteen-hole course (America's first); or playing tennis on the grass court on the front lawn. Blood sports were greatly favored, and Dr. Webb imported an English gamekeeper (along with English butlers, grooms, and dogmen) to raise ring-necked pheasants for organized, driven shoots for his guests in the fall. It was a lively if, by today's standards, undemanding and even frivolous existence.

William Seward Webb was at once a typical and an atypical scion of his era. By 1905 or 1910, there is no question that his various enterprises, as well as some disastrous financial investments to aid other family members, had depleted his wife's capital and eroded much of the money he had made himself. His relentless drive and ambition had also seriously compromised his health, which had been deteriorating since 1892, when he first developed rheumatoid arthritis. The scale of living at Shelburne Farms was somewhat reduced (the yacht, for instance, was sold, as were most of the hackneys), and descendants believe that the family may have been helped financially by Lila's brother Fred. In 1885 Dr. Webb had taken over the presidency of the failing Wagner Palace Car Company,

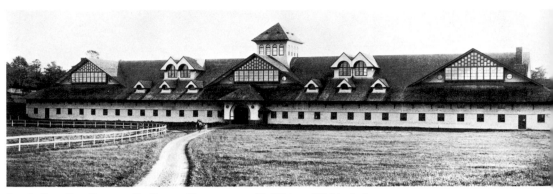

fig. 8. Breeding Barn at Shelburne Farms, 1902 [J. Watson Webb, Jr.]

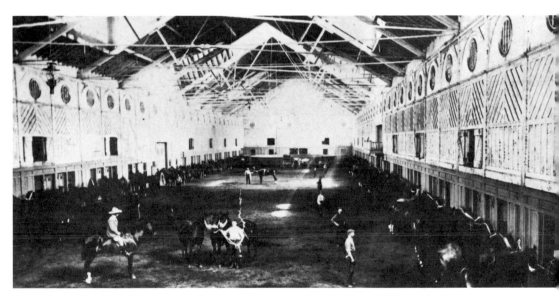

fig. 9. Inside the Breeding Barn at Shelburne Farms, 1902 [J. Watson Webb, Jr.]

where he remained as president until its merger in 1899 with the Pullman Company.[11] Between 1891 and 1892 Webb conceived and built the Adirondack and St. Lawrence Railroad, 186 miles through the heart of the uncharted Adirondack wilderness, which led to his establishment of a 147,000-acre tract of land in the Adirondacks as a virtual private research laboratory.[12] In addition, Webb served four years in the Vermont legislature, was a trustee of the University of Vermont, and a presidential appointee (McKinley) to the Board of Visitors of the United States Military Academy at West Point.

If one truly believes that opposites

attract, then the coming together of young Electra Havemeyer and William Seward Webb's son J. Watson in Shelburne is not at all surprising. Electra was an enormously wealthy, versatile, competent, worldly, young woman. Watson was a 1907 graduate of Yale and a dashing "new American gentleman" best known for his remarkable skill with horses. Electra grew up in a cultural cloister surrounded by fabulous treasures; she had been immersed since birth in serious business talk, extensive travel, broad acquaintance, and refined cultural activities, while Watson already was committed to a life of sport. Electra's parents were scholarly

fig. 10. J. Watson Webb in hunt attire at about age 20, c. 1906 [J. Watson Webb, Jr.]

in their own way, and immensely private people; Watson Webb's parents were prominent participants in the glittering excesses of their era. Both families left legacies to the public: the Havemeyers built up and then bequeathed their great art collections to The Metropolitan Museum of Art; the Webbs, through the marriage of their eldest son to the youngest Havemeyer, participated in the founding of one of our great collections of Americana.

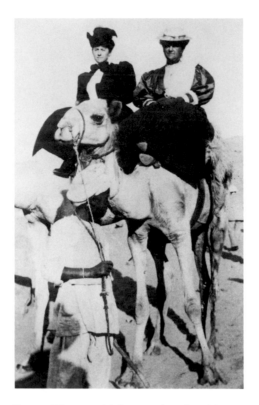

fig. 11. Electra with her mother, Louisine Havemeyer, on a trip abroad in 1909, possibly in Tunis [J. Watson Webb, Jr.]

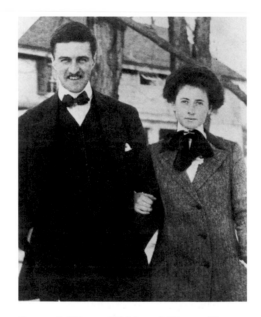

fig. 12. J. Watson Webb and Electra Havemeyer in Long Island, 1909 [J. Watson Webb, Jr.]

When Electra Havemeyer and Watson Webb were married in 1910, Electra already had an extremely large income from the trusts set up for her when her father died in 1907. Mrs. Havemeyer and Mrs. Webb built Electra and Watson a house in Syosset, Long Island, but Electra hated the mothers' lugubrious Victorian tastes (referred to as "early Pullman" by the family), and Watson found the house, called Woodbury, inconveniently far from the sporting action. His principal interests eventually required that the young couple live near Westbury. So, in 1921 they bought a small farmhouse there, near the polo fields. Electra immediately added a couple of wings to accommodate the family; she would continue to enlarge the house for the next twenty-five years. Westbury was Electra's family's real home, though they also kept a triplex at 740 Park Avenue in New York City and a summer "camp" in the Adirondacks near Tupper Lake. The camp encompassed 50,000 acres, twenty-seven bodies of water, and eighty-seven buildings, including a large house designed by Robert Henderson Robertson and built to the same scale as Shelburne House.

After their marriage, Electra and Watson returned every fall to the Webb estate in Vermont, where they both rode with the Shelburne Hunt, of which Watson was Master of Foxhounds. While they loved the outdoor life, they found that the formality of dinner clothes and a footman behind every chair dampened their enthusiasm for going up to Vermont. In 1913 they asked Watson's parents to give them one of the small brick farmhouses that had been abandoned twenty-five years earlier as Shelburne Farms was being assembled. The senior Webbs quickly consented, adding the southern 1,000 acres of the estate for good measure to

ensure that the newlyweds would continue to come to Vermont.

Electra filled the "Brick House," which now belongs to the Shelburne Museum, with local antiques and the "old furniture" still easily obtained from local dealers, because it fit the mood of the place and matched her young family's energetic lifestyle. Later she furnished their home in Westbury in the same comfortable way. By 1922 she had five children, and the simple American furnishings that were available in large supply in antique shops in Vermont and on Long Island held up well to their onslaughts. The European imports in high Victorian style that were favored by both sets of parents and by most of Electra's contemporaries were not to her taste. Since her teens Electra had been collecting American decorative arts and artifacts for her own amusement; the need to furnish completely several expanding households provided the opportunity for her to learn more about and acquire all sorts of American objects. Later in life, after she and her husband moved from Westbury, many of the furnishings in that house served as backgrounds to the early exhibits in the new museum buildings at Shelburne.

The Webb family followed an extraordinarily full and complex schedule. Soon after moving to the house in Syosset, Watson joined the American Expeditionary Forces in France, where he remained until after the Armistice. Electra had moved with her children to the house next door to her mother's residence on East 66th Street, and she wrote daily to her husband. Electra made her own contribution to the war effort: in 1917 she applied for and received a chauffeur's license, a requirement for all ambulance drivers, so that she could help transport wounded American soldiers returning

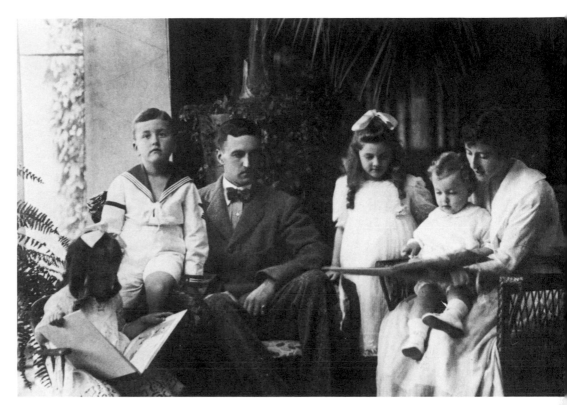

fig. 13. J. Watson Webb and Electra Webb with their children Lila, Samuel, Electra, and J. Watson Webb, Jr., at their Long Island home, Woodbury, summer 1917 [J. Watson Webb, Jr.]

fig. 14. J. Watson Webb with his pack of English foxhounds, c. 1914 [J. Watson Webb, Jr.]

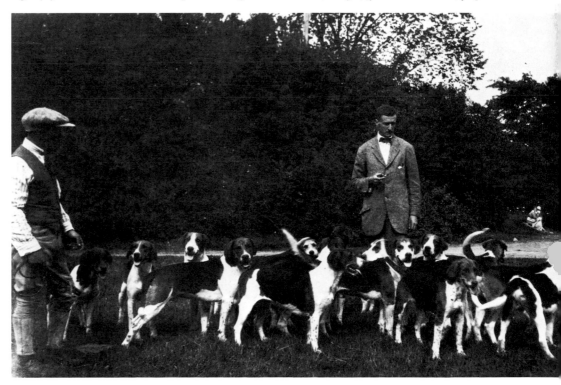

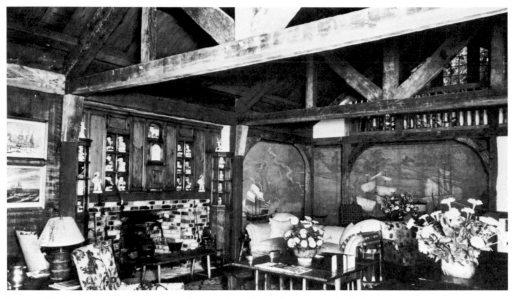

fig. 15. Living room at Westbury, Long Island [J. Watson Webb, Jr.]

fig. 16. Mrs. Webb on a hunting expedition in Alaska, 1937 [J. Watson Webb, Jr.]

from the war to the hospitals in New York City. Her considerable executive talent was exercised in managing several houses, a rigorous social calendar, the children's busy activities, and a sporting itinerary that eventually would take the family grouse shooting in Scotland, foxhunting in Vermont and England, quail shooting in South Carolina during the winter, salmon fishing in Canada, big-game hunting in Alaska and British Columbia, duck and pheasant hunting on Long Island, and year-round hunting and fishing in the Adirondacks. The children were expected to participate in as many of these activities as possible, at least until it was time for them to go off to boarding school around age ten. After her husband returned from France in February 1919, polo became the family's focus. Watson and his Westbury teammates became the best in the world: they represented the United States against England at the International Cup matches in 1921, 1924, and 1927 and won all three contests.

Electra and Watson Webb's life continued to be centered in Westbury until the spring of 1949 when they moved permanently to Vermont. Watson's decision to retire to Shelburne and to use the Park Avenue apartment only in the dead of winter or when passing through the city had been made in 1947, the same year that Electra founded her museum. The museum may have seemed a natural solution to the problem of what to do with the vast quantities of American furniture, decorative arts, and folk art treasures that Electra had labored so lovingly to collect and install in the house in Westbury. The house was not sold until 1955; but by that time the bulk of Electra's collections had been moved to Vermont.

Electra Webb was fifty-nine years old when Watson announced his "retirement" plans. At that point she must finally have decided it was time for her to begin what she had long dreamed of trying, namely, to create a museum "to preserve our American heritage." By now she also was keenly interested in ". . . doing something worthwhile for the citizens of the State of Vermont."

Meanwhile, Electra's in-laws in Shelburne had been suffering the effects of time. As noted above, the family fortune had been declining since about 1900. Then in 1926 William Seward Webb died. Shelburne Farms continued to operate until Lila Webb died in 1936, but on a diminished scale, and with, it is thought, assistance from Lila's brother Fred. Fred died in 1938, and with the passing of both Lila and Fred, an era was finished. Their descendants were left the complex task of settling the estate. Although Electra had once had her in-laws' approval to take over Shelburne Farms, her husband did not want it. His siblings did not wish to settle permanently in Vermont, and therefore decided to break up the estate. They were nearing resolution of this task when the Second World War interrupted them. By that time they had succeeded in selling and removing the elaborate greenhouses, and because they intended to demolish the mansion eventually, they removed the boilers and heating system for scrap to support the war effort.

When the war had ended and Watson and Electra had retired to the Brick House, Watson's brother Vanderbilt

16

Webb agreed to be responsible for the house and Shelburne Farms. He ultimately decided against tearing down the mansion, but their father's extensive carriage collection had to be removed from the 1901 coach barn. Electra prevailed on her brother-in-law, a close friend and advisor, not to allow the collection to leave Shelburne. If Van would give the carriages to her, she would put up a building for them in town and admit the public. (This was not her first demonstration of concern for the citizens of Vermont; in 1927 she had built a new town hall for Shelburne, in memory of her father.) Van Webb actively supported the scheme, and provided legal and practical advice to aid her dream. Thus the Shelburne Museum began.

In 1947 the village of Shelburne was like many other small Vermont towns. The Webbs had long since ceased to be the principal local industry; Shelburne now was best known as a quiet place where families from the city kept summer camps on the lake. The town lacked picture-book Vermont quaintness, but it did have a handful of charming New England structures at the crossroads. Electra bought one of them for $5,000 as a possible site for her new museum, but it proved inappropriate. Shortly afterward, the J. Simonds house (1830–1840), a particularly fine brick structure about 200 yards from the center of town, came on the market. It had an eight-acre field behind, which backed up on railroad tracks and open cropland beyond. Now there was plenty of room for her project.

Electra also recently had discovered an unusual, horseshoe-shaped, working dairy barn near St. Albans on one of her frequent drives through the countryside. She hoped to take it down and move it, but learned from the owner

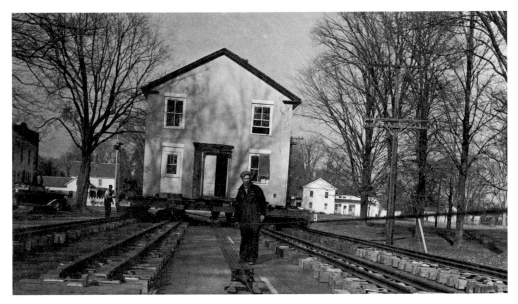

fig. 17. The Shelburne General Store, c. 1840, is moved to the museum grounds, 1955 [Shelburne Museum]

that his building was not for sale. He would be happy to let her send a survey crew to measure it and prepare plans for its replication. She hired some local carpenters who had done work for her over the years and sent them off to duplicate the horseshoe-shaped barn. Simultaneously, she began to install exhibitions in the Simonds house. And as these projects were moving forward, the selectmen of the town of Shelburne inquired whether she would like to move the old municipal barn to her new museum; they were about to replace it. She said she would, and the spontaneous pattern and breakneck pace that would characterize the museum's next thirteen years were firmly established.

Electra never had a master plan for the Shelburne Museum. She and her husband had always admired a small, brick schoolhouse (c. 1830) that sat abandoned in Vergennes, Vermont, beside the road they traveled back and forth between Shelburne and their camp in the Adirondacks. She acquired it in 1947 to prevent its collapse; soon many concerned Vermonters were calling from around the state to offer buildings for the new museum. The crew she had hired to help her with the horseshoe-shaped barn proved to be exceptionally resourceful, imaginative, and skilled. All manner and sorts of buildings and building materials began to roll down the roads toward Shelburne. In a 1958 Williamsburg speech about the development of the museum, Electra confessed her inability to say "no" to a plea to save beautiful buildings.[13] She believed in making extreme financial and emotional sacrifices to protect our American heritage, and she inspired several generations of preservationists and tastemakers to fight the fight harder. For her efforts, Yale gave her an honorary master of arts degree in 1956; the University of Vermont and Middlebury College already had similarly praised her with honorary doctorates of humane letters.

While a description of each building and its contents at the Shelburne Museum would far exceed the limits of this essay, some mention must be made of the intensity of effort expended between the founding of the museum

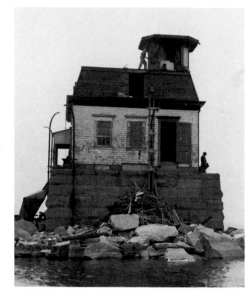

fig. 18. Workmen dismantling the Colchester Reef Lighthouse, c. 1870, in preparation for its move ashore, 1952 [Shelburne Museum]

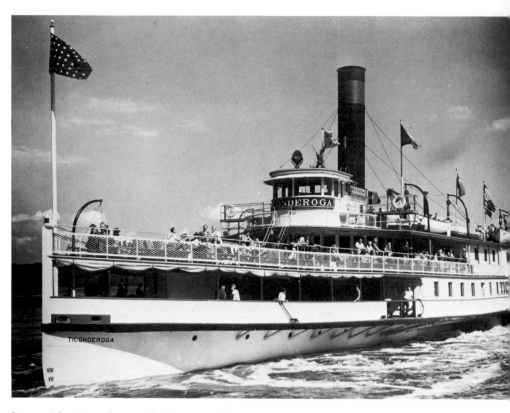

fig. 19. The *Ticonderoga*, the last steamship to travel Lake Champlain, in 1955. In September of that year the *Ti* was retired to the shipyard [Shelburne Museum]

and Mrs. Webb's death in 1960. All but seven of the more than three dozen structures on the inventory were moved to the site, which by the mid-1950s comprised forty-five acres. While most of the buildings came from Vermont, several were from as far away as Utica, New York, and Hadley, Massachusetts. The majority were taken apart and moved piece by piece. The moving of the slate jail from Castleton, sixty-four miles away, and the Tuckaway General Store, a substantial brick building in the middle of Shelburne, required particularly great deliberation, skill, and attentiveness, as they had to be brought intact to their new site.

Mrs. Webb and her crew did not shrink from challenges. Two buildings, the Charlotte Meeting House and the Vergennes School, were taken apart and moved brick by brick by the museum staff. Although it was customary to recycle such precious building materials in early northern New England, today we can only marvel at the practice. Similarly, several field-stone structures were painstakingly dismantled and reassembled. And, in what certainly must be one of the most unusual preservation efforts in recent times in Vermont, the museum workers dismantled and moved the Colchester Reef Lighthouse ashore in small boats. It is interesting to note that this project was deemed impossible by Mrs. Webb's insurance underwriters, who refused to provide workmen's compensation or general liability insurance for the project. The museum crew did it anyway, trusting that Mrs. Webb would take care of them if they became injured, which of course she would have. Electra's Yankee craftsmen, most notably Bob Francis and his brother Cliff, never doubted that the simple methods used to convey materials to and build the lighthouse in the 1870s would be perfectly adequate, in reverse, to move it back to land.

Serial feats of native ingenuity propelled the rapid development of the museum, but Mrs. Webb's incontestably most spectacular effort was the moving of the 220-foot, 900-ton side-paddle-wheel steamboat *Ticonderoga* almost two miles from Lake Champlain to the grounds of the museum.[14] Steamboating had always been an important activity on the lake, but with the end of the Second World War and gasoline rationing, the remaining boat lines fell on hard times. Alerted to the historical importance and financial predicament of the last paddle-wheeler on the lake, Mrs. Webb bought the "Ti" in 1950 to keep it from the wrecking yard. Not knowing what else to do with a steamboat, Electra chose to subsidize tourist cruises and created a subsidiary of the museum, the Shelburne Steamboat

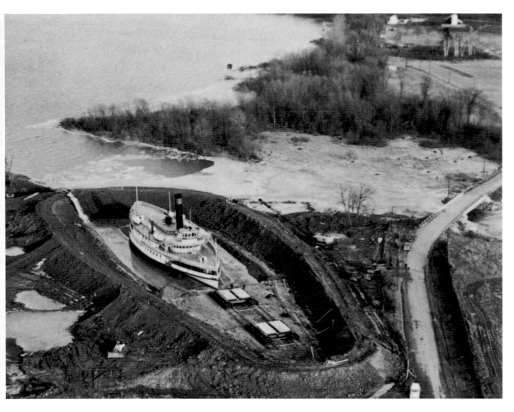

fig. 20. A 450-foot-long basin is flooded in order to position the *Ticonderoga* over the specially constructed railroad carriages that will transport it across several miles of frozen marsh to the museum grounds [Shelburne Museum]

fig. 21. Mrs. Webb and the *Ticonderoga* as it crosses the tracks of the Rutland Railroad en route to the Shelburne Museum, 1954 [J. Watson Webb, Jr.]

Company, to operate the "Ti" as an historical attraction.

After three seasons, however, the coast guard demanded hopelessly uneconomic repairs to its forty-seven-year-old boilers. The septuagenarian engineers advised against them, and a year of discussion ensued. Finally, it was decided the boat should be moved to a spot near the lighthouse on the museum grounds. The largest marine salvage company in the world was retained; a strategy, plan, and time-table were developed; and the wait for winter began.

The essence of the program was to build a cofferdam, float the boat onto a dual railway carriage, breach the cofferdam, and drag the cradle two miles across the frozen swamp to high ground and the museum. The project took nearly six months, during which time the *Ticonderoga* crossed railroad tracks, a main highway, high tension lines, and a variety of other natural and man-made obstacles. There also was a thaw in midwinter that loosened the footings under the cradle. Many people were certain the "Ti" would roll off the tracks onto its side in the bog. By this time the prime contractor also had been discharged. The always ingenious museum staff and a resourceful local rigging contractor saved the day; the project moved steadily toward its well-publicized, unusual finale.

While each of the buildings or structures at Shelburne has its own interesting history, Electra Webb used them primarily to display or illustrate either artifacts or historical notions to which she was particularly attracted, or which were in vogue in polite circles at the time she was moving and filling each building. The Great Founders of her generation saw their roles in museums primarily as storytellers, rather than as searchers for historical truths. All of them, most notably Henry Francis DuPont and Abby Aldrich Rockefeller, will be remembered as impassioned teachers laboring to create historical stage sets. Further, many of them sought to breathe their own or friends' personalities into these creations and assemblages. It would be unfair to accuse them, as some recent critics have, of playing dollhouses on a large scale, but there is no question that

19

they felt their mode of presentation would allow the public instantly and painlessly to learn something, and perhaps a great deal, about the American past.

The pace of work ordered by "the Boss" in the years 1947 to 1960 was intensely demanding. One can only imagine the strains and pandemonium caused, in a typical year—1950–1951, for example—by the moving and reconstruction of a large house, a country inn, the brick meeting house church, a stone residence, and a 168-foot, three-lane covered bridge—all in Vermont's hostile climate. Further, it is almost impossible to comprehend how Mrs. Webb and her staff managed simultaneously to increase the pace of collecting so as to be able to fill and organize these new exhibition spaces for the public. But she continued to expand her dealer and collector networks, ever emboldened by the growing enthusiasm with which her creation was being received by the general public. Her devotion to her family never diminished, but the Shelburne Museum had become the center of her being.

Electra's collecting urge and aesthetic taste were in some ways very similar to her father's: she was deeply moved by strong structural and sculptural forms while at the same time maintaining a fascination for rich surface detail. Although it would be impossible to establish a direct parallel between her parents' collecting and her own, they certainly shared an acquisitive nature. This much is evident in Electra's relentless pursuit of cigar-store Indians, carousel figures, weather vanes, and other three-dimensional folk icons. Perhaps too the Colman/Tiffany interior of the Havemeyers' home, with pictures squeezed like postage stamps among shimmering wall and furniture decorations, caused her to be drawn to

fig. 22. Every stone of a nineteenth-century cottage in South Burlington is numbered before the cottage is dismantled and reassembled on the museum grounds, 1950 [Shelburne Museum]

fig. 23. The covered bridge from Cambridge is reassembled over a specially built pond on the Shelburne Museum grounds, 1950 [Shelburne Museum]

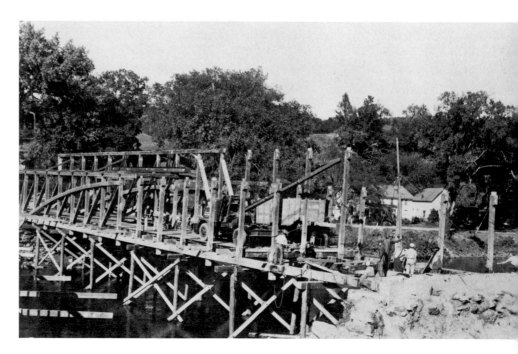

20

ornately worked and figured quilts and needlework and to hooked rugs. Her father's interest in miniatures, too, may help explain her own fascination with the myriad of small decorative objects found at Shelburne. Electra combined all these elements in the exhibition rooms at Shelburne, creating an effect that today appears strongly Victorian. The last fifteen years have seen a trend toward museum installation policies that take exception to Mrs. Webb's urge to pack the rooms to capacity. There can be no question, however, that the overall appearance of her aggregate collections is both stimulating and unforgettable.

Several new buildings were nearing completion when Mrs. Webb died in the fall of 1960. When her middle son, J. Watson, Jr., took over direction of the museum, he finished these projects, greatly improved and augmented many of the existing exhibits, and began the planning process for a building to serve as a memorial to his parents. (The senior Mr. Webb had predeceased his wife by less than a year.) After much deliberation, the Webb children decided to adapt to their purposes the basic structural elements of a high Greek Revival building their parents always had admired in Orwell, Vermont. The classical form seemed ideal to modify and fill with many of the Havemeyer treasures Electra had inherited and kept in the Webb triplex at 740 Park Avenue. The plan grew to include the removal of many of the decorative elements from that apartment and the replication as closely as possible of the ambience of the Webbs' New York existence.

The Electra Havemeyer Webb Memorial Building certainly is anomalous to Vermont, to the rest of the Shelburne Museum, and to Electra's lifelong preference for simple American

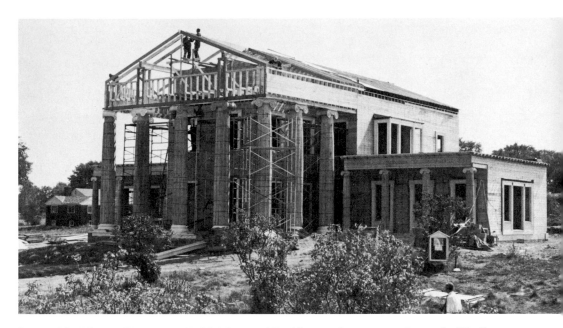

fig. 24. The Electra Havemeyer Webb Memorial Building under construction, 1965 [Shelburne Museum]

things over the fine European and oriental objects with which she had grown up. Yet it is entirely in keeping with Mrs. Webb's notion that her museum should be both eclectic and "create something of value for the State of Vermont." This building, with its Monets, Manets, Degas, and Rembrandts, is a museum within a museum and perfectly reflects Mrs. Webb's original notion that her creation was never intended to be anything more profound than a collection of great collections from which the public could learn about and enjoy the cultural "legacy of our forebears."

The opening of the Memorial Building in 1967 effectively ended the first stage of the Shelburne Museum's development. It had taken a mere two decades for Electra Webb and her family to create one of America's great museums. While the future is always uncertain, the underpinnings of a public facility and an undeniably world-class collection were firmly in place.

As she grew older, Electra Webb often quoted her mother's admonition

to the Havemeyer children to ". . . remember how blessed you are. And if opportunity ever offers, equalize the sum of human happiness and share the sunshine that you have inherited." Mrs. Webb's museum at Shelburne has given millions of visitors large measures of sunshine, beauty, excitement, and learning. Like other institutions, however, it exists in a time of accelerating change, and it faces difficult new practical challenges. A public non-profit corporation since Electra's death in 1960, today the museum depends on contributions and ticket income rather than a single patron to support maintenance, the collections, and the programs. Although Shelburne's importance as a repository and early center for Americana and folk art research is unquestioned, interest in these once-neglected subjects has expanded and flourished elsewhere. Likewise, the "junk" Mrs. Webb once picked up for a song has become very valuable. Serious issues of protection and conservation inevitably will force some modifications to the original pre-

fig. 25. Mrs. Webb at the Champlain Valley Fair, 1947 [J. Watson Webb, Jr.]

sentation and interpretive protocols set in place at Shelburne forty years ago. It is no longer simple to advance Electra's "simple" vision.

Early in this essay it was noted that Shelburne probably is the least changed of the major outdoor museums. In large measure, this is due to the efforts of Electra Webb's son Watson, Jr., and his siblings, who cleaved to their mother's vision, purpose, and methods. They adhered single-mindedly to the wish she had expressed on her deathbed, to "forge ahead." Now, in the face of increasing museological and public concern for the care and conservation of individual objects, we must consider the Shelburne Museum itself as an historical artifact. This perspective may eventually prove to be Shelburne's salvation; certainly it demonstrates that in a mere three generations America's out-

door museums have come full circle. Further tests undoubtedly lie ahead for these distinctive institutions, but they are certain to preserve for future generations the values honored by Mrs. Webb and her family and friends.

1. For a brief but cogent analysis of this chapter in American thought and history, see Richard Guy Wilson, "The Experience of Identity," *The American Renaissance: 1876–1917* [exh. cat., Brooklyn Museum of Art, 1979], 11–25; see also, in the same volume, the list of suggested further reading.
2. See Electra H. Webb, "Folk Art in the Shelburne Museum," *Art in America* 43, no. 2 (May 1955), 15–22. The entire issue is devoted to outdoor museums; it includes articles on Colonial Williamsburg, Old Sturbridge Village, The Farmers Museum at Cooperstown, Old Deerfield Village, and Mystic Seaport, and a checklist of outdoor museums east of the Mississippi.
3. On Henry Ford's objectives in creating Greenfield Village, a 260-acre "historic" town near Dearborn, see Walter Karp, "Greenfield Village," *American Heritage* 32, no. 1 (December 1980), 98–107, and Donald A. Shelley, "Henry Ford's Museum and Greenfield Village," *The Antiques Treasury*, ed. Alice Winchester (New York, 1959), 155.
4. Ford quotes reprinted in Geoffrey C. Upward, *A Home for Our Heritage: The Building and Growth of Greenfield Village and the Henry Ford Museum, 1929–1979* (Dearborn, 1979).
5. See Beatrix T. Rumford, "Uncommon Art of the Common People: A Review of Trends in the Collecting and Exhibiting of American Folk Art," *Perspectives on American Folk Art*, ed. Ian M. G. Quimby and Scott T. Swank (New York, 1980), 13–53.
6. The Sugar Refineries Company, known as the Sugar Trust, was the second company of its kind to be organized in America; the first was Standard Oil, formed in 1870 by the Rockefellers. See Frances Weitzenhoffer, *The Havemeyers: Impressionism Comes to America* (New York, 1986), 46–47; on the suit brought against the Sugar Trust in 1890, and on the subsequent re-formation of the American Sugar Refining Company, see Weitzenhoffer, 69.
7. Reprinted in Weitzenhoffer, 78.
8. Louisine Havemeyer, *Memoirs*, 51, reprinted in Weitzenhoffer, 79.
9. On the Vanderbilt family's building sequences, see Brooklyn 1979.
10. Reprinted in William C. Lipke, ed., *The Shelburne Farms: The History of an Agricultural Estate* (Burlington, 1979), 44.
11. See Charles H. Burdett, *Conquering the Wilderness* (1892), 80.
12. See Gifford Pinchot, *The American Spruce* (New York, 1898), v, and Burdett, 88.
13. Electra H. Webb, "The Shelburne Museum and How it Grew," talk delivered at Colonial Williamsburg Antiques Forum, 30 January 1958, transcript in Shelburne Museum Archives.
14. See Ralph Nading Hill, *The Story of the Ticonderoga* (Shelburne, 1957).

Rose-Colored Glasses
Looking for "Good Design" in American Folk Art

DAVID PARK CURRY

*. . . the world is, ultimately, an
aesthetic phenomenon.*

SUSAN SONTAG[1]

*The lack of an aesthetic vocabulary
does not prevent aesthetic operation.*

HENRY GLASSIE[2]

ONE OF THE MANY LESSONS we have learned from societies far older and with technologies different from our own is that being able to name something gives us a measure of power over it. Much of the business of art history over the past centuries has involved nomenclature: assigning categories, names, dates, and levels of quality to aesthetic objects.

Some of our business is still unfinished. "American folk art" has yet to be adequately defined, let alone understood.[3] Although the earliest collectors and connoisseurs of "American folk art" engaged in a kind of primitive word magic, ascribing traits and attributes to unknown artists, the artists themselves may never have enjoyed rugged individualism, naive peace of mind, or an "instinct" for design untainted by the refinements of academic training. With advancing scholarship, many of the underlying assumptions that governed the perceptions of early collectors of "American folk art" and their reactions to it no longer go unquestioned. A central issue that concerned early collectors—the idea that good design characterized the best "American folk art"—is the subject under examination here.

What can we say about the large pair of spectacles in cat. 9? It was made in the late nineteenth century, of gilded and painted wood. The enormous shop sign is based on a tiny form from daily life: metal eyeglasses. Eyeglasses are not art. What has happened to their form in the hands of the sign maker? It has been exaggerated, flattened. Why? So that we can now admire the formal properties of eyeglasses as a piece of design? Probably not. Yet the colossal spectacles are a pleasing balance of solid and void, flat and curve.

We can assume that the piece was intended to signal the availability of an optometrist's services, but we cannot check its effectiveness through sales receipts since the actual shop is not identified. The object may convey a quaint or whimsical aspect to us. We live in an age of media blitz with our sensibilities bombarded by two decades of pop art quotations, but this sign is *not* machined plastic; it's handmade, old, weathered.

What can't we say? Almost anything intelligent about the maker of the huge spectacles, and what kind of emotions he felt as he made them. We don't even know his name. Through these glasses we can only peer backward, indulging ourselves in the evocation of an age that seems simpler—chiefly because it's an age we do not live in ourselves.

We have a little more information about the origins of the broom in cat. 21. It was made for a Barnum and Bailey circus wagon, specifically, for their "Fairy Tales Float." It was carved and painted in 1902 by artisans working for the Sebastian Wagon Company. Again, we see a stylized version of a humble, everyday object. The broom is a gently undulating harmony of linear contrasts. But is it sculpture? Can it be art if it was made for a circus?

We are not always certain how to react to what we are seeing. Not only a

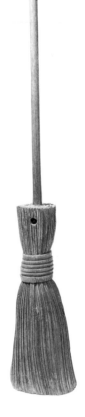

cat. 21

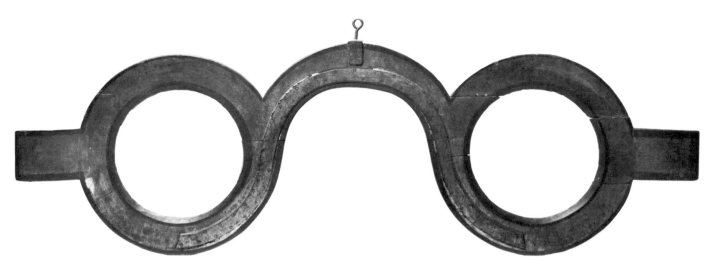

cat. 9

pecific object but also its general context help to determine our reactions. To keep the "folks" moving, P. T. Barnum put up a sign in his American Museum at Brooklyn: "this way to the egress!" Sideshow visitors who did not have the benefit of a classical education were enticed by the Latin word for "exit." Expecting to see yet another rare and wonderful sight, they flocked out into the street.

Tourists flock to the National Gallery of Art because it contains ART. The museum is noted for its exquisite installations of objects chosen for aesthetic appeal as well as historical and cultural importance. The textiles and sculpture included in *An American Sampler: Folk Art from the Shelburne Museum* are certainly rare and wonderful, and it is appropriate to enjoy them as aesthetic objects in a museum setting, as long as we know what we are doing. We are recycling something, and setting it in a new context. Colossal spectacles look different against a brick or clapboard building than in an elegant museum gallery. Did anyone even notice the broom when it was a small component of an enormous and gaudy float? The design of individual parts is less

emphatically evident seen against the whole.

Today most of us encounter "American folk art" in a museum or gallery setting, where formal design properties read far more clearly than they would on the street. *The Flowering of American Folk Art*, presented at the Whitney Museum in 1974, was the high point of an unquestioned acceptance of a design orientation toward eighteenth- and nineteenth-century "American folk art" in the northeast. Significantly, the installation was created by Marcel Breuer, the Whitney's architect. In the catalogue, Alice Winchester stated the parameters of the "good design" approach:

American folk art as we have come to understand it has its own qualities of vigor, honesty, inventiveness, imagination and a strong sense of design. While it shows imperfect technical mastery on the part of the maker, it makes effective use of color and of the pattern in form and line.

Winchester cited the once widely shared notion of collector Maxim Karolik, who opined that while folk artists "sometimes lacked the ability to describe, . . . it certainly did not hinder

their ability to express."[4]

The idea that "good design" characterizes the best "American folk art" can be dated and defined. The concept emerged in the 1920s, and by the next decade was well established. Imported aesthetic programs radically affected not only the recognition of American "folk" objects as art but also the criteria upon which such recognition was based. "American folk art" is bound up with the march toward abstract painting and international style architecture that dominated the fine arts of early twentieth-century Europe and America.

Daniel Robbins' insightful essay, "Folk Sculpture Without Folk" (1976), provides a succinct historiography of the relationship between "American folk art" and early modernism. Robbins observed that the recognition of "American folk art" followed major changes in aesthetic values. These, in turn, were imposed by a gradual acceptance of modern art. For a time, primitive, folk, and modern art were thought to be related in a fundamental way. The community of these objects was believed to rest in "plastic relationships among elements of design."[5] That belief

has now been qualified considerably. Robbins warns against making "erroneous identification of the aesthetic values and the appearance of certain works by modern artists with those of folk artists."[6]

Alas, most of the early literature on "American folk art" did pose such parallels, although these hot combinations are often fortuitous.[7] Robbins found two reasons why parallels were drawn:

The first is the continued attractiveness of the democratic notion that simple and untutored Folk can create work that rivals in value the selfconscious production of highly trained and sophisticated artists. The second is the still growing power of the idea that interested society can stamp its own artistic values upon almost any kind of object, that each man who approaches life as an artist will find art and will find it to the extent that he himself is creative. This is an extension . . . of Marcel Duchamp['s] . . . found object.[8]

Found objects are items from popular culture elevated to the status of art (fig. 1). Marcel Duchamp clearly

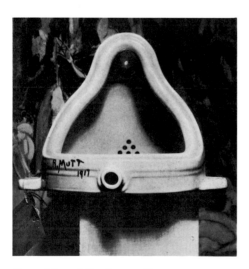

fig. 1. Marcel Duchamp, *Fountain*, 1917. Photograph by Alfred Stieglitz, reproduced in *The Blind Man* 2 (May 1917), 4 [Philadelphia Museum of Art, The Louise and Walter Arensberg Archives]

understood that richly ironic consequences result when form is separated from context, as when our giant eyeglasses are seen on a pristine art gallery wall. The concept has spread far beyond dada circles, and today we encounter many art movements that embrace the found object. The intense consciousness-raising that occurred once aesthetes and critics—and eventually the public—realized that the simple recognition of an object as a work of art could make it so, quickly spread to students and connoisseurs of "American folk art." All kinds of things, functional and nonfunctional, suddenly were seen to possess inherent artistic value. They were found, so to speak, to be art.

But neither scholarship nor art is immune to fashion. While the design orientation colors several recent major publications on "American folk art,"[9] the aestheticians' territory has seriously eroded since the 1970s. Folklorists especially have rejected folk art as design. At present the methodologies of material culture are satisfied by the study of folk art as document. Objects once automatically admired for their impersonal, abstract qualities are now seen as palimpsests that might lead us straight to the artists who made them.

It is not always certain who these people were, or what they thought about the things they made. But vigorous scholarship has forced us to discard the anthropological idea of "folk" in regard to American art. Robbins, along with Henry Glassie, Kenneth Ames, and others have demonstrated what certain influential early writers on this subject didn't suspect or chose to ignore: most "American folk art" was not created by "American folk."[10] While we have a number of cultural subsets, such as Afro-Americans or Pennsylvania Germans, an "American folk" in the

anthropological sense has never existed

Both Glassie and Ames have dismantled the phrase "folk art," suggesting that its components embody separate, possibly polarized concepts.[11] Once "folk" is subtracted from "American folk art," we are left with some kind of American art. In hunting for sources we quickly find that inspiration for "American folk art" was frequently not even American, so the idea of a unique national aesthetic must also be abandoned.[12] We are left with the word "art," that is, with a large group of aesthetic objects. We are forced to admit that the idea of "American folk art" as good design is a time-linked conception.

This admission does not render the concept totally useless or without importance, since an aesthetic approach to "American folk art" was a key factor in the development of mainstream modern art.[13] However, in the current intellectual climate, advocates of an aesthetic approach to "American folk art" have become an endangered species. By discounting the aesthetics perceived by early collectors and museum personnel, revisionist folklorists may overlook "American folk art's" contribution to modernism, chucking the *Dover Baby* out with the bathwater.[14]

Most of the "American folk sculpture" in the exhibition is actually popular art—normative rather than conservative or progressive, indebted to academic art in roundabout ways, and sometimes nationalistic in subject matter.[15] Very little of the material in the exhibition can qualify as folk art if we accept a folklorist's definition. Henry Glassie sees folk art as an expression of a "traditional aesthetic philosophy that governs the selection, production, treatment and use of forms."[16] We might make a convincing argu-

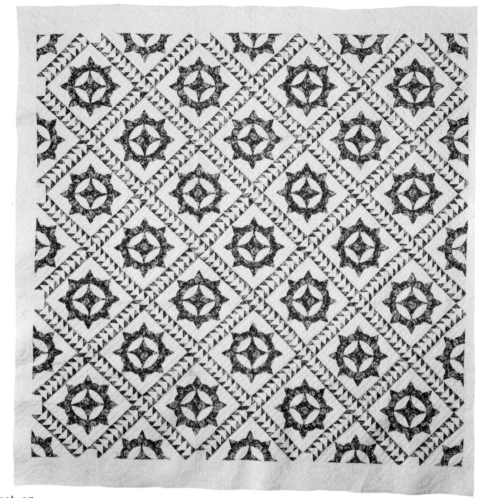

cat. 95

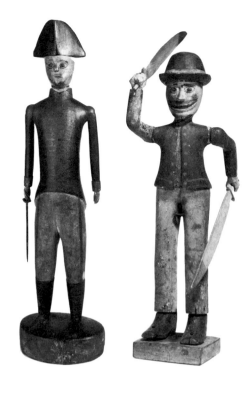

cat. 12 cat. 76

ment for considering certain textiles in the exhibition to be folk art. One is the quilt called *Caesar's Crown* (cat. 95). The pattern has an established name, suggesting that many versions exist. The quilt is characterized by a repetitive and symmetrical aesthetic—its maker produced a unified whole by repeating individually symmetrical units. According to Glassie, symmetry and repetition are universal principles of Western folk design. Glassie notes:

In most of western folk decoration there are two major laws operative: the dominance of form and the desire for repetition . . . the basic form of folk artifacts is never obscured by ornamentation. Rather, ornament serves frequently to reinforce the visual effect of form: its elements may be outlined or their shapes echoed in lines drawn on them.[17]

Glassie indicates that when anthropologically definable folk cultures choose to depict naturalistic and asymmetrical forms, such as the human body, the forms are geometrically reworked so they can be used within the decorative tradition of binary repetitiveness.[18] Two objects in the current exhibition, a late eighteenth-century *Revolutionary Soldier* (cat. 12) and a *Swordsman Whirligig* created one hundred years later (cat. 76) embody folk art characteristics of symmetrical, frontal form articulated by patterning.

Are the soldier and the swordsman actually folk art? Glassie observes:

Figurative . . . sculpture[s] that postdate the Renaissance and seem to be naive may be stabs at realism that failed, or they may be the products of an aesthetic flourishing outside the mimetic progression. Given their cultural milieux and the intentions of their artists, they may be bad or they may be good, and it is not always possible to tell which is which from the work alone.[19]

Unfortunately, once an object has been excised from its original context, we will have difficulty in answering this question.

Folklorists practice not only analysis of artifacts, but also behavioral observation and ethnoscientific questioning in order to elicit a folk aesthetic. Early writers and collectors of "American folk art" went astray here, judging quality in individual works taken out of context. However they were not interested in eliciting a folk aesthetic, but in finding a "tradition" that justified modern

abstract art, and they took what they needed from the folk and popular arts of the preceding two centuries.

The problem of classifying the objects in this exhibition is further complicated by the realization that folk, popular, and avant-garde aesthetics exist simultaneously within our culture, and, worse yet, may coexist within the same object. Glassie points out that "ideas of elite origin and popular dissemination [can] thrive within the folk tradition."[20] Claude Levi-Strauss used the term "bricolage" to describe the mental process in which an artist partially accepts a new idea, fusing the new with the old.[21] This happens in all kinds of creative endeavors—consider an American impressionist painter like Childe Hassam, who combined the advanced broken brushwork of the French with a linear scrutiny worthy of the earlier Pre-Raphaelites. Examine an

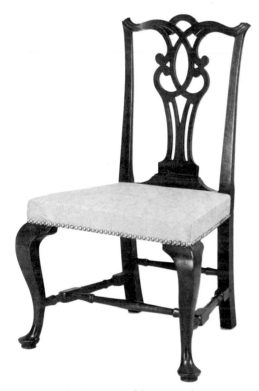

fig. 2. *Side chair*, possibly Massachusetts, 1760–1780 [Yale University, Mabel Brady Garvan Collection]

eighteenth-century American chair with a crest rail and pierced back splat in the Chippendale style, but resting on shod spoon feet, typical of the earlier Queen Anne style (fig. 2).

Why a particular object might reflect multiple aesthetics is a knotty problem indeed. Objects of material culture may embody not only an artist's conception but also a client's desires. Few artists can entirely escape this dilemma (if they even *see* it as a dilemma), and there have always been plenty of artists who tailor their creations to market, or to current popular taste.

In *The Adventures of Huckleberry Finn* (1884) Mark Twain satirizes popular art. Huck is taken in by the Grangerfords, a country family whose "young women had quilts around them, and their hair down their backs." Huck described their home: "I hadn't seen no house out in the country before that was so nice and had so much style." Among the furnishings were "a clock on the middle of the mantel-piece, with a picture of a town painted on the bottom half of the glass front" and "a big outlandish parrot on each side of the clock, made out of something like chalk, and painted up gaudy," and parlor curtains "with pictures painted on them of castles with vines all down the walls, and cattle coming down to drink," not to mention mourning pictures inscribed with touching sentiments as "Shall I Never See Thee More, Alas?"[22] Although he intends to poke fun, Twain makes it quite clear that these objects were owned with pride and pleasure.

How nineteenth-century Americans like the Grangerfords might have enjoyed owning a pair of painted wooden parrots by Wilhelm Schimmel (cat. 15) is one matter, but how an artist felt about making them might be quite another. It certainly was in Schimmel's

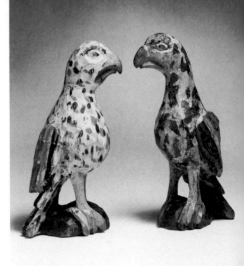

cat. 15

case—the man lived on the margins of society as a semialcoholic itinerant.[23] Early twentieth-century collectors, or today's museum-going public, might have other reactions to the parrots. As George Kubler has pointed out, art objects are relatively static things, but the meanings attached to them are mutable.[24]

Though the debate between folklorists and connoisseurs heated up considerably during the 1970s, aesthetic and folkloric approaches to material culture have coexisted since the middle of the nineteenth century. Even as design reformers in England were admiring (without much cultural understanding) the energetic geometries that embellished objects made by "primitive" (non-Western) cultures, William Thoms proposed the use of the term "folklore." Before 1846, objects of material culture were called "popular antiquities."[25] While designers drew inspiration from all manner of exotic objects displayed at the great world's fairs, folklore societies were founded in Britain (1878) and America (1888) to investigate the cultures in which these objects were made. As early twentieth-century avant-garde artists in America began to collect aesthetically pleasing

"American folk art," other students took an anthropological viewpoint.[26]

Kenneth Ames' controversial essay for the exhibition *Beyond Necessity: Art in the Folk Tradition* (1977) is seen as a watershed in current critical thinking about "American folk art." Ames' polemic shocked the folk art world by debunking long-cherished notions of an "American folk art" supposedly characterized by individuality, national uniqueness, and cultural innocence. In November of that year, a three-day conference on "American folk art" was held at the Winterthur Museum. Folklorists did battle with aestheticians, and some experts were left in doubt whether folk *art* exists or not. Others encountered the methodologies of folklorists for the first time. In his introduction to the seminar papers, Scott T. Swank noted that the conference aimed:

. . . not . . . to convince anyone that earthenware pots are more important than porcelain bowls, but to be more comprehensive and balanced in examining objects and to redress a neglect based on previously dominant elitist values[27]

While organizers of the conference stated that they didn't want to set up a simplistic dichotomy, pitting art history against folklore, the conference has since been called the "shootout at Winterthur." In an increasingly polarized field, doubts as to whether these objects can be considered art continue to plague us, although Glassie pointed out that any artifact must be considered art to the extent that it expresses "an intention to give and take pleasure."[28]

Difficulties over defining folk art have begun to reach the general public. In her recent review of *Young America: A Folk-Art History*, Charlene Cerny, director of the Museum of International Folk Art in Santa Fe, set forth the polarities of the debate:

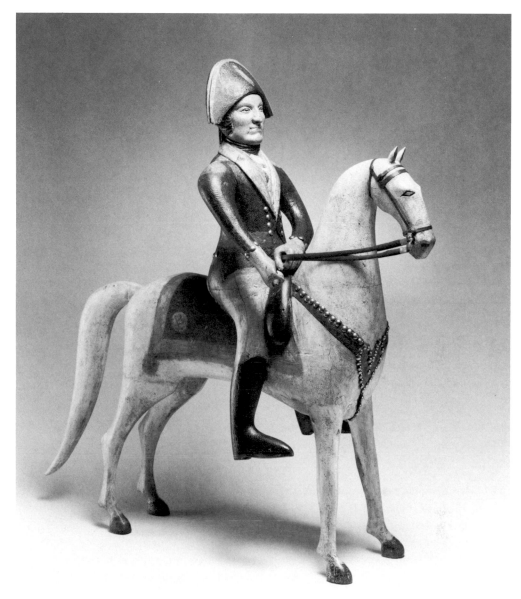

cat. 11

Unbeknownst to all but the inner circle of folk art aficionados, a battle rages between two camps. . . . One group—let's call them the "collector-connoisseurs"—holds indisputable title to the goods themselves. . . . By virtue of their involvement with folk art over the last 50 years, they are . . . the authors of most of the lavish, color-illustrated publications on American folk art and receive national media attention. Their exhibitions appear in such places as the Whitney Museum of American Art, and their approach is correspondingly elitist—they borrow the terminology of art historians to categorize as "paintings," "sculpture" and "decorative arts" the *collectibles* [italics mine] they so applaud for their "achievement in the realm of pure design."

Cerny continues:

. . . the contenders—the "folklorists" will do here—are young and populist, trained in graduate folklore programs at the four or five major universities in the United States that offer them. They take folk art very

seriously as "folk material culture" and prefer to view it in the context of the culture that produced (and continues to produce) it. They don't set much store by esthetic judgments, unless they are made by the folk group itself.[29]

But objects included in "American folk art" catalogues since the first significant exhibitions of the 1930s *are* paintings, sculpture, and decorative arts. There is no need to discard any terminology that might be useful, and I simply cannot imagine an exhibition of "collectibles" at the National Gallery of Art. Electra Havemeyer Webb—brought up amidst the glories of impressionist painting—spoke for herself in regard to her own holdings:

The creators [of these objects] can be kin or strangers and they can be rich or poor, professional or amateur, but in America, and particularly in Vermont and all of New England, they are still known as folks. . . . we must sense in all of [their] work . . . the strong desire . . . to create something of beauty.

Mrs. Webb concluded on a personal note: "Perhaps the creators did not think of it as art, but I am one who has thought so for approximately fifty years."[30]

It's a long way from Rome, Italy, to Andover, Massachusetts, where this sculpture of *George Washington on Horseback* was found (cat. 11), but immortalizing a political hero on a horse was an old idea when the equestrian statue of *Marcus Aurelius* was cast. Centuries later, one Mr. Coolidge—perhaps familiar with popular engravings of such subjects—simply contributed a word to an ancient conversation.[31]

Did the unknown maker of the crimper in cat. 44 ever see a classical nude on his travels, or some version of Hiram Powers' *Greek Slave*? Could he

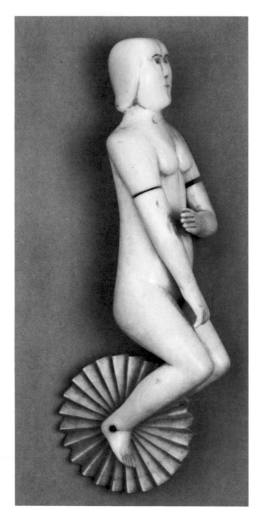

cat. 44

ever have encountered oriental "doctor's dolls" made of ivory? Would we respond differently to the object as a work of art if we knew its sources more precisely? Picasso once commented tartly, "you don't need the masterpiece to get the idea."[32]

How did the original owner feel about using this tool and how would a person with a feminist viewpoint feel today about crimping pastry with this object? Such questions tie the aesthetics of the crimper—its design properties—to a context of linear time.

A have/have not mentality seems to dominate current thinking about "American folk art." "Top-down diffu-

sionist theory"—the supposition that avant-garde or high style art is eventually imitated by popular or folk artists—is viewed by folklorists as misleading. Yet insinuations of elitism now leveled at early collectors lose some of their force when we read Henri Foçillon's reminder that early nineteenth-century romantics embraced "the concept of 'the People' as an active, primordial element placed in opposition to elites."[33] The current anti-aesthetic folk art rhetoric has a curiously 1960s ring to it, but the dichotomy is much older.

Whatever our feelings toward "blockbuster" exhibitions and other ventures in the mass marketing of culture since the 1960s, we can hardly gainsay the efforts of the museum profession to attract a wide public and to provide it with information about various kinds of art. Museums are not the elitist institutions they once were, and our galleries and special exhibitions are packed with visitors. Mrs. Webb, who collected most of the objects in the current exhibition, was not an anthropologist, but she believed "the word 'folk' in America meant *all* of us."[34]

Ames rightly pointed out that "art is not an eternal truth but a time-linked and socially variable concept."[35] In the time line compiled for this catalogue (page 184), I have tried to set events in the history of folk art beside developments in the arts and crafts movement, as well as the march toward modernism.[36] During the early twentieth century, not only painters and sculptors, like the Ogunquit group, but also composers, such as Charles Ives, George Gershwin, and Aaron Copland, sought a useable past that might contribute to a modern present. By juxtaposing cultural events on a time line, we can see more clearly what happened before, during, and after the critical period of the 1920s, 1930s, and 1940s. The

esulting literature of "American folk
rt" that connects eighteenth- and
ineteenth-century material objects to
ontemporary artistic concerns but fails
o relate to the people who made the
bjects appears, in retrospect, logical.
t is easy to agree with Michael
otwinick that "attitudes [toward] folk
rt have been more revealing about the
eholder than the maker."37

I doubt that the term "American folk
rt" will go away; it is as entrenched as
t is vague. To differentiate it from art
nade by identifiable folk groups, the
erm should be used in quotation
narks. My understanding of "American
olk art" is that it means the body of
opular painting, sculpture, and deco-
ative art collected in the early twenti-
th century, surrounded by a valence of
ttitudes toward both modernism and
the common man" that governed the
ollectors. Today one would no more
nistake a piece of "American folk art"
or an object created by an anthropo-
ogically defined "folk" than one would
ake Whistler's *Peacock Room* for a
hamber imported from Japan.

We might well follow the example
et by scholars who have studied the
mpact of the arts of Japan upon mid-
ineteenth-century painting and deco-
ative art. The word *japonisme* was
oined to indicate objects created by
rench, English, and American artists
vho were fascinated by the art of Japan
tself. Similarly, *primitivism* has been
lefined recently as "the interest of mod-
rn artists in tribal art and culture, as
evealed in their thought and work."38
he current furor over the nonethnolo-
ical orientation of the literature on
American folk art" has its parallel in
he history of scholarship on tribal arts:

During the last two decades, the words
rimitive and primitivism have been criti-
ized by some commentators as ethnocen-

tric and pejorative, but no other generic
term proposed as a replacement for "primi-
tive" has been found acceptable to such
critics; none has even been proposed for
"primitivism." That the derived term primi-
tivism is ethnocentric is surely true—and
logically so, for it refers not to the tribal arts
in themselves, but to the Western interest in
and reaction to them. Primitivism is thus an
aspect of the history of modern art, not of
tribal art The notion that "primitiv-
ism" is pejorative, however, can only result
from a misunderstanding of the origin and
use of the term, whose implications have
been entirely affirmative."39

Early "American folk art" enthusiasts
had neither much depth of anthropo-
logical knowledge nor a sympathetic
understanding of nonacademic artists.
Yet they were affirmative in their eager
search for a useable past, a "tradition"
that would justify the efforts of modern
artists to create works that were vigor-
ous, straightforward, and untainted by
academic formulas.

The first exhibition catalogues bear
witness to the design-oriented thoughts
of "American folk art" pioneers. In
October 1930, an early definition
appeared in a pamphlet for an exhibi-
tion of "American folk painting"
organized by three Harvard under-
graduates, Lincoln Kirstein, Edward
M. Warburg, and John Walker. Their
definition was quite romantic. They
thought "American folk art" was some-
thing "springing from the common
people . . . in essence unacademic,
unrelated to established schools, and,
generally speaking, anonymous."40

Later research showed that "Ameri-
can folk artists" sometimes had aca-
demic training and were aware of
developments in "established schools."
But in a commercialized, mechanized
world, anonymity has its allure. We
inherited from early studies of medieval
art the fictive notion that the great
cathedrals were created to express a

"And let's not forget Paul-Auguste Deschard, who did a really great job on the clerestory mullions on the north side of the nave. Take a bow, Paul-Auguste! Next, let's hear it for François de Cœur for his wonderful work on the ogival vaults. François? As for that rose window soaring above the reredos . . ."

Drawing by Stevenson; © 1979
The New Yorker Magazine, Inc.

common, anonymous spirit (fig. 3).
Theorists of the arts and crafts move-
ment celebrated the naive artist-
craftsman of previous centuries. The
fond wish that beautiful objects could
be created instinctively by "the com-
mon man" is wonderfully appealing in
a society not noted for intellectualism.

The first advocates of "American folk
art" hailed the idea of anonymity—
partly for lack of information. "The
carvers and moulders of weather vanes
are impossible to identify," and "the
majority of the figureheads were
anonymous" we read in Holger Cahill's
folk sculpture catalogue of 1931.41 Of
course, as scholarship advanced over
the next half century, the names of
makers were eventually attached to

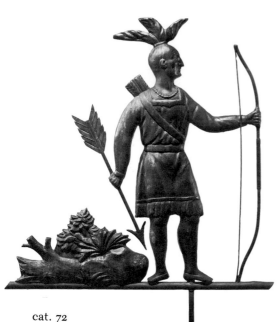

cat. 72

many folk art objects (see cat. 72).[42]

In the arts, a signature has a market value, despite the fact that the work may lack aesthetic or historical importance. Whatever the quality of a piece, it is significantly more difficult to convince a museum board to acquire, say, an American cabinet when it is not signed or labeled. Once a name is attached, the piece usually costs more.

However appealing the anonymous (and implicitly selfless) artisan might seem, most aspects of our cultural life have become increasingly professionalized. One or more researchers, along with a writer, all sign the most insignificant weekly report in *Time* magazine. Concomitantly, the importance of the "common touch" survives: on a huge Denver billboard the looming image of yet another anchorman-as-media personality assures the passerby, "it's like getting the news from a friend." A heterogeneous public, uncertain of its own expertise, conducts a restless search for authenticity and accreditation—becoming ever more dependent upon the opinions of author-

ities and the reassurance of the printed word.

This brings us to the validity conferred by a recognized institution on almost any sort of artistic endeavor. Harvard's "American folk art" exhibition was presented at the Society for Contemporary Art, and many of the important early exhibitions of "American folk art" were held in such bastions of modernism as the Newark Museum, the Museum of Modern Art, and the Whitney Museum of American Art.

Holger Cahill is the person most often credited with (or blamed for) establishing the working definition of "American folk art" that dominated the field until recently. His exhibition *American Folk Sculpture: The Work of Eighteenth and Nineteenth Century Craftsmen* opened at the Newark Museum on 20 October 1931, about a year after his groundbreaking exhibition of "primitive" American painting.

Art and craft are firmly linked in the exhibition title, and Cahill's text codified the design-oriented sensibility and democratic ideals that were applied to the nearly two hundred pieces of sculpture in his exhibition. Cahill wrote that the museum "stressed esthetic quality rather than technical proficiency." Again, anonymity was prized. Cahill applied the same definition to sculpture that he had used for painting:

The work of these men . . . is folk art in its truest sense—it is an expression of the common people and not an expression of a small cultured class. Folk art usually has not much to do with the fashionable art of its period. It is never the product of art movements, but comes out of craft traditions, plus that personal something of the rare craftsman who is an artist by nature if not by training It goes straight to the fundamentals of art—rhythm, design, balance, proportion, which the folk artist feels instinctively.[43]

Rigorous thinkers are driven mad by phrases such as "that personal something." What *are* the unstated aesthetic qualities that early collectors prized? We will not find them clearly defined in the early literature. Rather, we encounter generalities. Cahill, and the many connoisseurs who followed his lead, valued formal properties. Chalkware objects when "good in design and color . . . take their place with the best examples of American decorative sculpture in polychrome." Collectors liked "boldness" and "simplicity" in cigarstore Indians, although Cahill preferred their garish colors to be "mellowed by time."[44]

Personal taste and ill-digested theories muddy the waters here. Figureheads and cigar-store Indians were regularly repainted when they were in use on the bows of ships and next to the doors of shops, but a piece in "original condition" is considered more valuable in an art gallery today. Over the past century, much of America's painted country furniture was stripped, possibly through misapplication of an arts and crafts ideal: truth to materials. Bare wood was deemed more "honest" than "false" imitation graining by arts and crafts practitioners, but was irrelevant as far as painted country furniture is concerned.

Seemingly indefensible attitudes are held by connoisseurs in many fields. The elegant aesthete and collector Charles Lang Freer was challenged by a quite knowledgeable scholar on his attribution of a particularly prized piece of antique pottery, which later was found to be almost brand-new. Freer responded, "what you say may be true from the scientific point of view, but I prefer to rely upon the art-feeling expressed."[45]

Freer's approach to collecting oriental and American art can be understood

est in terms of the abstract aesthetic relationships he formulated to compare historically unrelated objects, including paintings, prints, and pottery from both the West and the East. Connoisseurship has always sailed in dangerous waters. Freer followed a vaguely stated, spiritual, synthetic system of aesthetics rather than an analytical one.[46] Yet his ideas resulted in a significant and cohesive art collection. As Glassie commented, "the lack of an aesthetic vocabulary does not prevent aesthetic operation."[47]

Aesthetics are, often enough, colored by politics. Arthur F. Eigner, then president of Newark's museum board, revealed a nationalistic bias in his introduction to Cahill's 1931 sculpture catalogue. During an economically and politically unstable era between world wars, Eigner wrote:

Last year the Newark Museum opened an important exhibit of American Primitive Paintings. . . . As charming as the paintings were, we could not persuade ourselves entirely that we were viewing an wholly native expression of American growth . . . most of the artists represented had no doubt seen originals or reproductions of paintings of foreign schools. . . .

When the men here represented laid their hands to their tasks, whether in the production of a weather vane, a decoy, an emblem, or a tradesman's sign, they doubtless did not aspire to the rank of painters of portraits and landscapes. They were fashioning articles for practical uses. Not being consciously engaged upon art, they consulted no guide but nature.[48]

In retrospect, Eigner's assumptions of unconscious art making seem condescending. We have gradually become aware of guides other than nature for "American folk sculpture" that make it impossible to view these pieces as free of outside inspiration. For example, the probable relationships between popular

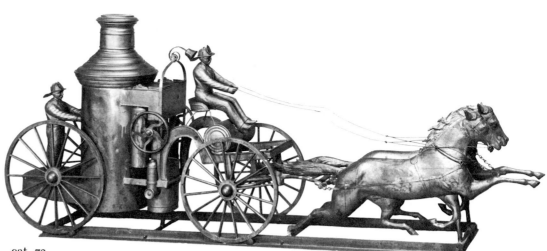

cat. 73

prints by Currier and Ives and elaborate weather vanes by several makers (see cat. 73) have been frequently observed.

Another American weather vane presents a stylized image of a circus rider (cat. 71). So does Seurat's painting, *Le Cirque* (fig. 4). While we haven't a shred of evidence to connect the two objects, we do know that Seurat was interested in both popular culture and in certain types of early art, particularly that of ancient Egypt. William Rubin's comments about tribal art may be applicable here:

When . . . ahistorical juxtapositions are visually convincing, they illustrate *affinities* rather than *influences*. . . . That such striking affinities can be found is partly accounted for by the fact that both modern and tribal artists work in a conceptual, ideographic manner, thus sharing certain problems and possibilities.[49]

cat. 71

Aesthetic criteria used by early collectors of "American folk art" can be partially extrapolated from then-current ideas about formal design. These ideas are rudimentary, general, and subject to the vagaries of personal taste—but they do exist. We find them set forth in the Museum of Modern Art's *Elements of Design*, an enormous set of handsome placards illustrated with examples of industrial design, as well as art by various modernists.[50] This publi-

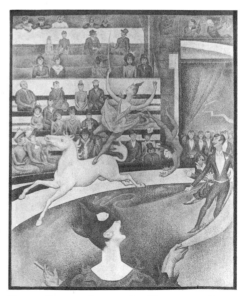

fig. 4. Georges Seurat, *Le Cirque*, c. 1890–1891, [Louvre, Paris]

33

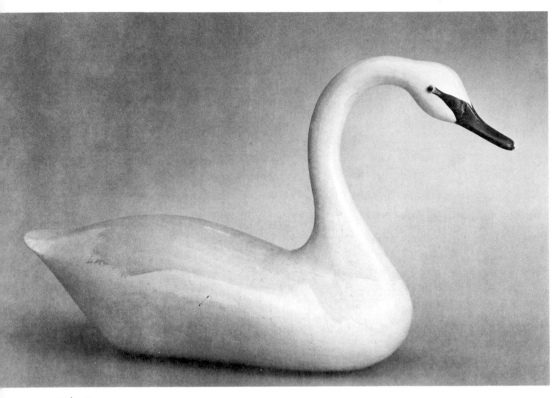

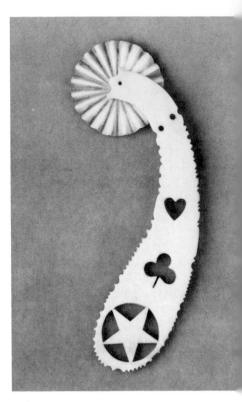

cat. 42

cat. 33

cation was intended to provide basic instruction in design principles, and was subtitled "a new experiment in visual education to show how certain fundamental principles are used in all fields of design."

Most of the shibboleths of "good design" appear: "Materials are chosen to fit the task." Designers use "basic elements": line, form, space, light, and color. Line is "a path of action," and a line's character "expresses the force creating it." We can find beauty through "precision and logic." Scattered objects will create accidental patterns, but "instinctively we want to rearrange them until our sense of order and balance is satisfied." We read that "simple massive forms are among man's greatest monuments to human dignity and power," and that a designer "must choose from the infinite variety of colors that exist [giving] order and meaning to the colors he uses by controlling

the area, shape, and placement of each."[51]

"Design is everywhere," says one card. "The images of design vary with each civilization. The elements of design never change," says another. I doubt that early collectors of "American folk art" thought twice about applying such standards to the objects they prized.[52]

Their criteria were grounded as much in what was gathered as in what was written. Three works from the Shelburne collection—an ornamented pastry crimper, a swan decoy, and a ram weather vane (cats. 42, 33, and 68)—have simple forms. The maker of the crimper has precisely located his cutout patterns, isolating them in a flat field surrounded by an active, nervous line—the scalloped edge. The maker may or may not have rearranged his patterns until his sense of order and balance was satisfied, but it obviously sat-

isfied the original collector, a relative of Mrs. Webb, and today it continues to satisfy the beholder.

Both the swan decoy and the ram weather vane have massive dignity. Shallow volumes interplay with seductive edges. Elegance of line abounds. It would be all too easy to take off from here, extolling the design sensibilities of these three artists from a twentieth-century point of view without knowing anything at all about the makers. The question of artist's intent should not be confused with the resulting work of art.

Each of the three objects mentioned above had a specific utilitarian function. However, while "usefulness" was a prime requirement for admiration of an item of "American folk art,"[53] exceptions were made from the beginning: "Most of these things were made for use, but here and there one finds examples of portrait sculpture, or a carving which has no apparent basis in util-

34

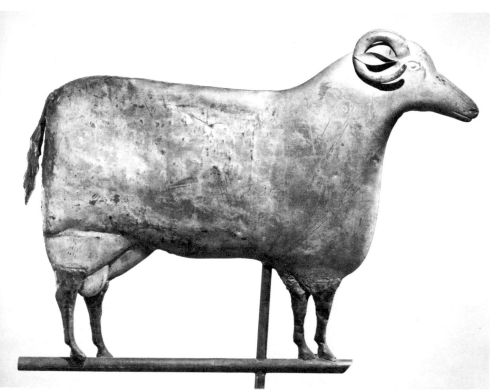

cat. 68

ity and which was made simply for the pleasure of making it."[54]

One such item was *The Preacher*, chosen as a frontispiece to Cahill's sculpture catalogue of 1931. Cahill had already featured it the previous year as one of three sculptures added to his "American folk painting" exhibition (fig. 5). Soon after the standing wooden figure was discovered in Indiana, it was said to depict Henry Ward Beecher. It is described at length in Cahill's sculpture catalogue:

With simplest and crudest means sculptor has achieved by the earnestness of his attempt, a remarkably vital figure. Sharp outline of flowing hair frames a face stern, determined, uplifted. Tiny straight hands clutch huge Bible from which spirit seems to draw strength. Absolute stillness of body, and curve of shoulders tend to concentrate interest on head. Figure seems complete in spite of lack of legs. Arms with loose sleeves are separate pieces applied.[55]

The Preacher was accorded continuing attention. It was reproduced in *Art of the Common Man* held at the Museum of Modern Art in 1932, and in Jean Lipman's *American Folk Art in Wood, Metal and Stone* (1948). Lipman's description follows:

The portrait of Henry Ward Beecher is said to have been carved about 1850 by a farmer named Corbin at Centerville, Indiana, during a visit which Beecher paid to Corbin's home. Through the most elementary means the humble carver transformed a log of wood into a vital figure which communicates the inspiration of a man of God. The body enclosed in a shell-like coat serves as a plain, organic base for the dramatically uplifted head; and our attention focuses on the squarely modeled face and tiny, tense hands that clutch and support a heavy Bible. The absolute simplicity of contour and plastic expressiveness make this homely carving a masterpiece of the highest order.[56]

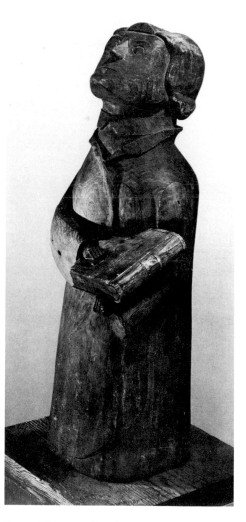

fig. 5. *The Preacher*, found in Centerville, Indiana [Abby Aldrich Rockefeller Folk Art Collection, Williamsburg]

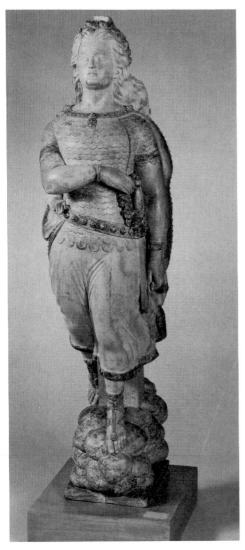

cat. 13

Over the ensuing decades, *The Preacher* was frequently lent for exhibition.[57] When it was reproduced in *The Flowering of American Folk Art* (1974), the accompanying text had changed very little since Holger Cahill's 1931 description:

An Indiana farmer is said to have carved the portrait of the Reverend Henry Ward Beecher during a visit the abolitionist minister paid to his home. One need not know the details of Beecher's career or the fervor of his anti-slavery crusade to feel what the carver felt: the presence of a deeply religious man who literally draws his strength

from the Bible and lifts his eyes, indeed his whole being, to behold his God. The impression of intensity and devotion is as powerful as that made by the carved saints on Romanesque churches and Gothic cathedrals.[58]

This was slightly closer to the truth—it has recently been proposed that the piece was inspired by a metal replica of the bronze monument to Martin Luther by Ernest Rietschel (1804–1861), erected in Worms in 1868 after being completed by his students.[59] But emotion projected upon an absent artist has not withstood the test of time, and *The Preacher* has not been lent for exhibition lately, though its strong design characteristics have not changed.

Perceptions of good design in "American folk art" have been most consistently applied in the publications of Jean Lipman. Looking at the *Belle of Bath* by Charles A. L. Sampson (p. 200 in time line), she wrote, "The scroll-work on which [the figure] stands harmonizes perfectly with the rich scalloped design of her dress, and both echo in stylized form the rolling waves of the sea."[60] Lipman's comments are general enough to be applicable to Sampson's *Brunhilda* figurehead included in the present exhibition (cat. 13). Considering a group of Lombard roosters (cat. 74), Lipman found:

cat. 74

The silhouettes of these weathervanes and others Lombard executed are extremely stylized, and the cut-out areas which indicate the arrangement of tail feathers greatly enhance the interest of the design. . . . The effect achieved through a flair for functional design and a natural vitality of execution, . . . would be hard to surpass in the most finished pieces of academic sculpture.

Academic art has been the enemy since the earliest rumblings of modernism back in the 1860s. William Rubin notes that mainstream artists who were engaged in primitivism admired simplicity in tribal materials because of the absence of "complex devices of illusionist lighting and perspective." Their own interests were affirmed by a "vigor and expressive power . . . [they] missed in the official art of their own day, which was based on classical and academic models."[62] Writers such as Lipman followed the lead of avant-garde painters, looking for and finding nonacademic simplicity and vigor:

. . . it is rather those simpler pieces that one feels could stand as pure design in comparison with any sculpture, native or foreign, primitive or academic, that will retain the most lasting value as American folk art.[63]

Lipman particularly admired an iron pheasant (fig. 7). As the "simplest

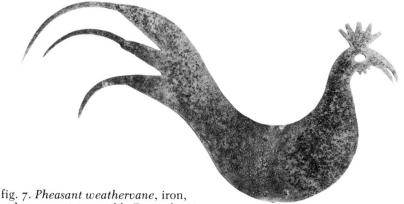

fig. 7. *Pheasant weathervane*, iron, unknown artist, possibly Pennsylvania [reproduced in Jean Lipman, *American Folk Art in Wood, Metal and Stone*, New York, 1948, fig. 43]

fig. 8. Constantin Brancusi, *Bird in Space*, polished bronze, c. 1928 [Collection of the Museum of Modern Art]

imaginable weathervane" it was "among the finest examples of American design." She went on, "if one of our modern sculptors had conceived this piece, one would talk of sophisticated simplification; actually its purity of line was the result of the unselfconscious instinct for design that guided the shears of some simple Pennsylvania ironsmith."[64] Of course, if we set the ironsmith's pheasant against the work of "one of our modern sculptors," such as Brancusi, we can see either the pheasant or *Bird in Space* (fig. 8) as an aesthetic whole, economical in its use of shape and line. However, neither piece could have resulted from anything other than calculated design decisions.

The apparent cultural desire for a Pennsylvania ironsmith to be "simple" is a real one, although it has nothing to do with the art he created. A nostalgic need for cultural innocence pervades not only art history but also our political history and popular culture. American mythologies play nightly on television. They feed much of our advertising. For many, they tint a world view. In a recent editorial, political journalist Garry Wills generalized:

. . . there is something depressing to the American spirit about having to keep the accounts of a world empire. We would have the empire without the sophisticated, compromising, accommodating mentality that it takes to administer vast responsibilities. We would keep the mores of a small village . . . in a time of great technological change and manipulation. Individual heroes were produced at State of the Union addresses to represent the "real America" in our complex age of interdependence.[65]

We have more than one example in our culture of a mythology surrounded by art and artifacts created to serve particular needs. The American open-range cowboy flourished a mere thirty years, from the 1860s to the 1890s. But, as Lonn Taylor points out, "The cowboy of the 1880s was . . . simply a hired hand on horseback. The cowboy of the 1980s is a figure in a national morality play." An English visitor recognized American mythmaking as early as 1887:

Distance is doing for [the cowboy] what lapse of time did for the heroes of antiquity His admirers are investing him with all manner of romantic qualities: they descant upon his manifold virtues and his pardonable weaknesses as if he were a demi-god. . . . Meantime, the true character of the cowboy has been obscured, his genuine qualities are lost in fantastic tales . . .[66]

Heroic characteristics shared by the mythical cowboy and the mythical "American folk artist" might include not only impossible daring and skill but also innocence, individualism, and love of rural life. The cowboy myth has been perpetuated in dime novels, stage productions, advertising, and film. Painting and sculpture reflect the mythology and were created in concert with it (fig. 9). As this century draws to a close, and artists continue to make "folk art," it is virtually impossible to believe that they do so in a vacuum of innocent naiveté.

In earlier centuries, images were replicated chiefly through prints; today, they are even more widely circulated through magazines and television. A neoclassical goddess can play the muse to an artist high or low: witness a weather vane, roughly contemporary

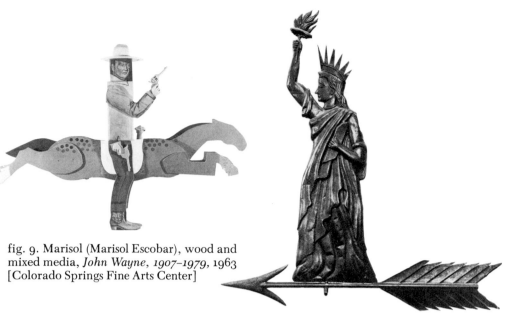

fig. 9. Marisol (Marisol Escobar), wood and mixed media, *John Wayne, 1907–1979,* 1963 [Colorado Springs Fine Arts Center]

fig. 10. *Liberty Weathervane,* metal [reproduced in Jean Lipman, *American Folk Art in Wood, Metal and Stone,* New York, 1948, fig. 48]

fig. 11. Bob Ramsour, *Liberty Figure,* painted sheet metal, c. 1983–1984, Denver, Colorado [photo by Lloyd Rule]

with Bartholdi's *Statue of Liberty* (fig . 10). Popular artists continue to create aesthetic objects drawing upon past forms. Bob Ramsour, owner of a Denver plumbing and heating firm, designed a Liberty figure "three or four years ago."[67] He is not particularly concerned with the exact date. Along with several of his employees, Ramsour fabricated the piece of sheet metal and painted it white. Media attention surrounding the restoration of Bartoldi's *Statue of Liberty* in 1986 convinced Ramsour to paint his piece minty green in imitation of patinated copper (fig. 11).

The very cloud of unwarranted assumptions that surrounds "American folk art" in a haze of naiveté and innocence may also make these objects unthreatening and accessible to the general public, unaware of the complex ways in which folk patterns are transferred and repeated. As is inscribed on the Shelburne's *Fourth of July* rug (cat. 121), "all had a good time." Watercolor offers a parallel case, in which a complicated and difficult medium has achieved widespread popularity, partially because of a long association with the nonthreatening Sunday painter.[68]

Anthropology and aesthetics are not,

after all, mutually exclusive. We can enjoy the design properties of "American folk art" in two ways: in folkloric terms as we learn more about the aesthetic systems, intentions, and aspirations of the creators, and in historical terms as we understand how "American folk art" fed the process of mainstream avant-garde abstraction.

When engaged in looking for "good design" in American folk art, we can take comfort from Susan Sontag's assertion that "the world *is,* ultimately, an aesthetic phenomenon." Although we would do well to discard our rose-colored glasses, we might, in good conscience, enjoy as background music Aaron Copland's 1942 composition, *Fanfare for the Common Man.*

1. Susan Sontag, "On Style" (1965), reprinted in *A Susan Sontag Reader* (New York, 1982), 148.
2. Henry Glassie, "Folk Art" (1972), in Thomas J. Schlereth, ed., *Material Culture Studies in America* (Nashville, 1982), 135.
3. American art in general is a young subset in the history of art; its study hardly existed until the late nineteenth century. Within it lurks "American folk art," a particularly ill understood category over which few scholars would dare claim intellectual dominion. The classic article on the difficulties of terminology is Alice Winchester,

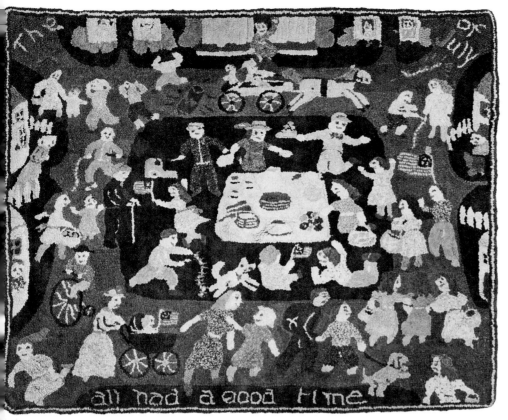

all had a good time.

cat. 121

"What is American Folk Art? A Symposium," *The Magazine Antiques* 57, no. 5 (May 1950), 355–362.

4. Alice Winchester, "Introduction," Jean Lipman and Alice Winchester, *The Flowering of American Folk Art* [exh. cat., The Whitney Museum of American Art] (New York, 1974), 9.

5. Daniel Robbins, "Folk Sculpture Without Folk," in *Folk Sculpture USA*, ed. Herbert W. Hemphill, Jr. [exh. cat., The Brooklyn Museum] (Brooklyn, 1976), 12. Robbins adds that there was a clear reason why the works of French "naive" artist Henri Rousseau, the art of various primitive peoples, and "American folk art" all were seen as crucially important during the 1930s. The "imagined community among all primitive art [which] extended to include the work of children, lunatics, and subconscious man as well as the work of people from the most diverse cultures in distant times and once remote places" came into being partly as a reaction against modern abstract art: "Vigor and raw strength came to be identified with meaningful invention

and the two were frequently confused."

The time line included in the present exhibition catalogue indicates that exhibitions of all these types of art coincide and overlap, having been staged by the same institutions during the 1930s and 1940s.

6. Robbins, 14.

7. The best examples appear in Jean Lipman, *Provocative Parallels: Naive Early Americans/International Sophisticates* (New York, 1975).

8. Robbins, 14, 16.

9. See, for example, Tom Armstrong, "The Innocent Eye: American Folk Sculpture," *200 Years of American Sculpture* [exh. cat., Whitney Museum of American Art] (New York, 1976), 74–111. Armstrong acknowledges his debt to Jean Lipman's approach. See also *American Folk Art: Expressions of A New Spirit* [exh. cat., Museum of American Folk Art] (New York, 1982), and Jean Lipman, Elizabeth V. Warren, and Robert Bishop, *Young America: A Folk-Art History* [exh. cat., Museum of American Folk Art] (New York, 1986).

10. To be fair, several contributors to the

1950 symposium on "What is American Folk Art?" were concerned about the anthropological dimensions of the material. Nina Fletcher Little wrote, "I like the generic term 'folk art' rather less . . . because to me the word 'folk' connotes a European class which had no counterpart in rural America." And E. P. Richardson complained, "I do not believe the frequently repeated explanation that its charm comes from the fact that American folk art was made by free and hardy native Americans who were ignorant of Old World customs and conventions. That is not altogether true, in the first place, and it is usually irrelevant, in the second. American folk art is not Americana. It is art" (*The Magazine Antiques* 57, no. 5 [May 1950], 360, 362).

11. In trying to sort out what "American folk art" may or may not be, I have found the writings of Henry Glassie to be the most useful. He notes, "The adjective 'folk' when applied to an object provides specific information about the source of the ideas that were used to produce the object," specifically the maintenance of tradition, while "saying of an object that it is 'art' provides information about the intentions of its producer" (129).

Kenneth Ames views "folk" and "art" as polarized words. He comments that "some of their meanings and associations are so incompatible that the term becomes a paradox: *folk* cannot modify *art*." See Ames, "The Paradox of Folk Art," *Beyond Necessity: Art in the Folk Tradition* [exh. cat., The Winterthur Museum] (Winterthur, Delaware, 1977), 13.

12. The demarcation of national boundaries does little to help us understand art. James McNeill Whistler, usually claimed as an American artist because of his birthplace, departed in 1859 and for the rest of his long life created pictures that place him within the mainstream of French and British painting. His pictures have virtually nothing to do with America. The time line included in this catalogue suggests that the anti-elitist notion of "the common man" was linked to political upheavals as early as the 1840s.

Glassie reminds us that "the interest in the folk artifact developed apace with romantic nationalism, receiving official sanction in the 1930s in Nazi Germany and depression America" (128).

But Henri Foçillon warned delegates to

the first International Congress of Folk Art in Prague (1928) that "*national* and *ethnic* frames of reference do not coincide with those of folk art, nor could they possibly do so. They are unstable and changing: the notion of race is confused and often artificial, and a people as such is only a complex, ancient or modern, which is temporarily stabilized in a language and a civilization. These same languages and civilizations must enrich themselves from without, on pain of dying." Foçillon, "Introduction to *Art Populaire* (1931) reprinted in Robert Trent, *Hearts and Crowns: Folk Chairs of the Connecticut Coast 1720–1840* [exh. cat., New Haven Colony Historical Society] (New Haven, 1977), 17.

13. Robbins notes, "One of the most interesting aspects of the acceptance of modern art in the United States is the very special place within it that was assumed by American folk art [which] furnished, almost over night, an unbroken American tradition with a clear relationship to what was being done by leading American artists in the early thirties" (19).

14. George Kubler's caveat that quality judgments are an integral part of art historical analysis is repeated in Trent's catalogue, *Hearts and Crowns*, 14: "Kubler has warned that the neglect or refusal of structuralists to recognize quality as a significant element in analysis of folk art renders folk art studies a branch of ethnology." Since its publication, Trent's catalogue has been cited more than once for retaining a basis for art historical qualitative judgment without denying the relevance of anthropological structuralist theory in regard to pattern and system.

15. For definitions of popular art, see E. P. Richardson, *A Short History of Painting in America* (New York, 1963), 4–6; and James Thomas Flexner, *Nineteenth-Century American Painting* (New York, 1970), chap. 6.

16. Glassie, 124.

17. Glassie continues, "Folk ornamentation is repetitive . . . in the ways Paul Klee described as simplest in his *Pedagogical Sketchbook*. Western folk ornamentation almost never reaches the sophistication of the nonsymmetrical balance of elite art or the rhythmic complexity of much of primitive art" (136).

18. Glassie, 137.

19. Glassie, 133–134.

20. Glassie notes, "The division of culture into folk (conservative), popular (normative), and elite (progressive) is often treated as if it carried socioeconomical validity. Although considered to be 'levels of society,' these abstract distinctions are most useful when thought of as opposing forces having simultaneous existence in the mind of every individual, though one or another of the modes of thinking may predominate in certain individuals or in the groups they combine to form" (130).

21. See Claude Levi-Strauss, *The Savage Mind* (Chicago, 1969), 16–22, cited in Glassie, n. 12.

22. Mark Twain, *Adventures of Huckleberry Finn* (1884; facsimile reproduction in *The Art of Huckleberry Finn*, ed. Hamlin Hill and Walter Blair [San Francisco, 1962]), 156–157.

23. See Ames on "The poor but happy artisan" (27–31).

24. George Kubler, *The Shape of Time: Remarks on the History of Things* (New Haven, 1967).

25. For a summary and analysis of design reform in England see Gillian Naylor, *The Arts and Crafts Movement: A Study in Its Sources, Ideals and Influence on Design Theory* (Cambridge, Massachusetts, 1971), chaps. 1, 2; and Brent C. Brolin, *Flight of Fancy: The Banishment and Return of Ornament* (New York, 1985), chaps. 5–8.

Thoms proposed the use of the term "folklore" in *Athenaeum* 982 (22 August 1846). For this information I am grateful to folklorist David Brose at the Colorado Council on the Arts and Humanities.

26. For a summary of the Ogunquit group's members and activities, see Beatrix T. Rumford, "Uncommon Art of the Common People: A Review of Trends in the Collecting and Exhibiting of American Folk Art," in Ian M. G. Quimby and Scott T. Swank, *Perspectives on American Folk Art* (New York, 1980), 14–15. Rumford's article is a very useful historiography of collecting "American folk art" during the early twentieth century.

While the Ogunquit painters and sculptors were collecting "American folk art" for aesthetic reasons, Allen Eaton organized the first of approximately thirty exhibitions on traditional crafts in Buffalo in 1919. He continued the exhibitions until 1932, and his approach was to treat objects within a social and cultural context, rather than to make the kinds of aesthetic judgments that artist–collectors were making.

27. Swank, "Introduction," *Perspectives on American Folk Art*, 6.

28. Glassie, 124.

29. Cerny adds, "Avoiding judgments like charming and quaint, the folklorists avidly study, rather than simply collect, folk artifacts, the better to understand both past and present American culture. Their books are often produced in limited quantities by university presses; the exhibitions they mount tend to emphasize the production process and the object's function rather than its appeal for art collectors today." See "Everyday Masterpieces," *The New York Times* (Sunday, 22 February 1987), section 7, page 15, column 1.

30. Electra H. Webb, "Folk Art in the Shelburne Museum," *Art in America* 43, no 2 (May 1955), 15–16.

31. The bronze image of Marcus Aurelius, who ruled A.D. 161–180, was moved to the Capitoline Hill in Rome by Paul III in 1538. It stood previously in the Roman Forum and in front of Saint John Lateran. For a long time it was believed to be a statue of the Christian Emperor Constantine. Misattributions and erroneous information are not confined to historians of "American folk art."

32. Picasso to William Rubin, cited in Rubin, "Modernist Primitivism: An Introduction," *'Primitivism' in 20th Century Art. Affinity of the Tribal and the Modern*, ed. William Rubin [exh. cat., The Museum of Modern Art] (New York, 1984), 1:14.

33. Foçillon, in Trent, 15. Early "elitist" collectors have, after all, left enormous collections of "American folk art" for scholars to study at leisure and for the general public to enjoy.

34. Webb, 15.

35. Ames also points out that the definition of art is altered "in response to complex patterns of social interaction" (16).

36. I am extremely grateful to Allison Green, Jane Fudge, Alice Lindblom, Leila Held, Virginia Stratton, and George Shackelford for their assistance with the time line.

37. Michael Botwinick, "Foreword," *Folk Sculpture USA*, 5.

38. Rubin, 1:1.

39. Rubin, 1:5.

40. Cited in Rumford, 25.

41. Holger Cahill, *American Folk Sculpture, the Work of Eighteenth and Nineteenth Century Craftsmen* [exh. cat., The

Newark Museum] (Newark, 1931), 14, 24.

42. See, for example, Pauline A. Pinckney, *American Figureheads and Their Carvers*, (New York, 1940), which identified over 800 artists. See also Clara Endicott Sears, *Some American Primitives: A Study of New England Faces and Folk Portraits* (Boston, 1941). Eventually, studies of single artists were written, for instance, Mary C. Black, "A Folk Art Whodunit [Jacob Maentel]," *Art in America* 53, no. 3 (June 1965), 96–105.

43. See Cahill, *American Folk Sculpture*, 13. See also Cahill's essay in *American Primitives: An Exhibit of the Paintings of Nineteenth-Century Folk Artists* [exh. cat., The Newark Museum] (Newark, 1930), and Cahill, "Folk Art: Its Place in the American Tradition," *Parnassus* 4, no. 111 (March 1932), 1–4, where he asserted that "the best folk art" pieces had been valued for "their genuine esthetic merit and for their definite relation to certain vital elements in contemporary American art." Cahill was consistent in his definition of "American folk art" throughout his career.

44. Cahill, *American Folk Sculpture*, 18 (chalk figures), 14 (cigar-store Indians).

45. Freer to Rufus E. Moore, 18 November 1901, Freer archive, The Freer Gallery of Art, Smithsonian Institution.

46. David Park Curry, "Charles Lang Freer and American Art," *Apollo* 118, no. 258 (August 1983), 164–179.

47. Glassie observes that commentators from the historian Vasari to contemporary folk artists often do not or cannot clearly articulate their aesthetic prejudices (135).

48. Cahill, *American Folk Sculpture*, 9.

49. Rubin, 1:24–25.

50. Robert Jay Wolff, Elodie Courtes, Victor E. D'Amico, and Alice Otis, *Elements of Design* (New York, Museum of Modern Art, 1945).

51. See cards 4, 7, 10, 15, 21. Here is a passage in which the early "American folk art" literature reflects interest in a relationship between materials, technique, and style: "The ease with which the pine could be cut abetted the American carvers' [of figureheads] natural inclination to model their surfaces in broad planes, and to pay less attention to elaborate detail than to the large contours of the silhouette." Jean Lipman, *American Folk Art in Wood, Metal and Stone* (New York, 1948), 31.

52. Jean Lipman, discussing a weather vane, commented on its "complex and beautifully balanced" profile. Lipman noted "the line flows around the head, wings, and body with interestingly varied rhythm. The strong vertical lines of the supporting rod and the exactly horizontal arrow establish a sense of stability, and emphasize by contrast the rounded contours of the figure. This weather vane was certainly not designed with these aesthetic principles in mind, but the maker instinctively wrought his figure with a dynamic balance of lines and masses, which resolve themselves into a rich formal pattern for our design-conscious modern eye" (55).

53. Glassie summarizes this belief and its implications: "The artistic nature of a folk artifact is generally subordinate to its utilitarian nature so that most folk art exists within the immediate context of folk craft. The problem of folk art (as opposed to folk craft) scholarship, then, lies less in identifying specific forms and techniques than it does in identifying the characteristics of the traditional aesthetic philosophy that governs the selection, production, treatment, and use of forms" (126).

Early catalogues on "American folk art" are organized by forms (cigar-store Indians, figureheads, weather vanes) and by technique or material (wood, metal, stone). While compilers understood, it would seem, the subordination of the artistic to the utilitarian, they did not identify traditional folk aesthetics, but rather projected their own avant-garde aesthetics upon the objects in question.

54. Cahill, *American Folk Sculpture*, 17.

55. Cahill, *American Folk Sculpture*, 40. The catalogue notes were written by Cahill's assistant, Elinor Robinson.

56. Lipman, 178. Lipman viewed *The Preacher* as both a "specific interpretation of a pioneer American life" and as "sculpture reduced to its universal common denominator."

57. *The Preacher* has an extensive exhibition history. It was originally sold by Edith Halpert. It appeared in both of Cahill's Newark Museum exhibitions, 1930 and 1932. It was shown in Cahill's *Art of the Common Man* at the Museum of Modern Art, also in 1932. It was lent to the Jeu de Paume in Paris for an exhibition of three centuries of American art in 1938. It was shown again at the Museum of Modern Art in 1939. From 1957 until 1966, the piece was shown in Baltimore, Dallas, New York, Minneapolis, Santa Fe, Jacksonville (Florida), and elsewhere.

58. *The Flowering of American Folk Art*, 123.

59. Rumford, 30. The attribution was made in 1975 by John Maas. In his letter to Jean Lipman, Maas noted that the Rietschl sculpture was unveiled in 1868 and was immediately followed by wood engravings and music boxes with a replica on the lid—these were available in the United States almost immediately. I am grateful to the staff of the Abby Aldrich Rockefeller Collection at Colonial Williamsburg for supplying this information.

60. Lipman, 31.

61. Lipman, 51.

62. Rubin, 1:2.

63. Lipman, 55.

64. Lipman, 55.

65. For Garry Wills on the Iran-*contra* affair, see "What Happened" *Time* 129, no. 10 (9 March 1987), 40–41. Wills discusses the situation as a "vast community exercise in make-believe."

66. "On a Western Cattle Ranch," *Fortnightly Review* 47 (1887), 516, cited in Lonn Taylor, "The Open Range Cowboy of the Nineteenth Century," in Taylor and Ingrid Maar, *The American Cowboy* [exh. cat., American Folklife Center, Library of Congress] (Washington, 1983), 17.

67. Telephone conversation, Jane Fudge with Bob Ramsour, May 1987.

68. Although most artists find watercolor technically challenging, the finished pieces seem to be accessible, nonthreatening, something that can be enjoyed by the general public for aesthetic reasons whether or not subject matter is clearly understood. A flood of nineteenth-century manuals, often published by companies selling the necessary materials, helped to identify watercolor as an amateur's medium.

Some recent well-attended exhibitions include Transco Energy Company, *Contemplating the American Watercolor*; National Gallery of Art, *Winslow Homer Watercolors*; *American Traditions in Watercolor: The Worcester Art Museum Collection*. Moreover, survey exhibitions of important collections often include a large number of watercolors. Watercolors made up about one third of the pictures included in *The Bostonians: Painters of an Elegant Age, 1870–1930*, Boston, Museum of Fine Arts.

Flowers from the Needle

JANE C. NYLANDER

THE PRODUCTS OF AMERICAN LOOMS and needles have always been prized for their qualities of design, color, and workmanship. The earliest settlers wove threads into linens, bed coverings, curtains, cushion covers, rugs, and carpets. Because these things were useful, people could rationalize the investment of tremendous amounts of time, whether they used costly materials or made thrifty use of things at hand. Homemade blankets, coverlets, and carpets were ornamented with geometric forms defined by the technology of the loom. Naturalistic forms of leaves and flowers, birds, and fanciful animals could only be wrought with the needle. Imported English, French, or Indian textiles offered rich colors and designs ranging from simple block-printed flowers to complex narratives printed from engraved copperplates. Until the advent of inexpensive machine-printed wallpapers and color lithography in the mid-nineteenth century, the greatest variety of visual ornament and richest color in many households was achieved through the medium of textiles.

The making of quilts, blankets, and floor coverings offered American women an opportunity to express their creative impulses, experiment with color and form, and participate in current fashion. Within the confines of domesticity, women were able to find aesthetic expression as well as a satisfying sense of productivity in the manufacture of textile items for use within the family. Some of these are barely more than utilitarian objects, but the best are truly works of art. Women's letters and diaries prior to the mid-nineteenth century give no indication that this was a particularly self-conscious expression, however. The words used to describe textiles are usually related to work, help, time required, and quantity produced. Occasionally there is a reference to the achievement of a satisfactory color effect or the exchange of a prized pattern, but these are not related to aesthetics in the twentieth-century sense of the word.

Despite a common misconception that American quilts, coverlets, and hearth rugs have only recently been rediscovered, they have always been valued by their creators and treasured in families, even if the glories of their design and color were not articulated values. In rural areas, domestically produced textiles and fancy work have been exhibited at the agricultural fairs sponsored by state and county agricultural associations (fig. 1) beginning in Massachusetts in 1808. The earliest agricultural fair in the Connecticut Valley was the Cattle Show, Plowing Match, and Fair of the Hampshire, Franklin & Hampden Agricultural Society held at Northampton on 18 October 1818, where "a few but choice specimens of Household Manufactures were examined."[1] The purpose of such fairs was to display and celebrate the products of local farms and manufactures. To encourage participation, lists of offered prizes were published in advance of the fair date in local newspapers and in the regional agricultural press. Later, the list of winners was also published. In the area of textiles, quality and quantity of production were highly valued. The comments of the committee on household manufactures at the Berkshire County (Massachusetts) Fair in 1838 are typical: "Rich products of the card and spinning wheel, substantial fabrics of the loom, tasteful ornaments of the frame and needle, have come with a beauty of coloring and fineness of texture unrivalled to show what the industry and taste of the frugal housewife can effect."[2]

In the earliest fairs, quilts and hearth rugs were not categories for which prizes were offered. However, it is clear that these and a wide variety of other items termed "fancy articles" were exhibited along with the sheeting, shirting, tablecloths, broadcloth, and blankets for which premiums were offered. At the Brighton Cattle Fair of the Mas-

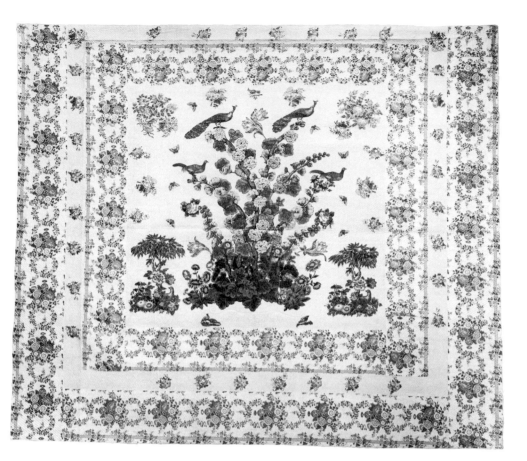

cat. 83

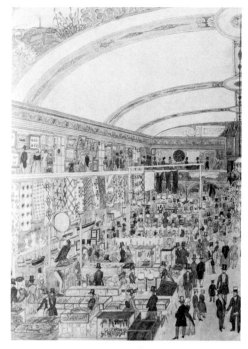

fig. 1. B. J. Harrison, annual fair of the American Institute at Niblo's Garden, New York City, c. 1845, watercolor [Museum of the City of New York]

sachusetts Agricultural Society in 1824, for example, "the tables were covered, as in past years, with a variety of substantial fabrics and fancy articles, not objects of a specific premium."[3] Prizes ranging from two to five dollars were awarded to the best of these, including coverlets, counterpanes, straw bonnets, needlework, artificial flowers, lace, knit stockings, cricket coverings, hearth rugs, and a patchwork carpet.[4]

Carpets and hearth rugs began to be exhibited in sufficient numbers that many of the societies offered prizes specifically for these categories. In 1824 the Worcester committee admired several floor coverings for their "brilliancy of color" and "tasteful arrangement," hoping that "the competition on the present occasion will tend to render this useful article fashionable in every respectable family";[5] two years later the Hillsborough, New Hampshire, committee described "excellent hearth rugs, elegantly worked with fanciful figures, fit for the parlour of a 'republican nabob.'"[6]

Hearth rugs manufactured by commercial carpet mills in England and America were made in styles that matched or complemented the room-sized carpets over which they were laid. By at least the 1820s small rugs with bouquets of flowers, cornucopias, cats and dogs or more exotic animals were designed and manufactured especially for use as hearth rugs.[7] American women copied these designs in embroidery on small rugs, and the craft became so popular that by the 1830s hearth rugs were the largest category of domestic art displayed at some of the New England agricultural fairs.

Most of the early nineteenth-century hearth rugs made by hand were embroidered in wool with the same kinds of simple running or back stitches that were used for embroidered bed rugs and blankets at this time. Until at least 1850, few examples made use of strips of woven cloth hooked through the backing, but this technique predominated in the late nineteenth century. Hooked rug making proliferated at that time because of the successful introduction and widespread marketing of stamped or stenciled colored rug patterns on burlap. Exotic or domestic animals and floral motifs continued to be popular, and patterns imitating oriental

43

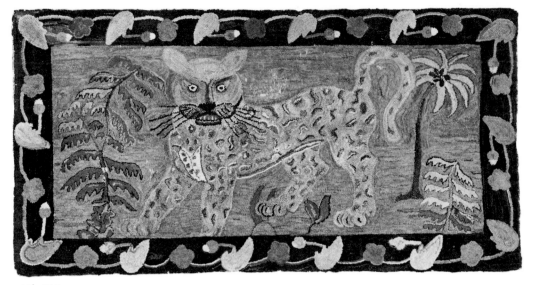

cat. 120

or Aubusson carpets were also available. Some hooked rugs illustrated family narratives or celebrated patriotic themes. These original designs are more truly folk art.

Coverlets were also exhibited at the New England agricultural fairs. Nine were shown at the Brighton Cattle Show of the Massachusetts Society for Promoting Agriculture in 1836 and described as being "of excellent workmanship and of good materials . . . fine specimens of this branch of domestic industry, which has been handed down from our venerable grandmothers from generation to generation, displaying the skill and ingenuity and taste of each successive generation, tokens of the comfort of the good old times."[8]

Premiums given at many cattle shows for "cotton and wool counterpanes" may have been for overshot or Jacquard woven coverlets, but it is difficult to be certain. *Counterpane* was a word used frequently in the late eighteenth and early nineteenth centuries to refer to a bed covering intended to be used as the visible, outer covering, much in the way that *bedspread* is used today. *Coverlid*, the word most frequently

encountered in probate inventories of the same period, is thought to derive from the French *couvre lit* (bed covering), though it is also apparently a phonetic spelling of the English word *coverlet*, itself no doubt derived from the French as well.

Quilting is a labor-intensive activity that requires large quantities of time as well as abundant cloth. In the colonial period, patching or piecing together small pieces of fabric was not considered an essential part of quilt making. Most quilting of this period was done by stitching together two layers of solid fabric with a middle layer of carded textile fiber, usually wool. Quilting in this period was used for both bed coverings and garments, especially petticoats. Indeed, we find far more references to quilting "coats" in women's diaries than to work on "bedquilts."

The kind of early quilt most highly prized by collectors today is made of glazed wool and embellished with elaborate pictorial designs in the quilting itself. Such quilts are often described as examples of early American folk art, yet it is important to remember that quilts were imported in the eighteenth cen-

tury and that both here and in England they were sometimes made by professional quilters, hired to do the work. Calamanco (a glazed wool) and silk bed quilts of various widths were advertised in Boston, New York, and Philadelphia newspapers throughout the eighteenth century. For his daughter Judith's wedding outfit in 1720, Judge Samuel Sewall of Boston ordered household furnishings and textiles from London, among them "A good fine large Chintz Quilt well made."[9]

Some American women copied the motifs on imported quilts and quilted petticoats; occasionally they introduced their own original designs. The work is often a series of repeated geometric motifs, but sometimes there are large flowers and feathers. Occasionally the quilting stitches define a central medallion surrounded by borders; sometimes there is an overall floral pattern very like that embroidered on bed rugs of the same period. The elaborate quilting was done in thread of a color that matched that of the fabric of the quilt top, but close stitching and thick batting resulted in spectacular three-dimensional effects. When the top of such a quilt was made of a glazed wool such as calamanco, the effect of reflected candlelight must have been dramatic. The backs of both domestic and imported quilts are usually of coarse handwoven wool in natural sheep's gray or in one of the tan to gold tones most easily achieved with local dyestuffs. It is virtually impossible to tell the domestic from the imported examples unless an owner or maker's name is worked into the design.

The kind of textile most frequently referred to as a woven coverlet today is the nineteenth-century combination of factory-spun cotton and factory- or handspun wool overshot woven in fairly geometric designs, or in the more

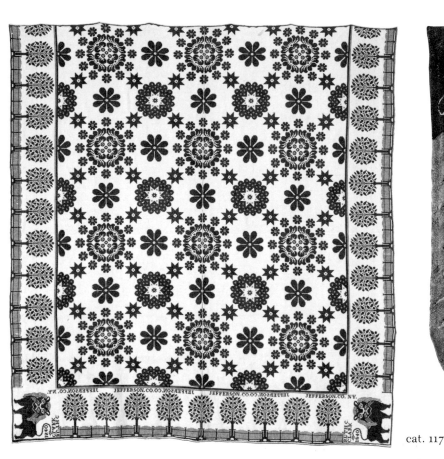

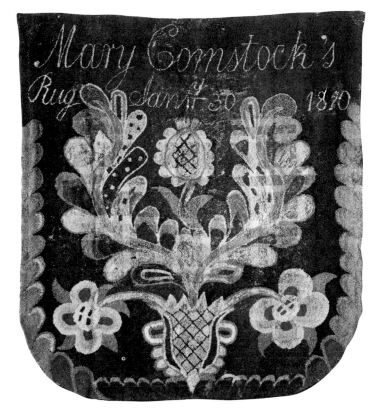

cat. 117

cat. 113

pictorial patterns that were made possible by the mechanical action of the Jacquard loom. Most of the latter were produced by professional weavers, many of them men, who worked in small shops or factories, chiefly in New York, Pennsylvania, or the states of the old Northwest Territory, Ohio, Indiana, and Illinois. Few Jacquard coverlets with firm New England provenance have been identified; in fact, it seems clear that most of the Jacquard looms in New England in the second quarter of the nineteenth century were located in carpet mills.

The elaborate stitchery that characterizes eighteenth-century quilting is time-consuming and requires special equipment. Quilting frames are seldom recorded in probate inventories, yet they were essential for completion of the work. Such an item was not diffi-

cult to make or expensive to acquire; perhaps they were simply overlooked by those who recorded estates. When Elisha Williams of Wethersfield, Connecticut, died in 1785, his estate was valued at nearly three thousand pounds sterling; the single quilting frame listed in the household inventory was only valued at three shillings.

Although quilting was often done by family members, it is also known that even in eighteenth-century New England this kind of work was sometimes rewarded by cash or credit. In preparing the wedding outfit for his daughter Mary in 1762, Samuel Lane of Stratham, New Hampshire, recorded payments for "Shalloon for a Bed-Quilt 27 £, Lining 20 £," as well as a charge of fourteen pounds for "Quilting."[10]

"Ruggs" are much more commonly listed as bed coverings than are bed

quilts in eighteenth-century American probate records. Unfortunately, few examples survive. Some of them must have been coarsely woven blankets with a thick pile, while others were certainly the hand-embroidered bed rugs so highly prized by twentieth-century collectors. Often referred to today as "yarn-sewn," these rugs are embroidered in bold designs using wool and a large needle. Sometimes as many as ten or eleven strands of handspun wool were carried in the needle at one time, allowing each stitch to "bloom" on the surface of the work. Sometimes the stitches were clipped on the surface to create a pile. Mary Comstock of Shelburne, Vermont, used a handspun and handwoven plaid wool blanket for the background of her spectacular 1810 bed rug (cat. 113), but this was unusual. Normally a plain linen sheeting or

45

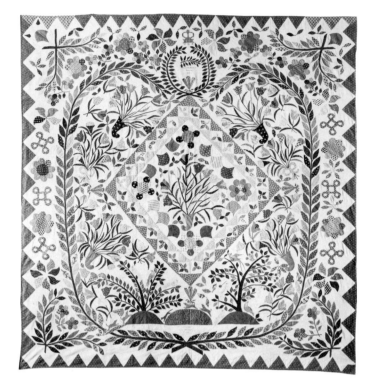

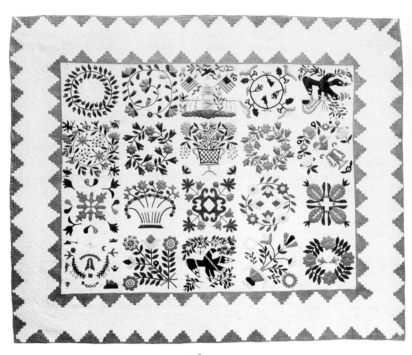

undyed woolen blanket was used as the base for an embroidered bed rug.

Often the designs of embroidered bed rugs are closely related to those of the glazed woolen quilts of the same period. The sources of these are unknown, but it is clear from the way in which similar motifs are repeated by needlewomen in different areas that there was either a common source or a common teacher for this type of work. Dorothy Seabury's 1819 rug (cat. 114) is more stylized than many earlier examples and is among the latest dated examples of this kind of work now known.[11]

Pictorial quilting and subtle overall embroidery enjoyed another heyday early in the nineteenth century when inexpensive factory-made white cotton became the preferred basis for bed coverings. Splendid white quilts and counterpanes were made in both the southern states and New England. Later this kind of work continued to be used in white areas of background

within more colorful patchwork or appliqué quilts. This type of work has not been widely collected or imitated in the late twentieth century.

Of all the bed coverings that have attracted the eye of collectors in the twentieth century, none is more important than the colorful cotton quilt. The development of the calico printing industry in nineteenth-century England, France, and America, as well as the ingenuity, color sensibility, and taste of the women who designed and worked the quilts, were responsible for this new form of textile art. In most cases the women were housewives with many obligations.

The two basic techniques employed in making quilt tops are appliqué and patchwork. The latter produces geometric designs with remarkable variety and subtlety. In contrast, appliqué is usually employed to create a picture out of pieces of fabric. The designs are sometimes set within individual blocks,

but they are often free-ranging and sometimes treat the entire quilt surface as an individual picture. The piece of appliqué signed by Ann Robinson and "finished January 27, 1814" (cat. 81) is distinguished for its overall design and color sensibility, yet, like many textiles, it is a reflection of the tastes of her time. It is related in style and composition to the "Greenfield Hill" quilt formerly in the collection of the Henry Ford Museum and to others in private collections known to have been made in southern Connecticut at about the same date.

Other appliqué quilts in the Shelburne collection are also absolutely typical of their time. Early nineteenth-century examples in the style identified by Caulfeild and Saward as "broderie perse" indeed suggest the designs of Indian palampores with their central trees bearing various fruits, flowers, and birds. The Major Ringgold quilt (cat. 89) is a superior example of the mid-nineteenth-century Baltimore

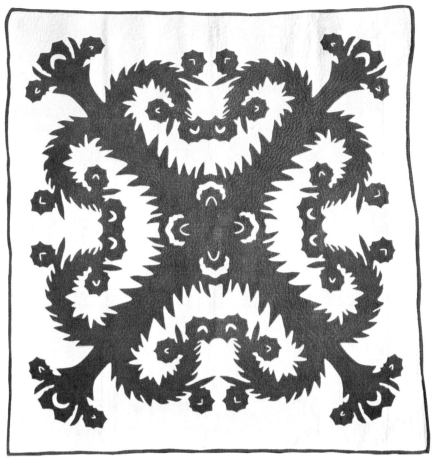

style, practiced there by professional quiltmakers and imitated by skilled amateurs.

Late nineteenth-century Hawaiian quilts with their careful appliqué of a single massive cutout motif are a unique form (see cat. 108), yet the Shelburne collection contains a few appliqué quilts that suggest a source for the evolution of this design from a traditional New England form. Several of the quilts are composed of blocks with repeated appliqué motifs cut from individual pieces of folded fabric.

Patchwork in America seems to have originated sometime in the eighteenth century. Early examples are usually fairly simple in design and restricted in color variation. Eight-pointed stars and simple nine-patch motifs predominate. These are found in both imported and homemade woolen fabrics. Printed cottons were also used for early patchwork, with block-printed designs far more successful than the large-scale copperplate prints that were cut into small pieces and reassembled. Many quilts containing late eighteenth-century printed cottons are unsophisticated in overall design and color harmony, reflecting the inexperience of the maker.

Patchwork and quilts were not distinguished in separate categories in the exhibitions at the first New England agricultural fairs, and it is clear that some were shown as incidental household manufactures. At the 1827 Brighton (Massachusetts) Cattle Show, "Among the specimens of household industry, the patchwork carpet, by Miss Bates, of Weymouth; and a bedquilt of the same fabric, by another lady, were much commended, as works of patient industry."[12] Other examples of such work shown at similar fairs in the second quarter of the nineteenth century were also praised; apparently no attempt was made to employ aesthetic criteria in judging the work.

Nineteenth-century authors such as Sarah Josepha Hale and Lydia Maria Child agreed that much of the value of patchwork was in the transformation of idle moments and worthless bits of fabric into objects of utility. In fact, the process of making patchwork might in some cases be valued over the result. In 1835, Mrs. Hale advised that "Little girls often find amusement in making patch-work quilts for the beds of their dolls, and some even go so far as to make cradle quilts for their infant brothers and sisters."[13] Lydia Maria Child also recognized the thriftiness of using fabric scraps for quilting in the first edition of *The American Frugal Housewife* (1833): "'time is money,' . . . In this point of view patchwork is good economy. It is indeed a foolish waste of time to tear cloth into bits for the sake of arranging it anew in a fantastical figure; but a large family may be kept out of idleness, and a few shillings saved by thus using scraps of gowns, curtains, &c."[14] Mrs. Child expressed similar ideas in *The Girl's Own Book*, admitting that "it is very silly to tear up large pieces of cloth for the sake of sewing them together again," yet this seemed "old-fashioned" to her and therefore virtuous, certainly better for girls than to be "standing round wishing they had something to do."[15]

Although many fanciful names have been applied to patchwork quilt designs, it is difficult to know when such names first entered common parlance. New England women's diaries of the eighteenth and early nineteenth

centuries reveal very few references to such names. An undocumented quotation, apparently late eighteenth century in origin, by the usually accurate antiquarian, Alice Morse Earle, names several patterns and describes their being exchanged by two women after morning meeting: "Anne Bradford gave to me last Sabbath in the Noon House a peecing of the Blazing Star; tis much finer than the Irish Chain or the Twin Sisters."[16]

An author in *Godey's Lady's Book* in 1835 remarked that "Patch-work may be made in various forms, as stars, triangles, diamonds, waves, stripes, squares, &c.,"[17] but no specific pattern names were given. It was not until 1849 in a story called "The Quilting Party" by T. S. Arthur that *Godey's* made direct reference to quilt pattern names such as "Irish Chain" or "Job's Trouble" in addition to "block work" and "evening star." Yet, the context in Arthur's story suggests that these names were traditional favorites, for the story is a nostalgia piece, depicting common practice in an earlier, unspecified, generation.[18] It is uncertain how these names originated and how widely they were used, even though it is clear that different names were used in different places for designs that appear to be identical. A radiating star may have been called a "Blazing Star," "Star of Lemoyne," "Star of Bethlehem," or a "Star of Texas," depending on when and where one lived; but as late as 1859, sewing manuals and women's magazines were still publishing a variety of patterns all identified simply by the word "patchwork." The results of the work may well have been visually spectacular, but the aesthetic was not always articulated.

Certainly some people purchased new material to cut up and arrange in patterns for patchwork, but probably only a few quilts began this way. Even so, new fabric was highly desired for the best patchwork, and women eagerly collected unwashed scraps of printed cottons. The above-mentioned Anne Bradford offered to exchange pieces for her quilt, saying "I want yelloe peeces for the first joins, small peeces will do. I will send some of my lilac flowered print for some peeces of Cicelys yelloe India bed vallants, new peeces, not washed peeces."[19] There are numerous early nineteenth-century stories such as *Busy Idleness* in which the heroine Charlotte canvasses the community for scraps of calico with which to make "a patchwork counterpane for her own little tent bed," an ambitious project in which a "radiating star" was to be the centerpiece.[20] Charlotte's problem was that she had more fun visiting her neighbors and collecting the fabric than cutting her pieces carefully and setting them together in an orderly fashion.

Maintaining a sense of usefulness, keeping busy, and enjoying the interplay of color and form must have been significant sources of satisfaction for women on the fringes of society as well as those who bore responsibility for busy households and large families. This is suggested by documents such as the 1818 probate inventory of Jane Sanderson of Sandwich, New Hampshire, which included "patchwork made from old calico for bed quilts" valued at one dollar. Since her entire personal property was only valued at six dollars and sixty-two cents, one wonders if the manufacture of patchwork out of scraps of old material was in fact a pleasure for this old maiden lady. Some historical records give support to this idea. When Lydia Luther of Cranston, Rhode Island, died in 1844, her estate included "30 ps. [pieces] Small Cotten Cloths & small bags" valued at fifty

fig. 2. Pattern for quilting design, from the diary of Sarah Snell Bryant, 1806 [Houghton Library, Harvard University]

cents as well as "6 Bed Spreads of patch work unfinished" valued at three dollars. It may well have been that, especially late in life, the creation of a splendid design out of nothing and keeping busy were far more important than the necessity of creating utilitarian bed coverings.

But what, exactly, were the patterns? The 1774 probate inventory of Hannah Eastman of Almsbury, Massachusetts, contains reference to a "Pattern for a bed Quilt" valued at four shillings as well as a "Quilt frame" valued at two shillings.[21] Was the pattern a large-scale drawing on paper or was it something else? The diary of Sarah Snell Bryant of Cummington, Massachusetts, illustrates patterns for quilting designs in 1806 (fig. 2) and a patchwork design in

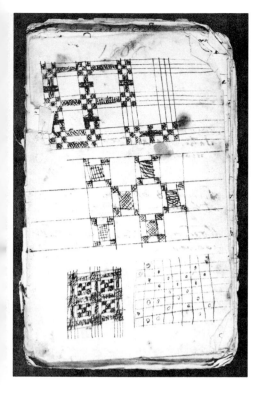

fig. 3. Pattern for patchwork design, from the diary of Sarah Snell Bryant, 1808 [Houghton Library, Harvard University]

HEXAGON PATCH-WORK.

Little girls often find amusement in making patch-work quilts for the beds of their dolls, and some even go so far as to make cradle-quilts for their infant brothers and sisters.

Patch-work may be made in various forms, as stars, triangles, diamonds, waves, stripes, squares, &c. The outside border should be four long strips of calico, all of the same sort and not cut into patches. The dark and light calico should always be properly contrasted in arranging patch-work.

fig. 4. Hexagon patchwork design, *Godey's Lady's Book*, January 1835

1808 (fig. 3) and includes a reference to drawing "a pattern for a quilt."[22] It is unclear whether she drew the pattern directly on the cloth or made up a kind of template that would insure consistency as the design was repeated over the surface of the work. The collections of the Society for the Preservation of New England Antiquities, Old Sturbridge Village, and several other museums contain paper, wood, and tin patterns for cutting pieces and outlining actual quilting motifs. Many unwashed quilts such as Shelburne's Double Irish Chain (cat. 94) in this exhibition still show the pencil marks that were drawn around such a pattern to indicate the placement of the quilting stitches.

Patterns were also useful in cutting out fabric pieces for patchwork and appliqué work. Mrs. Pullan advised that "Tin patterns are very useful in cutting out patchwork, as paper is apt to become tumbled."[23] The first mention of hexagon patchwork in *Godey's Lady's Book* in 1835 (fig. 4) insisted that "To make it properly you must first cut out a piece of pasteboard of the size you intend to make the patches . . . then lay this model on your calico, and cut your patches of the same shape, allowing them a little larger all round for turning in at the edges." The author also recognized the value of paper patterns in aligning the pieces in this exacting work. Each hexagon was to be basted to a paper pattern cut from old letters or copybooks and the papers were to "be left in, to keep the patches in shape till the whole is completed."[24] Many quilts of this type, especially those made of silk, survive with the paper patterns still in place.

Even at the height of the nineteenth century, when domesticity and the products of the feminine hand were revered, some writers expressed ambivalent feelings about patchwork. One author, Mrs. Pullan, wrote in her needle-work guide: "Of the patchwork with calico, I have nothing to say. Valueless indeed must be the time of that person who can find no better use for it than to make ugly counterpanes and quilts of pieces of cotton."[25] In sharp contrast was the attitude of Miss Florence Hartley, who viewed patchwork with affection in 1859: "we own to a liking for Patchwork, genuine old fashioned patchwork, such as our grandmothers made and such as some dear old maiden aunt with imperfect sight, is making for fairs and charities, and whiling away otherwise tedious hours. We love to see a bed spread with the pretty square and rounds and curious shapes, which mingled with white look so clean and gay."[26]

Mrs. Pullan did recognize that the key to success in patchwork is the arrangement of the colors, and this is certainly the key to traditional patchwork designs and to the new styles that were introduced in the years following the Civil War. Although patchwork of calico continued to be made throughout the nineteenth century and survived in many areas right up until its revival in the mid-twentieth century, patchwork with silk and velvet, which was more ornamental than utilitarian, was considered most stylish in the last half of the nineteenth century. Miss Eliza Leslie anticipated the change in status of the patchwork quilt as early as the sixth edition of *The House Book* in 1843 when she wrote, "patch-work quilts of old calico are seen only in inferior chambers; but they are well worth making for servants' beds. The custom of buying new calico, to cut into various ingenious figures, for what was called handsome patch-work, has

become obsolete."[27] If the fad for "hand some patchwork" was superseded by other types of work in the mid-nineteenth century, the reality of domestic production was entirely the opposite. In households across this country the manufacture of pieced quilts continued to produce objects of utility and great beauty.

Several distinct styles of patchwork belong to the last half of the nineteenth century. Simplest of these is "log cabin quilting," referred to in the England of the 1880s as "American or Canadian" patchwork (see cats. 106, 107).[28] In this kind of work, straight rectangles of graduated length are cut and placed in such a way that they form a series of squares. By arranging contrasting light and dark strips in different ways, specific types of patterns can be formed. Best known among these are the "Pineapple," "Log Cabin," and "Courthouse Steps." This type of work is found in fine silk and satin as well as in unmatched scraps of worn wool, calico, or denim. It was a simple technique, depending wholly on accurate cutting and skilled color arrangement for its effect. Some examples of this, although made from fine silk, are a visual disaster, while others made of worn and faded calico, are stunning.

Crazy quilting was long thought to be the oldest and simplest kind of American quilting. It appealed to the concept of frugality and was first put forth as being a very old technique in 1929 by Ruth Finley in *Old Patchwork Quilts and the Women Who Made Them*. Recent research, notably that of Sally Garoutte and Penny McMorris, has shown that this style of patchwork was first introduced about 1874. Promoted by women's magazines and sewing machine companies, crazy quilting was a needlework fad embraced by women of all economic levels. It

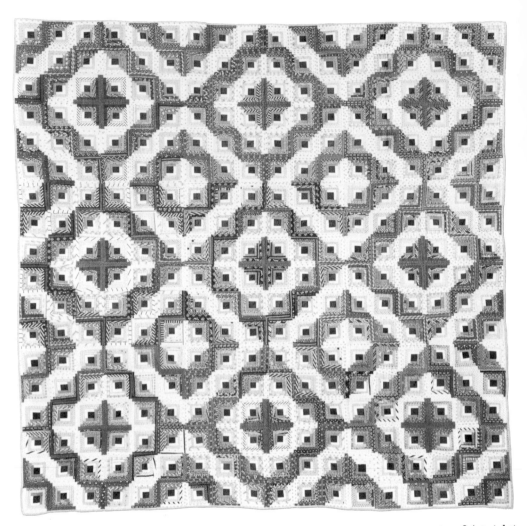

cat. 105

cat. 106 (at right)

employed the stylized but apparently random arrangement of fabrics of varying color, fiber, and texture together with ornamental embroidery. A variety of stitches covered all intersections of cloth, and occasional bits of pictorial embroidery or oil painting depicted such things as spiders, fans, sunflowers, or Kate Greenaway figures. Kits containing a suitable variety of fabrics and careful instructions were available by mail order, and printed cottons imitating crazy patchwork were available for furnishing purposes and for clothing. Crazy patchwork seldom employs actual quilting, but finished pieces are usually called "crazy quilts."

By the mid-nineteenth century, Victorian sentiment began to express itself in quilts and quilting. "Annette," the author of a story called "The Patchwork Quilt" in *The Lowell Offering*, described the associative feeling evoked by each piece in her patchwork quilt: "a piece of each of my childhood's calico gowns, and of my mother's and sisters'."[29] Some nineteenth-century patchwork was composed particularly to express such sentiments in permanent form. Numerous stories document the collection of significant scraps of fabric from family members and neighbors for the creation of a sort of memorial textile. One of these, with each piece care-

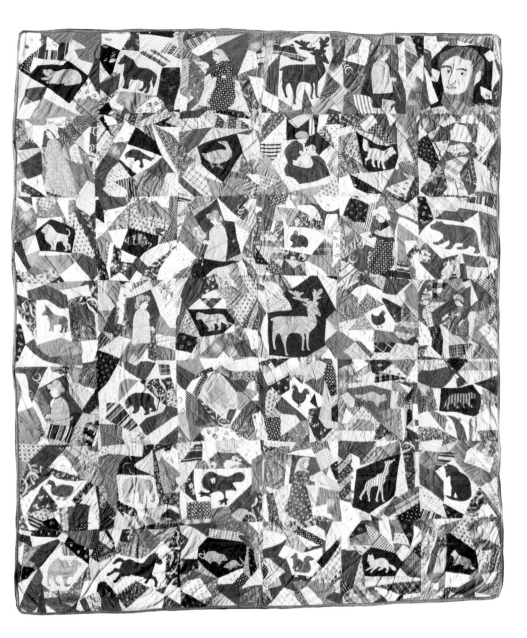

ment. Sometimes men and boys were invited for supper and dancing after the work of quilting was finished. Some diaries reveal that the quilt was not always finished at the party and a smaller group of close friends and relatives was called back the following day to finish the piece, remove it from the frame, and put on the binding.

Quilting parties were important occasions within communities, and they were useful in accomplishing a tedious piece of work, but they were not necessarily the place to produce a prize-winning quilt. The finest quilting requires close attention and consistent work. It seems unlikely that the quilts treasured today for their fine stitching were produced in group situations.

Quilting fulfilled the moral and aesthetic needs of nineteenth-century women, bound by the cult of domesticity and their individual circumstances. Quilting was acceptable at any economic, religious, or social level because its product was something considered useful within the home. However, quilting also fostered friendship and interaction among women while it permitted an expression of delight in color and design. The "rediscovery" of quilting and other textile arts has both illuminated the past and brightened our own time.

fully labeled, survives in the collections of the Society for the Preservation of New England Antiquities.

Nineteenth-century quilts gave concrete expression to the female friendships that had been fostered by quilting parties. Autograph quilts and friendship quilts were made for presentation to minister's wives, new brides, departing missionaries, retiring ministers, or school chums (see cat. 101). Many of these were carried forth from the place

where they had been made and treasured thereafter as tangible expressions of sisterhood.

Throughout the history of American quiltmaking, the quilting party has been an important social occasion. The pattern of work as revealed in women's diaries shows that quilting parties were given when a quilt top had been finished. Invitations were sent to friends and neighbors, usually for an afternoon work session to be followed by refresh-

cat. 92, detail

1. *Hampshire Gazette* (18 October 1818).

2. *New England Farmer* (14 November 1838), 46.

3. *New England Farmer* (5 November 1824), 117.

4. *New England Farmer* (5 November 1824), 117.

5. *New England Farmer* (3 January 1824), 181.

6. *New England Farmer* (6 October 1826), 83.

7. Nina Fletcher Little, *Floor Coverings in New England* (Sturbridge, 1972).

8. *New England Farmer* (2 November 1836), 181.

9. Alice Morse Earle, *Customs and Fashions of Old New England* (New York, 1893), 118.

10. Samuel Lane Papers, Courtesy of the New Hampshire Historical Society.

11. William Warren, *Bed Ruggs, 1722–1833* (Hartford, 1972).

12. *New England Farmer* (28 December 1827), 114.

13. *Godey's Lady's Book* (January 1835), 41.

14. Lydia Maria Child, *The American Frugal Housewife* (Boston, 1833), 1.

15. L. M. Child, *The Girl's Own Book* (New York, 1833), 225.

16. Alice Morse Earle, *The Sabbath in Puritan New England* (New York, 1890), 110.

17. *Godey's Lady's Book* (January 1835), 41.

18. *Godey's Lady's Book* (September 1849), 185.

19. Earle, *Sabbath*, 110.

20. Jane Taylor, *Busy Idleness* (New York, n.d.), 11.

21. Alice Hason Jones, *American Colonial Wealth*, 3 vols. (New York, 1977), 661.

22. Courtesy of the Houghton Library.

23. Mrs. Pullan, *The Lady's Manual of Fancy Work* (New York, 1858), 193.

24. *Godey's Lady's Book* (January 1835), 41.

25. Mrs. Pullan, *The Lady's Manual of Fancy Work* (New York, 1858), 95.

26. Miss Florence Hartley, *The Ladies' Handbook of Fancy and Ornamental Work* (Philadelphia, 1859), 189.

27. Miss Leslie, *The House Book*, 6th ed. (Philadelphia, 1843), 311.

28. Sophia Caulfeild and Blanche C. Saward, *The Dictionary of Needlework* (London, 1882, reprinted New York, 1972), 379.

29. *The Lowell Offering* (Lowell, 1845), 201–203.

Catalogue

Trade Signs

THE AMERICAN TRADE SIGN is part of a long European and English tradition that originated with the Romans. Prior to the advent of general public education and literacy in the late eighteenth century, proprietors relied on carved and painted signs to supply a strong visual message to the public. The purpose of these signs was not only to interpret trades or services, but also to attract business. Trade signs usually carried no more written information than the proprietor's name; a two- or three-dimensional trademark or symbol quickly explained the nature of the business.

As taverns sprang up along main traffic routes, their brightly painted signs alerted passersby that food, drink, and lodging were available within. These signs usually featured a strong image, such as the sun depicted on one side of the E. Noyes tavern sign (cat. 7). One early traveler, David Schoef, wrote that taverns were recognizable at a distance because their signs "hung from a sort of gallows arrangement which stands out over the road and exhibits the sign of the house."

The names and consequent symbols used for tavern signs can often be traced back thousands of years. Sources include Greek and Roman mythology, heraldic images, and guild emblems. The smiling sun on the E. Noyes sign can be related to ancient Roman inn signs featuring the god Apollo who was believed to invite good health with his

rays. The mounted figure of the revolutionary war hero General Stark on the reverse side follows in a long European tradition of knights and soldiers depicted on signboards. Medieval inn signs often employed emblems of trade guilds to attract members of a specific profession. Fish, for example, represented the guild of boatmen and fishermen, while flags were often found on tavern signs located near military headquarters. The fish and flag sign (cat. 3) may have been used at an inn located near a naval yard.

The spread of literacy in America does not seem to have diminished the use of iconic trade signs. In fact, the number and variety of signs multiplied as towns and cities grew and commerce flourished. Trade and tavern signs, common as early as 1710, were omnipresent by the 1840s. Tradition certainly played an important role in the proliferation of trade signs in America. The trade sign also took on new meaning and importance in the increasingly aggressive and commercial new "land of opportunity." Competitive proprietors recognized that good signs were crucial in drawing attention and imparting a message at a glance. A trade sign did more than serve as symbol of a man's trade or business; it also provided graphic testimony to the success of an enterprise.

Henry David Thoreau felt that tavern and trade signs were designed to stimulate the viewer's senses, "some to

catch him by the appetite, as the tavern and victualling cellar, some by the fancy as the dry goods store and jeweler's, and others by the hair, or by the feet, or the skirts, as the barber, the shoemaker, or the tailor." Trade signs symbolizing the goods or services offered were typically oversized replicas of such actual objects as a tooth (cat. 4), key (cat. 5), or gun (cat. 6). Some trade signs, such as the oversized rocking chair (cat. 2), also demonstrated the skill and expertise of the proprietor or the quality of the goods he offered. Although some signs, such as the spectacles (cat. 9), provided space for a short message, the lack of competition in a rural community often made it unnecessary for a tradesman to identify himself on his sign. However, an urban watchmaker such as Louis Fremeau, located in the main business district of a city, would rarely miss the opportunity to include his name on the face of the pocket watch (cat. 1) that advertised his shop.　　　C.O.

1
Watch Repair Sign
c. 1845
Carved, polychromed wood
38.1 diameter (15)
The Fremeau family operated a watch repair and jewelry shop on Church Street, Burlington, Vermont, from 1845 to 1958
Gift of Mrs. Louis Fremeau

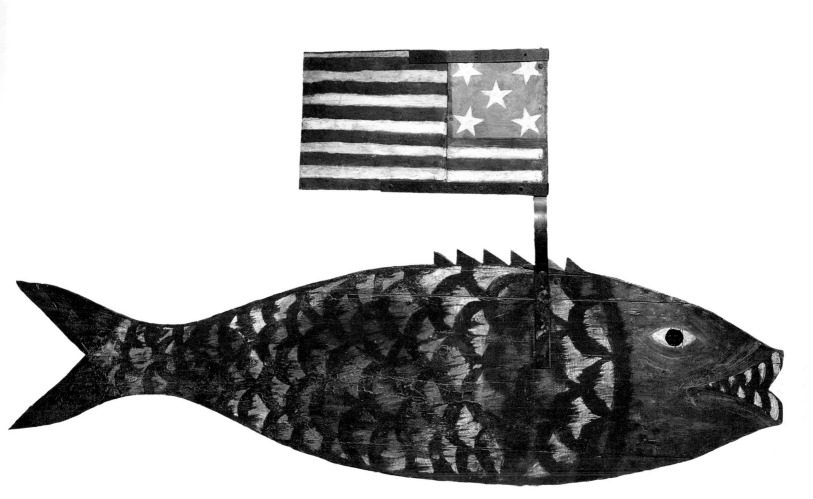

2
Rocking Chair Sign
1849
Carved and turned wood, polychromed
and gilded
195.6 x 114.9 x 91.4 (depth at seat)
(77 x 45¼ x 36)
Made by the Boston Rocker Company
of Morrisville, Vermont

3
Fish with Flag Sign
c. 1850
Sawn and polychromed wood with
polychromed iron flag
86.4 x 153.7 x 1.85 (34 x 60½ x ¾)
Found in central New York State

4
Dentist's Sign
c. 1850
Carved, polychromed wood
57.8 x 31.1 x 29.2 (22³/₄ x 12¹/₄ x 11¹/₂)
Gift of Julius Jarvis

5
Locksmith's Sign
c. 1870
Tin with lead solder
24.8 x 78.7 x 3.2 (height at oval handle)
(9³/₄ x 31 x 1¹/₄)

6
Gunsmith's Sign
c. 1870–1900
Carved, polychromed wood
30.5 x 243.8 (12 x 96)
Found in Poughkeepsie, New York

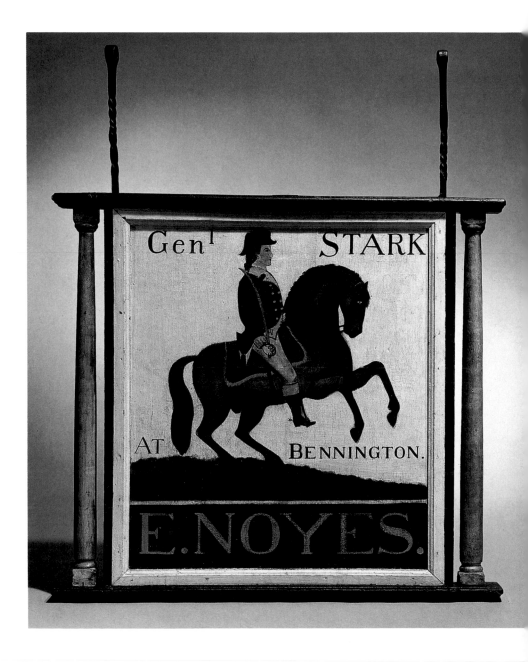

7
Tavern Sign
c. 1870
Sawn and turned, polychromed wood
76.2 x 85.7 x 8.3 (30 x 33³/4 x 3¹/4)
General Stark led a militia of New
Hampshire and Vermont troops at
the Battle of Bennington in the
Revolutionary War

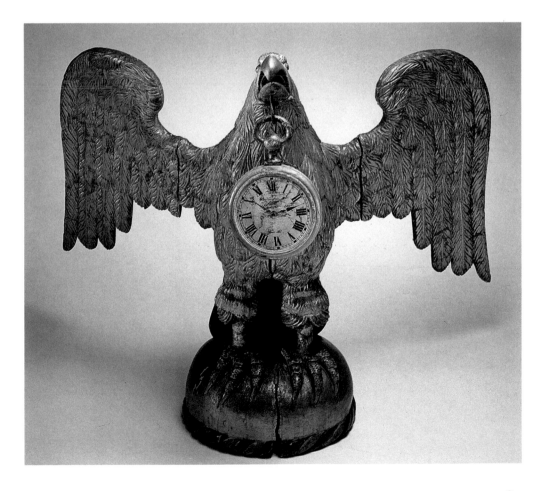

8
Clock Shop Sign: Eagle with Watch
c. 1875
Carved, polychromed wood with iron
hook and iron reinforcements
76.8 x 102.2 x 76.2 (30¼ x 40¼ x 30)
Used by watchmaker John Gordon of
New London, Connecticut

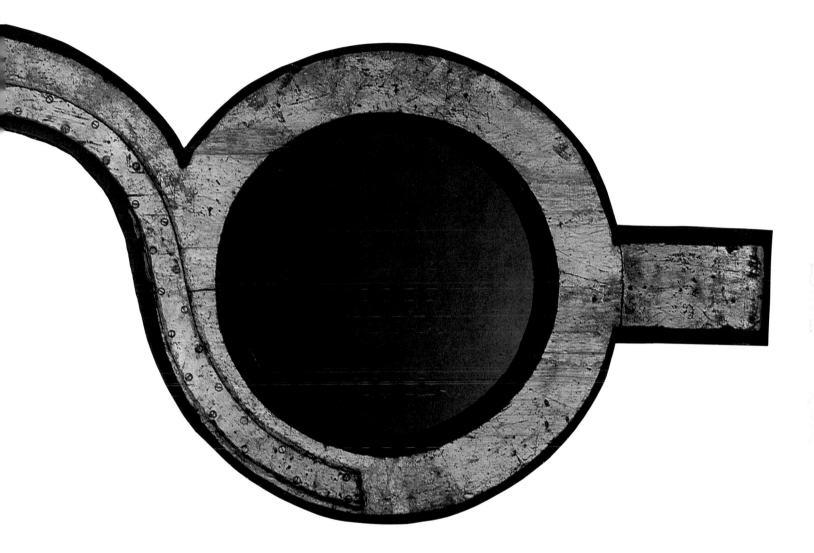

9
Optician's Sign
c. 1880
Polychromed, gilded sawn wood with
iron reinforcements and glass lenses
62.9 x 212.1 x 2.5 (24³/₄ x 83¹/₂ x 1)

10
Presentation Coffee Pot
1887
Polychromed sheet tin with lead solder
75.6 x 43.2 diameter (at base) x 16.5
diameter (at lid) (29³/₄ x 17 x 6¹/₂)
Inscribed, *Individual coffeepot/
presented/to/J.H. Webb/by his
Friends/of the South Salem/Whist
Club/May 25th/1887/Capacity
(illegible) Gals.*
Gift of Henry Coger

Carvings

NINETEENTH-CENTURY AMERICA TEEMED with clever and talented wood-carvers, both amateur and professional. These men produced a wide variety of decorative work, including figureheads and other carvings for ships, eagles for public buildings, trade figures and signs for cigar shops and other businesses, toys, household ornaments, and whimsies.

Wilhelm Schimmel, represented here by wood carvings of an eagle (cat. 16), a rooster (cat. 17), and two parrots (cat. 15), is the best known of America's untutored whittlers. A German immigrant, Schimmel (1817–1890) came to Pennsylvania's Cumberland Valley around 1860, where he made a meager living as an itinerant craftsman for the next thirty years. Carved eagles with cross hatching similar to Schimmel's were common in Germany in the Middle Ages, and he seems to have drawn inspiration for his bold, vigorous designs from a well-established German tradition. All Schimmel's carving was done with a pocket knife, using blocks of pine. Knife marks were smoothed with worn pieces of glass before painting. Schimmel used ordinary oil-based household paint, often in vivid colors. He probably drew his paint supply from the dregs of leftover tins, which may help to explain the oddness of some of his color combinations. In addition to the birds represented here, Schimmel is known to have carved lions, dogs, squirrels, and a few representations of Adam and Eve in the Garden of Eden.

Schimmel was an eccentric and something of a local legend in his time. On his death a local paper ran the following obituary: "'Old Schimmel,' the German who for many years tramped through this and adjoining counties, making his headquarters in jails and almshouses, died at the almshouse on Sunday. His only occupation was carving heads of animals out of soft pine wood. These he would sell for a few pennies each. He was apparently a man of very surly disposition."

John Haley Bellamy (1836–1914) of Kittery, Maine, is also best known for his eagles (cat. 18). Bellamy was a well-trained professional carver, however, and his highly refined birds could not be more different from Schimmel's work. A builder's son, he apprenticed as a ship carver in Boston and worked in both the Boston and Portsmouth, New Hampshire, navy yards. Most of his working career was spent in Kittery; his business card advertised "house, ship, furniture, sign and frame carving and garden figures."

Ship carving was an important adjunct to the burgeoning shipbuilding trade in eighteenth- and nineteenth-century America; every major port and shipyard on the East Coast supported ship carvers whose shops stood side-by-side with those of the sailmakers, ropemakers, and other craftsmen of the waterfront. Training was by apprenticeship with a recognized master, who conferred a certificate of apprentice-ship upon completion of study.

The stock-in-trade of ship carvers was, of course, the figurehead. In ancient times, figureheads had graced the prows of Egyptian and Phoenician ships as well as those of the Romans, Greeks, and Vikings. First intended to appease the gods of the seas, figureheads continued to represent the guardian spirits of the ships they guided, even into the nineteenth and twentieth centuries. The Brunhilda figurehead (cat. 13), drawn from Teutonic mythology, was made by an unknown carver who was obviously highly skilled and well trained.

Other carvings seem to have been made strictly for aesthetic delight. The Revolutionary soldier (cat. 12), an early toy with articulated arms, must have brought many hours of fun to the boy to whom it was presented. The whimsical squirrel cage (cat. 20) also undoubtedly was made for a child's amusement. The four jointed figures worked their up-and-down saws to the rhythm of the pet squirrel's antics on the central treadmill; nesting boxes on either side of the treadmill housed the animal(s) during periods of inactivity. Both playthings were probably made by fathers for their own children.

The rooster barber chair (cat. 19) is clearly the work of a professional carver. Another carving designed for children's eyes, the oversized wooden broom, was originally part of a carved circus parade wagon, "The Fairy Tales

Float." The wagon was carved in the shop of the famous woodcarver Samuel A. Robb (1851–1928) (see cats. 55 and 56), working under the auspices of the Sebastian Wagon Company. In 1902 the newly formed partnership of Barnum and Bailey, Ltd., contracted with the Sebastian firm for a dozen "tableau" wagons, six racing chariots, and a bandwagon for the circus' homecoming after several years of touring in Europe. The wagons Robb produced were the most elaborate ever created. His "Golden Age of Chivalry" wagon featured an enormous winged green dragon, and the intricately carved bandwagon, which was 28 feet long and 10½ feet high, was drawn by a team of forty matching bay horses, all under the reins of a single driver. R.S.

11
George Washington on Horseback
c. 1780
Carved, polychromed wood, and leather
54.6 x 17.8 x 50.8 (21½ x 7 x 20)
Attributed to a "Mr. Coolidge"
Found in Andover, Massachusetts

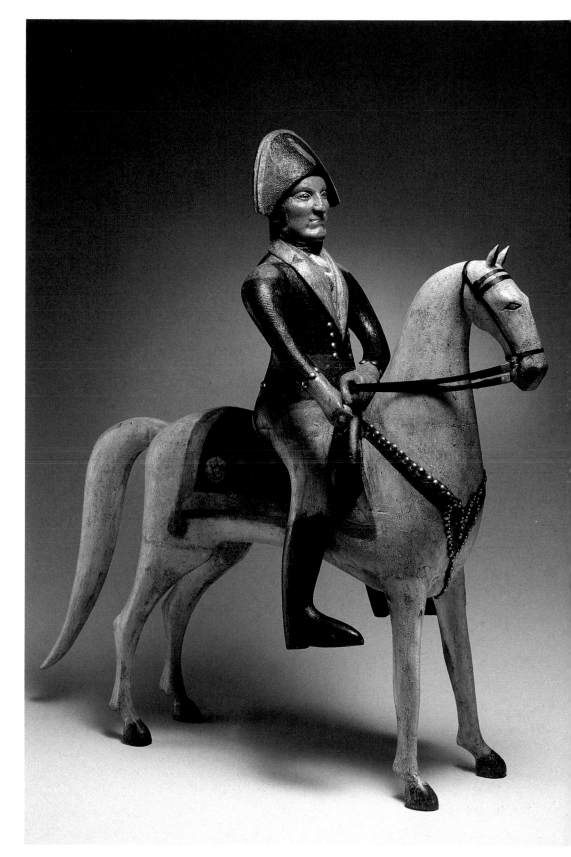

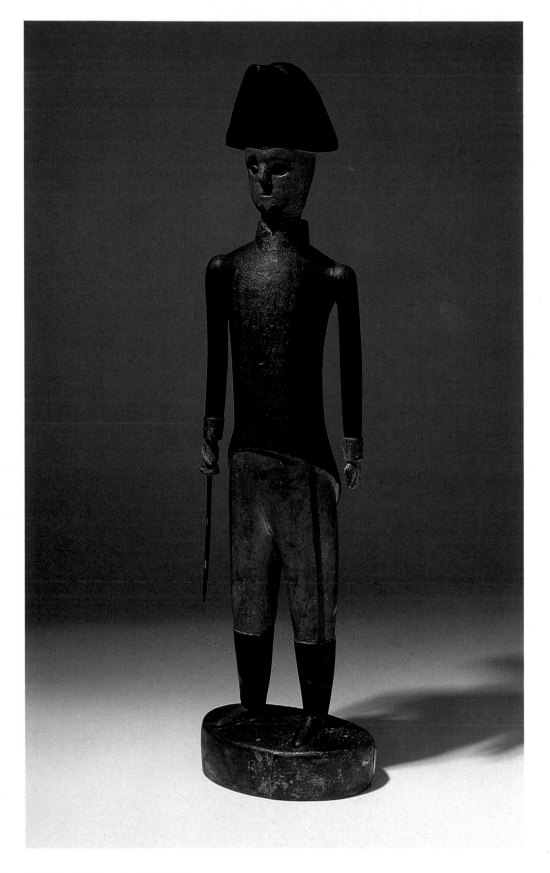

12
Revolutionary Soldier
c. 1785
Carved, polychromed wood
66.0 x 17.2 x 10.8 (with base)
(26 x 6³/₄ x 4¹/₄)
Found in New York City

13
Brunhilda Figurehead
c. 1850
Carved, polychromed, and gilded
wood
185.4 x 45.7 x 55.9 (73 x 18 x 22)
Attributed to Colonel A. L. Sampson of
Bath, Maine
Found on Nantucket Island

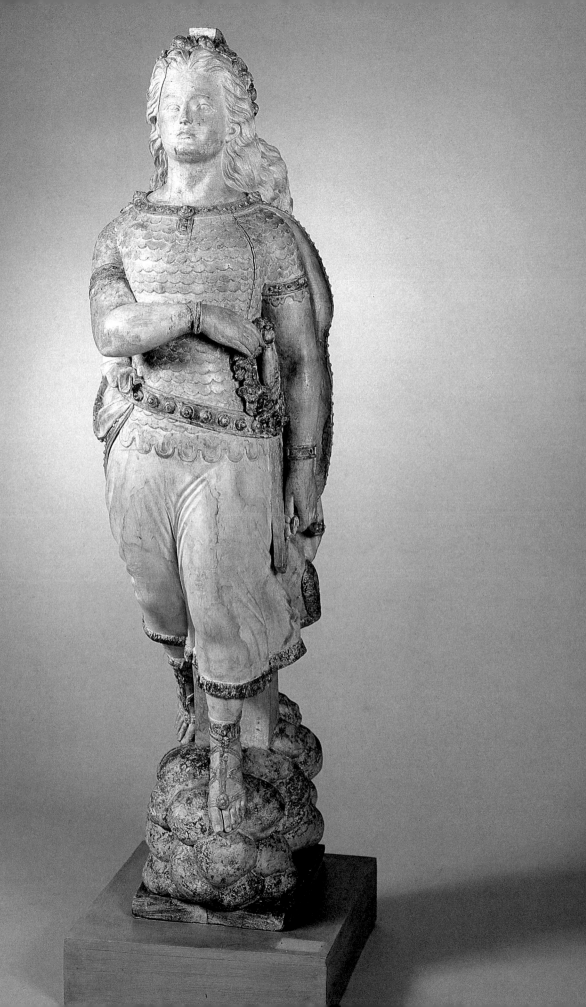

14
Eagle on Uncle Sam's Hat
c. 1870
Carved, polychromed wood
61.0 x 27.9 x 59.1 (24 x 11 x 23¹/₄)
Inscribed, *Eagle House US*
Found in Pittsburgh, Pennsylvania,
where it was used as a sign outside a
veteran's boarding house

15
Pair of Parrots
c. 1875
Carved, polychromed wood
Each 19.1 x 8.3 x 5.1 (7¹/₂ x 3¹/₄ x 2)
Made by Wilhelm Schimmel
(1817–1890), Cumberland Valley,
Pennsylvania
Gift of Mrs. D. W. Bostwick

17
Rooster
c. 1875
Carved, polychromed wood
35.6 x 15.2 x 7.6 (14 x 6 x 3)
Attributed to Wilhelm Schimmel
(1817–1890), Cumberland Valley,
Pennsylvania

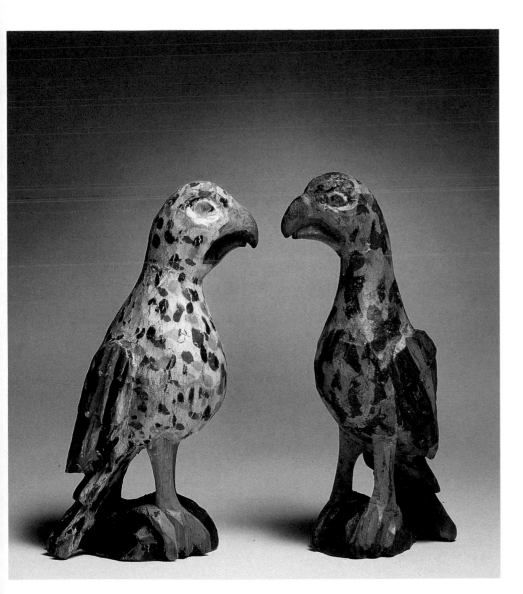

71

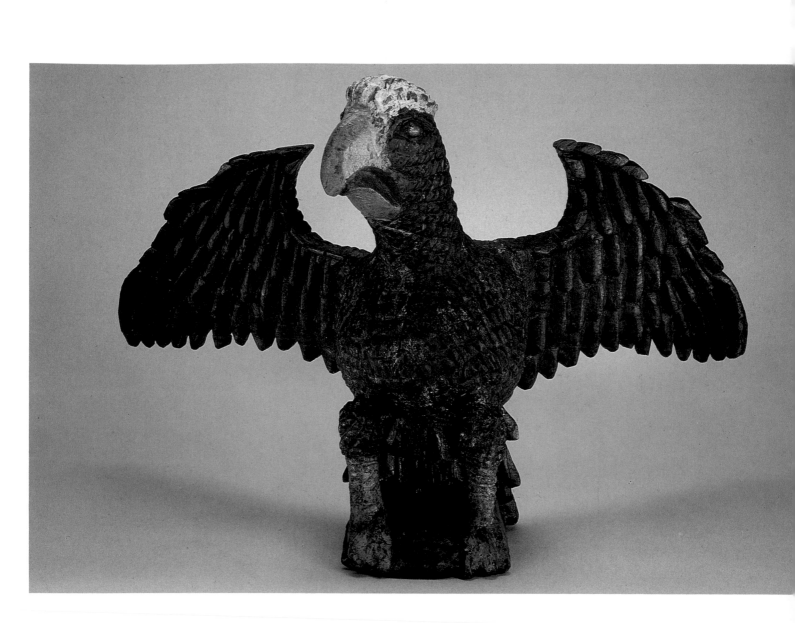

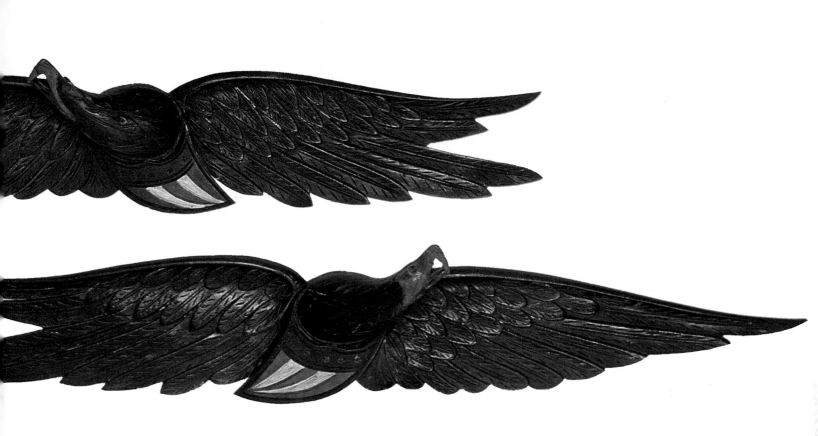

16
Eagle
c. 1875
Carved, polychromed wood
36.8 x 66 x 48.3 (14¹/₂ x 26 x 19)
Made by Wilhelm Schimmel
(1817–1890), Cumberland Valley,
Pennsylvania
Gift of Mrs. D. W. Bostwick

18
Pair of Eagles
c. 1880
Carved, stained, and polychromed
wood
Each 22.9 x 105.4 x 12.1 (9 x 41¹/₂ x 4³/₄)
Made by John Haley Bellamy
(1836–1914) of Kittery, Maine
Gift of J. Watson Webb, Jr.

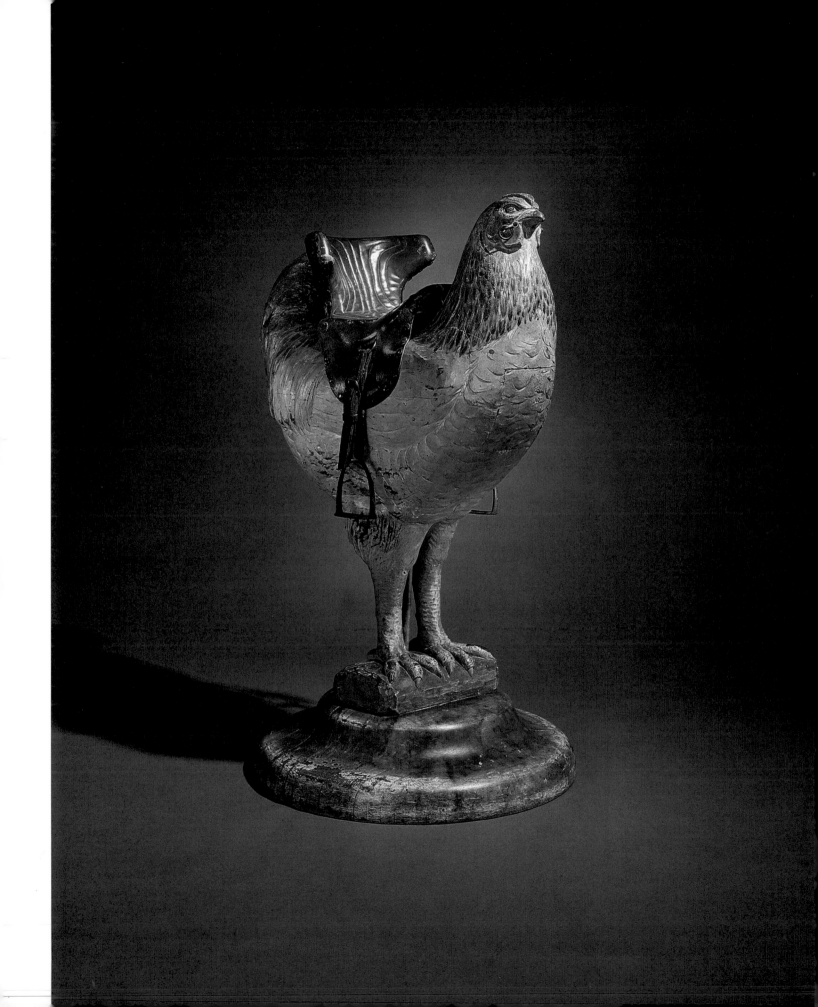

19
Rooster Barber Chair for Children
c. 1890
Carved, polychromed wood with
molded leather seat and brass
attachments
109.2 x 64.8 x 74.9 (43 x 25½ x 29½)
A drawer in the breast held the barber's
tools
Found in California
Gift of J. Watson Webb, Jr.

20
Squirrel Cage
c. 1900
Carved, sawn, and turned,
polychromed wood with iron rods and
iron nails
66.0 x 61.0 x 21.6 (26 x 24 x 8½)

21
Circus Wagon Broom
c. 1902
Carved, polychromed wood with iron
reinforcements
228.6 x 38.1 x 24.1 (at base of broom)
(90 x 15 x 9½)
Carved by the Sebastian Wagon
Company, New York City, for the
"Fairy Tales Float" Barnum and Bailey
Circus Wagon

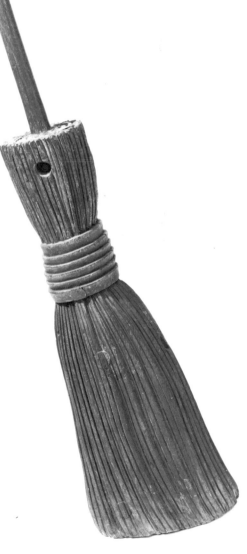

Decoys

Wildfowl decoys, made to lure game birds within shooting range, have been used by American hunters for centuries. The Indians originated the idea in response to the abundance of the continent's wild game. The earliest extant Indian decoys, found in Nevada and now in the collection of the Museum of the American Indian, Heye Foundation, represent canvasback ducks. The decoys were made from woven reeds embellished with paint and feathers. Carbon dating has placed the decoys c. 1000 A.D., perhaps earlier. The high quality of their craftsmanship suggests the idea was not a new one.

White settlers were quick to take note of Indian hunting methods, which, like the abundance of game, were entirely new to them. The decoy crafted from wood to ensure permanence soon became an essential part of the settlers' hunting gear. The earliest decoys made by whites were probably carved in the late 1700s. Although only a handful of extant decoys are dated by oral tradition to before 1800, the idea spread rapidly and by 1840 the wooden decoy was firmly established in American hunting tradition.

The earliest wooden decoys were probably primitive "stick-ups" similar to the New Gretna, New Jersey, shorebird (cat. 24) and the Barnegat, New Jersey heron (cat. 26). Mounted on poles and stuck into beach sand or marsh muck, these simple forms suggested the quarry's shape at a glance.

They made no attempt at realistic depiction. Like all effective decoys, they were made to be seen from a distance; once the birds were close enough to know better, it was too late. The earliest floating decoys were also undoubtedly solid-bodied and simply carved, like the red-throated loon (cat. 32).

Every major hunting area in North America produced decoys. Variations in hunting methods and water conditions affected local decoy-making traditions, and an astonishing number of regional variations developed. Coastal New Jersey decoy makers, for example, were challenged to create a compact, lightweight, but sturdy lure that could be easily carried in the small, narrow boats used in the area. They fashioned decoys with torpedo-shaped bodies made from two hollowed-out pieces of wood joined by nails and carefully sealed at the seam line. The heads were separately carved and attached with a screw or nail before the body halves were joined. Because the decoys were used in salt water and required frequent repainting, the painted patterns were simple and stylized. This regional style developed before 1850 and is still practiced in the area. The red-breasted merganser by Nathan Rowley Horner (cat. 37) represents the ultimate refinement of the coastal New Jersey tradition.

The elegant economy of the coastal New Jersey style influenced other areas as well. Albert Laing (1811–1886) of Stratford, Connecticut, grew up in New Jersey and employed many elements of the New Jersey tradition in his decoys, which exerted a profound influence on later Stratford craftsmen and, through them, on makers in other areas, especially the mid-West. Laing's birds (cat. 23), remarkably sophisticated for their time, added such new ideas as detailed comb paint, varied head positions and the use of nonrusting copper nails to the basic New Jersey hollow two-piece form. The Stratford tradition begun by Laing reached its acme in the work of Charles E. "Shang" Wheeler (1872–1949). Wheeler admired Laing's work (in fact, he repainted the Laing bird illustrated); his mallard (cat. 36) exhibits his careful attention to detail.

The history of decoy making in America is inseparably intertwined with the history of the commercial exploitation of this country's wildfowl. The years following the Civil War saw the combination of improved transportation systems, more advanced weapons, and abundant game. Professional market gunners worked in most areas, supplying game to meet the intense public demand. Well-made decoys were among the tools most vital to their trade. To meet the needs of the market gunners and the many well-to-do sportsmen who traveled from the cities to shoot birds, scores of craftsmen turned to decoy making full-time. In the late 1800s decoy making became a

cottage industry. Several "factories," produced thousands of decoys and began to market their wares by mail-order. The Mason Decoy Factory of Detroit (active 1896–1924) was the largest and most successful of these enterprises. Though decoys such as their pintail (cat. 29) had bodies turned on a lathe, the heads, finish work, and painting were all still done by hand.

Federal conservation legislation brought the market gunning era to an end just after the First World War and substantially reduced the demand for decoys. Many craftsmen continued to make them, but by the end of the Second World War, the traditional wooden bird faced increasingly strong competition from the cheap, sturdy, and effective new lures made of plastic and other synthetics. R.S.

22
Canada Goose
c. 1849
Carved, polychromed wood, brass plates and pin
29.2 x 61.0 x 28.3 (11^1/$_2$ x 24 x 11^1/$_8$)
Attributed to Charles C. Osgood (1820–1886) of Salem, Massachusetts. The removable head is attached to the body by a pair of interlocking, pinned brass plates.
Gift of Mrs. P. H. B. Frelinghuysen

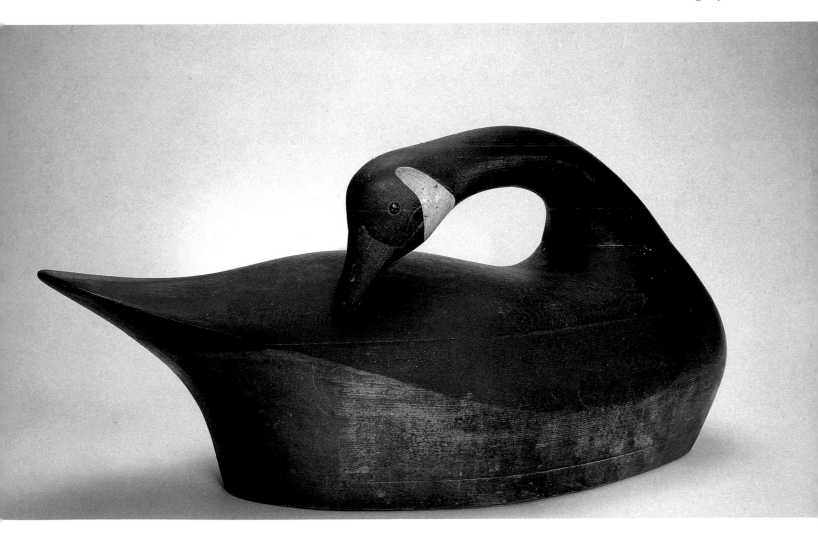

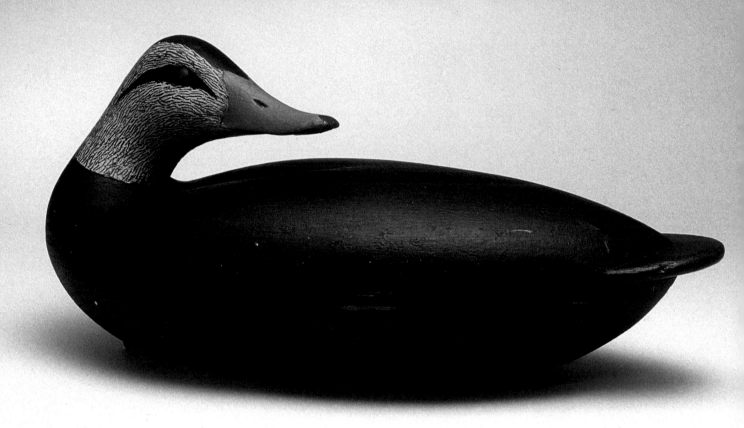

23
Black Duck
c. 1850
Carved, polychromed wood
17.2 x 33.0 x 15.6 (6¾ x 13 x 6⅛)
Made by Albert Davids Laing
(1811–1886) of Stratford, Connecticut.
Laing carved and painted this decoy as
a canvasback; it was repainted as a
black duck by Charles E. "Shang"
Wheeler (see cat. 36)

24
Shorebird
c. 1870
Carved, polychromed wood with iron
nail bill
15.2 x 24.8 x 5.1 (6 x 9¾ x 2) (excluding
base)
Found in New Gretna, New Jersey

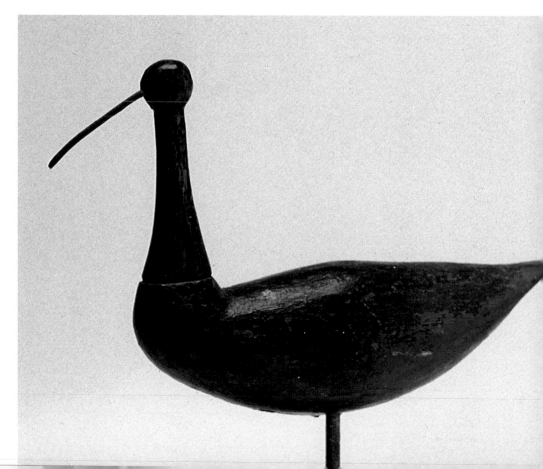

26
Great Blue Heron
c. 1890
Carved, polychromed wood
54.6 x 76.5 x 9.8 (excluding base)
(21½ x 30⅛ x 3⅞)
Found in Barnegat, New Jersey

25
Pair of Dowitchers
c. 1890
Carved, polychromed wood
Each 11.4 x 22.9 x 5.7 (4½ x 9 x 2¼)
(excluding base)
Found in Massachusetts

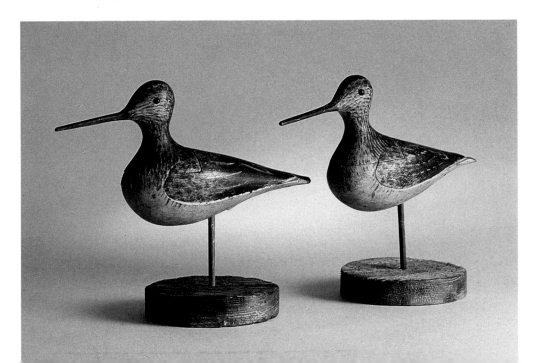

27
Ruddy Duck Drake
c. 1890
Carved, polychromed wood
15.2 x 24.5 x 12.1 (6 x 9⅝ x 4¾)
Made by Lee Dudley (1861–1941) of
Knott's Island, North Carolina

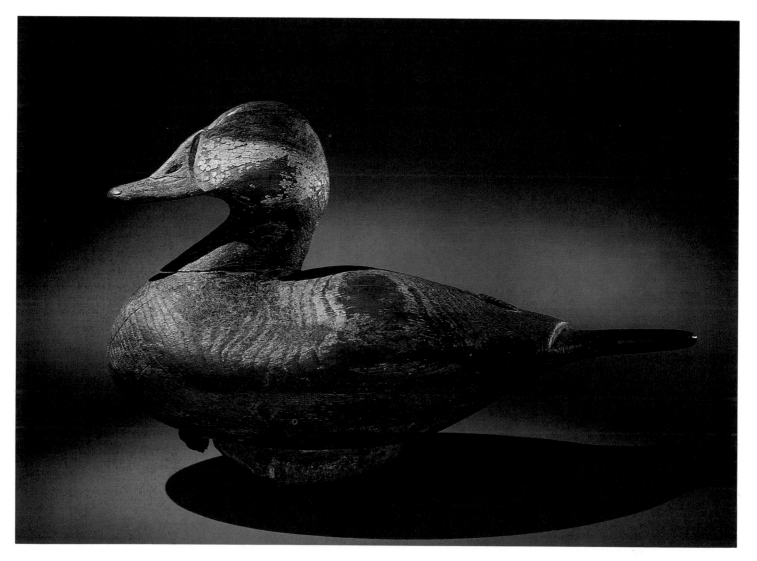

29
Pintail Drake
c. 1900
Carved, polychromed wood
19.1 x 52.7 x 12.7 (7 1/2 x 20 3/4 x 5)
Made by the Mason Decoy Factory of
Detroit, Michigan
Gift of William R. Miller

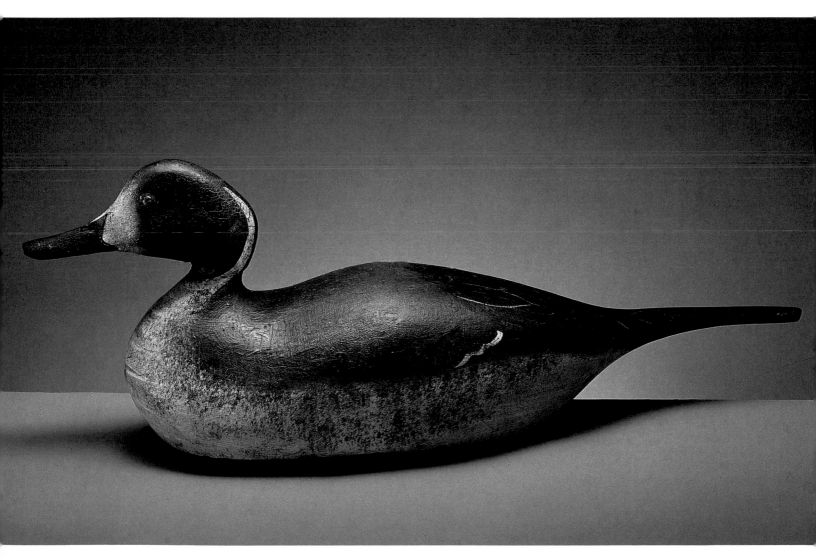

28
Yellowlegs
c. 1890
Carved, polychromed wood
13.3 x 30.5 x 6.4 (5$^{1/4}$ x 12 x 2$^{1/2}$)
Made by William Bowman
(1824–1906?) of Lawrence, Long
Island, New York

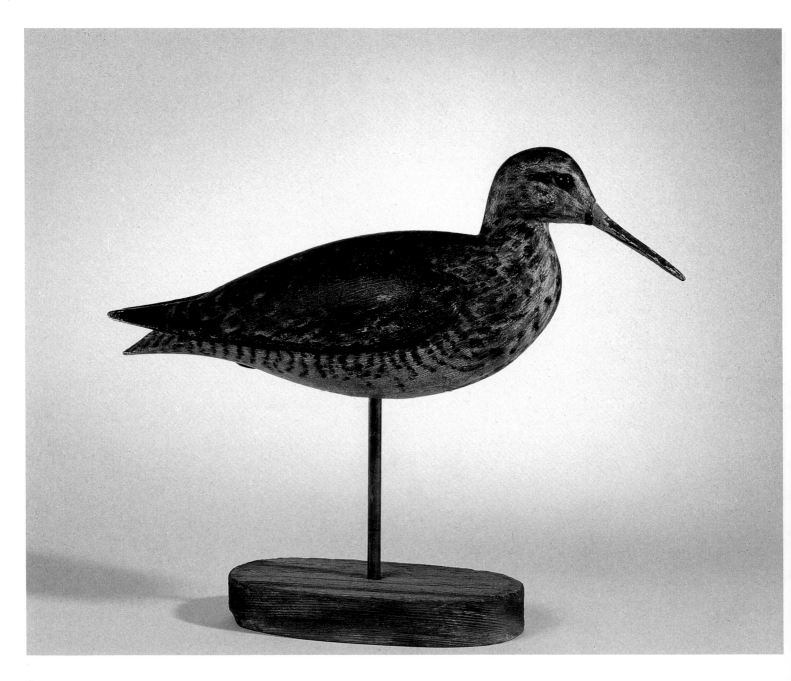

30
Pair of Willets
c. 1900
Carved, polychromed wood with iron
nails wrapped with sheet lead
Each 19.1 x 33.0 x 6.4 (7$^{1}/_{2}$ x x 13 x 2$^{1}/_{2}$)
Found in Connecticut

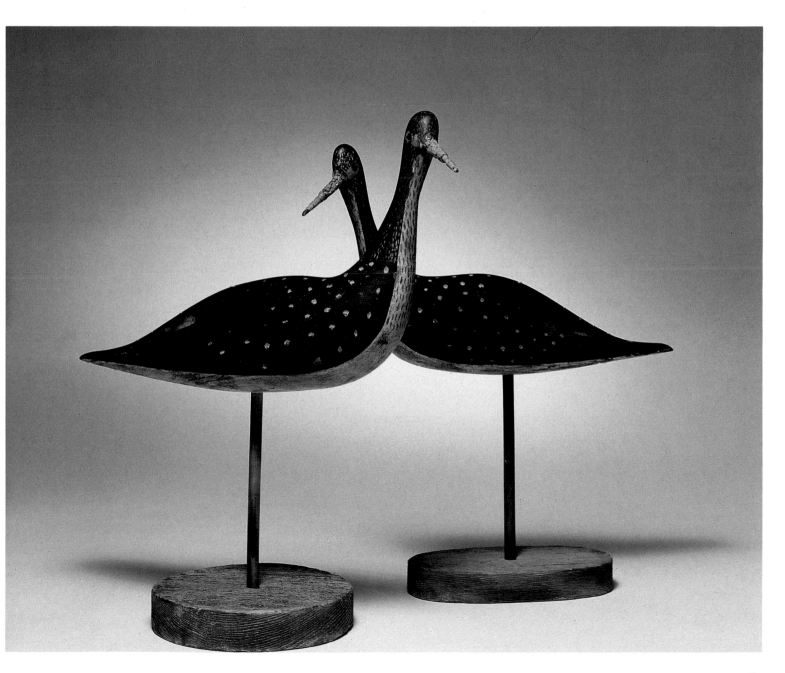

31
Yellowlegs
c. 1900
Carved, polychromed wood
8.9 x 40.0 x 5.7 (3^1/$_2$ x 15^3/$_4$ x 2^1/$_4$)
Made by Thomas Gelston (1851–1924)
of Quogue, Long Island, New York

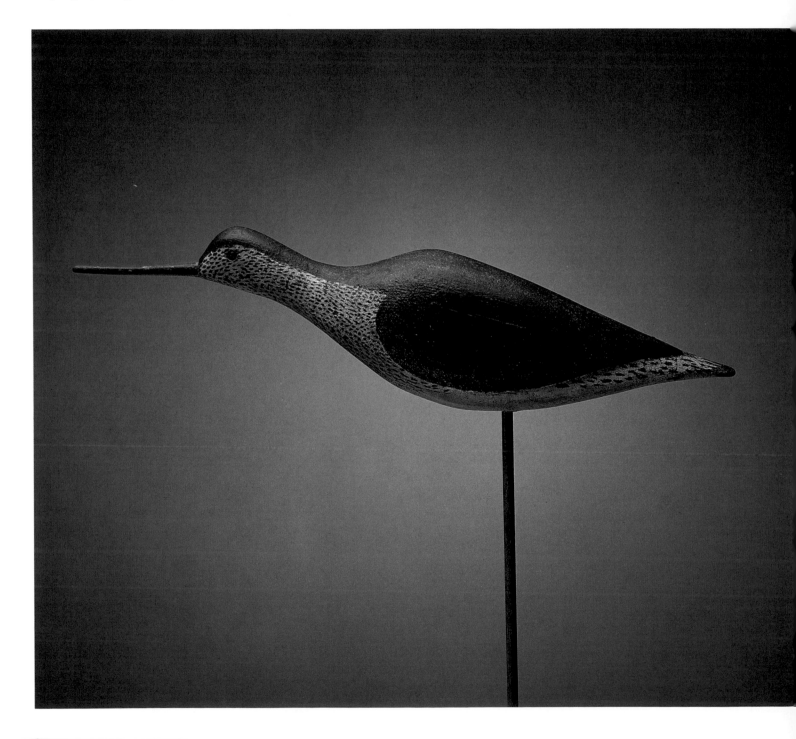

32
Red-Throated Loon
c. 1900
Carved, polychromed wood, rawhide
26.0 x 64.8 x 15.6 (10¼ x 25½ x 6⅛)
Probably made in Maine or Nova Scotia

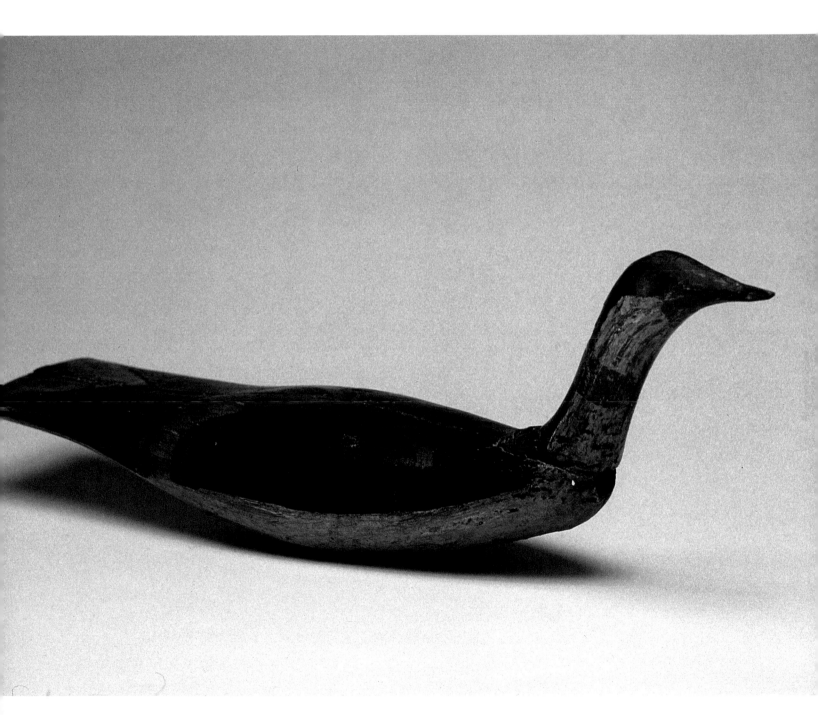

33
Swan
c. 1910
Carved, polychromed wood
51.8 x 88.9 x 29.9 (20³/₈ x 35 x 11³/₄)
Made by John Holly, Jr. (1851–1927) or
William Holly (1845–1923) of Havre de
Grace, Maryland

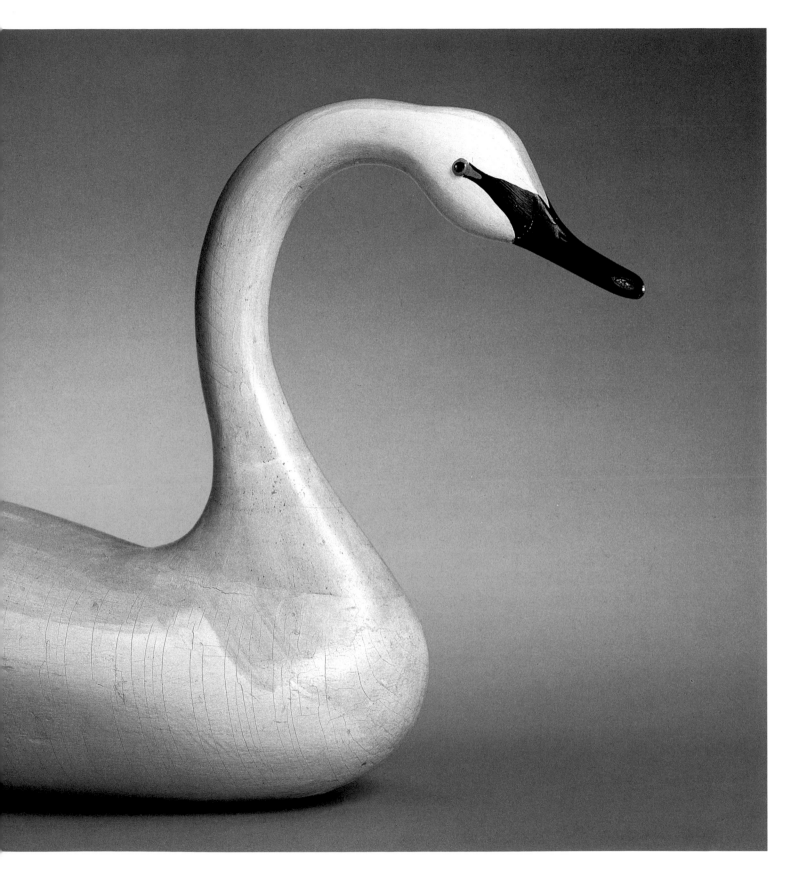

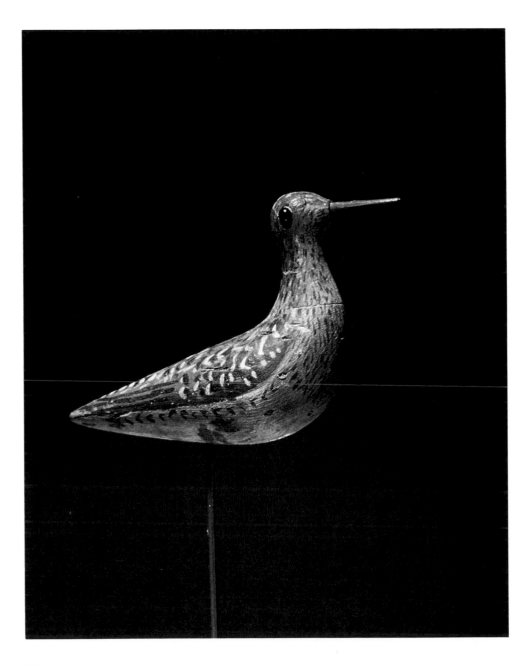

34
Peep (Least Sanderling)
c. 1910
Carved, polychromed wood
10.2 x 17.2 x 5.1 (4 x 6³/4 x 2) (excluding base)
Attributed to John Glover of Duxbury, Massachusetts
Gift of Winsor White

Black Duck
c. 1920
Carved, polychromed wood
19.1 x 39.4 x 14.6 (7¹/2 x 15¹/2 x 5³/4)
Made by A. Elmer Crowell (1862–1952)
of East Harwich, Massachusetts

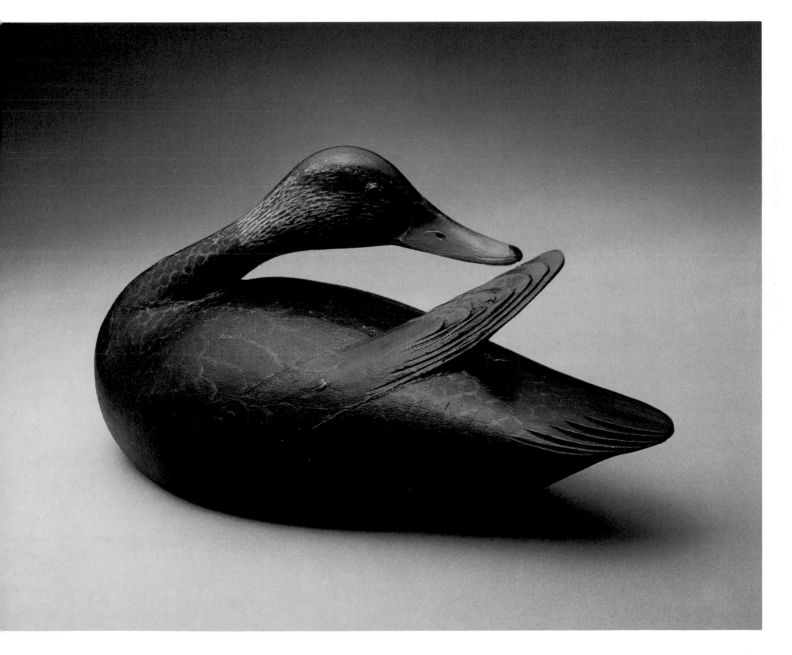

36
Mallard Drake
c. 1923
Carved, polychromed wood, iron
tail feather
13.0 x 43.5 x 16.2 (5^1/$_8$ x 17^1/$_8$ x 6^3/$_8$)
Made by Charles E. "Shang" Wheeler
(1872–1949) of Stratford, Connecticut

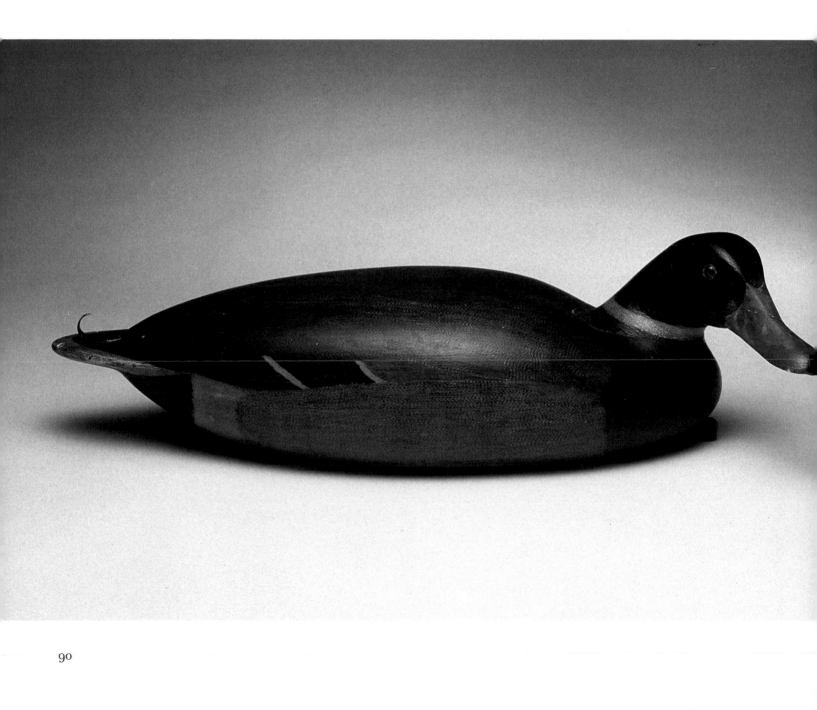

Red-Breasted Merganser Drake
c. 1930
Carved, polychromed wood
15.2 x 41.3 x 14.0 (6 x 16¹/₄ x 5¹/₂)
Made by Nathan Rowley Horner
(1882–1942) of West Creek, New Jersey

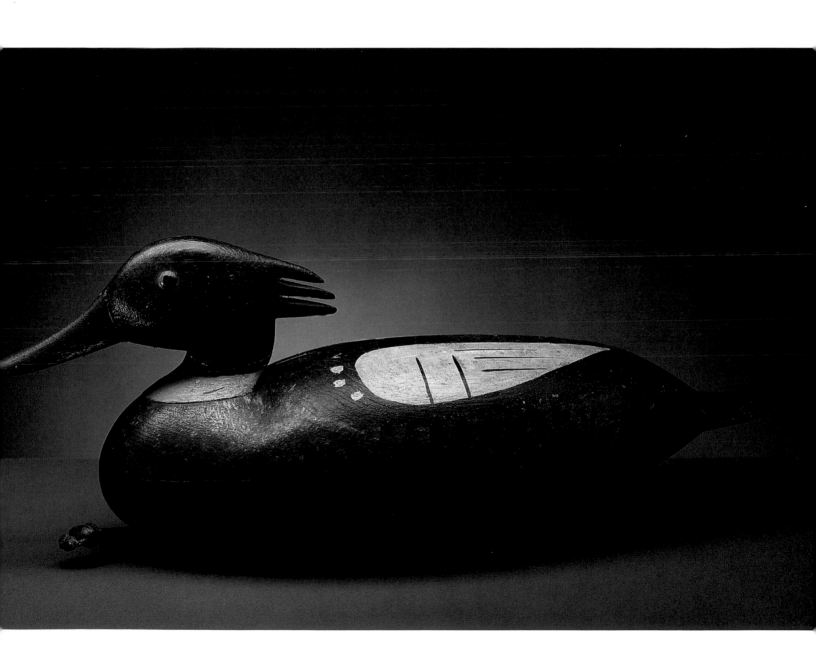

Scrimshaw

"THROUGHOUT THE PACIFIC, and also in Nantucket, and New Bedford, and Sag Harbor, you will come across lively sketches of whales and whaling scenes, graven by the fishermen themselves on Sperm Whale-teeth, or ladies' busks wrought out of the Right Whale-bone, and other like skrimshander articles, as the whalemen call the numerous little ingenious contrivances they elaborately carve out of the rough material, in their hours of ocean leisure" (Herman Melville, *Moby Dick*)

The American whaling industry, begun by Nantucket settlers in the early eighteenth century, was firmly established after the Revolution and dominated the world market in the nineteenth century. At its peak in 1850, 700 whalers carried more than 20,000 men from the South Pacific to the Arctic in search of the great whales. Voyages could last from three to five years; whale blubber was processed and stored on board the ships.

For the thirty sailors aboard a whaling ship, life was both tedious and hard. The excitement and danger of a whale kill were often followed by weeks of waiting once the job of "cuttin-in" and "trying-out" the whale blubber was completed. Monotony was relieved by such pastimes as gaming, fancy rope work, and carving. Log books such as the one kept by Captain Nehemiah West of the Dartmouth brig *By Chance* record the endless hours spent watching the seas, "All these twenty four hours

small breezes and thick foggy weather. So ends the day. All hands employed scrimshanting."

Sailors used whale bone and teeth left after processing to make homecoming gifts for friends and loved ones. Saws and files were used for cutting, turning, and shaping the whalebone. With gimlets and awls they bored and pierced holes; with needles and knives they pricked and incised designs. Finally, sandpaper or sharkskin were used to smooth the ribbed teeth. The sailor's own hands gave the final polish. Melville reported that "Some of them had little boxes of dentistical-looking implements especially intended for the skrimshandering business, but in general they toil with their jackknives alone and with that almost omnipotent tool of the sailor, they will turn you out anything you please in the way of a mariner's fancy."

The simplest and most familiar form of scrimshaw is the whale tooth decorated with engraved scenes recording the whale chase and capture. Sometimes portraits of famous figures or designs were copied from popular illustrations (cat. 48). Sailors also employed carved whale bone combined with such materials as tortoise shell, horn, pewter, silver, or wood to fashion kitchen implements, domestic and needlework tools, and fashion accessories.

The pie crimper was the most popular of the kitchen implements fashioned by scrimshanders. The crimper's intri-

cate rosette zigzag wheel and fork was used to cut, press, and pierce pie pastry. Handles could be pierced with hearts and flowers copied from embroidery or quilt patterns or carved with designs inspired by such images of the sailor's everyday world as the ship's compass or figure head (cat. 44). Thoughts of home often inspired the scrimshander to include a special message in his work. One sailor engraved a New Year's greeting on his crimper's pastry stamp, while another added a penned inscription, *Rem.ᵉ me* (cat. 41).

The scrimshander could use a wide variety of materials to make yarn swifts. The basket ribs on the swift included in the exhibition (cat. 46) were shaped from the whale's jaw bone, while teeth were used for the yarn holder, lower clamp, and spool holders. The center shaft was turned from a long walrus tusk, and the sewing box built from wood veneer.

Busks first became popular as a sailors' gift in the mid-eighteenth century, when women's fashion dictated the wearing of stiff bodice corsets. Although nineteenth-century clothing styles eliminated their use, sailors continued to make busks as special keepsakes, the most personal and intimate gifts for a wife or sweetheart. Traditional designs of hearts, birds, and flowers are often interspersed with images of palm trees or fronds drawn from the sailor's travels.

The Civil War marked the beginning

f the end of the American whaling
ndustry. Confederate commerce raid-
ers captured many of the slower mov-
ng Yankee whale ships. Many were
ourned or sunk when the Confederacy
collapsed. Alternative fuels such as ker-
osene also reduced the demand for
whale oil and spermaceti candles. Nat-
ural disasters, such as the destruction in
871 and 1876 of hundreds of whaling
vessels by massive pack ice, and years of
overhunting brought the whaling
ndustry to a virtual standstill as the
nineteenth century ended. C.O.

8
**Busk: Heart-Shaped Top with
Palm Tree**
c. 1840
ncised, painted bone
34.3 x 3.8 x .15 (13$^{1/2}$ x 1$^{1/2}$ x $^{1/16}$)
Gift of George Frelinghuysen

39
Busk: Birds, Flowers, Stars
c. 1840
ncised, painted, and inked bone
34.7 x 3.8 x .15 (13$^{11/16}$ x 1$^{1/2}$ x $^{1/16}$)
Gift of George Frelinghuysen

44
Crimper: Woman Riding Wheel
c. 1850
Carved and inked ivory
12.4 x 4.8 x 3.8 (4⁷/₈ x 1⁷/₈ x 1¹/₂)
Gift of George Frelinghuysen

42
Crimper: Heart, Club, and Star
c. 1850
Carved ivory
14.6 x 5.1 x 1.25 (5³/₄ x 2 x ¹/₂)
Gift of George Frelinghuysen

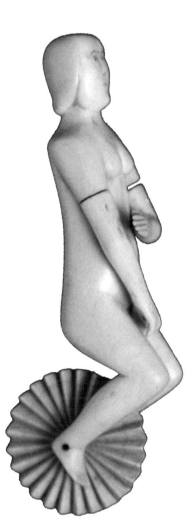

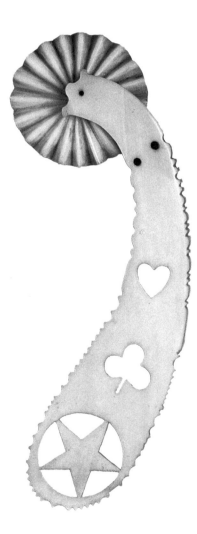

40
**Crimper: Double Eagle Head
and Hand**
c. 1840
Carved, incised ivory colored with red
wax; brass and silver
20.0 x 10.6 x 3.5 (7⁷/₈ x 4³/₁₆ x 1⁶/₁₆)
Gift of George Frelinghuysen

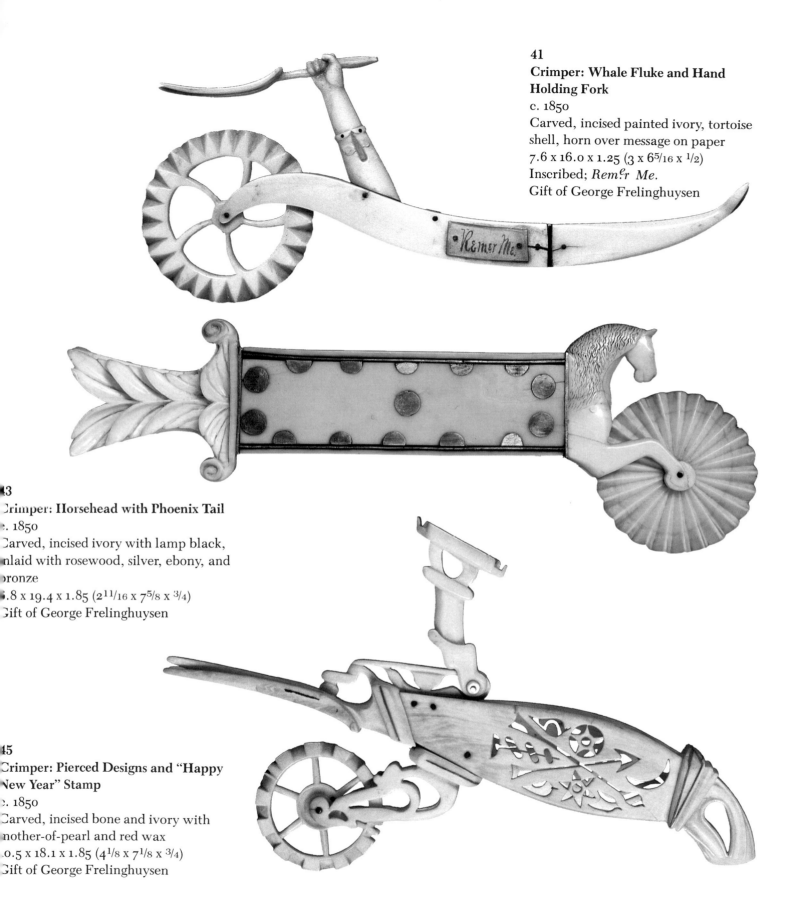

41
Crimper: Whale Fluke and Hand Holding Fork
c. 1850
Carved, incised painted ivory, tortoise shell, horn over message on paper
7.6 x 16.0 x 1.25 (3 x 6⁵/₁₆ x ¹/₂)
Inscribed; *Rem.ᵉr Me.*
Gift of George Frelinghuysen

43
Crimper: Horsehead with Phoenix Tail
c. 1850
Carved, incised ivory with lamp black, inlaid with rosewood, silver, ebony, and bronze
6.8 x 19.4 x 1.85 (2¹¹/₁₆ x 7⁵/₈ x ³/₄)
Gift of George Frelinghuysen

45
Crimper: Pierced Designs and "Happy New Year" Stamp
c. 1850
Carved, incised bone and ivory with mother-of-pearl and red wax
10.5 x 18.1 x 1.85 (4¹/₈ x 7¹/₈ x ³/₄)
Gift of George Frelinghuysen

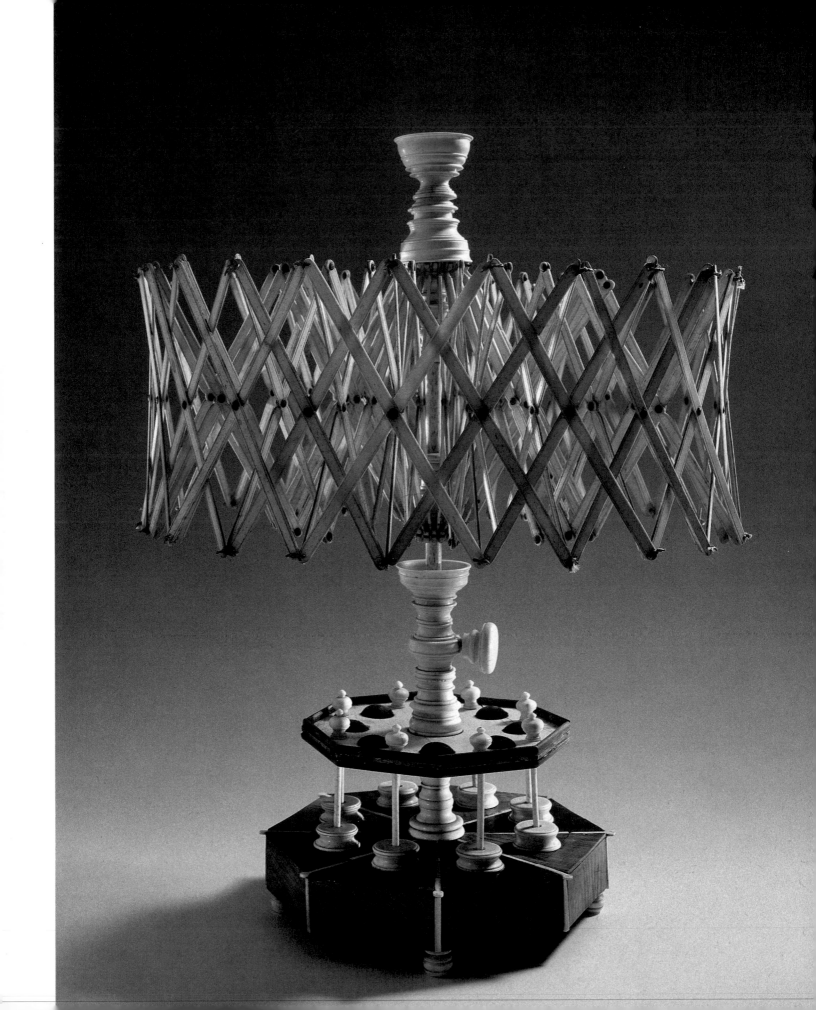

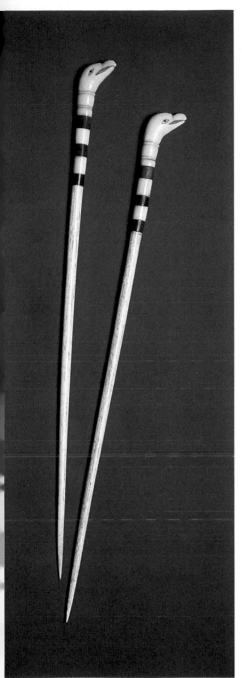

47
Knitting Needles: Eagles' Heads
c. 1850
Carved, incised ivory and bone, colored with red wax; rosewood inlays; walrus ivory heads and whale bone shafts
32.4 x 2.5 x 1.05 (12³/₄ x 1 x ⁷/₁₆)
Gift of George Frelinghuysen

48
Sperm Whale's Tooth
c. 1850
Incised and inked ivory
4.8 x 8.9 x 19.4 (1⁷/₈ x 3¹/₂ x 7⁵/₈)
George Washington is depicted here on horseback, while an eagle over a shield with four American flags is shown on the other side; a continuous whaling scene encircles the base of the tooth
Gift of George Frelinghuysen

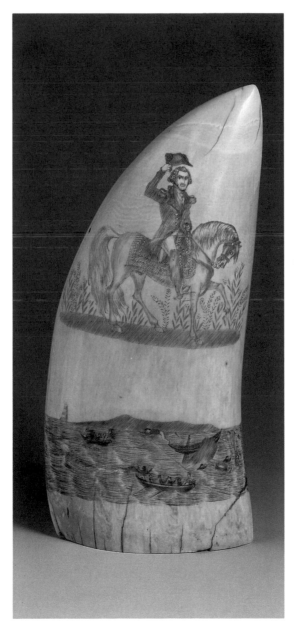

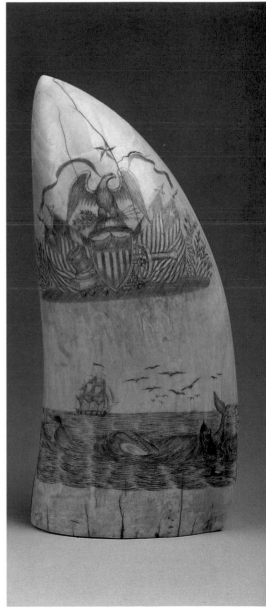

46
Swift
c. 1850
Turned and incised whale ivory and bone; wood padded with velvet
49.5 x 20.5 x 20.3 (width and depth at base) (19¹/₂ x 8¹/₁₆ x 8)
Gift of George Frelinghuysen

Trade Figures

TOBACCO AND THE AMERICAN INDIAN have always been inextricably linked in the public imagination. Carved wooden cigar-store figures made their first appearance in English and Dutch tobacco shops in the early 1600s. These early figures were small, made to stand on a countertop inside the shop. And because most carvers had never seen an American Indian, many of the figures depicted blacks, dressed in the head-dresses and beads reported by travelers and chroniclers of the New World. In the late 1600s, more accurate likenesses of American Indians became widely known in Europe. With the introduction of snuff around 1700, the Scottish highlander entered the permanent repertory of cigar-store figures (cat. 55).

Cigar-store figures were in use in America well before the Revolutionary War, but they were not common until the mid-1800s. From about 1850 to 1900, thousands of cigar-store figures were made; during these years, no respectable tobacconist kept shop without one. Most American cigar-store figures were life-size or even bigger. A contemporary account published by Frank Weitzenkampf in *The New York Times* on 3 August 1890 describes the variety of popular characters: "Times change and so does the popular taste. At first the red man ruled the market almost completely. Then came a heavy sprinkling of other figures—fiery Scotchmen, English officers with small fatigue caps or high bearskins, and

heavy swells of ante-bellum times and the war period, with marvelously wide pantaloons and waving mutton-chop whiskers, simpering Dolly Vardens with short-cut skirts, bustles, and hats tilted forward over the eyes. Then came grave Turks, gorgeous sultanas, and columbines with alarmingly short skirts. Punch, with rubicund nose and protuberant chin, was a favorite figure. There was also the conventional plantation [figure] . . . with striped pantaloons and a great expanse of shirt collar."

Most cigar-store figures were the work of professional wood carvers. Some of these men, such as John Cromwell (1805–1873) (cat. 49) and the Canadian Louis Jobin (1845–1928) (cat. 53), began their careers as ship carvers, supplying figureheads, stern boards, and other ornaments for wooden sailing ships; as steamboats came to dominate the waterways, the carvers transferred their skills to the production of cigar-store Indians. Other carvers, such as New York's Samuel A. Robb (1851–1928), built their reputation on cigar-store figures, although they did a wide variety of other carving as well. In an 1881 advertisement Robb offers "Show Figures and Carved Lettered Signs A Speciality, Tobacconist Signs in great variety, on hand and made to any design, Ship and Steamboat Carving, Eagles, Scroll Heads, block letters, Shoe, Dentist and Druggist Signs, etc." Diversity was the professional wood-

carver's stock-in-trade. Robb's "etc." included the carving of circus wagons with elaborate figural tableaux for Adam Forepaugh and Barnum and Bailey (cat. 21), several life-size baseball players used as trade figures for sporting goods stores, and the "Inexhaustible Cow," a larger-than-life Coney Island attraction that provided milk at 5¢ a glass from spigots fitted into its wooden udder. The cow's hollow interior served as an ice box for milk cans.

Almost without exception, cigar-store figures were carved from solid pieces of white pine, often cut from spars bought in local shipyards. Most carvers used paper patterns to mark the basic form, which they then roughed out with a hand axe. After the general proportions were defined, a chisel was used to bring the figure to the finishing stage; details were carved with specialized tools. Extended limbs such as the squaw's right arm (see cat. 52) were carved separately and secured with screws. Finally, the entire figure was sanded smooth and painted. Most figures were mounted on bases, often equipped with wheels so they could be easily moved outside the shop in the morning and back in at night for protection from vandalism.

Although a few cigar-store figures were still in use into the 1920s, demand for new figures was sharply reduced after the turn of the century, largely due to the introduction of electric signs,

which could advertise a business after dark. The few carvers who remained in the business worked primarily at repairing and touching up older figures. Samuel Robb, ever resourceful, carved eagles, architectural panels, molds for castings, and even a few ventriloquist's dummies. Louis Jobin turned exclusively to the creation of religious figures for churches in his native Quebec. By the end of World War I, the cigar-store figure had become an anachronism. R.S.

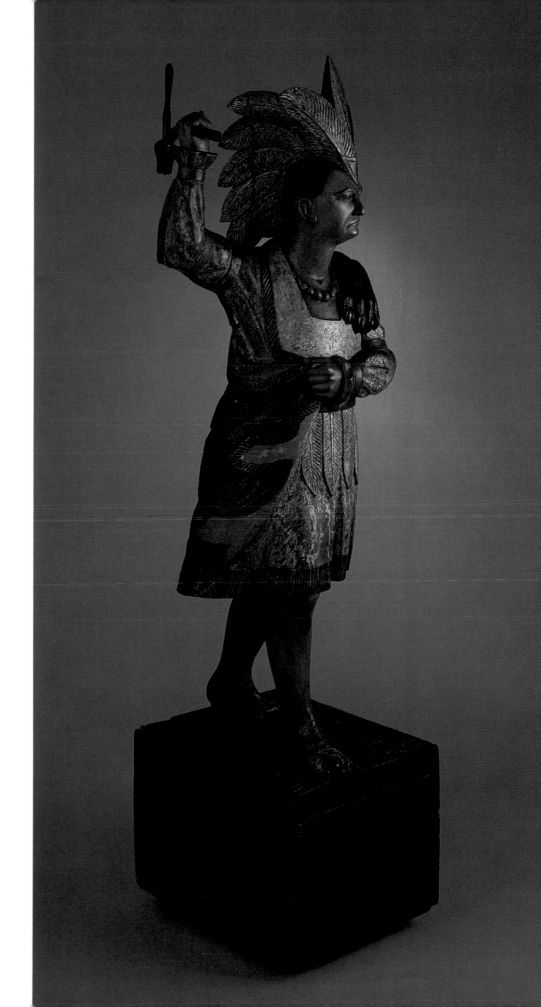

49

Cigar-Store Indian with Hatchet
c. 1855
Carved, polychromed wood
179.1 x 41.0 x 53.3 (including base)
(70 1/2 x 16 1/8 x 21)
Attributed to John Cromwell
(1805–1873) of New York City;
Cromwell originated this design, which
was copied by several later craftsmen

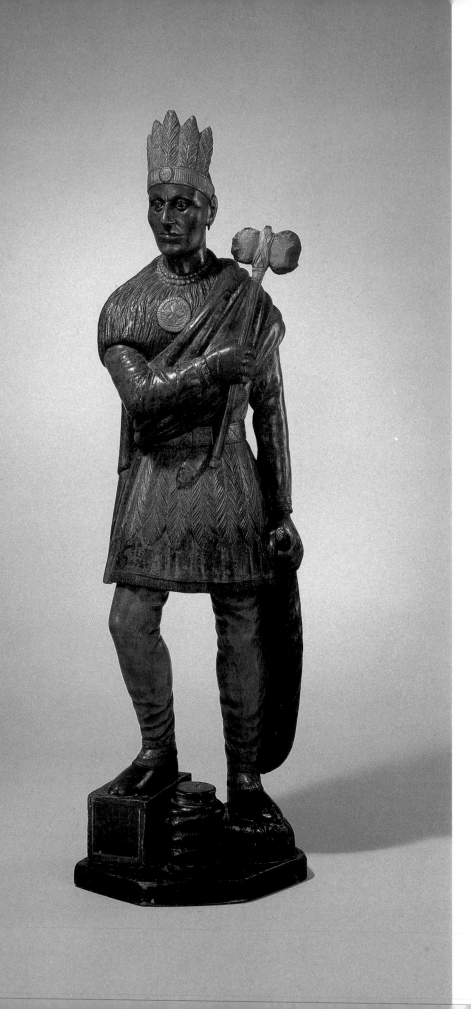

50
Indian with War Club
c. 1870
Carved, polychromed wood
146.7 x 38.1 x 29.2 (57³/4 x 15 x 11¹/2)
(including base)

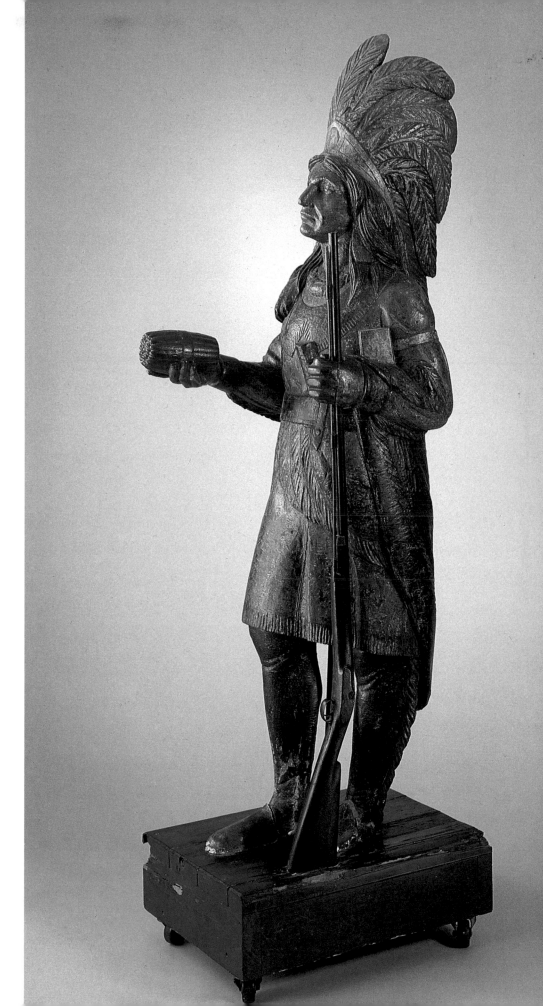

51
Indian with Rifle
c. 1880
Carved, polychromed wood
231.1 x 50.2 x 69.9 (91 x 19³/4 x 27¹/2)
(including base)

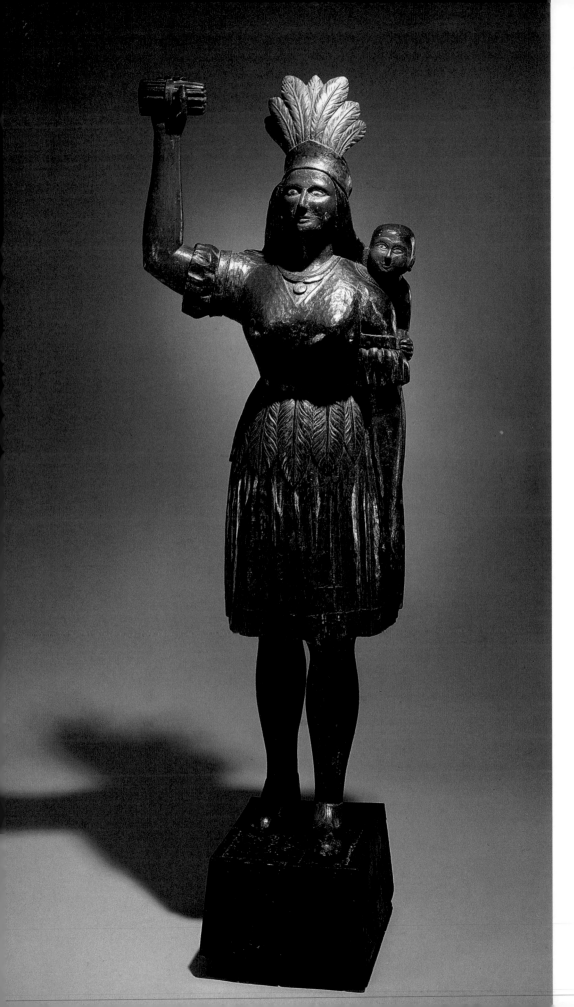

52
Indian Squaw and Papoose
c. 1880
Carved, polychromed wood
195.6 x 68.6 x 50.8 (77 x 27 x 20)
(including base)
Found in Maine

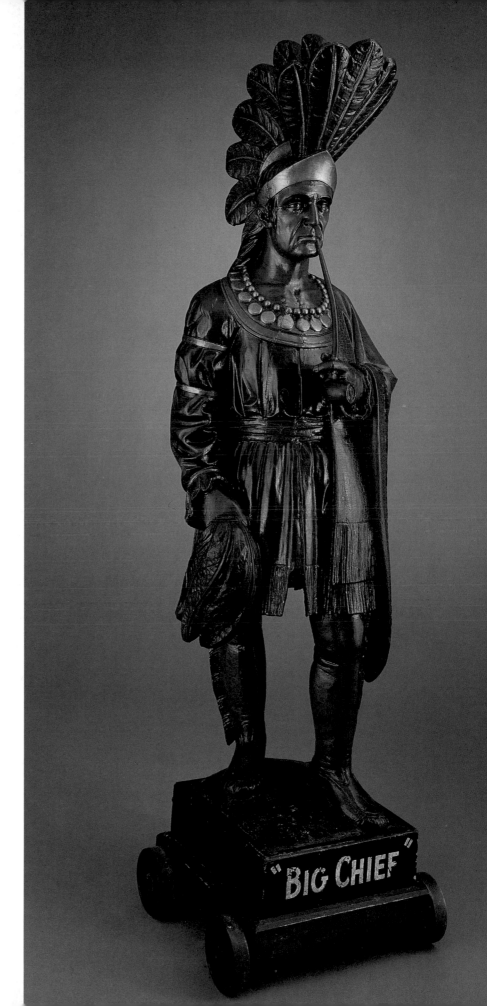

53
Indian with Pipe
c. 1885
Carved, polychromed wood
192.4 x 52.1 x 55.9 (including base)
(75³/₄ x 20¹/₂ x 22)
Made by Louis Jobin (1845–1928) of
Quebec

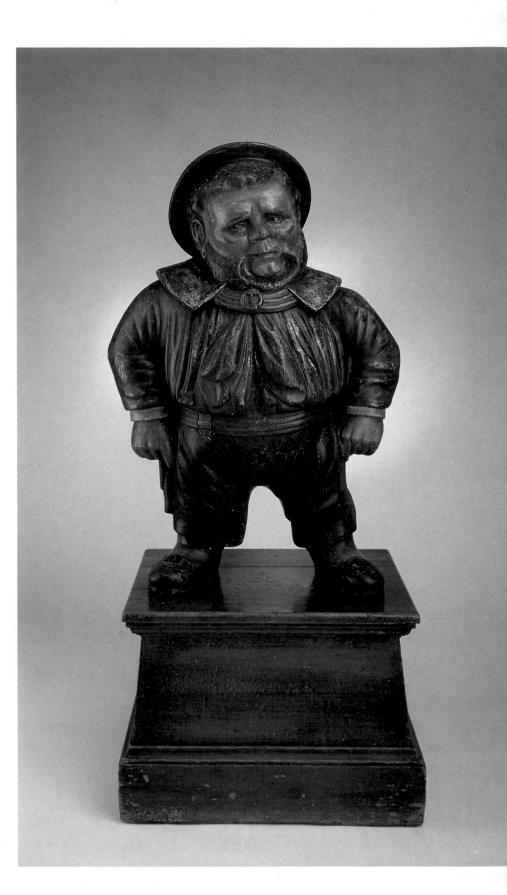

54
Jack Tar
c.1860–1870
Carved, polychomed wood
74.9 x 106.7 x 38.1 (29½ x 42 x 15)

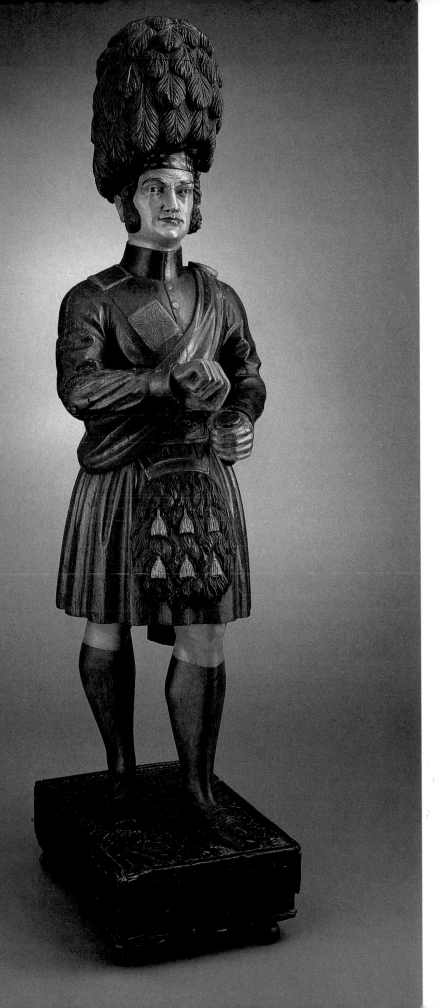

55
Scottish Highlander
c. 1878
Carved, polychromed wood
226.1 x 50.8 x 63.5 (89 x 20 x 25)
(including base)
Shop of Samuel A. Robb (1851–1928) of
New York City

105

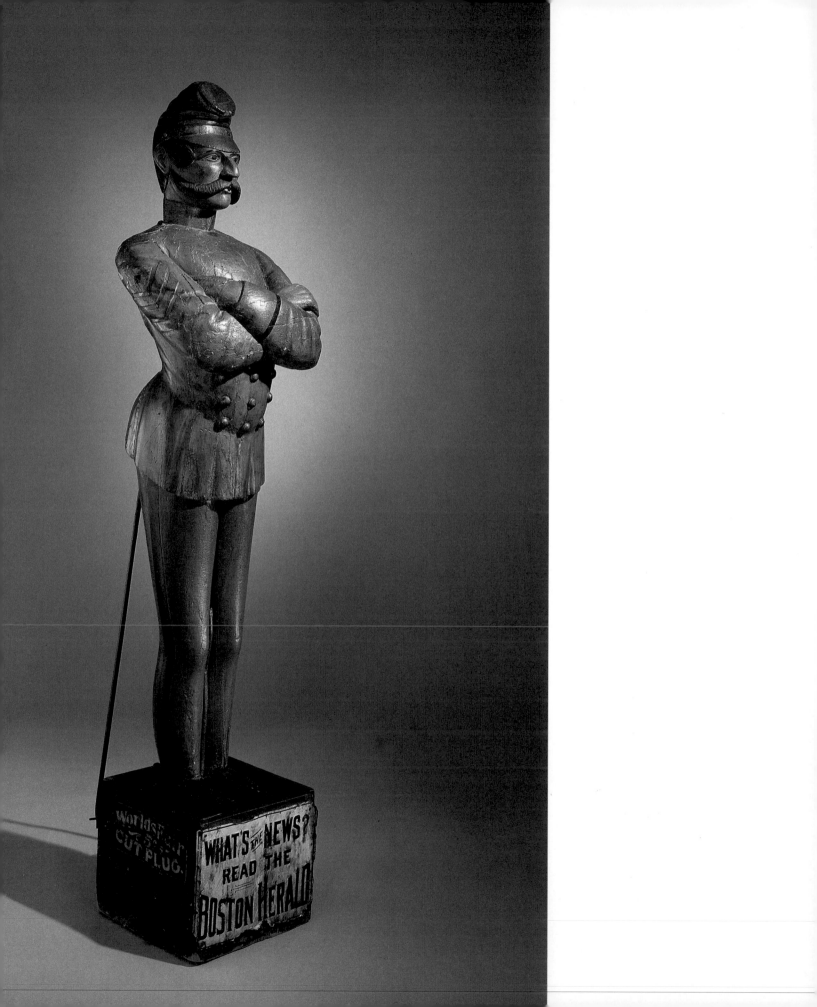

56
Captain Jinks
c. 1880
Carved, polychromed wood, with iron
rods and stamped, painted tin placards
190.5 x 43.2 x 43.2 (including base)
(75 x 17 x 17)
Shop of Samuel A. Robb (1851–1928) of
New York City; attributed to Robb's
associate Thomas J. White. This is a
caricature of Robb in his National
Guard uniform

Carousel Animals

Although the carousel reached its greatest level of popularity and artistic refinement in America, it was a European invention. Revolving platforms carrying various kinds of seats first became popular in France in the 1700s. The amusement soon spread to Germany and England, where two major innovations appeared in the 1800s. German wood-carvers introduced the idea of using carved wooden animals as seats; the English were the first to employ a steam engine to rotate the circular platform on which the seats were placed. Carousels turned by mule or manpower were in use in America early in the nineteenth century; these featured very simple wooden horses, strung from chains, which rocked back and forth as the platform was turned. The familiar up-and-down motion of the carousel figure became possible only with the use of steam-driven gear systems.

The American carousel industry came into being shortly after the Civil War and had its heyday from 1890 through the late 1920s, when the Great Depression forced most of the major companies either to shut down or drastically cut back their production. Large, elaborate carousels became fixtures of the new city parks that had been built for a general public with increasing amounts of leisure time and disposable income. Several manufacturers also built smaller, portable carousels, which could move from place to place with the country fairs and carnivals that entertained rural Americans each summer.

The major carousel companies employed a number of professional craftsmen (carpenters, painters, carvers, metalworkers, mechanics). Patterns for animals were usually designed and drawn by one of the master carvers. The carpenters then assembled basic block forms of the body, head, and legs by pegging and gluing a number of pieces of wood together. This method gave the carvers the best possible surface for their highly detailed work. Heads and legs were usually carved first and then attached to the body block for finish work. Although the basic forms were determined by the patterns, each carver brought his own style to the detailing of saddlery, tack, musculature, and mane. After the carvers and painters had added the finishing touches, the animals were mounted on the carousel machine.

Many carousels also featured elaborately carved chariots for less adventurous or agile riders, as well as carved and painted shields and trim and a variety of painted panels placed to disguise the machinery and add to the appeal of the ride. Music was provided by a band organ, also often produced by the carousel company and decorated with intricate carving.

The five carousel animals included here (see cats. 57–61) are products of the Gustav Dentzel Company of Philadelphia. The German-born Dentzel opened the first carousel manufacturing business in America in 1867. Dentzel's shop produced the most realistic and graceful of all carousel animals; his carvers paid enormous attention to anatomical detail, and his painters rendered every nuance of the animal's coloration. These Dentzel figures are from a forty-animal carousel completed by the Dentzel shop c. 1902 and now owned by the Shelburne Museum. The three-row machine carried twenty-nine horses and four chariots; menagerie figures include three giraffes, three goats, three deer, and a lion and tiger.

Most of the figures were grouped in threes, with the largest and most elaborate animal on the outside in order to draw riders onto the carousel. The right or "romance" side of these outer row figures (facing out from the counterclockwise turning machine) always received special attention from the carver. The giraffe (cat. 60) and horse (cat. 59) in this exhibition are both outer row figures. The giraffe's left side is plain; its romance side, by contrast, carries a wealth of decoration. The horse's romance side features a deeply carved, wavy mane, cocked head with carved flower on the forehead, a face carved on the chest at the edge of the saddle blanket, an eagle's head at the back of the saddle, and tassel decorations at the thigh.

The giraffe and horse were finish carved by Daniel Muller (1872–1952),

the most gifted of Dentzel's employees. Muller, who studied at the Pennsylvania Academy of the Fine Arts, is credited with creating many elements of the Dentzel style. He designed many of the patterns from which the Dentzel carpenters built the basic body forms finished by Muller and other master carvers. Muller joined the Dentzel firm in 1888. He and his brother Alfred left Dentzel around the turn of the century and founded their own company a few years later, operating successfully until 1917. They rejoined Dentzel after their company went out of business; Daniel worked for the Dentzel firm until its demise in 1928. R.S.

57
Tiger
before 1903
Carved, polychromed wood with glass, leather, brass, and iron attachments
127.0 x 203.2 x 36.8 (50 x 80 x 14 1/2)
Made by Gustav A. Dentzel Carousel Company of Philadelphia; carved by Daniel Muller (1872-1952)

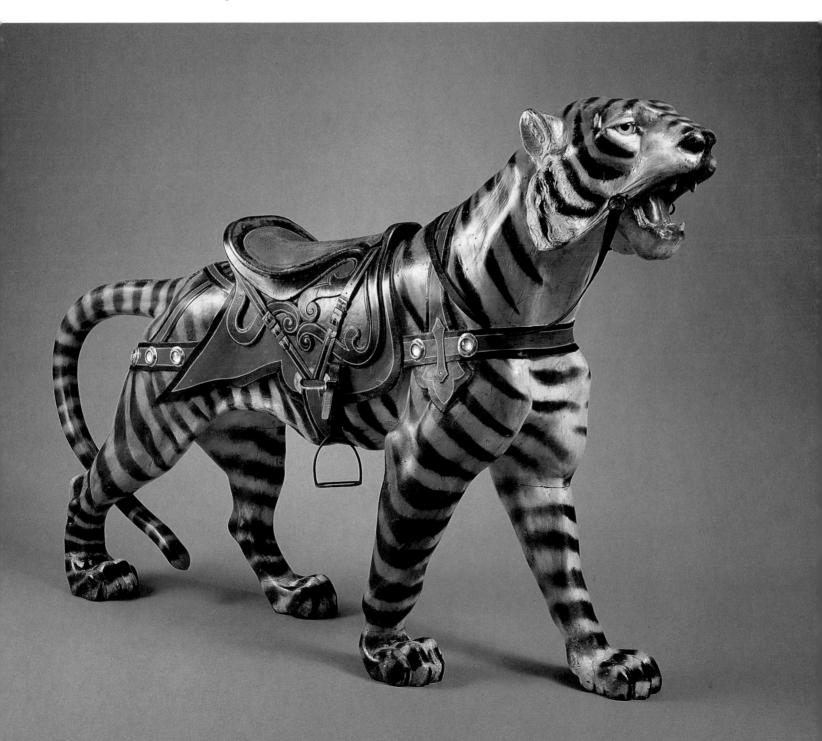

58
Goat
before 1903
Carved, polychromed wood with glass,
leather, brass, and iron attachments
141.0 x 167.6 x 30.5 (55 1/2 x 66 x 12)
Made by Gustav A. Dentzel Carousel
Company of Philadelphia; carved by
Daniel Muller (1872-1952)

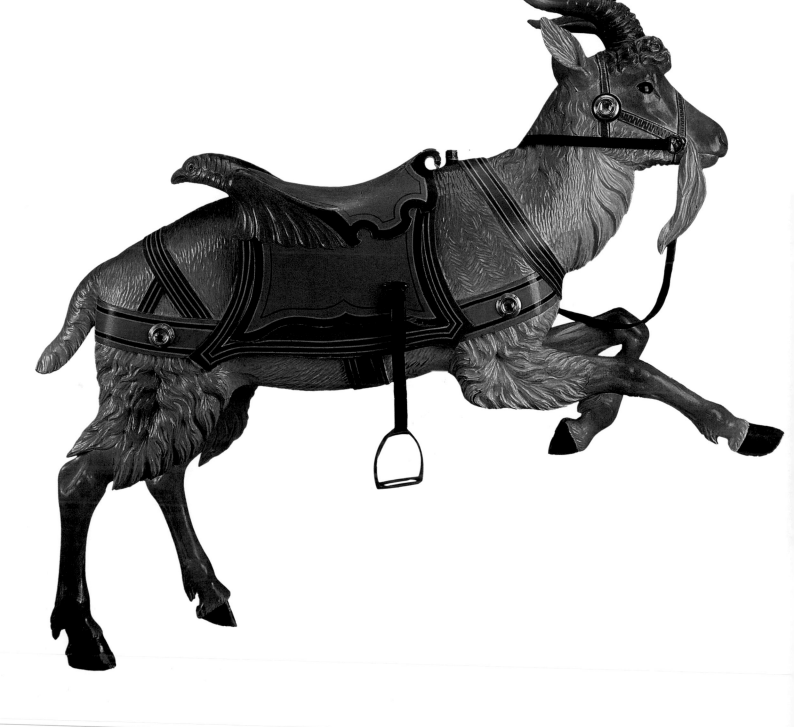

59
Horse
before 1903
Carved, polychromed wood with glass,
leather, brass, and iron attachments
149.9 x 165.1 x 30.5 (59 x 65 x 12)
Made by Gustav A. Dentzel Carousel
Company of Philadelphia; carved by
Daniel Muller (1872–1952)

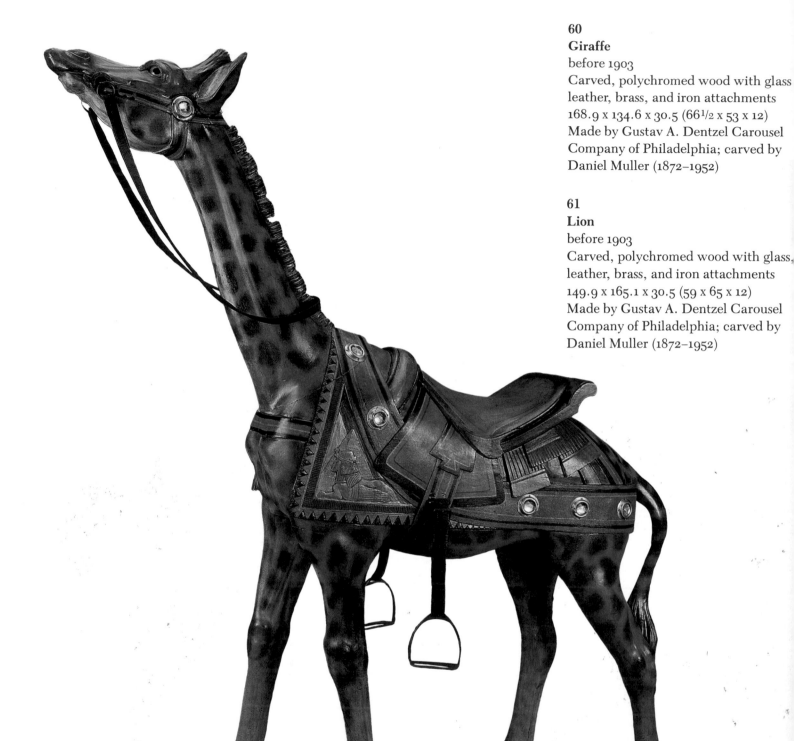

60
Giraffe
before 1903
Carved, polychromed wood with glass
leather, brass, and iron attachments
168.9 x 134.6 x 30.5 (66½ x 53 x 12)
Made by Gustav A. Dentzel Carousel
Company of Philadelphia; carved by
Daniel Muller (1872–1952)

61
Lion
before 1903
Carved, polychromed wood with glass,
leather, brass, and iron attachments
149.9 x 165.1 x 30.5 (59 x 65 x 12)
Made by Gustav A. Dentzel Carousel
Company of Philadelphia; carved by
Daniel Muller (1872–1952)

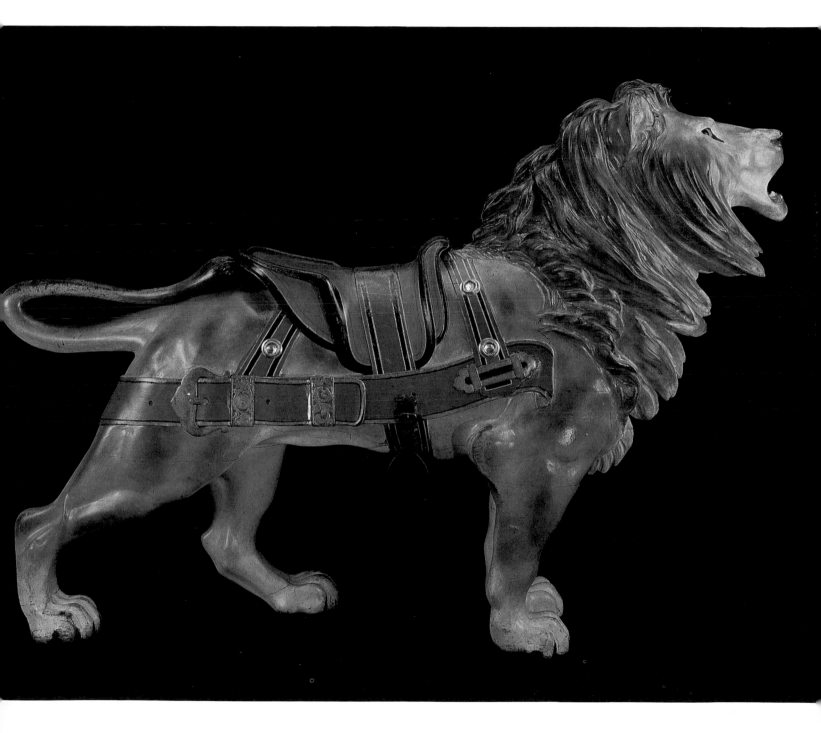

Weather Vanes & Whirligigs

FOR HUNDREDS OF YEARS weather vanes have been used as wind direction indicators and rooftop decorations. The earliest recorded weather vane, a bronze figure of Triton, capped the Tower of the Winds near the Acropolis in Athens a hundred years before the birth of Christ. The weathercock, a symbol of vigilance, topped bell towers of European churches throughout the Middle Ages, and English kings granted nobles the right to fly fanes, metal flags bearing the family coat of arms, over their castles. In later years, weathercock and fane merged to form the generic term "weather vane."

English settlers carried the European tradition to this country; vanes made as early as 1673 are still extant. These early American weather vanes were primarily metal flags, similar to the old country's fanes. Shem Drowne, maker of America's most famous weather vane, the gilded copper grasshopper that has topped Boston's Faneuil Hall since 1742, crafted an Indian archer vane for that city's Province House about 1716. Other early American subjects included fish, especially the sacred cod, so vital to coastal New England's economy, and the coiled snake of Benjamin Franklin's "Don't Tread on Me" flag. Weathercocks were probably the first vanes to move from the public perches of the European tradition (churches, meeting houses, and civic buildings) to the American barn roof. Other common barnyard animals such

as cattle, sheep, pigs, horses, and dogs soon entered the American weather vane maker's repertoire.

Although Shem Drowne's grasshopper was fashioned in copper, a material that became a favorite with later commercial manufacturers, most early vanes were made either of wood or sheet iron. Drowne's vane is also atypical because it is three-dimensional; most early handmade pieces were flat silhouettes, cut rather than molded. The wooden rooster (cat. 62) and the sheet-iron Indian archer (cat. 66) demonstrate how early craftsmen used these materials in making weather vanes. Both vanes depict a common theme in an uncommon, individual way. Because weather vanes were made to be seen only from a distance, silhouetted against the sky, their forms emphasize essential features. Proportions were often exaggerated for effect and clarity; note the Indian's oversized, misplaced eye and tiny hands and feet and the cock's extended, sinuous neck and enormous paddle tail.

Prior to 1850, most weather vanes were unique and handmade. A few professional craftsmen, like Shem Drowne, are known, and blacksmiths and woodworkers may have also made weather vanes. Most, however, were crafted by the farmer or homesteader to decorate his barn. All this changed in the second half of the nineteenth century, as American manufacturing and marketing matured.

The first full-time commercial weather vane manufacturer was Alvin L. Jewell of Waltham, Massachusetts, near Boston, who opened his doors in 1852. Jewell, a gifted designer and craftsman, created a line of weather vane forms imitated by all later businesses. He was also the first to publish a catalogue of his designs. His vanes were made of copper molded in iron forms, which had been cast from carved wooden models. Each part of the vane was molded in two symmetrical halves and joined with solder. This new method allowed Jewell and his followers to mass produce identical vanes. Jewell's hollow copper vanes were clear, simple forms, recognizable from any viewpoint. They were an immediate success.

After Jewell's death (in a rooftop fall) in 1867, his business and patterns were sold at auction. The successful bidders, L. W. Cushing, an engineer, and Stillman White, a mechanic, continued and expanded Jewell's business, introducing a number of new designs. Several other companies, primarily in the greater Boston and New York areas, entered the field in the next decade. Demand was tremendous. In the closing decades of the nineteenth century, nearly every cupola, turret, and rooftop in America sported a commercially made vane. The Massasoit produced by Cushing and White's chief competitor, Harris and Co. (cat. 72), is a fine example of commercially molded copper

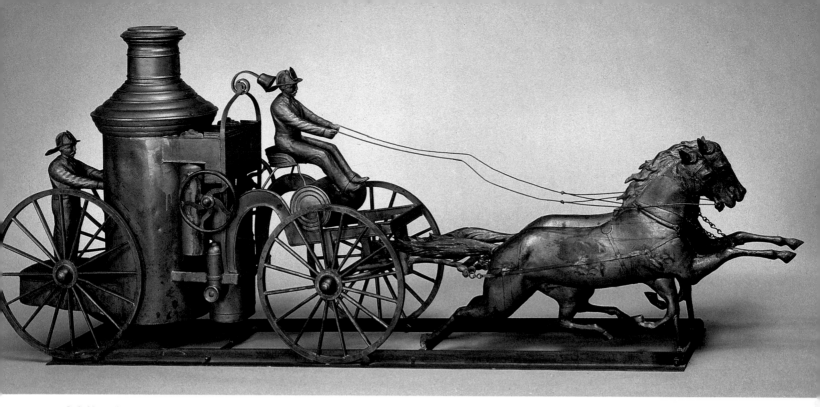

vanes, and differs from the earlier sheet-iron version of this theme. Although some exaggeration is still used, as in the enormous arrow tip, the figure's proportions are generally realistic, and the molded three-dimensional construction allows attention to surface details of the costume and features. Like the earlier vane, the figure is silhouetted in profile. Since most of the details would be impossible to see when the vane was placed on a roof, they probably were intended to make the product more attractive to potential buyers viewing it in a catalogue or display room. The massive and elaborate fire engine (cat 73) was a form offered, with small variations, by most of the commercial manufacturers of the late nineteenth century. The vane in this exhibition clearly demonstrates the fine detail that could be achieved using molded copper. Not all manufactured vanes were so complex: the simple silhouette butterfly (cat. 70) was a form again offered with small variations by several manufacturers.

A close relative of the weather vane is the whirligig, a figural device powered by wind. The most basic forms, represented here by the swordsman (cat. 76), were standing figures with paddle arms that flailed in the wind. These not only pointed the wind direction, like the weather vane, but also allowed viewers to gauge wind velocity without venturing outside. Undoubtedly, however, whirligigs were made primarily for fun.

Many whirligigs are amusing caricatures of soldiers, Indians, and other stock characters. Some clever craftsmen built very elaborate whirligigs with a number of small figures who sawed wood, rode bicycles in circles, or performed other energetic tasks. In a high wind, the action could be frantic. These complex devices were powered by the geared movement of wind catching wheel, like that of the *Spinning Woman* (cat. 77). This figure, which apparently served as a trade sign, spun wool at the wheel and moved her foot up and down on the treadle. The speed of her work depended entirely on the prevailing winds.

R.S.

cat. no. 73

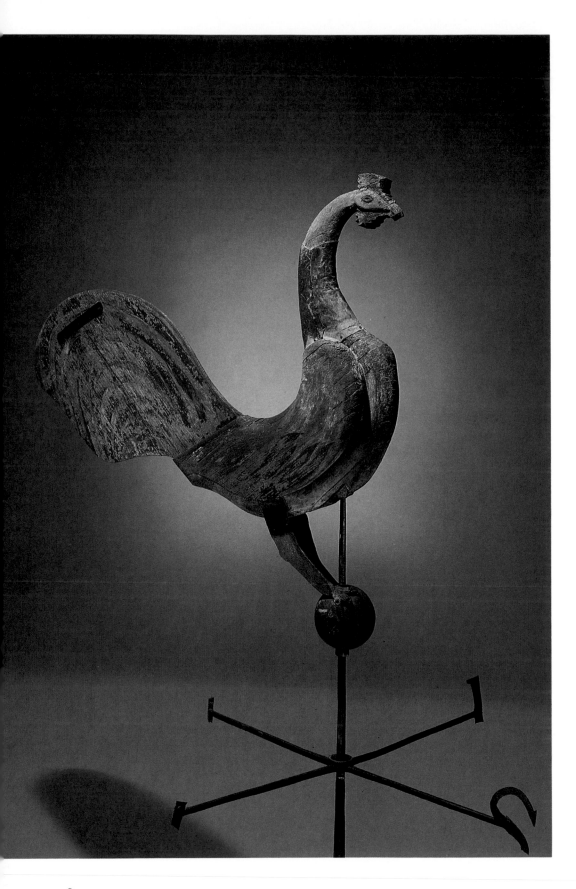

62
Cock
c. 1780
Carved, polychromed wood, wrought iron legs
86.4 x 114.3 x 38.1 (34 x 45 x 15)
This vane sat atop the barn at the Old Fitch Tavern, Bedford, Massachusetts The tavern was built in 1731 and operated as an inn from 1766–1808.

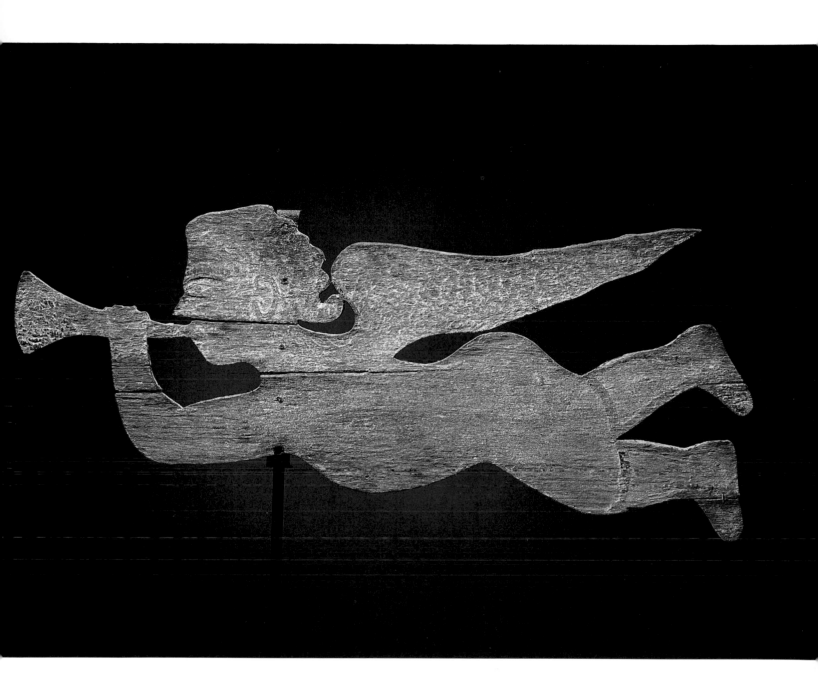

63
Gabriel
c. 1800
Sawn, polychromed wood with iron reinforcements
33 x 85.1 x 1.3 (13 x 33½ x ½)
Found in Ridgefield, Connecticut

117

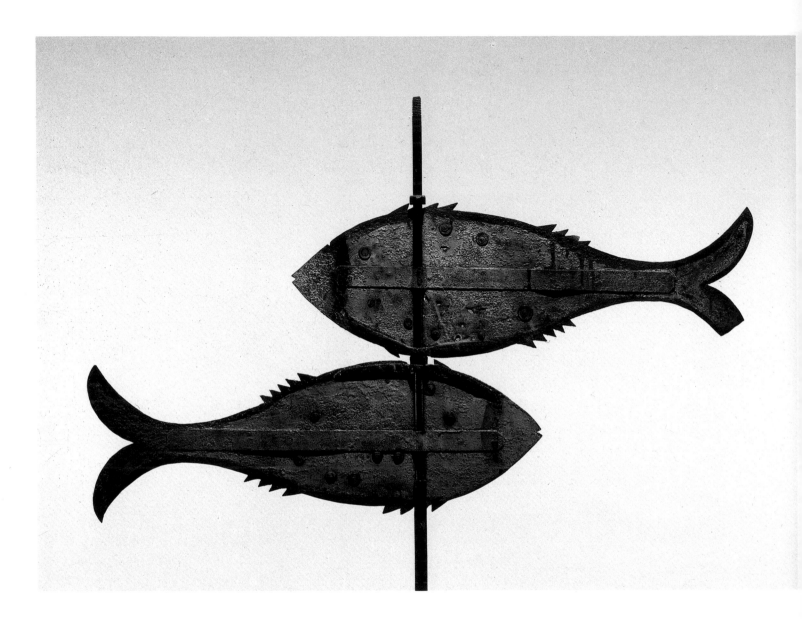

64
Pisces
c. 1800
Hammered, polychromed sheet iron
53.3 x 83.8 x 3.2 (21 x 33 x 1¹/₄)

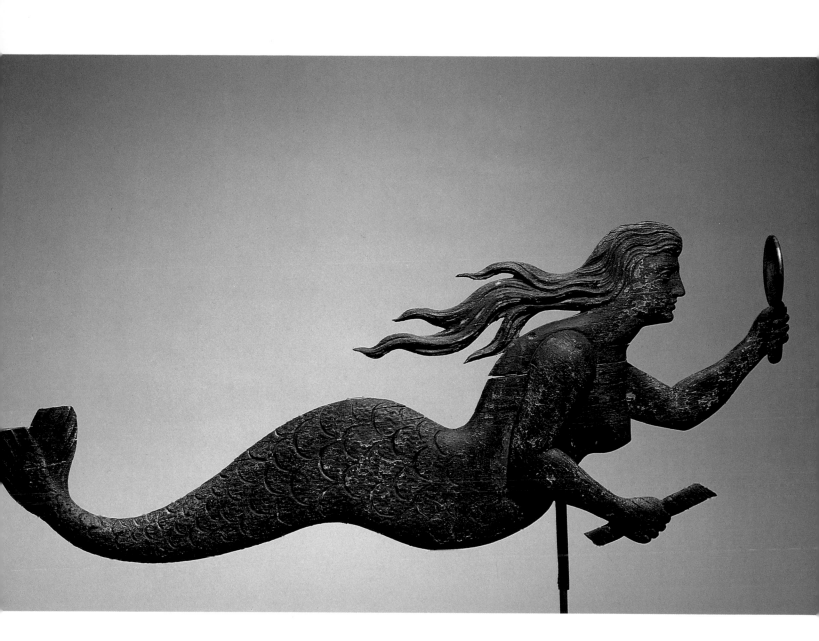

65
Mermaid
c. 1825–1850
Carved wood, originally polychromed
57.2 x 133.4 x 11.4 (22¹/2 x 52¹/2 x 4¹/2)
Found in Wayland, Massachusetts

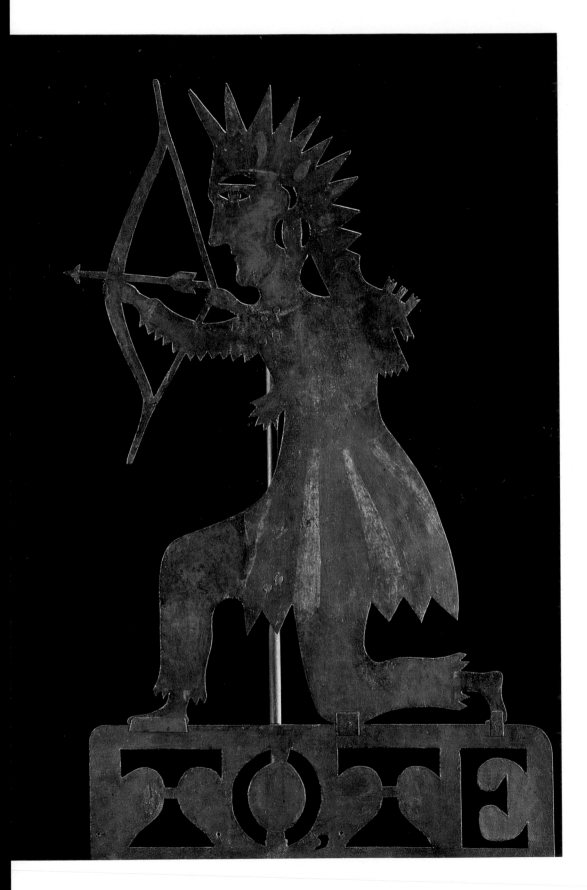

66
TO,TE—Indian Hunter
c. 1860
Polychromed sheet iron
129.5 x 78.7 x .15 (51 x 31 x 1/16)
TO,TE stands for "Totem of the Eagle,"
an emblem of the Improved Order of
Redmen, an early American fraternal
organization
Found in Pennsylvania

67
Locomotive
c. 1860
Sheet zinc, brass rod, iron pipes, and
iron bars
55.9 x 111.8 x 7.6 (22 x 44 x 3)
Used on a railroad station in
Providence, Rhode Island; the sunburst
lightning rod is probably a later
addition

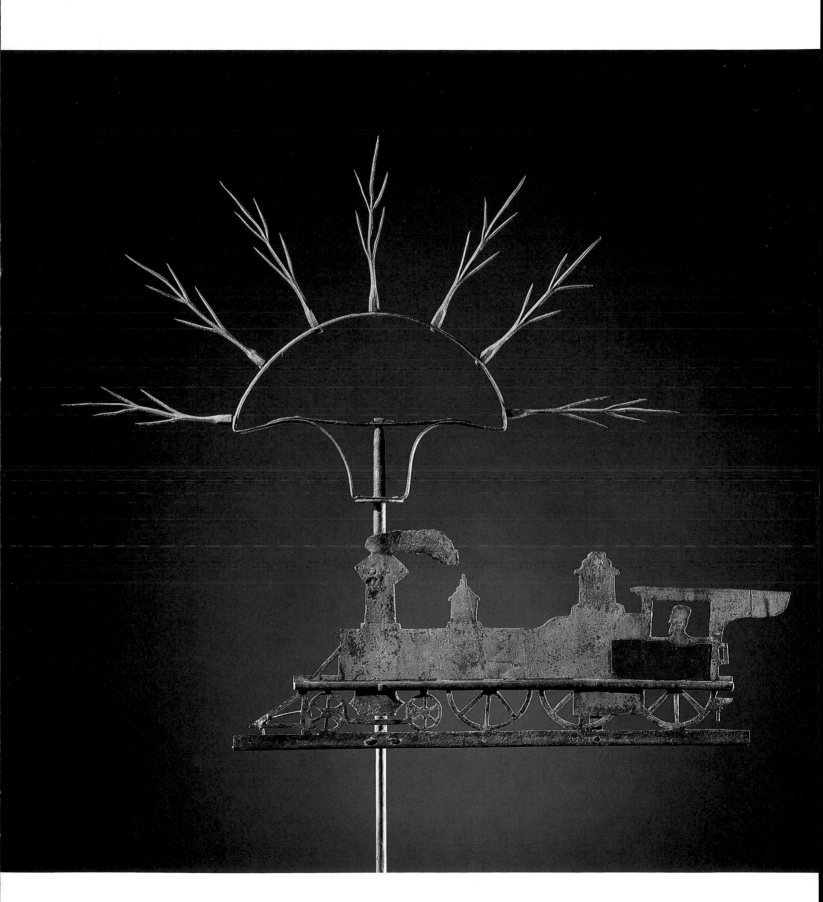

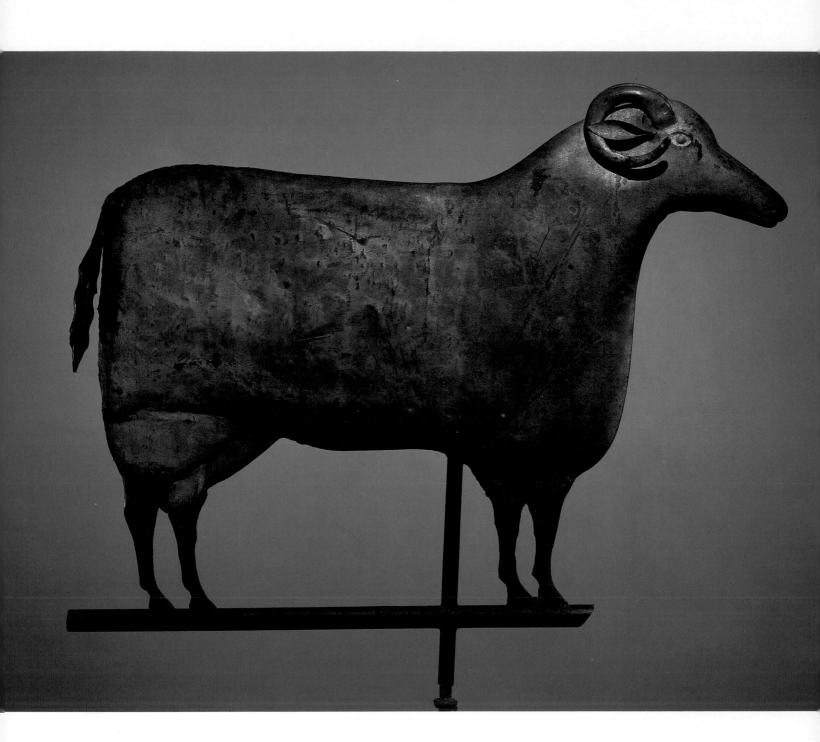

68
Ram
c. 1860
Hammered sheet copper with lead
solder, polychromed and gilded, with
tin rod

91.4 x 114.3 x 22.9 (36 x 45 x 9) with
swinging vane extension of 16.2 x 77.5 x
74.9 (6³/₈ x 30¹/₂ x 29¹/₂)
Used on a woolen mill by the
Androscoggin River, Livermore Falls,
Maine

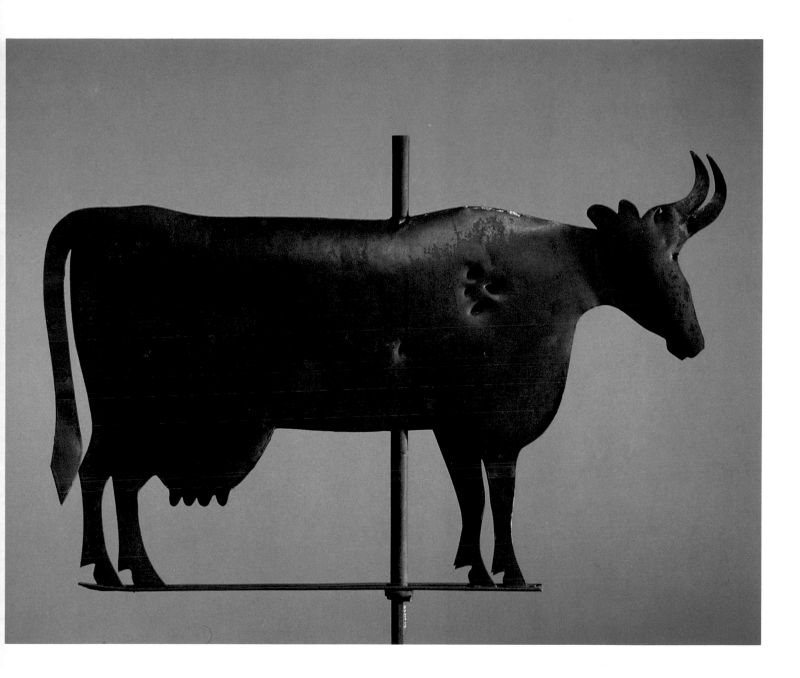

69
Cow
c. 1870
Hammered sheet iron
62.2 x 93.4 x 4.5 (24$^{1}/_2$ x 36$^{3}/_4$ x 1$^{3}/_4$)
Found in Hardwick, Vermont

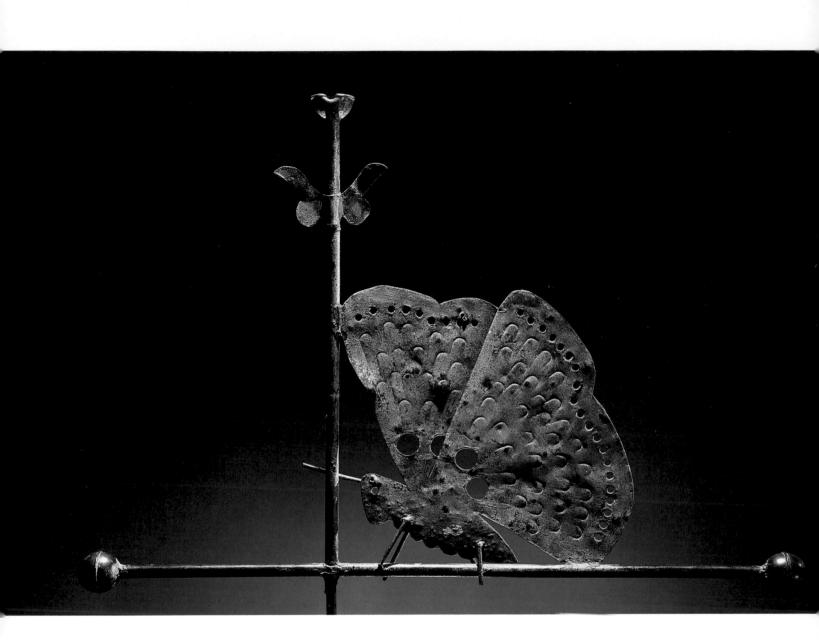

70
Butterfly
c. 1880
Pierced, cut, and polychromed sheet copper
48.3 x 69.9 x .15 (19 x 27$^1/_2$ x $^1/_{16}$)
Manufactured by an unknown company

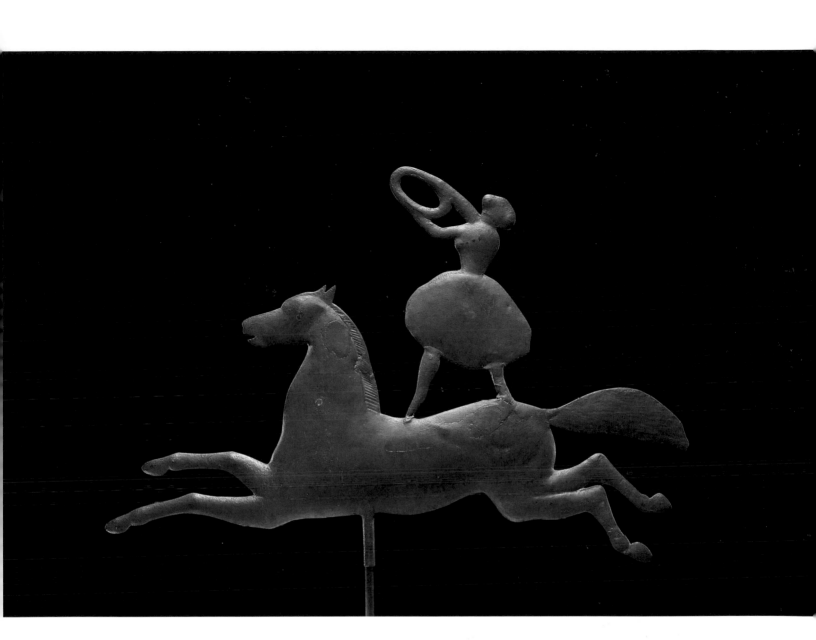

71
Circus Equestrienne
c. 1885
Hammered, gilded sheet copper filled
with lead, on wrought iron pivot
99.7 x 87.6 x 3.2 (including rod)
(39¹/₄ x 34¹/₂ x 1¹/₄) with swinging
extension of 13.0 x 76.2 x 81.3
(5¹/₈ x 30 x 32)
Found in Massachusetts

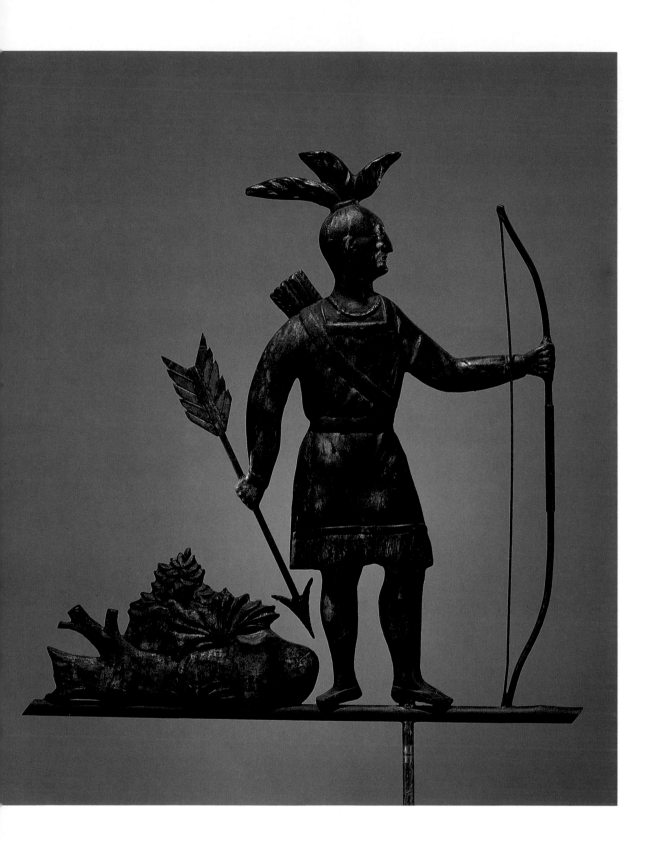

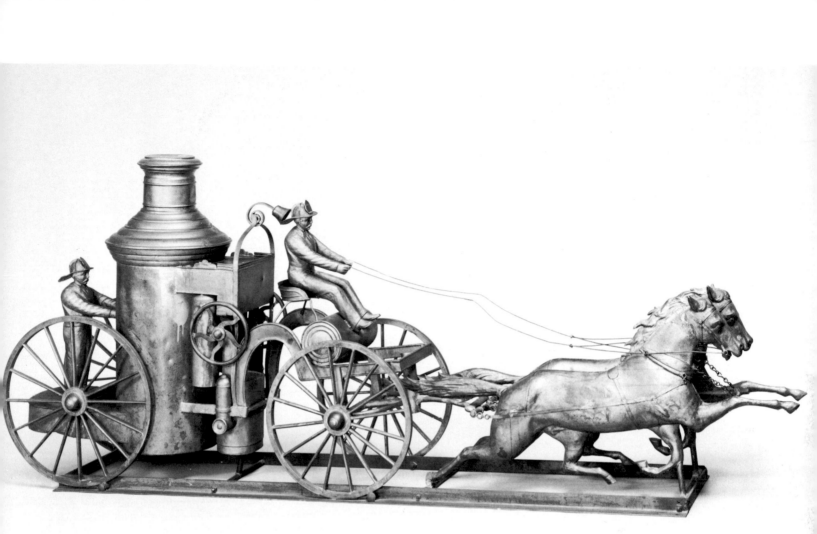

72

Massasoit, Indian Chief of the Wampanoag

c. 1885

Hammered, polychromed sheet copper with lead solder

77.8 x 76.8 x 7.0 (30⅝ x 30¼ x 2¾)

Harris & Co., Boston, Massachusetts

73

Fire Engine

c. 1890

Polychromed, hammered copper, tin and lead

94.0 x 225.4 x 41.9 (37 x 16½ x 88¾)

Used on a firehouse in Manchester, New Hampshire; attributed to J. W. Fiske Company, New York City

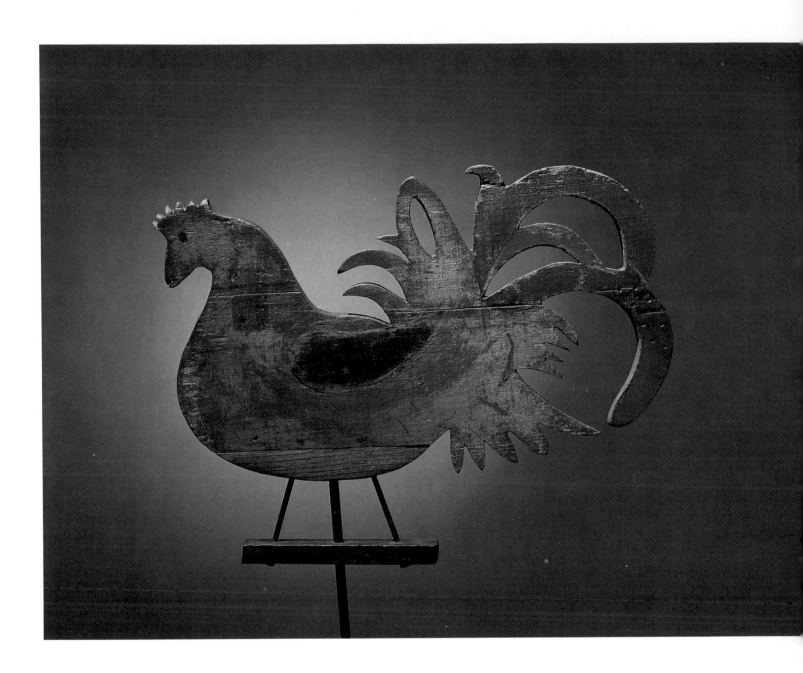

74
Rooster
c. 1890
Carved, polychromed wood
40.6 x 51.4 x 1.85 (including base)
(16 x 20¹/₄ x ³/₄)
Attributed to James Lombard (b. 1865)
of Bridgton, Maine

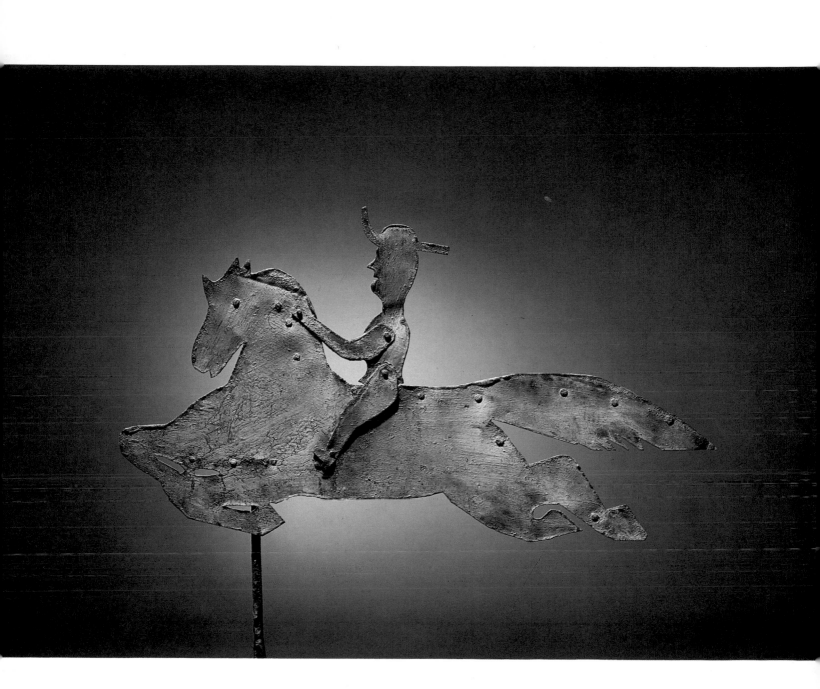

75
Horse and Rider
c. 1900
Polychromed sheet metal
88.9 x 96.5 x 1.25 (35 x 38 x 1/2)
(excluding base)

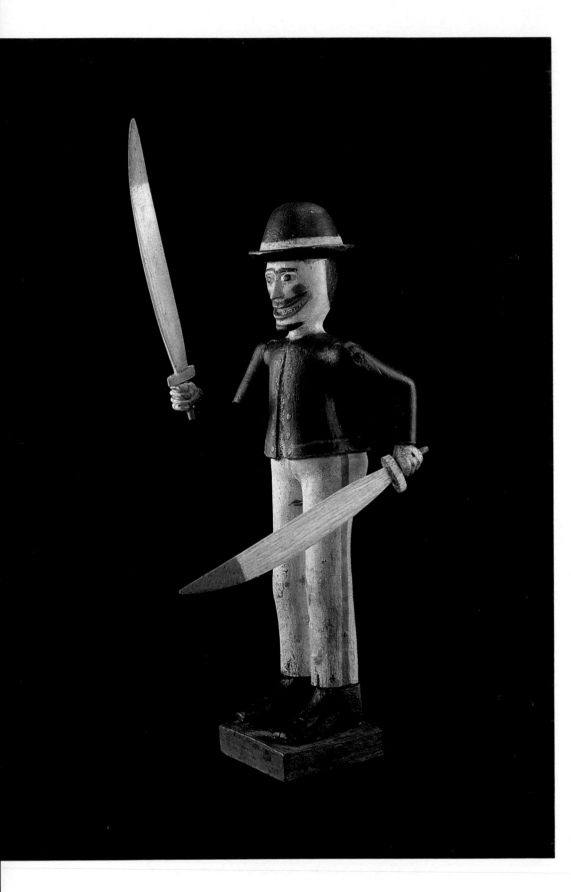

76
Swordsman Whirligig
c. 1870
Carved, polychromed wood
44.5 x 12.7 x 9.5 (excluding base)
($17^{1}/2$ x 5 x $3^{3}/4$)

77
Spinning Woman Whirligig
c. 1875
Carved, polychromed wood with iron
attachments
68.0 x 57.2 x 57.2 (including base)
($26^{3}/4$ x $22^{1}/2$ x $22^{1}/2$)
Used as a trade sign in Salem,
Massachusetts

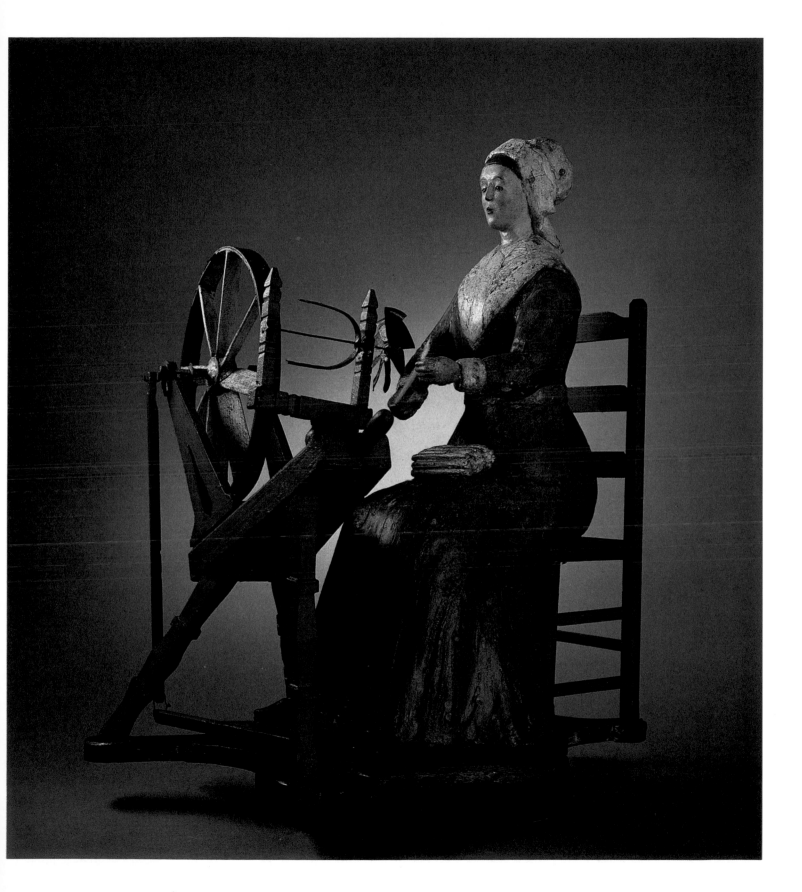

Quilts & Counterpanes Bed Rugs & Coverlets

THE QUILTS, COVERLETS, BLANKETS, and bed rugs included in this exhibition illustrate the variety of decorative bedcovers used in eighteenth- and nineteenth-century America. Every style and technique of manufacture is represented: whole cloth, pieced, and appliquéd quilts; coverlets woven in overshot, twill, and double cloth; and elaborately embroidered blankets and bed rugs.

A quilt is a warm bedcover made by joining layers of cloth—usually a top, interlining, and backing—by stitching or "quilting" them together. The method by which the quilt top is made —pieced, appliquéd, or "plain"—determines the nature and type of design.

The tradition of pieced-work quilts evolved from the early settlers' need for thrift. Small pieces of fabric cut from worn clothing or bedcovers were joined or seamed together in a predetermined pattern to create a larger textile. Pieced patterns include large overall designs such as the Double Irish Chain (cat. 94) or Star of Bethlehem (cat. 99) and grid designs such as the Mariner's Compass (cat. 100) or Caesar's Crown (cat. 95).

Appliqué comes from the French word "appliquer," meaning to put on or lay on. Appliqué patterns tend to be more pictorial and representational than pieced ones, which are not laid out on a ground, because the quilt-maker is allowed greater flexibility in arranging the pattern pieces. Like pieced patterns, the designs can be laid out in an overall pattern (cat. 81) or on a grid (cat. 89).

Whole cloth quilts, an example of plain construction, were often made from lengths of glazed, richly colored woolen fabric imported from England; they were backed with handwoven woolen cloth and filled with hand-carded raw wool or cotton. The elaborate scroll and foliate quilting patterns of the whole cloth quilt made in Corinth, Vermont (cat. 80), impart a sense of elegance to these early textiles.

Before factory-woven goods were widely available, woven bedding, blankets, and coverlets were made by the women of a household or professional weavers on enormous "barn frame" looms. These looms, built from massive oak beams joined with mortices and tenons, typically measured 4 by 6 feet and stood 5 feet high. Warp (vertical) threads stretched away from the weaver and were threaded through harnesses suspended above the frame on pulleys; foot treadles activated the harnesses, allowing the weaver to insert the weft (horizontal) threads. Plain weave cloth, the most basic weave structure, was made by interlocking the warp and weft threads in a simple over-one, under-one pattern. In more complex weave structures, such as twill and overshot, the weft threads pass over groups of warp threads to create distinctive patterns.

Blankets woven in twill, with its characteristic diagonal ribs, were trea-sured for their durability and warmth. When embroidered in colorful hand-spun and hand-dyed yarns with such design motifs as flowers, stars, and birds (cat. 112), these plain textiles became quite decorative.

Another type of bedcover, the bed rug, was made by embroidering multiple strands of handspun yarn in a looped running stitch on one side of a ground fabric, to create a deep pile. Dorothy Seabury (cat. 114) used newly woven cloth as a ground for her embroidery work.

Overshot coverlets, popular throughout America, were so named because the colored wool weft yarns overshoot or float over groups of warp yarns in a specific pattern. While most overshot coverlets were woven in dark blue and white, some weavers chose to emphasize the bold geometric patterns by using two or more colors (cat. 115). Patterns and weave constructions used in coverlets often reflect regional influences. For example, the elaborate coverlet (cat. 116) with a checkerboard pattern of diamond twill and overshot blocks is a type of multi-harness bedcover produced only by professional weavers in Pennsylvania.

Jacquard coverlets were introduced in the early nineteenth century. Because of their elaborate floral and mosaic patterns, they were advertised as "fancy" coverlets to differentiate them from handwoven pieces with geometric patterns. The Jacquard loom attachment,

mounted over a hand loom, was a sophisticated device that controlled the pattern by the use of punched cards. This system allowed the weaver to design representational patterns; he could also incorporate his name and the name of his customer into the weave. Often a logo, such as the lion used by Harry Tyler of Jefferson County, New York, was woven as a corner block to identify a weaver's work (cat 117). C.O

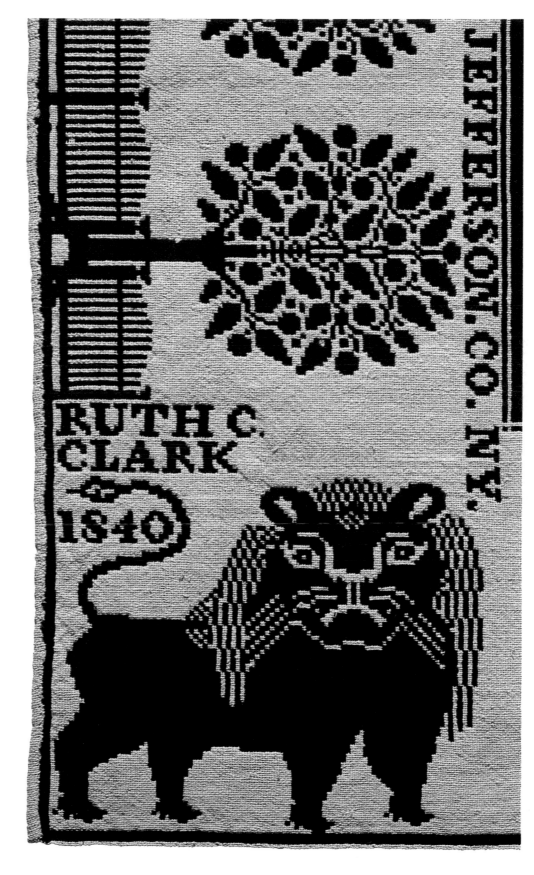

cat. no. 117, detail

133

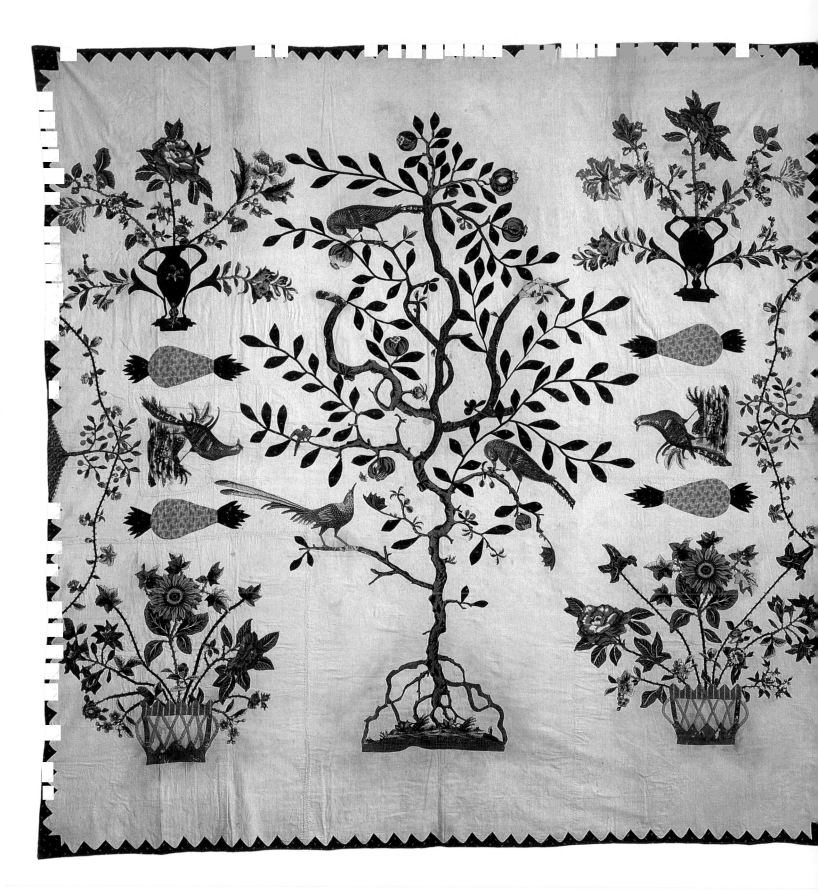

78
Tree of Life Counterpane
late 18th century
Cottons and linen; appliquéd
269.2 x 261.6 (106 x 103)

79
Whole Cloth
c. 1800
Glazed wool, handwoven wool back,
quilted
213.4 x 210.2 (84 x 82¾)
Found in Burlington, Vermont

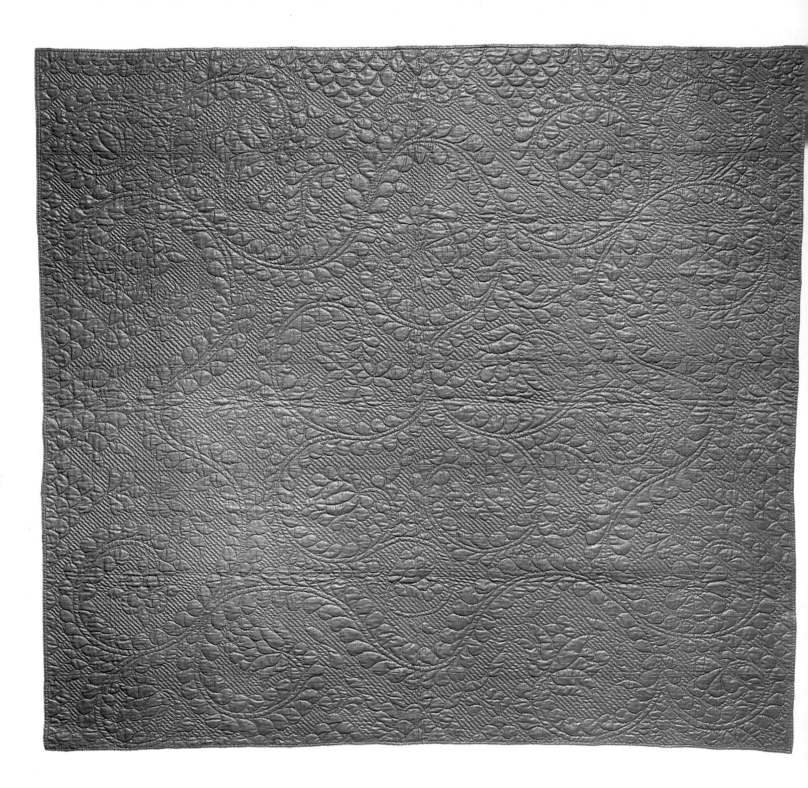

80
Whole Cloth
c. 1800
Glazed wool face, homespun wool
blanket ground

251.5 x 277.5 (99 x 111)
Made in Corinth, Vermont

136

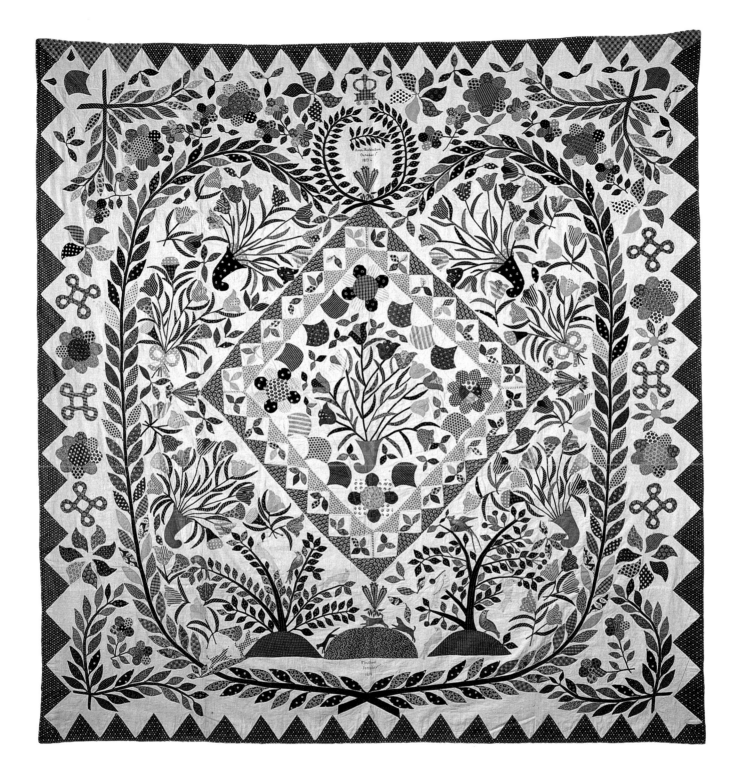

81

Ann Robinson Counterpane

1814
Cotton and linen; appliquéd and
embroidered

250.8 x 236.9 (98³/₄ x 93¹/₄)
Signed, *Ann Robinson, October 1, 1813,*
finished January 27, 1814

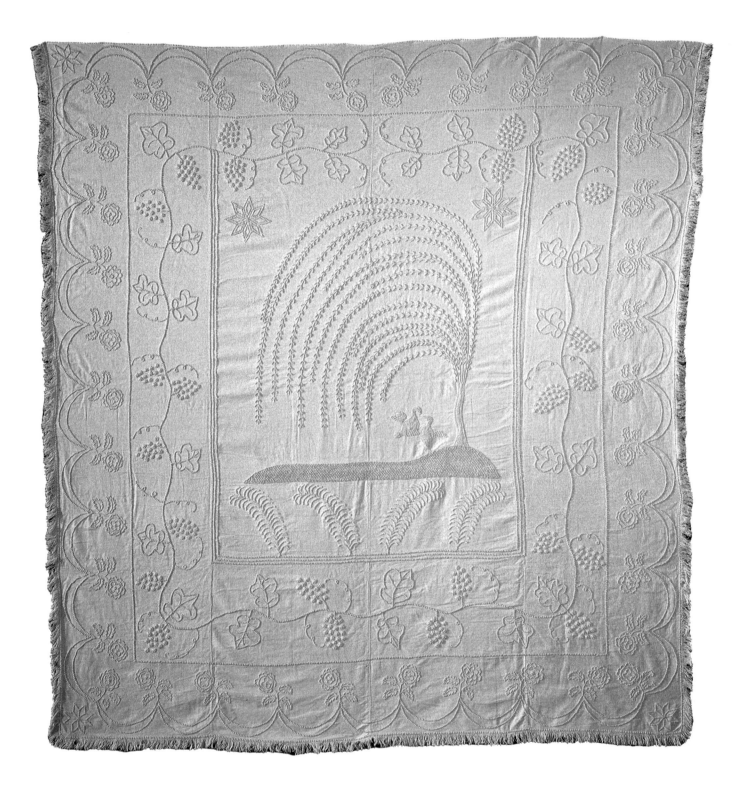

82
Weeping Willow Counterpane
1825

Cotton yarn on bird's-eye weave
ground
251.5 x 261.6 (99 x 103)

Made by Laura Collins of Guilford,
Connecticut
Gift of Mrs. George A. Comstock

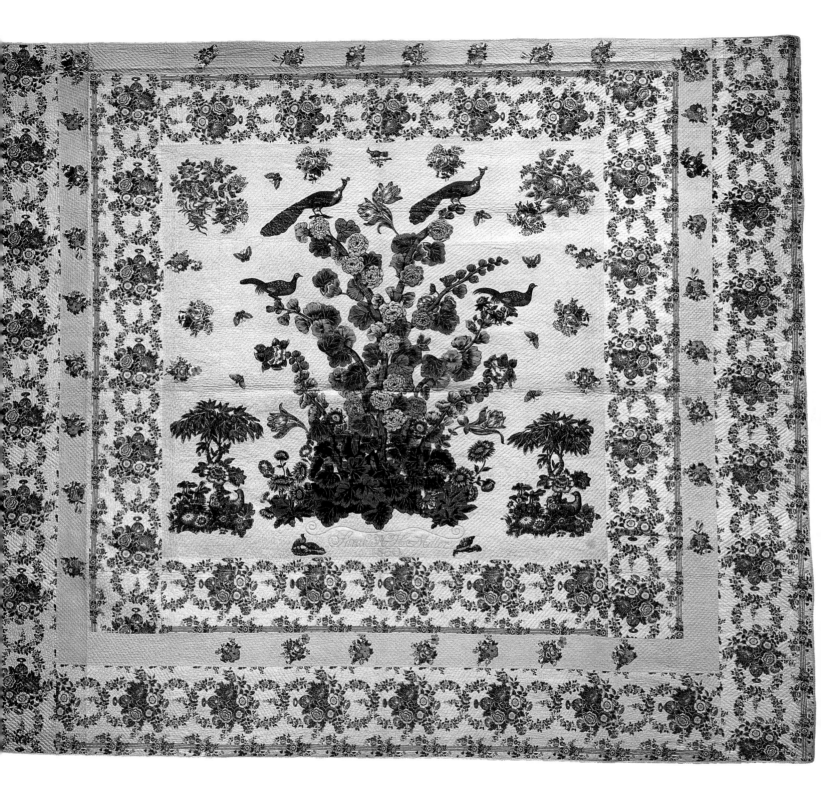

83
Tree of Life
1830

Cotton; appliquéd
276.9 x 317.5 (109 x 125)
Signed, *Sarah T. C. H. Miller/1830*

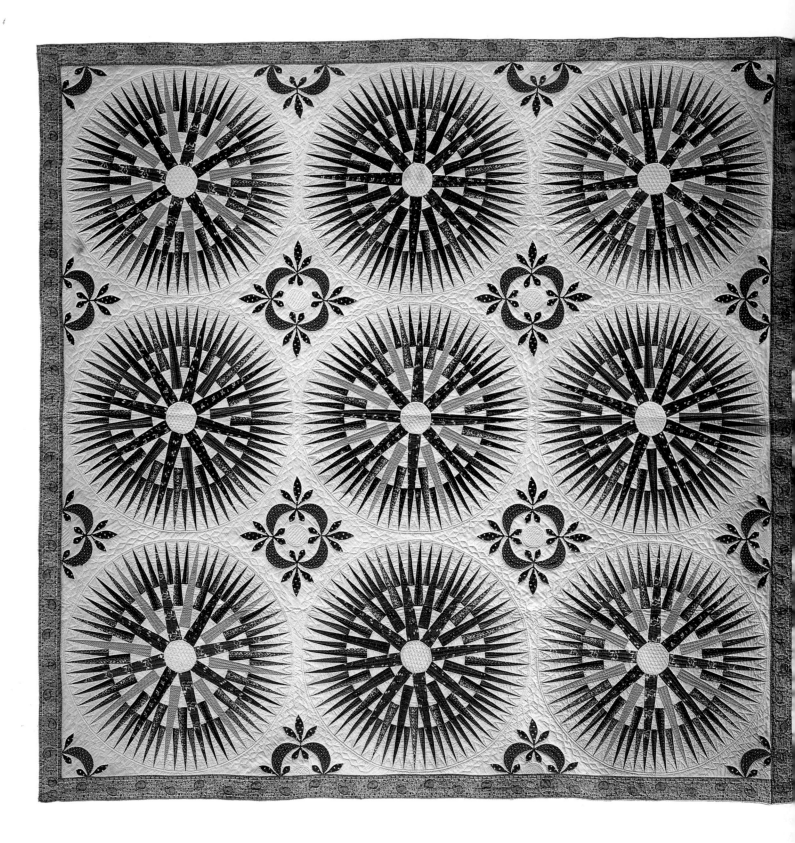

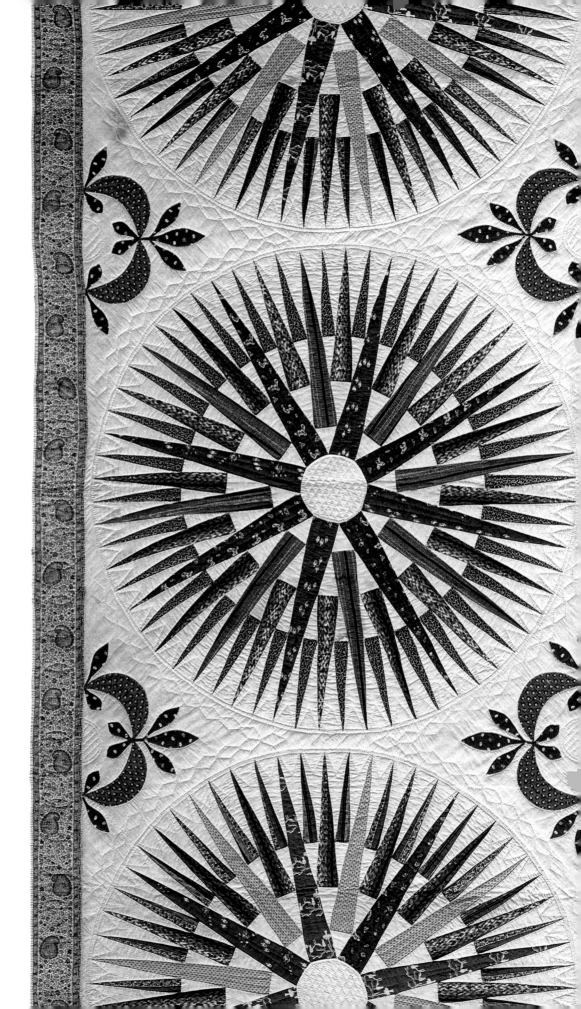

84
Mariner's Compass
1835
Cotton; pieced, appliquéd, and quilted
250.8 x 243.8 (98¾ x 96)
Made in New Jersey

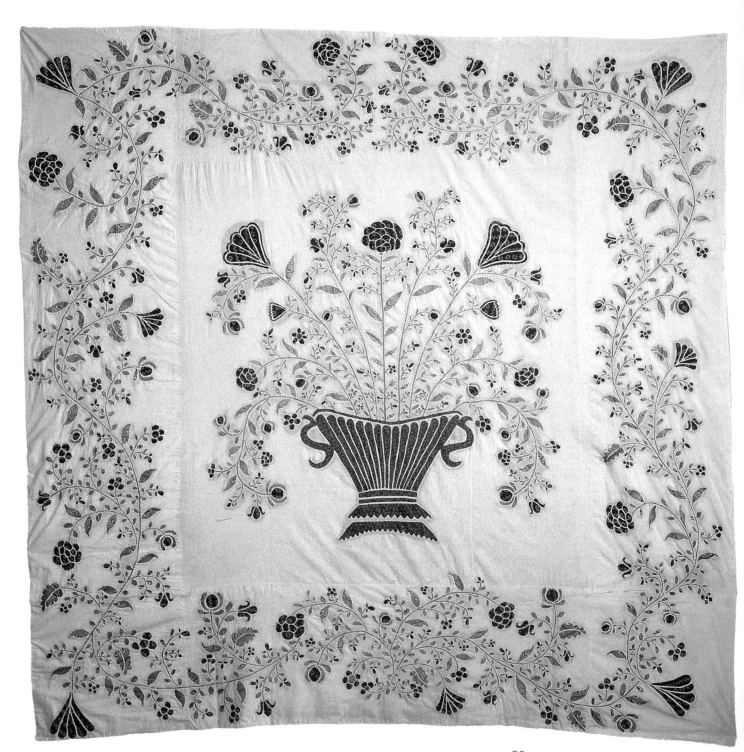

85
Basket of Flowers
c. 1840
Cotton; reverse appliqué
188.0 x 186.7 (74 x 73½)
Gift of Mrs. John C. Wilmerding

86
Willow Oak
c. 1840
Cotton; appliquéd, pieced, and quilted
178.4 x 233.7 (70¼ x 92)
Made in Boston

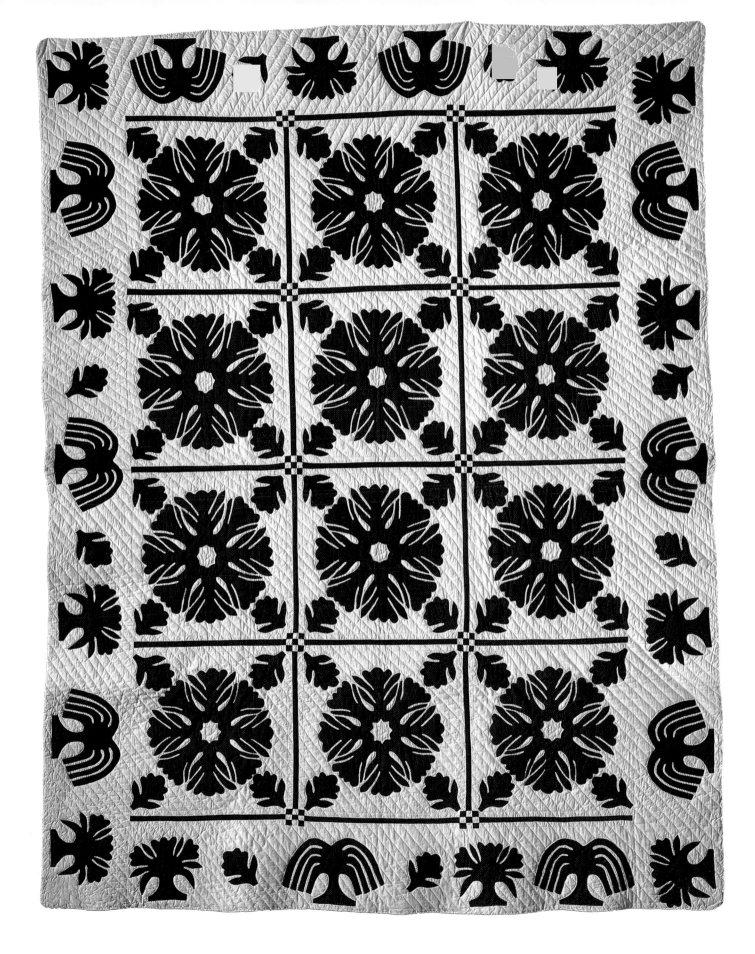

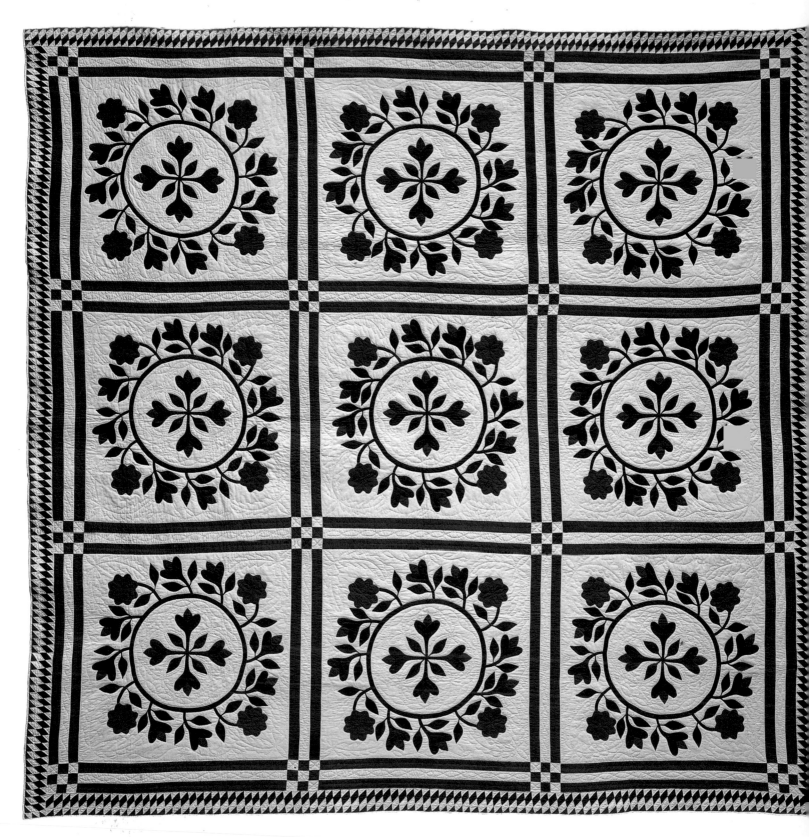

87
Presidential Wreath
c. 1840
Cotton; appliquéd with pieced border
237.5 x 238.8 (93 1/2 x 94)
Made by the Traver family of Sand
Lake, New York
Gift of Mrs. Kate Webb Harris

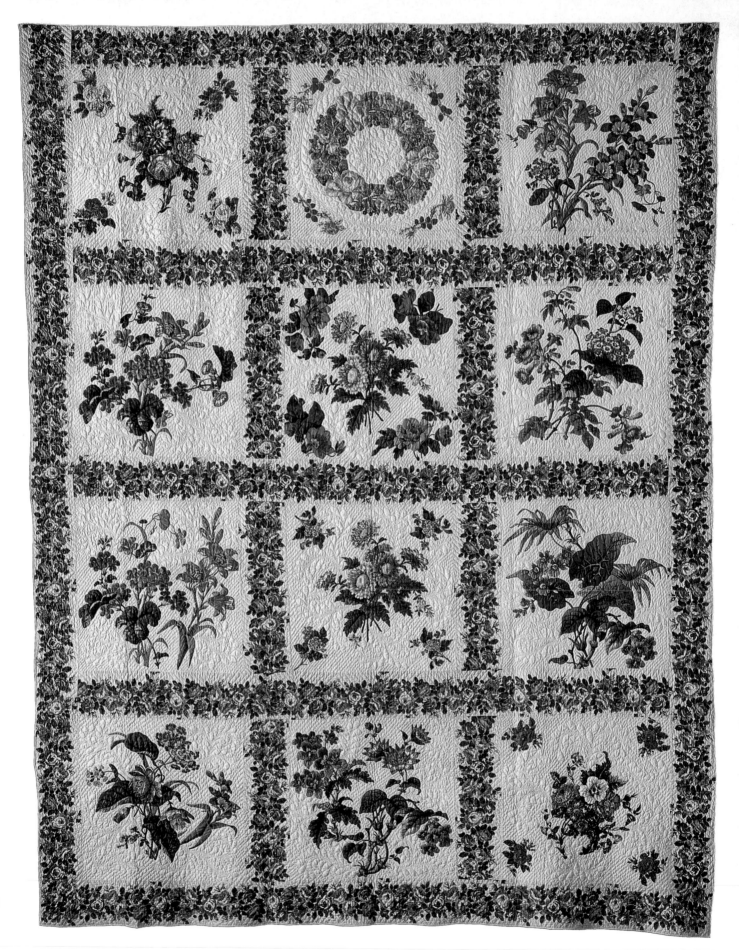

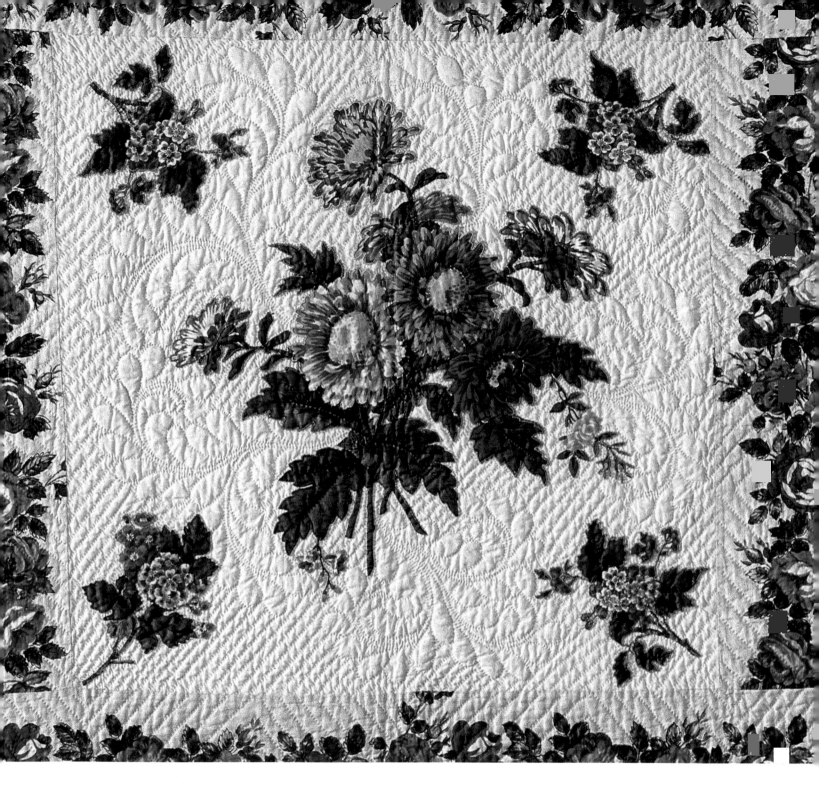

88
Chintz Album
c. 1840
Cotton; appliquéd and quilted
203.2 x 274.3 (80 x 108)
Made by Mrs. Ridgley of Baltimore

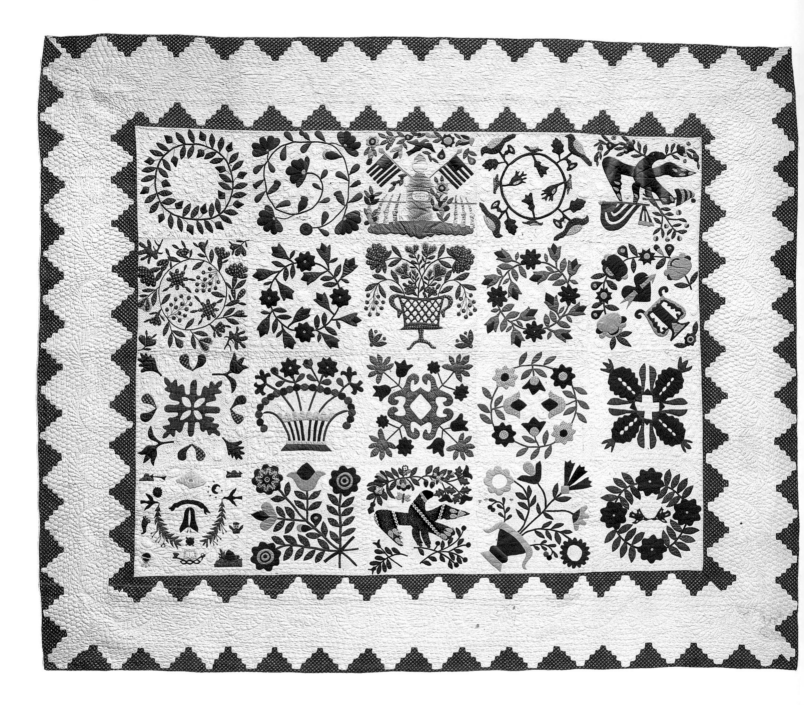

89
Major Ringgold Album
c. 1846
Cotton; padded appliqué, quilted,
inked inscriptions
236.2 x 275.6 (93 x 110¼)

90
Baltimore Style Album
1847
Cotton; appliquéd and quilted,
stamped inscriptions
254.0 x 259.1 (100 x 102)
Quilters' names include Elizabeth
Miller, S. A. Mules, and Margaret Head

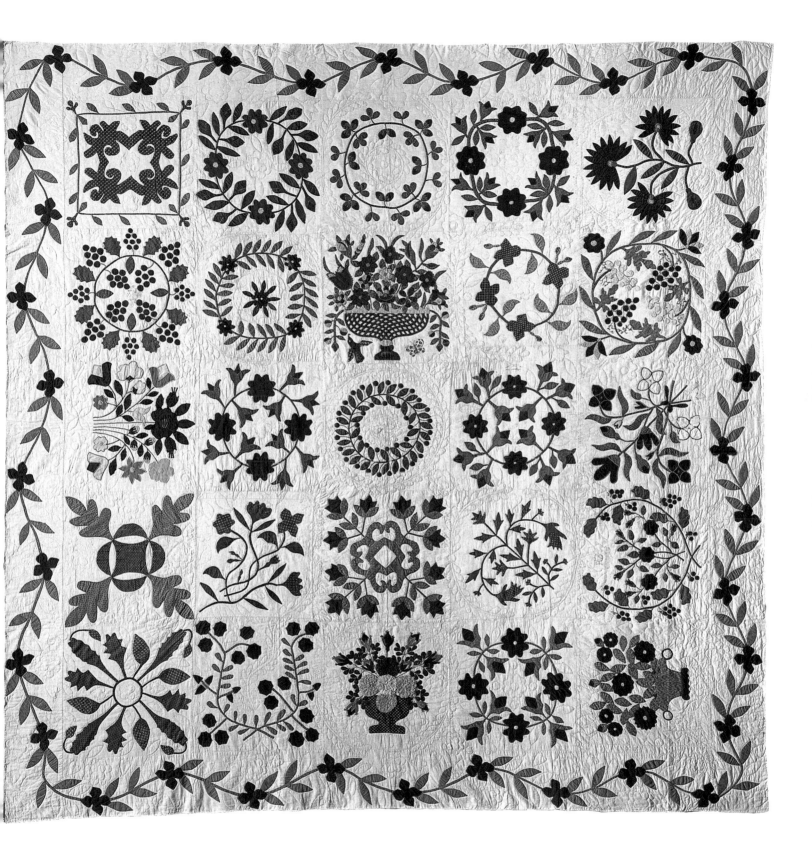

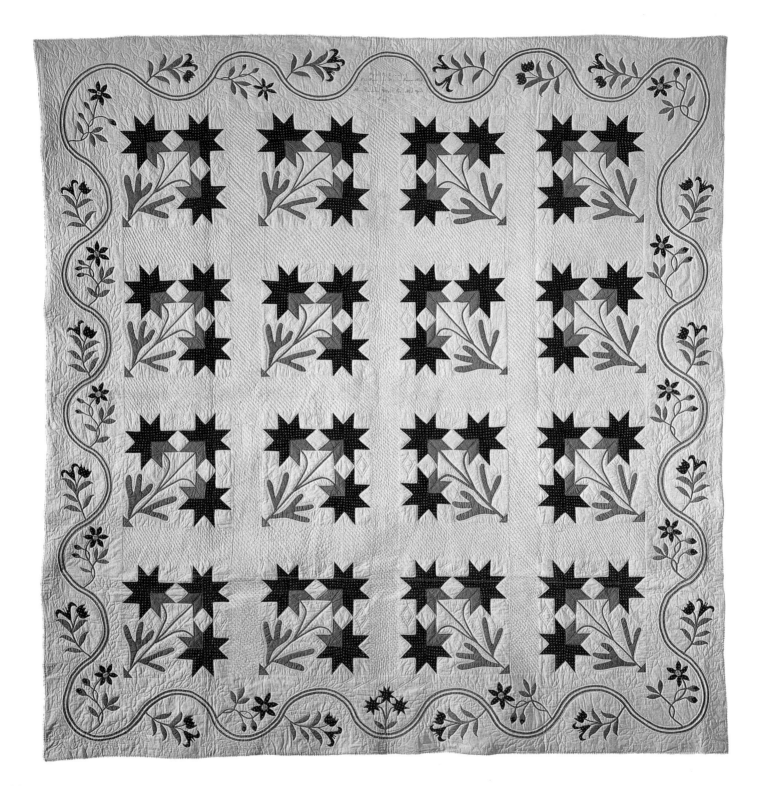

91
Peony and Prairie Flower
1847
Cotton; pieced, appliquéd, and quilted
241.3 x 233.7 (95 x 92)

Made by Parnel R. Grumley of North
Greenwich, New York
Gift of Mrs. Daryl Parshall

150

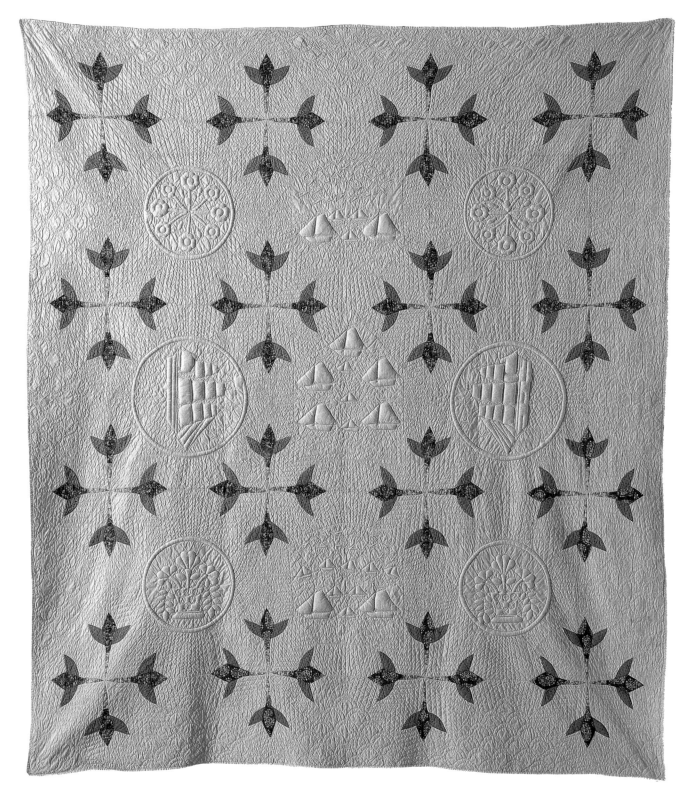

92
Trilobe Flower with Trapunto Ships
c. 1850

Cotton; padded appliqué and quilted
223.5 x 196.9 (88 x 77½)
Probably made in Massachusetts

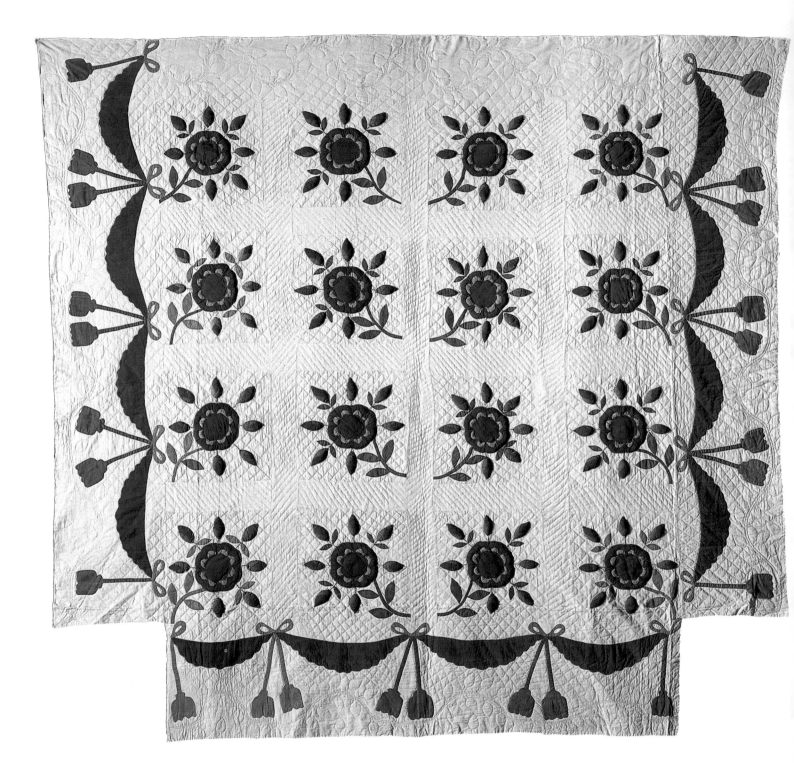

93
Vermont Rose of Sharon
c. 1850

Wool and cotton yarns, cotton; padded
appliqué, embroidered and quilted
215.9 x 208.3 (85 x 82)

Made by Sarah Barber of Waterville,
Vermont

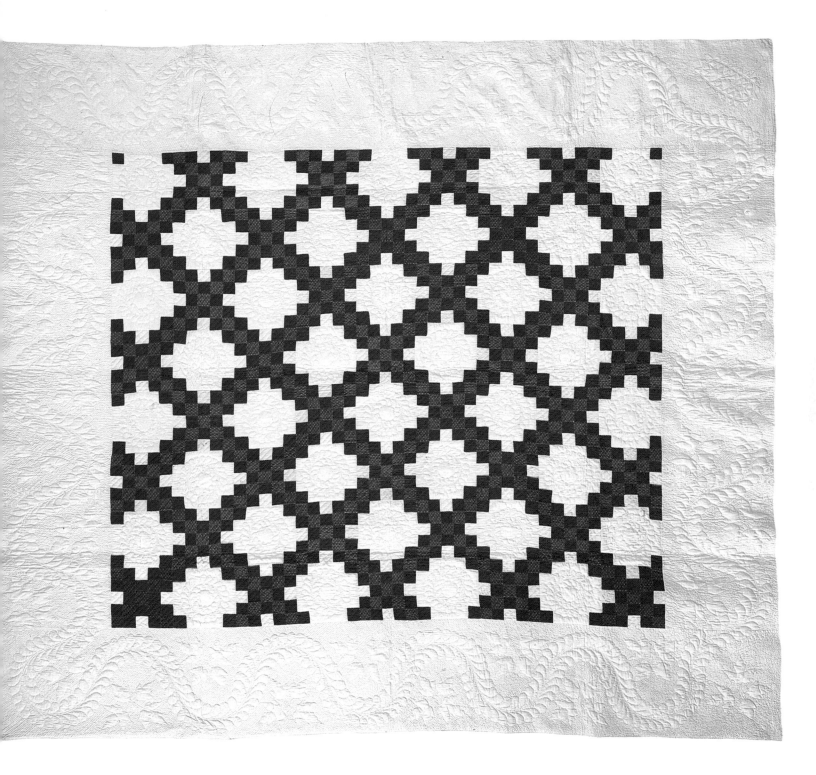

94
Double Irish Chain
c. 1850

Cotton; pieced and quilted
227.3 x 254.0 (89¹/₂ x 100)

Made by Miss Margie Gorrecht of York
County, Pennsylvania

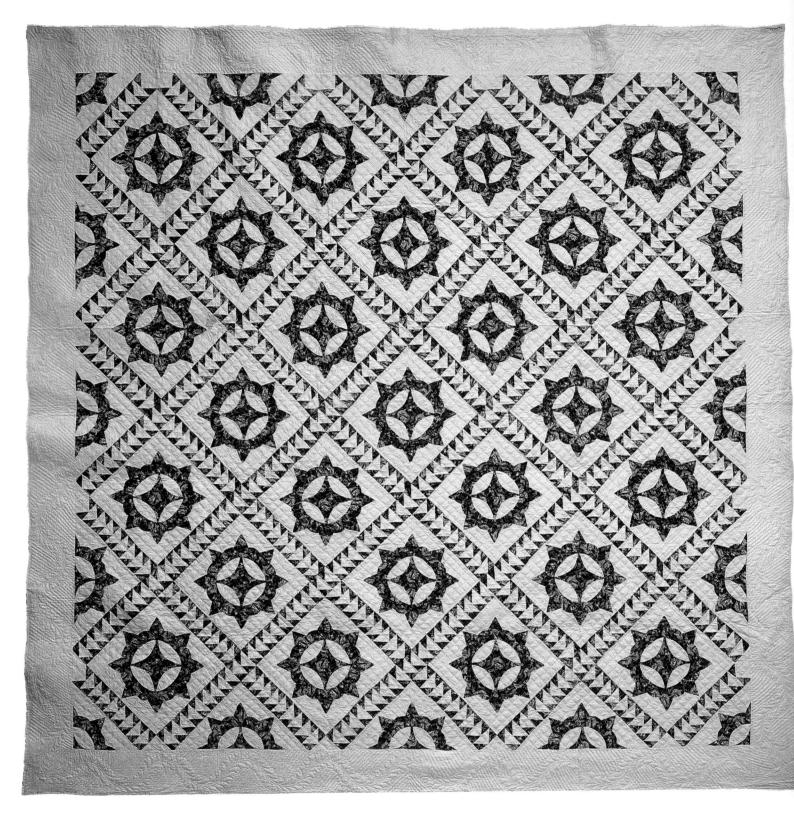

95
Caesar's Crown
c. 1850

Cotton; pieced and appliquéd
277.5 x 280.0 (111 x 112)

Made by Miss Elizabeth C. Kinzer of
Pennsylvania

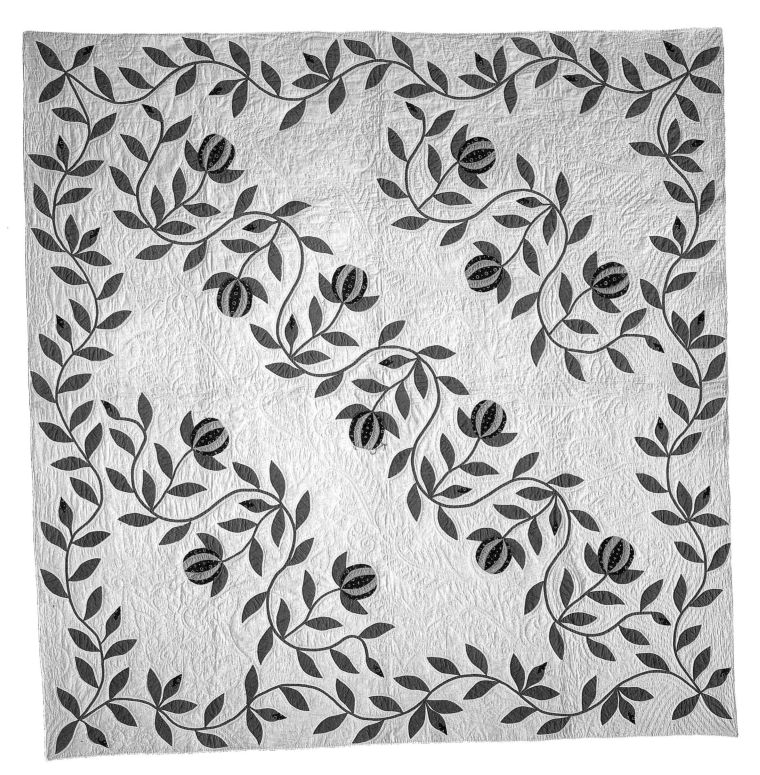

96
Bias Pomegranate
c. 1850
Cotton; appliquéd and quilted
208.3 x 210.8 (82 x 83)

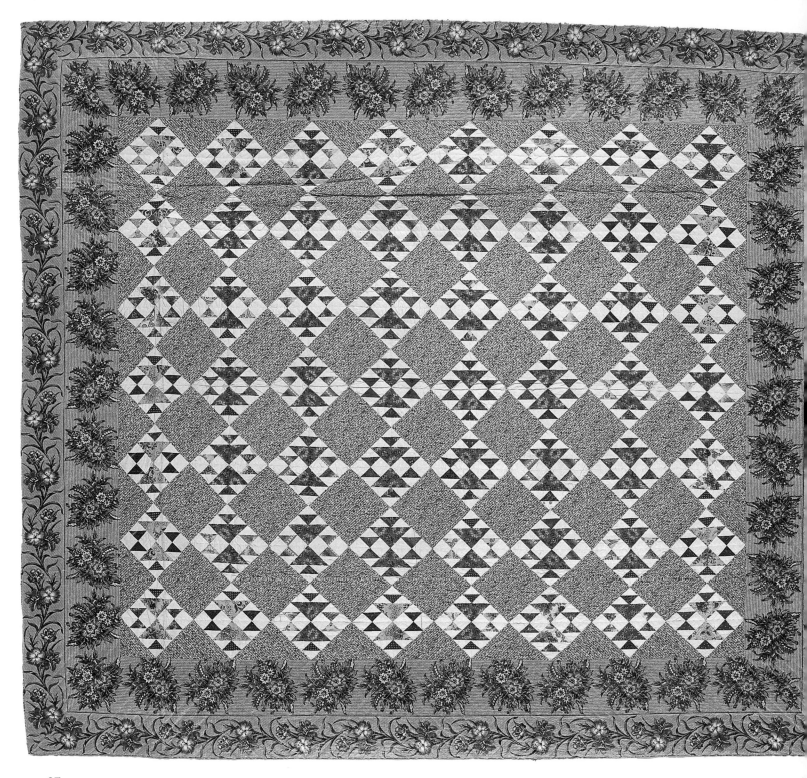

97
Fox and Geese
c. 1850
Cotton; pieced and quilted
221.0 x 246.4 (87 x 97)

156

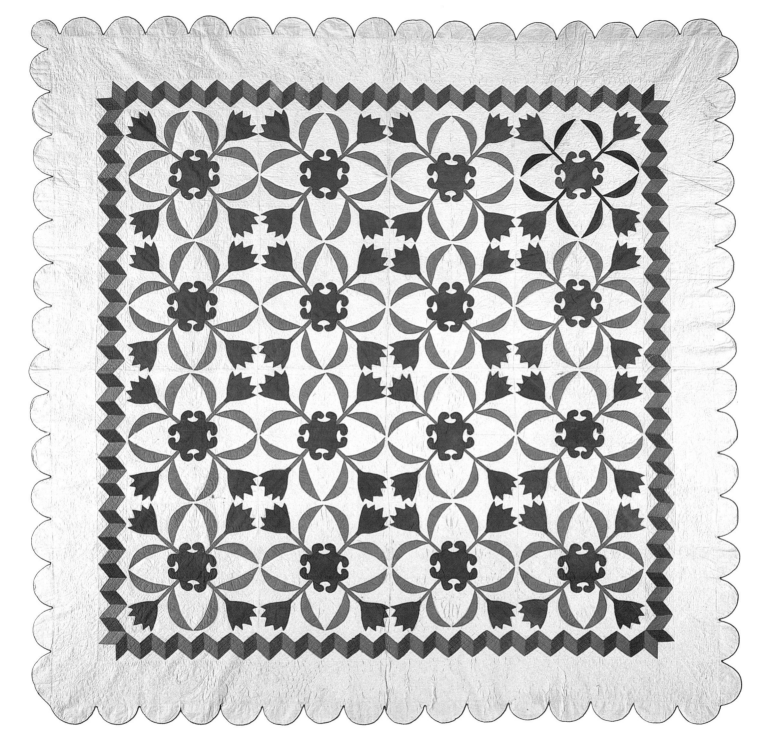

98
Tulips and Orange Slices
c. 1850
Cotton; appliquéd and quilted
241.3 x 241.3 (95 x 95)
Found in Kingston, Massachusetts

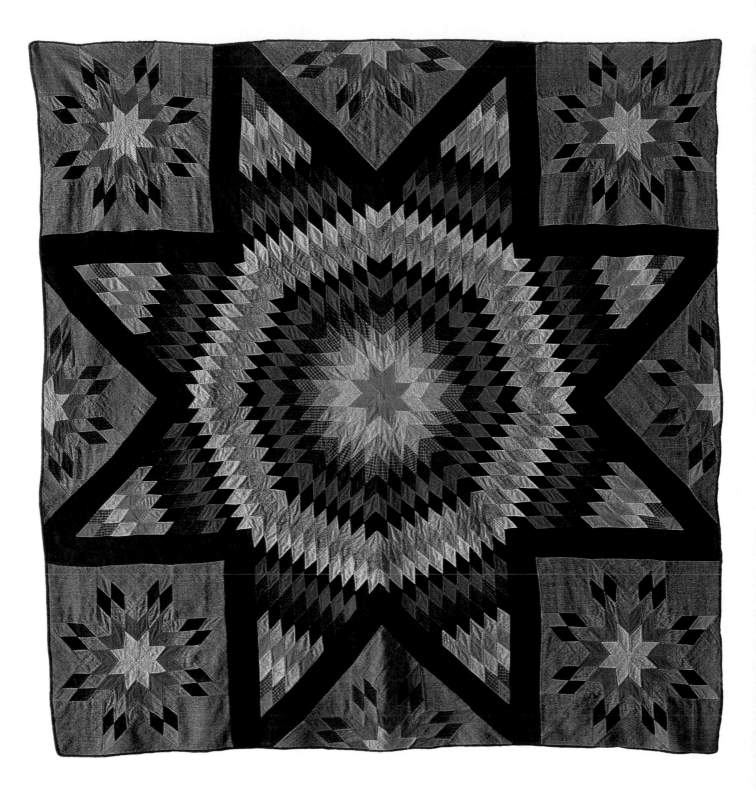

99
Star of Bethlehem
c. 1850

Wool and cotton; pieced and quilted
185.4 x 181.6 (73 x 71½)

Made by Mrs. Emile (Marie) Marin of
Saint Pie, Quebec

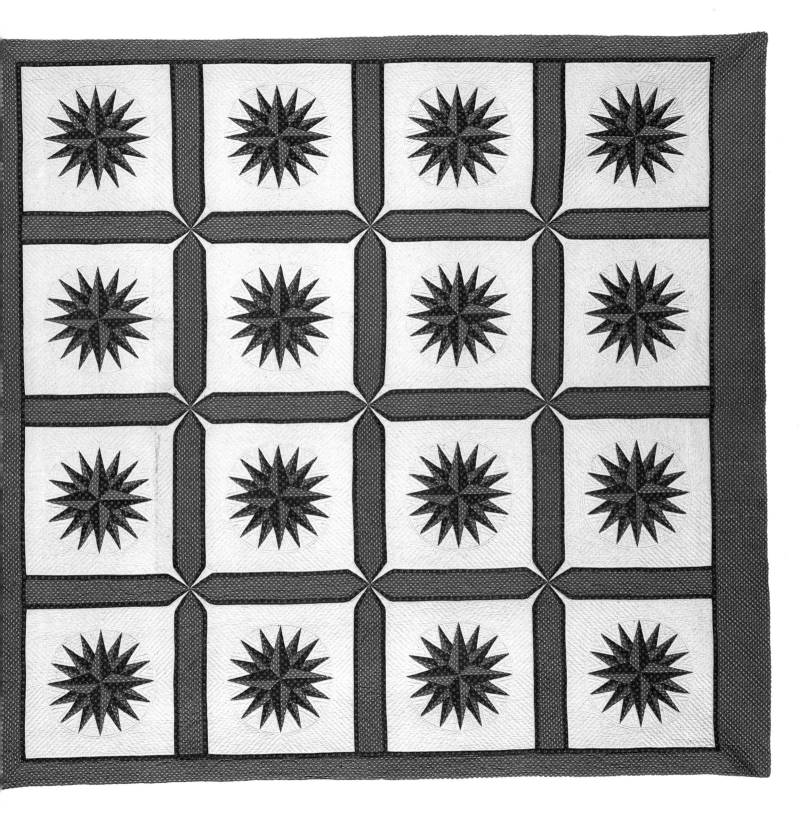

100
Mariner's Compass
before 1852

Cotton; pieced and quilted
238.8 x 228.6 (94 x 90)

Made by Mary Canfield Benedict of
Arlington, Vermont

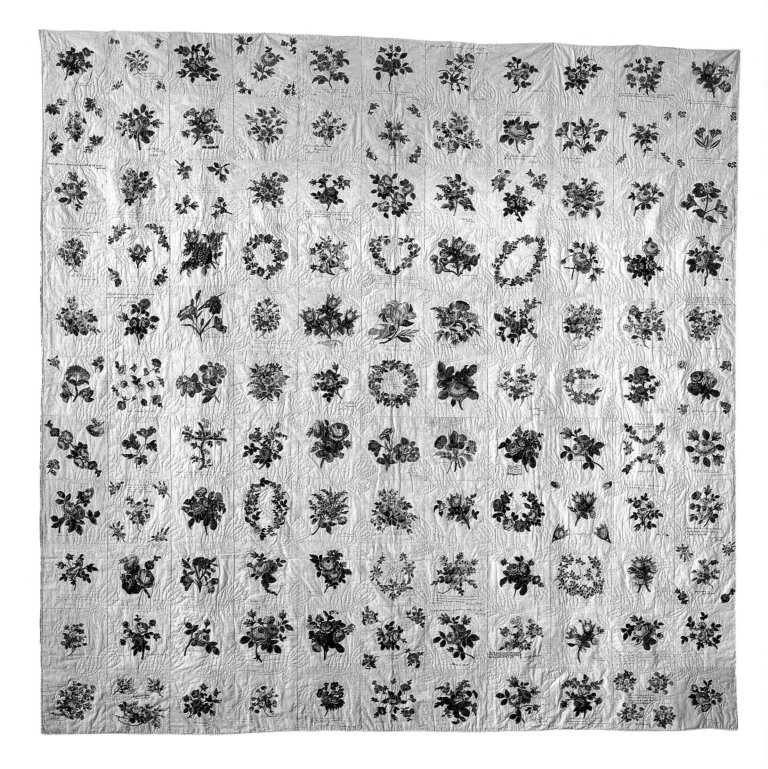

101
Cory Friendship/Chintz Album
1852–1853
Cotton; appliquéd and pieced
236.2 x 237.5 (93 x 93½)

Made for Reverend Benjamin L. Cory
by the parishioners of the Presbyterian
Church in Perth Amboy, New Jersey
Gift of Mr. Willard Kiggins, a Cory
descendant

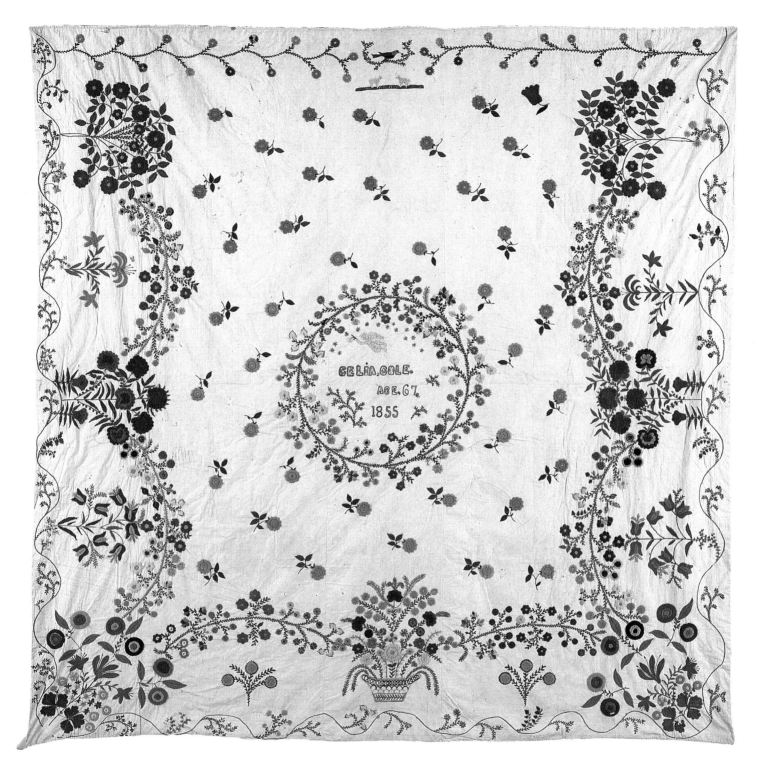

102
Celia Cole Counterpane

1855
Worsted wool yarns, cotton;
embroidered

218.4 x 215.9 (86 x 85)
Made by Celia Cole of New Hampshire
Signed, CELIA COLE, AGE 67, 1855

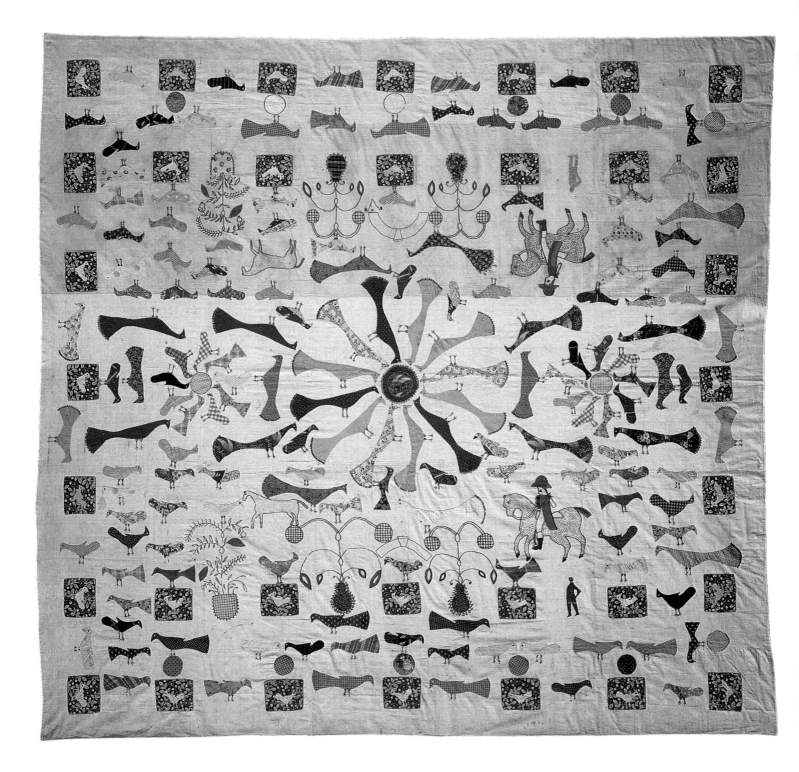

103
Peacocks and Pea-hens Counterpane
c. 1860

Cotton and linen; appliquéd and
embroidered
254.0 x 265.4 (100 x 104 1/2)

162

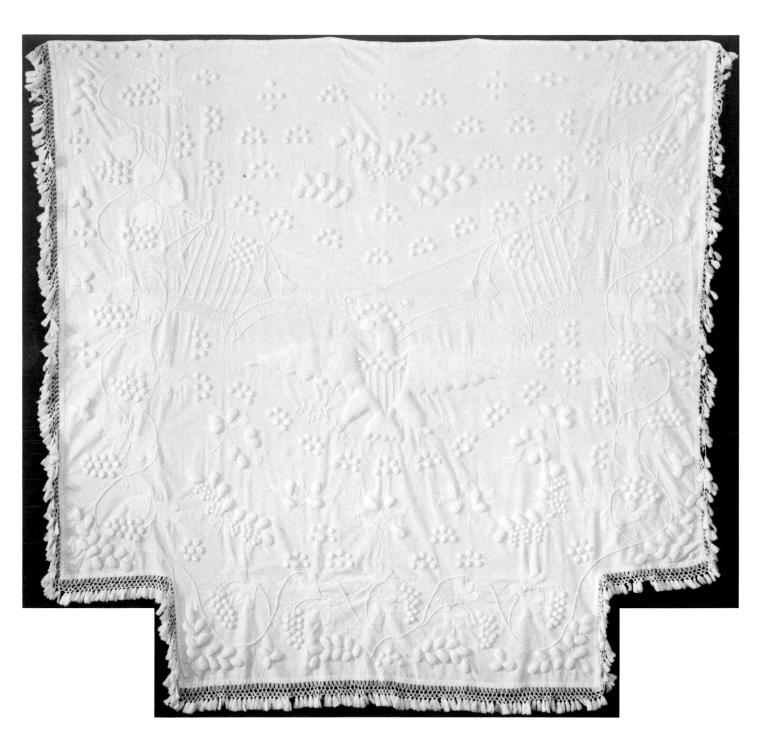

104
Eagle Candlewick Counterpane
c. 1862
Multistrand cotton yarn, cotton;
embroidered

207.0 x 216.5 (81¹/₂ x 85¹/₄)
Signed, *Done by Myrtilla Newman,*
Dixfield, M [Massachusetts] 62
Gift of Mr. J. Watson Webb, Jr.

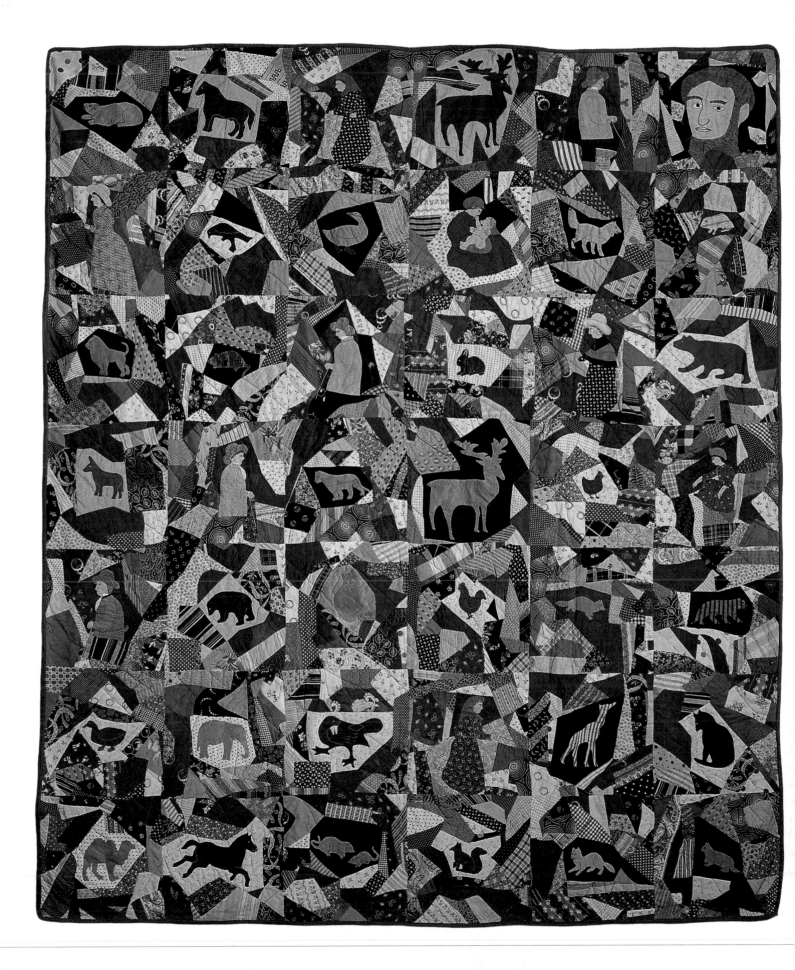

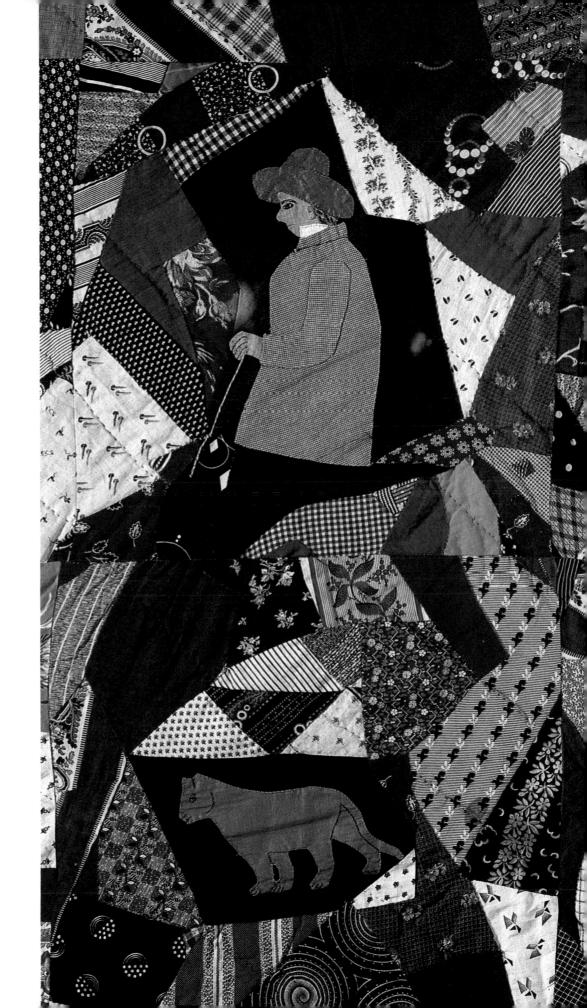

105
Haskins Family
c. 1870
Cotton; pieced, appliquéd, and
embroidered
176.5 x 210.8 (69½ x 83)
Made by Mrs. Samuel Glover Haskins
of Granville, Vermont

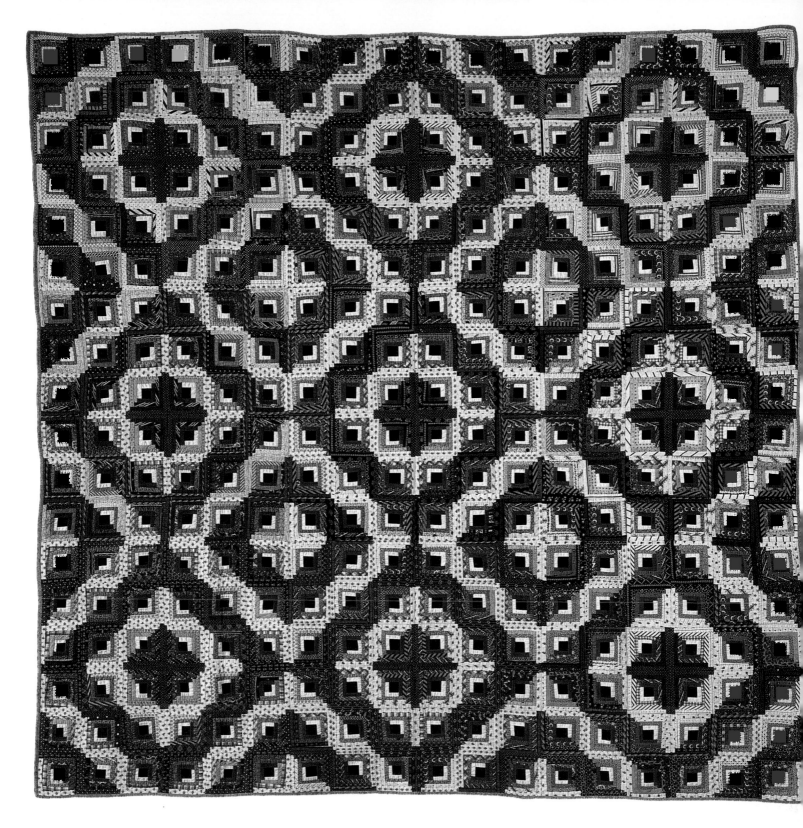

106
Log Cabin, Pieced
c. 1870

Wool and cottons; pieced
177.8 x 177.8 (70 x 70)
Gift of Mrs. J. S. Hockenberry

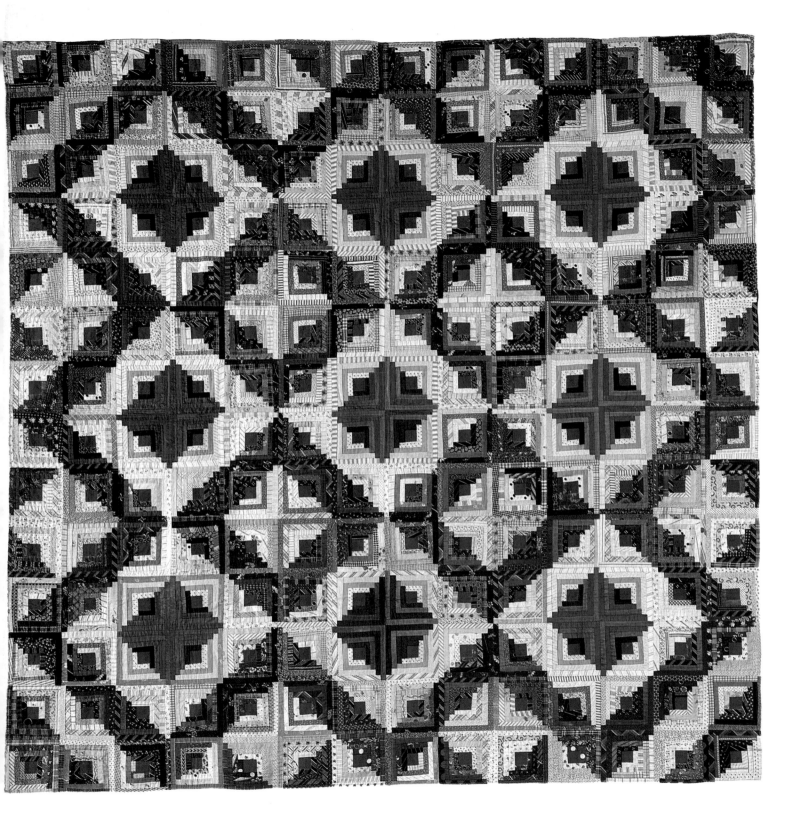

107
Log Cabin, Barn Raising
c. 1870

Cotton; pieced and tied
182.9 x 185.4 (72 x 73)

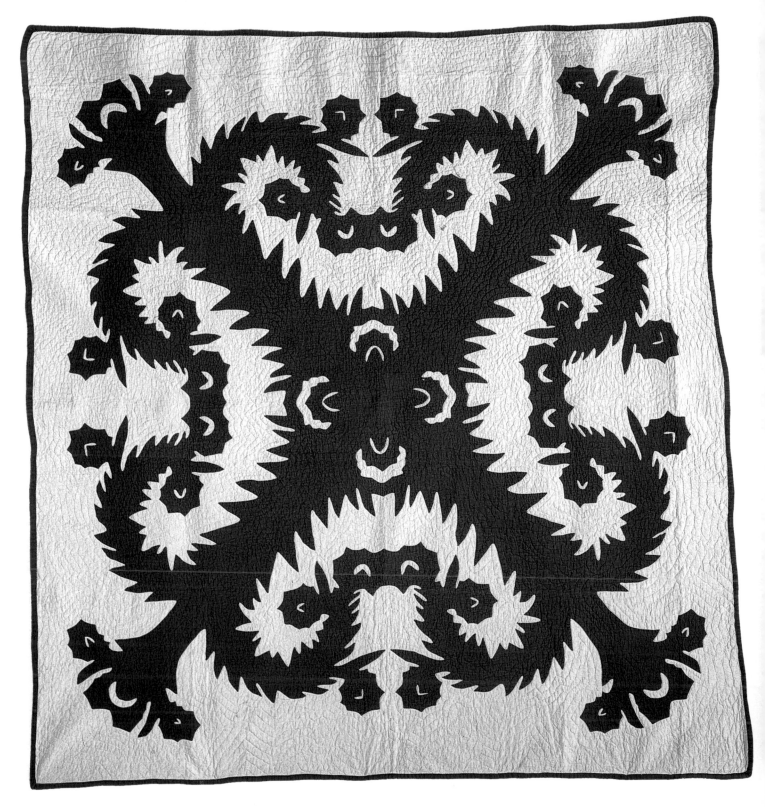

108
Hawaiian Quilt
c. 1880

Cotton; appliquéd
199.4 x 190.5 (78½ x 75)

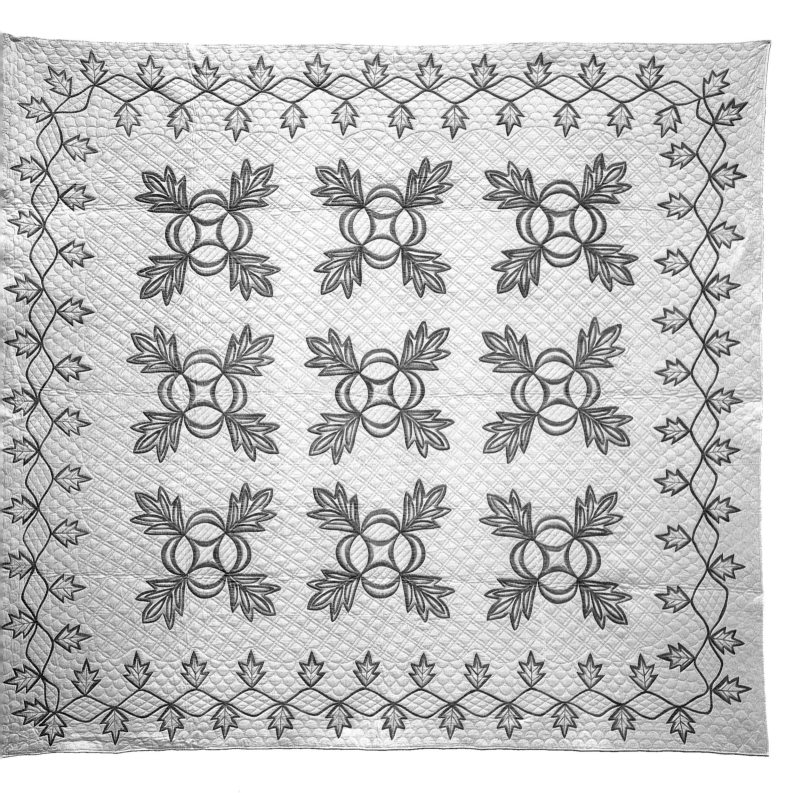

109
Stenciled Leaf
c. 1890

Cotton; stenciled with paint, quilted
207.7 x 226.4 (81³/₄ x 89¹/₈)
Found in Buffalo, New York

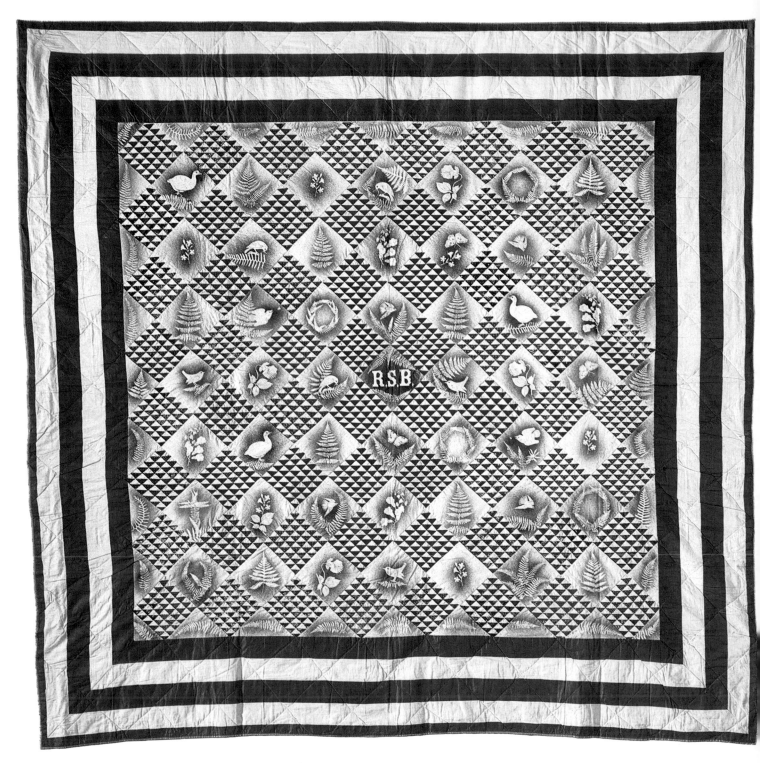

110
Spatterwork
c. 1900
Cotton; painted spatterwork, pieced
226.1 x 226.1 (89 x 89)

Signed, *R.S.B.*
The quilt's spattered designs were
created by sponging, spattering, or
dabbing paint around leaves, ferns, or
cut-paper patterns

111
Amish Sawtooth Diamond
c. 1880

Wool and cotton; pieced and quilted
208.9 x 205.7 (82¼ x 81)
Initialed, *J.S.B.*
Lancaster County, Pennsylvania

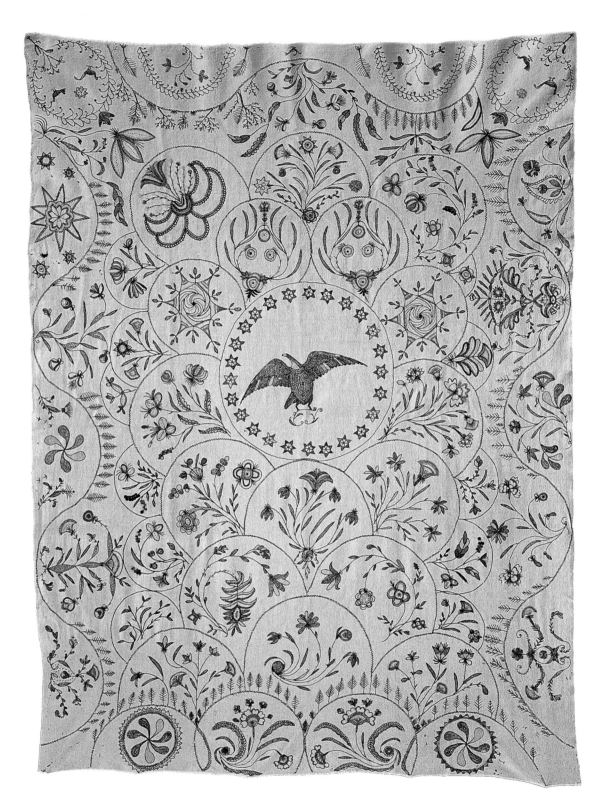

112
**Embroidered Blanket: Scalloped Eagle
and Flowers**
c. 1800

Wool yarns on twill-weave wool
ground, vegetable dyes
243.2 x 192.4 (95¾ x 75¾)

Made by the Spear family of South
Burlington, Vermont
Gift of Dr. & Mrs. Fletcher McDowell

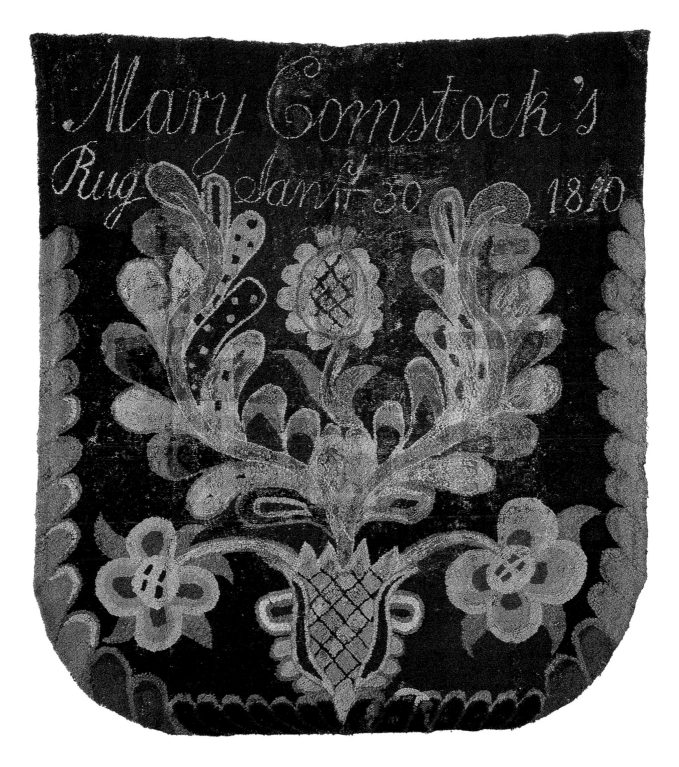

Handspun wool yarns sewn on
handwoven twill-weave wool blanket
214.0 x 193.0 (84¼ x 76)
Made by Mary Comstock of Shelburne,
Vermont

113
Mary Comstock Bed Rug
1810

Signed, *Mary Comstock's Rug, Jan^y 30,
1810*
Gift of Mrs. Henry Tracy

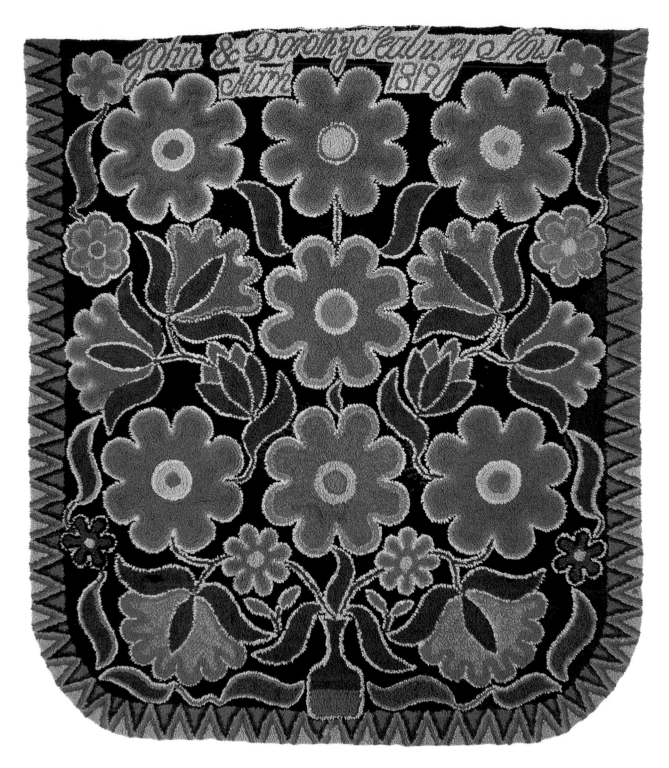

114
Seabury Bed Rug
1819
Handspun wool yarns sewn to wool
ground

236.2 x 256.5 (93 x 101)
Made by Dorothy Seabury of Stowe,
Vermont
Signed, *John & Dorothy Seabury,
Stow, March 1819*

Gift of Robert J. Whiting, a Seabury
descendant

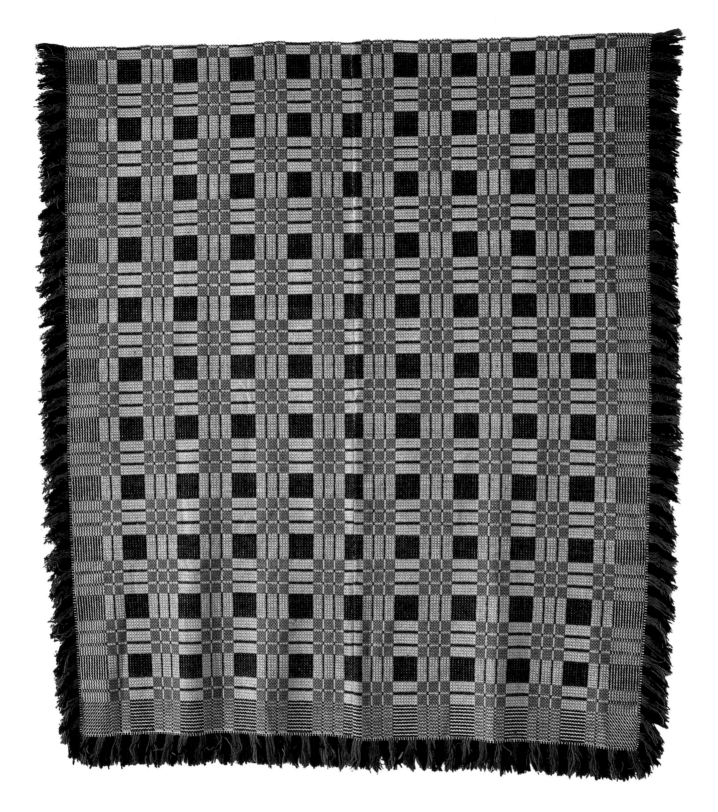

115
Nine Patch Pattern Coverlet
c. 1830

254.6 x 219.1 (100¼ x 86¼)
Made in Pennsylvania

Cotton and wool, handwoven overshot
weave construction

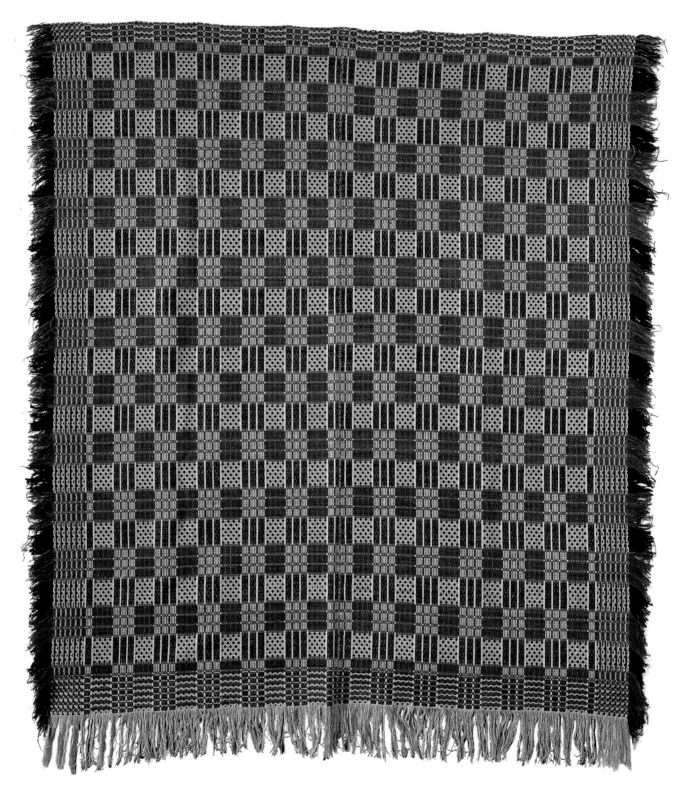

116
Multi-Harness Point Twill Coverlet
c. 1830

Wool and cotton, handwoven
254.0 x 218.4 (100 x 86)
Made in Pennsylvania by a professional
weaver

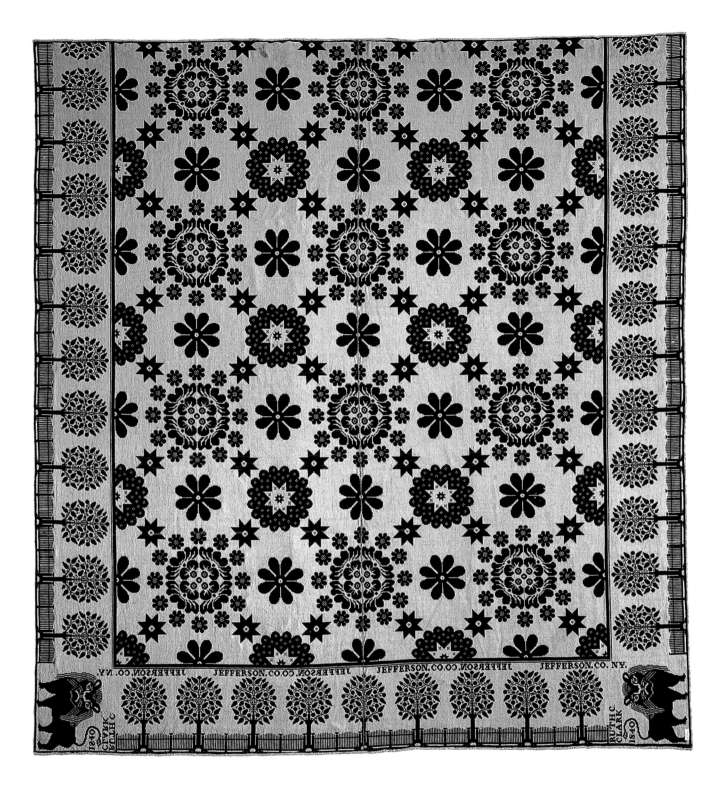

117
Tyler Lion Coverlet
1840

Cotton and wool, Jacquard-woven
double cloth
210.8 x 188.0 (83 x 74)

Woven by Harry Tyler, Butterville
Township, Jefferson County, New York
for Ruth C. Clark

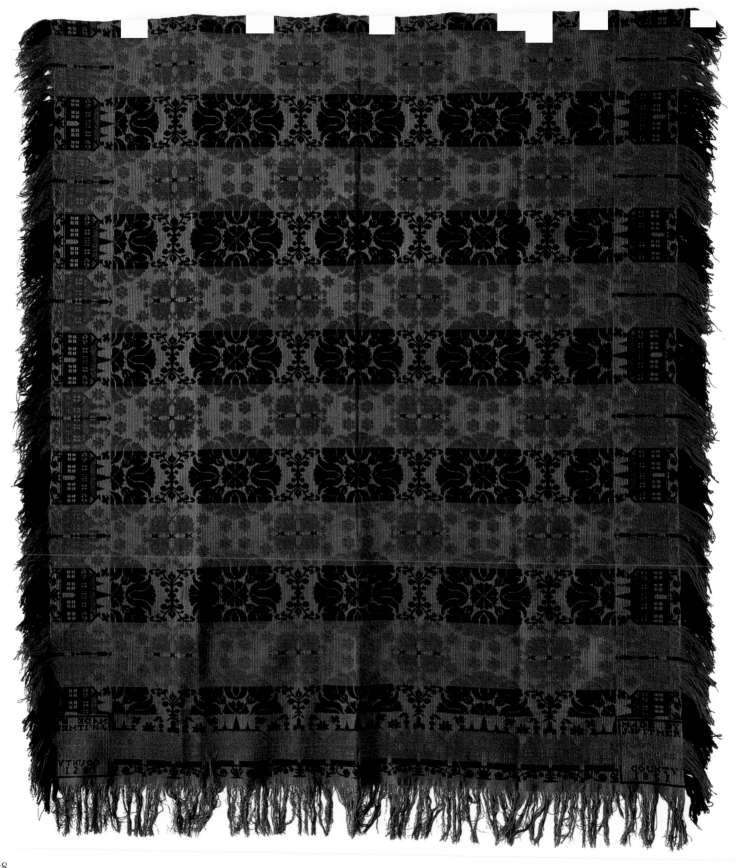

118
Schoolhouse Border Coverlet
1851
Cotton and wool, Jacquard-woven tied
double cloth
246.4 x 226.1 (97 x 89)
Woven by Jacob Witmer, Manor
Township, Lancaster County,
Pennsylvania

Rugs

FEW SETTLERS IN COLONIAL AMERICA could afford the luxury of rugs or carpets in their homes; most found other ways to protect and decorate floors. Sand was one of the first materials used as a floor covering; it absorbed moisture and mud and, when smoothed and swirled into patterns with a broom, served a decorative purpose. By the eighteenth century, floor covers such as straw matting, floor cloths, and woven carpet became common. While some sewn, braided, and other types of homemade rugs might have been used in the late eighteenth century, the earliest known examples date from the 1800s.

Yarn-sewn rugs, made by embroidering strands of yarn in a closely spaced running stitch on a wool or linen foundation fabric, were extremely popular in the early nineteenth century both as bed and floor coverings. The Bengal Tiger rug (cat. 119) was probably designed as a hearth rug to cover the hearthstone in the summer months or, in a more wealthy home, to protect an expensive room-sized carpet from ashes and flying embers. The rug maker might have copied the tiger design from a woodcut in Thomas Bewick's *The Quadrupeds*, published in Philadelphia in 1810, which illustrated a variety of domestic and exotic animals.

Hooked rugs, generally considered a rural craft, were widely made and used in the middle to late nineteenth century. They also enjoyed a resurgence of

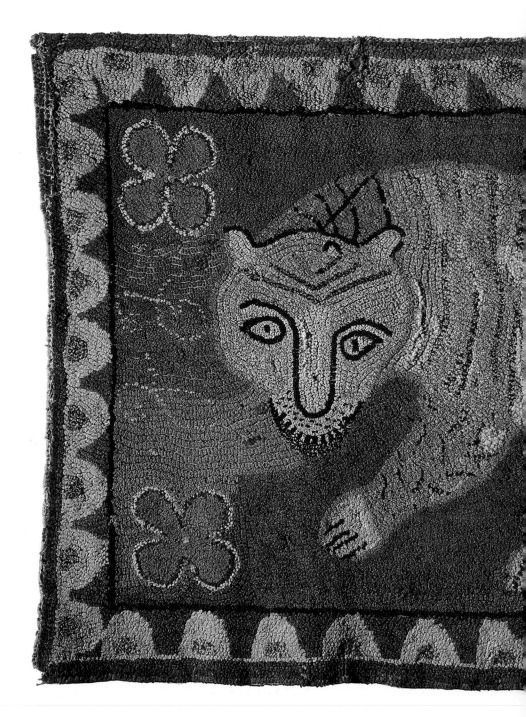

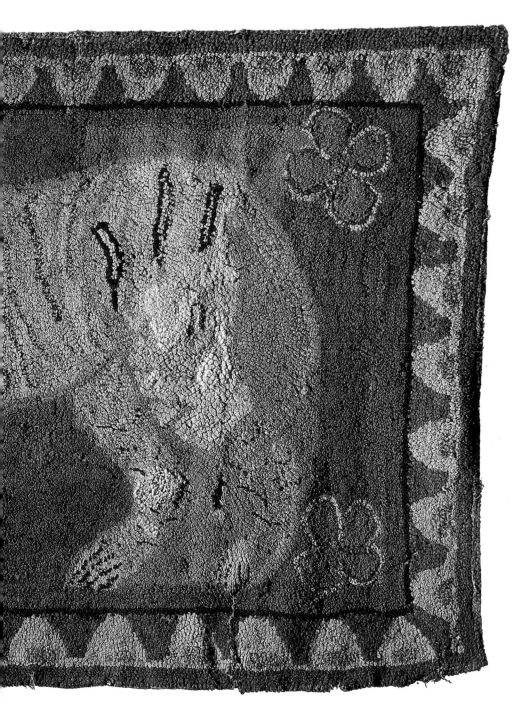

popularity in the 1920s and 1930s. Believed to be indigenous to North America, the earliest examples came from maritime Canada and northern New England. The rug maker could recycle scraps of fabric into useful and often beautiful floor coverings. The pile surface was made by using a hook to pull a narrow cloth strip up through a coarsely woven foundation fabric in a series of loops. The closeness of the loops determined the density and durability of the finished rug.

Like earlier rug styles, designs for hooked rugs were geometric, or based on flowers and animals or copied from printed illustrations. Rugs depicting scenes from everyday life, such as the 4th of July celebration (cat. 121), are more unusual and clearly the work of a creative imagination.　　　C.O.

119
Bengal Tiger Rug
c. 1820
Handspun wool yarns sewn on
handwoven wool ground
104.8 x 170.2 (41¼ x 67)
Signed, *C. C.* (?)

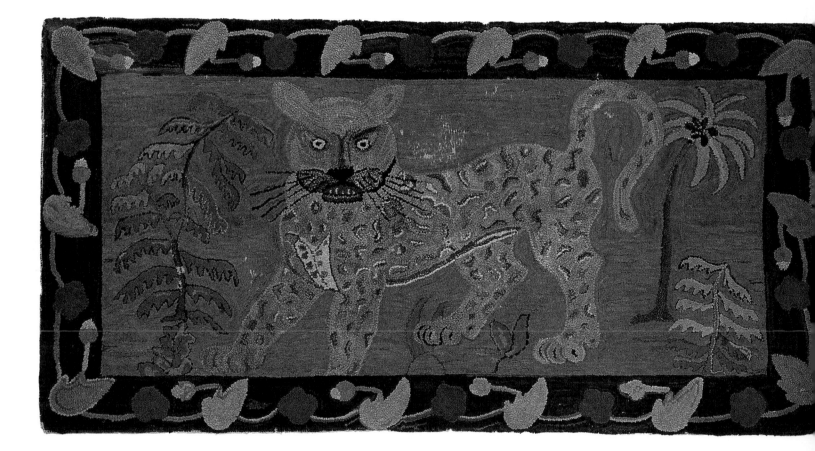

120
Leopard Rug
c. 1880
Wool fabric hooked on burlap ground
94.6 x 179.1 (37$^{1}/_{4}$ x 70$^{1}/_{2}$)

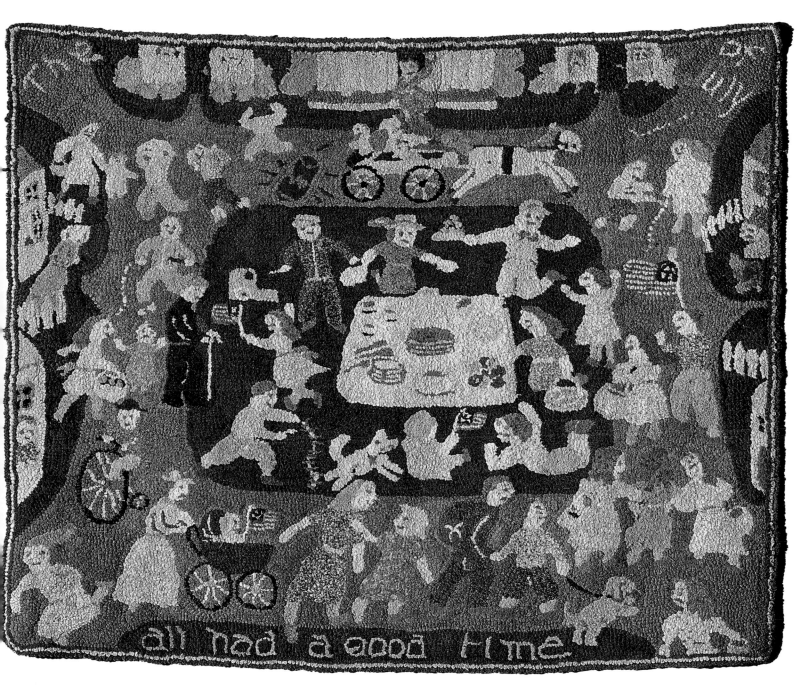

121
Fourth of July
c. 1940
Wool, cotton, and nylon fabrics hooked
on burlap ground
95.3 x 115.6 (37$^{1/2}$ x 45$^{1/2}$)
Signed, *The 4 of July, all had a good*
time
Gift of Mr. Fred MacMurray

Time Line

DAVID PARK CURRY

THE MATERIALS INCLUDED IN THIS EXHIBITION, which were selected for their aesthetic appeal, most clearly fall under the rubric "popular art." They were first admired and collected during an era when democratic ideals made a romantic hero of the untrained artist. American folk art was taken out of context by artists and collectors, who drew inspiration or satisfaction from it without necessarily understanding the art they borrowed. During the same period, handwork was celebrated. Moreover, nonacademic artistic solutions seemed both to presage and affirm the desire for abstraction in avant-garde painting and sculpture.

This time line was prepared to offer the general reader a chronological view of events in the field of folk art, set against related developments in the arts and crafts movement, as well as the march toward modernism in avant-garde art. Familiar political and cultural events are mentioned to provide an easily recognized time frame. Ethnic arts (European peasant crafts, African tribal arts, Native American arts), and arts of distinctive American cultural subsets (Pennsylvania Germans, the Shakers, Afro-Americans, and the Spanish-American makers of *santos*), are considered alongside the yet-ill-defined body of nineteenth- and twentieth-century painting, sculpture, and decorative arts that were accepted as "American folk art" until that concept underwent rigorous scrutiny in the 1970s. Out of the welter of events from mainstream academic and avant-garde painting, sculpture, and applied arts, an attempt has been made to select those in which a conscious element of populism or a desire to link art and industry blurs the line between so-called "fine" art and its supposedly lesser brethren. I hope that it will become clear to the reader that popular and fine arts are inextricably intertwined. As Daniel Robbins noted in his 1976 essay, "Folk Sculpture Without Folk," "the juncture between high art and popular interest is often desired, but seldom achieved." That artists able to claim all degrees of training and sophistication have been seeking such a juncture for the past century and a half is crucial to our understanding of the objects they have left to us.

I am extremely grateful to Allison Green, Jane Fudge, Alice Lindblom, Leila Held, Virginia Stratton, and George Shackelford for their assistance with the time line.

Complete information on the time line illustrations may be found beginning on page 206.

1848 **Europe**
Rioting in France leads to the abdication of Louis Philippe and establishment of the Second Republic. Liberal movements in Austria, Germany, and Italy are met by conservative backlash. Painters in England form the Pre-Raphaelite Brotherhood, adopting "truth to nature," and signaling avant-garde artists' increasing dissatisfaction with academic formulas as well as the desire to redefine the so-called "lesser" or decorative arts.

1849 **Boston**
Henry David Thoreau publishes *Civil Disobedience*.

1851 **London**
"The Great Exhibition of the Works of Industry of All Nations" at the Crystal Palace in Hyde Park popularizes a nationalistic approach to the fine and applied arts, and heralds a modern effort to combine art with industry.

John Ruskin publishes first of two volumes of *Stones of Venice*. Becomes the cornerstone of the arts and crafts movement, combining twin desires to reform society and escape it. Such dualistic thinking will eventually color the earliest collectors' reactions to folk art.

London, Crystal Palace

GENERAL
Paris
Louis Napoleon effects a coup d'etat and establishes himself as monarch.

1852 **London**
Museum of Ornamental Art started at Marlborough House. Eventually becomes the Victoria and Albert Museum. Under the leadership of Henry Cole, a primary force behind the Great Exhibition of 1851, the museum receives its first collections from that international fair. The museum serves as a design repository to inspire British industrial artists. Other countries will follow Britain's lead in establishing museums of applied arts.

New York
American Art Union closes. Had tried to popularize a national school in American art by selling inexpensive engraved copies of landscape paintings.

New York, Crystal Palace

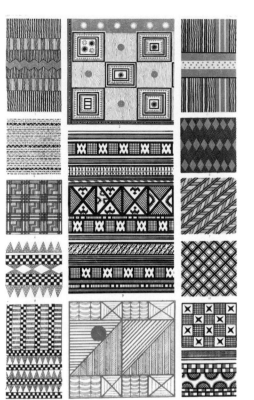

Jones, *Grammar of Ornament*

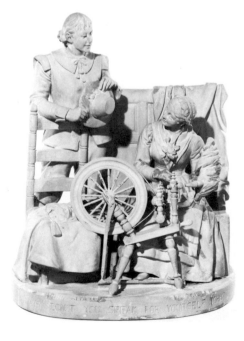

Rogers Group

1853 New York
New York Crystal Palace hosts America's first world's fair. Popular and fine arts again intermix; this will become characteristic of the great international fairs.

1854 London
Working Mens College founded. Ruskin becomes an instructor, promulgating connections between a high moral state and the creation of arts and crafts. Members of the arts and crafts movement will borrow heavily from folk sources.

1856 London
Owen Jones publishes *The Grammar of Ornament*, one of several attempts to analyze ornament during the era. Compiles decorative patterns from cultures then thought to be "primitive," including Egypt and China. *Grammar* eventually becomes a source for decorative arts motifs and has an impact upon abstract painting by Whistler.

1857 Paris
Félix Bracquemond discovers Japanese prints in Hokusai's *Mangwa*. The craze for "japonisme" shortly follows, spreading from Paris to Britain and the United States.

1859 New York
John Rogers opens his studio. Eventually produces about eighty plaster "Rogers Groups": inexpensive sculpture depicting genre subjects, political events, and scenes from popular literature. Although attuned to the aesthetic canons of academic sculpture, these pieces are intended for a broad audience.

GENERAL
London
Charles Darwin publishes *Origin of the Species*. Has an impact upon determinist theories of art history that view art as a by-product of craft technology.

1860 Bexleyheath, Kent
Philip Webb and William Morris complete the building, decoration, and furnishing of Red House, which typifies a growing European interest in vernacular architecture and peasant arts and crafts fostered by a romantic view of the simple life of the "folk," nourished by an intellectual climate rife with democratic and nationalistic ideals.

1861 GENERAL
The unification of Italy occurs, the Russian serfs are emancipated, and America's Civil War begins.

1862 London
"The International Exhibition" introduces the arts of Japan to a wide audience. Morris, Marshall, Faulkner & Co., founded in 1861, exhibit "functional medievalism" in furniture design. Both medieval and oriental designs are presented out of context, and inspire artists. The same thing will happen to folk art in the 1920s and 1930s.

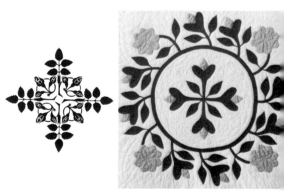

Dresser, *Art of Decorative Design*, detail
cat. 87, *Presidential Wreath*, detail

Christopher Dresser publishes *The Art of Decorative Design*, the first of his many books on rational design. Dresser finds a nonhistorical basis for the decorative arts by looking at nature, geometric forms, and the functional purpose of the object being created.

1863 Paris
Union Centrale des Beaux Arts
appliqués à l'Industrie established.

Salon des Refusées includes works by
Edouard Manet, Camille Pissarro,
Johann Jongkind, Armand Guil-
laumin, James McNeill Whistler,
Henri Fantin-Latour, and Paul
Cézanne.

1866 Cambridge, Massachusetts
Peabody Museum of Archaeology
and Ethnology founded at Harvard.
Neglected by fine arts museums,
many collections of ethnic art will
be acquired by museums of archae-
ology or natural history over the
next century.

1867 Paris
"Exposition Universelle."

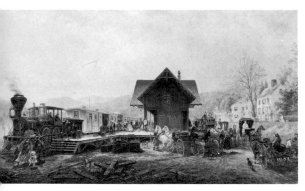

Henry, *The 9:45 Accommodation*

New York
Edward Lamson Henry paints *The
9:45 Accommodation, Stratford,
Connecticut.* Many of his genre
scenes celebrate the "good old days,"
or contrast the old with the new.
Henry also amasses a large collection
of artifacts, including antique cos-
tumes and carriages. Eventually he
becomes involved in historic preser-
vation as well.

GENERAL
Hamburg
Marx publishes the first volume of
Das Kapital. Two other volumes fol-
low, in 1885 and 1895

1868 London
Charles Locke Eastlake publishes
Hints on Household Taste for a

middle-class audience, preaching
the superiority of handmade objects
in an era dominated by machine-
made products. The book will
achieve wide popularity in the
United States in the 1870s.

1869 New York
American Museum of Natural
History founded.

GENERAL
London
Matthew Arnold condemns Victo-
rian economic and political "bad
taste" in *Culture and Anarchy.*

1870 Boston
Museum of Fine Arts, Boston,
founded. Chartered to exhibit indus-
trially applied art.

New York
The Metropolitan Museum of Art
founded. Chartered to encourage art
in industry.

GENERAL
Franco-Prussian War declared.

First transcontinental train departs
Boston on its thirty-nine-day
journey.

1871 Paris
The Paris Commune, a populist
movement against Napoleon III,
involves dissatisfied artists.

Brooklyn
P. T. Barnum founds "The Greatest
Show on Earth," stimulating the
need for elaborately carved circus
wagons and figures later considered
folk art.

GENERAL
Washington, D.C.
Walt Whitman publishes *Demo-
cratic Vistas.*

1872 London
French dealer Paul Durand-Ruel
exhibits impressionist works. Does so
again in 1873, 1874, and 1875 when
he closes his London gallery.

1873 Vienna
"Universal Exposition of Arts and
Industry."

cat. 67, *Locomotive* weather
vane

GENERAL
London
Herbert Spencer publishes *The
Study of Sociology.*

France
Economic collapse followed by
six-year depression.

United States
Panic of 1873 precipitates five-year
depression.

1874 Paris
First impressionist exhibition. An
important impressionist goal will be
to paint "modern life," and artists
will draw heavily on the popular
culture of their era for inspiration.

United States
Crazy quilting promoted by wom-
en's magazines and sewing machine
companies. Both patchwork and

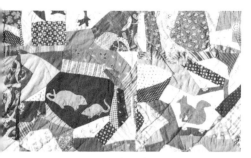

cat. 105, crazy quilt, detail

appliqué quilts have, by this time, already enjoyed a century of popularity. Although not necessarily inspired by quilts, collage in painting will not become important for nearly four decades.

1875 New York
Winslow Homer makes his last illustration for *Harper's Weekly.* Early involvement with popular illustration will characterize the careers of many American painters.

1876 Paris
Second impressionist exhibition. Edmond Duranty publishes *La Nouvelle Peinture;* Georges Rivière writes first article on impressionists.

New York
Decorative Art Society founds first chapter to provide profitable occupation for artistically talented women. Other chapters follow in Boston, Philadelphia, and Chicago.

Philadelphia
"Centennial Exposition." Benjamin Holmes shows twelve canvasback duck decoys in Hunting and Sporting section and wins a medal. The Colonial Kitchen display includes needlework, as do additional exhibits.

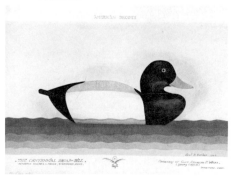

GENERAL
United States
Alexander Graham Bell invents telephone.

1877 London
William Morris founds "Anti-Scrape," a society for the preservation of historic buildings.

Paris
Third impressionist exhibition.

New York
Society of American Artists founded in opposition to the National Academy of Design.

1878 London
Folklore Society founded. William Thoms had proposed use of the term "folklore" earlier, in *Athenaeum* 982 (22 August 1846). Prior to this, objects of material culture were called "popular antiquities."

Whistler-Ruskin libel suit becomes a landmark in the battle over the acceptability of abstract painting. Whistler's work is compared to "delicately tinted wallpaper," that is, to decorative art.

Paris
"Exposition Universelle."

GENERAL
Washington, D.C.
Thomas Edison patents the phonograph.

Holmes, canvasback decoy
New England kitchen interior, 1876

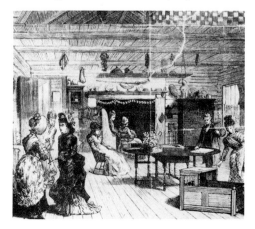

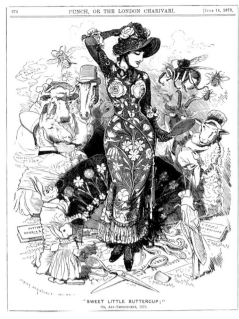

"Sweet Little Buttercup, or Art-Embroidery," *Punch,* 1879

1879 London
Vogue for "art embroidery" peaks.

Paris
Fourth impressionist exhibition.

Sorgenfrie, near Copenhagen
Founding of the Frilandsmuseet, a department of the Danish National Museum. This outdoor or "village" museum illustrates rural living conditions from the Danish past. Buildings from various parts of Denmark are reerected in a large park and furnished with period decorative arts. Similar institutions, among them the Shelburne Museum, will appear in the United States half a century later.

Boston
Archeological Institute of America founded. Sponsors a ten-year study of southwestern Pueblo Indians. Anglo painters will not begin painting in Taos and Santa Fe until the turn of the century.

Cincinnati
Women's Pottery Club started. The Rookwood Pottery will follow in 1880, inaugurating the American art pottery movement.

New York
Louis C. Tiffany and Company,
Associated Artists, organized.
Includes the talented embroidery
designer Candace Wheeler.

1880 **Paris**
Fifth impressionist exhibition.

1881 **Paris**
Sixth impressionist exhibition.

"Lucy," the Margate elephant

Margate, New Jersey
"Lucy," a sixty-five-foot building
shaped like an elephant, erected as
part of a summer home development
scheme. Combines eighteenth-
century tradition of visionary, fanci-
ful architecture with nineteenth-
century advertising sensibilities.
Designated an historic landmark
in 1966, during the heyday of
pop art.

1882 **London**
Sophia Caulfeild and Blanche C.
Saward publish *The Dictionary of
Needlework*.

Arthur Heygate Mackmurdo founds
The Century Guild. Members create
exquisite arts and crafts objects fol-
lowing the principles of William
Morris.

Paris
Musée d'Ethnographie du Trocadéro
(now Musée de l'Homme) opens.
Houses collections of ethnic arts.
Paul Gaugin will not paint in the
South Sea Islands for another nine
years, whereas African art will have
little impact on painters for another
quarter of a century.

"O. W."
" O, I eel just as happy as a bright Sunflower
Lays of Christy Minstrelsy

Æsthete of Æsthetes !
What 's in a name ?
The poet is WILDE,
But his poetry 's tame.

Caricature of Oscar Wilde, *Punch*, 1881

United States
Oscar Wilde, on tour through 1883,
popularizes the British aesthetic
movement concepts that take hold in
America during the 1880s.

1883 **Boston**
French impressionist paintings
exhibited at the Manufacturers' and
Mechanics' Institute.

Musée d'Ethnographie de Trocadéro

1884 **Brussels**
Société des Vingt founded to pro-
mote avant-garde art. Ten years
later it reforms as La Libre Estheti-
que, dedicated to unification of all
the arts.

Paris
Henri Rousseau, later hailed by
avant-garde artists as a "primitive"
painter, obtains permit to copy mas-
terworks at Louvre, Luxembourg,
and Versailles museums.

Hartford
Albert Hastings, curator at the
Wadsworth Atheneum, goes "china
hunting" and buys two pieces of red-
ware. Eventually becomes a major
collector. His purchase reflects the
fact that pottery was among the first
kind of folk art collected in America.

New York
Mark Twain publishes *The Adven-
tures of Huckleberry Finn*, which
includes a satire of popular art: fur-
niture, chalkware figures, and
school-girl painting.

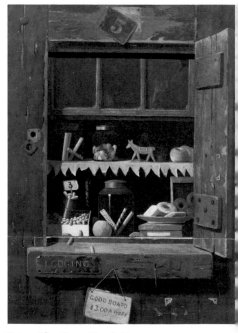

Peto, *The Poor Man's Store*

1885 **Philadelphia**
Poor Man's Store typifies the realist
paintings of the 1880s and 1890s by
Peto, Harnett, and others. These
pictures often focus upon humble

material objects. An exaggerated version of realism will return in force nearly a century later.

1886 Paris
Last impressionist group show. Henri Rousseau exhibits at the Salon des Indépendants.

New York
"A Special Exhibition of Works in Oil and Pastel by the Impressionists of Paris," organized by Paul Durand-Ruel for the American Art Association, proves so popular that it reopens at the National Academy of Design. Bostonians begin collecting impressionist art.

The Statue of Liberty is installed in New York harbor.

GENERAL
American Federation of Labor organized.

1887 Great Britain
National Association for Advancement of Art and Its Application to Industry established.

1888 London
C. R. Ashbee launches Guild and School of Handicraft in the East End. Similar efforts to employ and uplift the poor through arts and crafts training will occur in the United States.

Art and Craft Exhibition Society established. Its members lecture in America, stimulating the organization of many similar groups.

Boston
American Folklore Society founded. Their emphasis on written and oral traditions rather than arts and crafts endures into 1950s.

1889 Paris
"Exposition Universelle" includes displays of African tribal art as well as the technologically daring Eiffel Tower.

Boston
Companies including Fiske, and Parker & Gannet , advertise commercially made weather vanes inspired by handcrafted examples.

Tobacconist's shop, 1869

GENERAL
Boston
First electric trolleys in America.

1890 Kelmscott, Oxfordshire
William Morris founds Kelmscott Press. Following Morris' lead, American designers such as the Roycrofters will design books in the arts and crafts style by 1896.

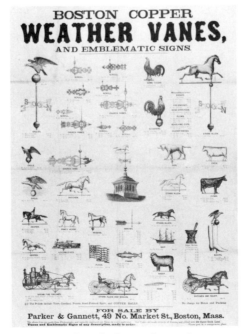
Advertising broadside, Parker & Gannett

New York
F. W. Weitenkampf writes "Lo, the Wooden Indian. The Art of Making Cigar-Shop Signs," for *The New York Times* (3 August 1890), 13.

1891 Washington, D.C.
Thomas Edison granted patents for both a radio device that transmits signals electrically without the use of wire, and for his motion picture camera. Edison's "Kinetescope," along with Thomas Armat's "Vitascope," will project the first true motion pictures in 1896.

1893 London
The Studio commences publication.

MacMonnies, *Triumph of Columbia*

Chicago
Events at the "World's Columbian Exposition" include the third international folklore congress. Progressive architects dismayed at the fair's *retardataire* neoclassical plaster façades.

Frank Lloyd Wright begins independent architectural practice.

New York
Alice Morse Earle publishes *Customs and Fashions of Old New England.* Typifies the antiquarian approach to America's past.

Edwin Atlee Barber, director of the Pennsylvania Museum and School of Industrial Art (later renamed Phila-

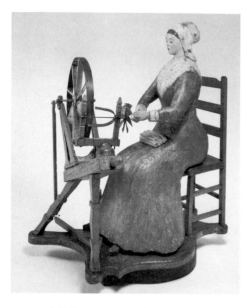

cat. 77, *Spinning Woman Whirligig*; compared with "Ye Olde Tyme" Restaurant, World's Columbian Exposition, 1893

delphia Museum of Art), publishes *Pottery and Porcelain of the United States.*

1894 **Philadelphia**
Gustav A. Dentzel's factory for carved carousel figures thrives, applying techniques of mass production to objects that will later be considered folk art.

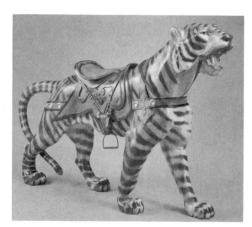

cat. 57, *Tiger*, Dentzel factory

1895 **Paris**
Siegfried Bing publishes *La culture artistique en Amerique*, admiring American vernacular architecture along with high-style decorative arts by Louis Comfort Tiffany.

Minneapolis
Chalk and Chisel Club organized. In 1899, it becomes Minneapolis Arts and Crafts Society.

1896 **Chicago**
First issue of *House Beautiful*.

Detroit
Mason Decoy Factory combines hand and machine processes, making rough-turned decoys that are hand finished. The factory will be active until 1924.

New York
First public showing of a motion picture.

Rousseau, *Sleeping Gypsy*

1897 **Paris**
Rousseau exhibits *Sleeping Gypsy* at the Salon des Artistes Indépendants.

Vienna
Founding of Vienna Secession. Objects treasured by the "common man"—this time the furniture of

"Herr Biedermeier," the typical nineteenth-century, middle-class German—will become an important design source for Secession decorative arts. The Secession holds its first exhibition in 1898.

Boston
First major arts and crafts exhibition in America, held at Copley Hall.

Boston Society of Arts and Crafts founded.

Chicago
Chicago Arts and Crafts Society founded.

Doylestown, Pennsylvania
Anthropologist Henry Mercer collects old tools and craft products that document methods being supplanted by industry. Eventually amasses 30,000 objects for his display, "Tools of the Nation Makers."

New York
Museum for the Arts of Decoration at Cooper Union (later Cooper-Hewitt Museum) founded. Will become the Smithsonian Institution's National Museum of Design.

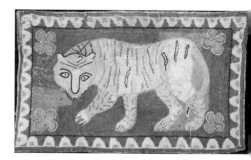

cat. 119, *Tiger*, hooked rug

United States
During the late nineteenth century, unique hooked rugs are prized. At the same time, widespread marketing of stamped or stenciled colored rug patterns on burlap stimulates the making of hooked rugs. Similarly, both unique and factory-made weather vanes are available.

1898 **Glasgow**
First wing of Charles Rennie Mackintosh's School of Art completed. Several of Mackintosh's most impor-

tant commissions will be for public gathering places, such as tea rooms.

Deerfield, Massachusetts
Blue and White Needlework Society, an early group of amateur craft workers, begins. By 1900 thirty trained workers are creating needlework based upon past designs. Disbands in 1926.

1899 **Cooperstown, New York**
New York State Historical Society founded.

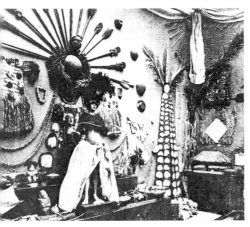
"Exposition Universelle," Paris

1900 **Paris**
"Exposition Universelle" shows tribal arts.

Vienna
Charles Rennie Mackintosh exhibits at the Vienna Secession. Sigmund Freud publishes *The Interpretation of Dreams*.

New York
Guild of Arts and Crafts of New York organized.

GENERAL
Subway systems built in Paris and New York.

1901 **Buffalo**
"Pan-American Exposition."

Chicago
Art Institute of Chicago begins annual exhibitions of applied art.

Frank Lloyd Wright delivers address, "The Art and Craft of the Machine," to Arts and Crafts Society.

Philadelphia
House and Garden first published.

Syracuse
The Craftsman begins a fifteen-year publication run, popularizing the ideas of the arts and crafts movement.

1903 **Vienna**
Founding of the Wiener Werkstätte, a "manufacturing guild of craftsmen." Operates until 1932.

Chicago
William Morris Society founded.

Philadelphia
Edwin A. Barber publishes *Tulip Ware of the Pennsylvania German Potters*.

Pennsylvania German earthenware dish

GENERAL
Kitty Hawk, North Carolina
Orville and Wilbur Wright make their first airplane flight.

1904 **Philadelphia**
Edwin A. Barber publishes *Marks of American Potters*.

Providence
Handicraft Club organized. Had begun as the Art Workers Guild in about 1885.

St. Louis
"Louisiana Purchase International Exposition."

Washington, D.C.
The U.S. Bureau of Labor publishes *The Revival of Handicraft in America*.

1905 **Paris**
"Primitive" artist Rousseau exhibits *The Hungry Lion* as fauves gain notoriety at the Salon d'Automne.

Los Angeles
Los Angeles Society of Arts and Crafts founded.

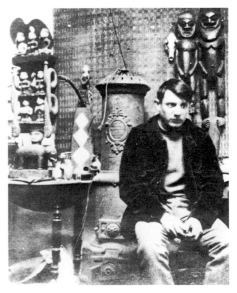
Picasso in his studio in the Bateau Lavoir

1906 **Paris**
In this year and 1907, Henri Matisse, André Derain, Maurice de Vlaminck, and Pablo Picasso "discover" African and Oceanic masks.

Detroit
Detroit Society of Arts and Crafts founded.

Providence
Eliza Greene Metcalf Radeke acquires 1,445 duplicates from Emily de Forest's extensive peasant pottery collection. Mrs. Radeke had begun by collecting Windsor chairs in the 1880s, after helping her mother at the Rhode Island Pavilion of the Philadelphia Centennial in 1876.

Washington, D.C.
The Freer Gallery of Art founded. Completed in 1921, it is the first art

museum in Smithsonian Institution constellation. Collections accepted by Smithsonian officials primarily because of an archeological interest in Freer's oriental holdings.

GENERAL
First radio transmission of voice and music, broadcast from Massachusetts.

1907 **Munich**
Deutsche Werkbund forms, associating artists and craftsmen with commercial firms.

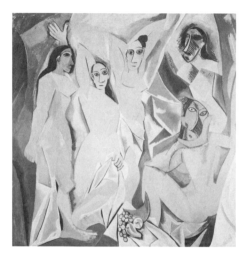

Picasso, *Demoiselles d'Avignon*

Paris
Picasso paints *Demoiselles d'Avignon*. Salon d'Automne presents Cézanne retrospective. This exhibition, along with one in 1904, solidifies Cézanne's impact on both fauves and cubists.

Boston
National League of Handicraft Societies organized.

Providence
Eliza Greene Metcalf Radeke exhibits her collection of European and American "peasant" pottery at the Rhode Island School of Design, and four years later starts collecting Pennsylvania German pottery.

Stamford
Electra Havemeyer Webb, daughter of Mr. and Mrs. Henry O. Havemeyer, well-known collectors of European art, purchases a cigar-store Indian for $15.

1909 **Paris**
Ballet Russe first appears in Paris, generating fresh interest in colorful peasant costumes.

Newark
The Newark Museum founded under director John Cotton Dana. His interest in design and industry also influences other museums. Eventually, the museum hosts two important early exhibitions of folk art.

1910 **Berlin**
Ausgefuhrte Bauten und Entwurfe, Frank Lloyd Wright's designs, published.

Milan
Technical Manifesto of Futurist Painting published in Milan and then in Paris. The poet Filippo Marinetti had published his Futurist Manifesto in *Le Figaro* the preceding year. The futurists will exhibit their work in London and Paris in 1912.

Paris
Georges Braque and Picasso develop high analytic cubism.

Boston
Society for the Preservation of New England Antiquities established.

Cassatt, *Mother and Child*, The Metropolitan Museum of Art, Bequest of Mrs. H.O. Havemeyer

Walpole Society founded by elite group of antiquarians.

New York
The artist Max Weber organizes posthumous Rousseau exhibition at Alfred Steiglitz' Gallery 291.

1911 **Munich**
Der Blaue Reiter founded by Wassily Kandinsky and Franz Marc. In 1912, their *Blaue Reiter Almanach* will publish several types of folk art.

Paris
Braque and Picasso use lettering as structural components in cubist still life. Braque had introduced lettering into his painting in 1909.

Maison Cubiste, a house decorated by Left Bank cubists for the Salon d'Automne, is an attempt to make the language of cubism intelligible to the general public.

1912 **Newark**
Newark Museum shows "Modern German Applied Art."

New York
Eliza Calvert Hall publishes *A Book of Handwoven Coverlets*.

Ogunquit, Maine
In about 1912, artist and writer Hamilton Easter Field begins to fur-

cat. 52, *Indian Squaw and Papoose*, cigar-store figure, detail

192

nish cottages with decoys, weather vanes, homemade rugs, nonacademic paintings.

Paris
Picasso creates his first collage, *Still Life with Chair Caning*.

Picasso, *Still Life with Chair Caning*

1913 **London**
Roger Fry opens the Omega Workshops, aiming to produce painted furniture, fabrics, rugs, pottery, and other items made by artists in the spirit of post-impressionist painting. The venture is not a commercial success and will close in 1919.

Moscow
Mikhail Fedorovich Larinov originates an exhibition of icons and popular prints. Russian cubo-futurists seek to create sculpture out of space, rather than mass, using materials and methods derived from modern technologies.

New York
Marcel Duchamp's *Nude Descending a Staircase, No. 2,* creates a scandal at the "International Exhibition of Modern Art," at 69th Regiment Armory. The exhibition, which introduces avant-garde art to many Americans, also travels to Chicago and Boston.

Ogunquit, Maine
School of Painting and Sculpture launched by Hamilton Easter Field, joined by Robert Laurent, an artist and native of Brittany.

Washington, D.C.
The creation of decoys intended only for display is stimulated when the Weeks-McLean Act, which outlaws night and spring shooting and interstate transport of birds, reduces the need for mass-produced utilitarian decoys.

Shelburne, Vermont
Electra Havemeyer Webb begins acquiring Americana to furnish the "Brick House."

GENERAL
Vienna
Freud publishes *Totem and Taboo*.

Detroit
Henry Ford introduces assembly line to the automobile industry.

1914 **Florence**
Futurist Filippo Marinetti publishes "Geometric and Mechanical Splendor and the New Numerical Sensibility," available in English translation by May 1914.

London
Italian futurist exhibition at Dore Galleries.

New York
Elie Nadelman, a former member of the Parisian avant-garde with an interest in primitive art, arrives. Nadelman had collected folk art in his native Warsaw.

Gallery 291 exhibits "Negro Art," stressing the aesthetic qualities of African tribal pieces.

GENERAL
Austria declares war on Serbia; Germany declares war on Russia. First World War ensues.

1915 **New York**
Dada artist Marcel Duchamp arrives. His emphasis upon "the found object" extracted from the context of mass culture and treated as a work of art will feed the concept that naive or untutored folk artists can create work rivaling fine art.

San Francisco
"Panama-Pacific International Exposition" includes futurist art. Elaborate Beaux-Arts buildings testify to the weakening of the arts and crafts movement.

Los Angeles
D. W. Griffith films *Birth of a Nation*. For this film, and for *Intolerance* and others, Griffith will draw upon popular imagery and genre scenes from prints and the stage to "give [the people] what they know."

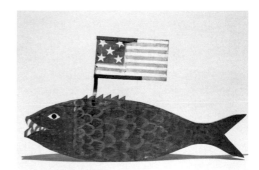

cat. 3, *Fish with Flag Sign*

GENERAL
Sinking of the *Lusitania*.

1916 **New England**
Artists Robert Laurent and Bernard Karfiol purchase folk art objects.

New York
Elie Nadelman creates wooden figures with simplified carving, outline, and color similar to folk sculpture.

Nadelman, *Woman at the Piano*

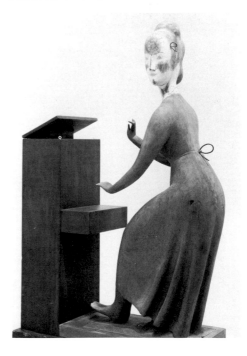

Museum of the American Indian founded.

1917 Leiden
De Stijl movement and periodical founded by Theo van Doesburg, Piet Mondrian, and others. Their first manifesto, published the following year, calls for "international unity in life, art, and culture."

Paris
Sergey Pavlovich Diagilev stages Erik Satie's *Parade*, with sets and costumes by Picasso, at the Théàtre du Chatelet.

GENERAL
Outbreak of Russian revolution.

United States enters First World War.

1918 Moscow
Schukin and Morozov collections of modern French art are nationalized.

Hartford
Albert Hastings Pitkin publishes *Early American Folk Pottery Including the History of the Bennington Pottery*.

New York
Architect Joel Barber begins collecting decoys.

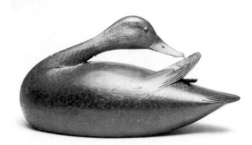

cat. 35, Crowell, *Black Duck*

Washington, D.C.
Migratory Bird Treaty ends all shorebird shooting and all trade in wildfowl. Market-gunning era ends, and decoy factories go out of business. Ornamental decoys become ever more important.

GENERAL
Armistice treaty ends First World War.

1919 Berlin
Mies van der Rohe embarks on first projects for glass skyscrapers.

Moscow
"Fifth State Exhibition of the Trade Union of Artist-Painters of the New Art: From Impressionism to Non-objectivity" one of twenty-one state exhibitions through 1921; underscores links between art and industry.

Weimar
Bauhaus founded by Walter Gropius. First Bauhaus proclamation: "A Guild of Craftsmen without Class Distinction."

Buffalo
Allen Eaton organizes the first of approximately thirty exhibitions on traditional crafts. Eaton will treat objects within a social and cultural context, rather than judging aesthetic merit. He will continue to organize such exhibitions until 1932.

New York
Elie Nadelman marries Viola (Mrs. Joseph A.) Flannery, a collector of European embroideries.

Max Eastman publishes *Education and Art in Soviet Russia in Light of Official Decrees and Documents*, while John Reed's *Ten Days that Shook the World* provides a first-hand account of the Russian revolution.

1920 Berlin
Dada fair. As an artistic and literary phenomenon, dada began in Zurich in 1916. By the end of the First World War there are dadaist groups in Paris, Berlin, and New York. Attacking traditional notions of aesthetic form, dadaists will hail industrially manufactured "found objects" as works of art.

Moscow
Vladimir Tatlin and others publish statement, "The Work Ahead of Us," on uniting art with utilitarian intentions.

Paris
Piet Mondrian's *Le Neoplasticism* published. He begins to apply principles he started developing in 1917 to his own studio environment.

Le Corbusier and Amédée Ozenfant start *L'esprit nouveau*, a periodical that articulated principles of purism, a variant of cubism characterized by architectural simplicity, machinelike contours and volumes, and unmodulated color. They exhibit paintings the following year.

New York
Hamilton Easter Field launches *Arts Magazine*.

Karfiol, *Making Music*

By 1920, artists involved in the Ogunquit circle include Wood Gaylor, Marsden Hartley, Stefan Hirsch, Bernard Karfiol, Yasuo Kuniyoshi, Niles Spencer, and William Zorach. These painters take comfort and inspiration from American folk art as they struggle to break away from academic representational and impressionist tendencies of late nineteenth-century art.

GENERAL
Washington, D.C.
Nineteenth Amendment grants American women the right to vote. Prohibition goes into effect.

1921 Syosset, Long Island
Electra Havemeyer Webb and her husband, J. Watson Webb, sell Woodbury House, a gabled Tudor mansion built and decorated for them by their mothers, Louisine Elder Havemeyer and Lila Vanderbilt Webb. They move to a smaller farmhouse in Westbury. Electra proceeds to furnish the second house with Americana, described by Louisine as "American trash."

Moscow
Principles of Russian constructivism first published. Artists Alexandre Rodchenko and Lloubovi Popova work in industry and applied art.

Boston
Ethel Bolton and Eva Coe write *American Samplers* for the Massachusetts Society of the Colonial Dames in America.

New York
Civic Club exhibits Russian posters.

1922 Berlin
First showing of constructivist works outside Russia.

Weimar
Wassily Kandinsky joins Bauhaus as Form Master for wall painting workshop.

New York
The Magazine Antiques publishes first issue.

Ogunquit, Maine
On his death, Hamilton Easter Field bequeaths Ogunquit properties to fellow folk art collector Robert Laurent.

GENERAL
Rome
Benito Mussolini forms fascist government.

1923 Moscow
From Easel to Machine, essay on avant-garde painting, published by critic Nikolai Tarabukin.

Paris
De Stijl architects exhibited at Galerie L'Effort Moderne. James Joyce publishes *Ulysses;* his use of slang and mundane detail shocks some readers.

Petrograd
Last Russian exhibition to include nonobjective art.

Brooklyn
Brooklyn Museum exhibits "Contemporary Russian Paintings and Sculpture" and "Congo Art."

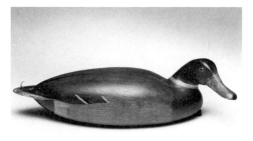

cat. 36, Wheeler, *Mallard Drake*

Bellport, Long Island
Joel Barber's decoy collection exhibited. First of a number of annual decoy exhibitions organized by sportsmen. "Shang" Wheeler's mallard decoy wins grand championship award.

New York
Wassily Kandinsky's first one-man show in America presented by the Société Anonyme.

Nadelman folk art museum

Riverdale-on-Hudson, New York
From now until 1928, Elie and Viola Nadelman collect folk art they will use for a museum built between 1924 and 1926 on their estate. They gather 15,000 European and American objects sharing a common craft background, including paintings, sculpture, wagons, sleighs, furniture, rugs, ceramics, dolls, and religious items.

Worcester
Worcester Art Museum exhibits *Mrs. Freake and Baby Mary* (c. 1674). Director Raymond Henniker-Heaton praises the artist's "unconscious" nonacademic skills.

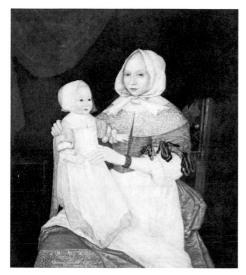

Mrs. Freake and Baby Mary

1924 Paris
Toward Plastic Architecture summarizes Theo van Doesburg's notion of architecture as synthesis at the expense of painting and sculpture as independent categories. André Breton publishes the first surrealist manifesto.

Lovelock Cave, Nevada
Archeologists discover canvasback decoys more than 1,000 years old.

New York
"Early American Art," held at the Whitney Studio Club, introduces American folk art to the New York public. Organized by painter Henry Schnackenberg, the exhibition includes loans from both artists and early private collectors. Three illustrations in the eight-page catalogue are photographs by Charles Sheeler. Categories of art are eclectic.

Dealer interest in folk art evident with Valentine Dudensing's exhibition of "Early American Portraits and Landscapes." Most belong to his client Robert Laurent.

Modern Russian art exhibited at the galleries of the Société Anonyme.

George Gershwin performs *Rhapsody in Blue*, with its references to popular music.

1925 Dessau
Bauhaus moves into new buildings designed by Walter Gropius.

Paris
"Exposition Internationale des Arts-Décoratifs et Industriels Modernes." Le Corbusier presents his "Pavillion de l'Esprit Nouveau." United States declines to participate because "there is no modern design in America."

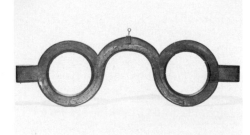

Magritte, *Ceci n'est pas une pipe*, compared with cat. 9, *Optician's Sign*

Surrealist painters' first group exhibition at Galerie Pierre.

New York
Fernand Léger exhibited at the Anderson Galleries under the aegis of the Société Anonyme.

Ogunquit, Maine
Edith Gregor Halpert, wife of painter Sam Halpert, encounters folk art furnishings during a summer visit.

Phillips, *Wife of the Journalist*, The Art Museum, Princeton University, gift of E. D. Balken

United States
Active private collectors of folk art during the 1920s include Eleanor and Mabel Van Alstyne, and Edward Duff Balken, a Princetonian who served as curator of prints at the Carnegie Institute between 1915 and 1935.

1926 Brooklyn
Société Anonyme exhibition of 300 modern works at the Brooklyn Museum. Widespread reviews pay most attention to constructivist abstraction.

Cambridge, Massachusetts
Isabel Carleton Wilde becomes first dealer to market "American primitives."

EXHIBITION OF AMERICAN PRIMITIVES
Beginning November 1st
ISABEL CARLETON WILDE announces an important exhibition of American Primitives including paintings on velvet and glass, portraits in oil, water colors, pastels, and tinsels. Many of these are in their original old frames.
20 SOUTH STREET *formerly* MARSH LANE
between Boylston and Dunster Streets
CAMBRIDGE *Telephone* PORTER 2285 MASSACHUSETTS

Wilde advertisement from *Antiques*, 1926

New York
Works by Piet Mondrian are exhibited in the United States through the efforts of Katherine Dreier at "Société Anonyme Internationale."

Ogunquit, Maine
Holger Cahill and Edith Halpert visit Ogunquit. Cahill, a contemporary art curator, and Halpert, who opens her "Downtown Gallery" this year, becoming a powerful dealer in contemporary art, will popularize the notion of collecting and appreciating American folk art on an aesthetic basis. Their impact parallels that of Oscar Wilde as a popularizer of aesthetic movement ideas forty-five years earlier.

Williamsburg
Colonial Williamsburg founded.

1927 Stuttgart
Die Wohnung, an international architecture exhibition, initiates public acceptance of the international style. Vernacular architecture will suffer neglect for almost half a century. Much of it will be lost to the wrecker's ball.

Bloomfield Hills, Michigan
Cranbrook Academy of Art founded.

New York
Juliana Force presents a loan exhibition of folk art from the Wilde collection at the Whitney Studio Club.

Homer Eaton Keyes, editor of *The Magazine Antiques*, looks at folk art "from the perspective of someone conditioned to look at modern art," and argues for aesthetic evaluation.

A. E. Gallatin opens Gallery of Living Art at New York University. Collection includes about seventy modern French works, by Picasso, Braque, Juan Gris, and Léger.

At the "Machine-Age Exposition," machines, industrial products, photography, painting, sculpture, and architecture are displayed in an ordinary commercial building.

Le Corbusier's *Vers un Architecture* published in English.

New York to London: First commercial transatlantic telephone service begins.

New York to Paris: Charles Lindbergh makes first solo transatlantic flight.

New York to Washington: First experimental television transmission.

1928 Brooklyn
The American chapter of the International Commission on Folk Arts, under the auspices of the League of Nations, created to document, preserve, and exhibit traditional folk arts and crafts in order to foster better understanding among people of all nations. Their first congress is held in Prague this year.

New York
Abby Aldrich Rockefeller visits Edith Halpert's Downtown Gallery. Mrs. Rockefeller's interest in modern art precedes her aesthetic approach to folk art.

Edward and Faith Andrews publish "The Furniture of An American Religious Sect," in *The Magazine Antiques*, as the first of many articles and books that will firmly establish an aesthetic, design-oriented approach to the study of Shaker objects.

R. H. Macy and Company organizes "The First International Exposition of Art in Industry." Several other department stores mount similar exhibitions.

1929 Barcelona
Mies van der Rohe's German Pavilion for World's Fair establishes his reputation on an international scale.

Dearborn, Michigan
Henry Ford Museum opens.

New York
Edith Halpert adds folk art to the modern paintings for sale at her Downtown Gallery. Abby Aldrich Rockefeller is among her early customers.

Abby Aldrich Rockefeller and others found Museum of Modern Art.

GENERAL
New York
Stock market crash: depression will ensue. The Great Depression fosters regionalism in American painting and isolationism in American politics.

1930 Dessau
Mies van der Rohe appointed director of Bauhaus.

Cambridge, Massachusetts
Harvard undergraduates Lincoln Kirstein, Edward Warburg, and John Walker stage an "Exhibition of American Folk Painting in Connection with the Massachusetts Tercentenary Celebration" at Harvard Society of Contemporary Art. The objects chosen for the exhibition are eclectic, an indication that rigid categories of folk art have not been established. The organizers believe that folk art has "valid and direct links with contemporary art."

Wood, *American Gothic*

Cedar Rapids, Iowa
Grant Wood paints *American Gothic*, which will become an icon of the regionalist painters.

Newark
Cahill's exhibition, "American Primitives: An Exhibit of the Paintings of Nineteenth-Century Folk Artists," at

the Newark Museum. Objects are chosen on an aesthetic basis, and Cahill understands the word "primitive" to mean nonacademic. Parts of exhibition travel the next year to Rochester, Chicago, and Toledo.

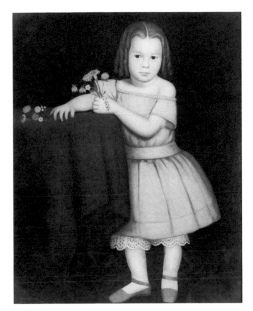

Girl with Flowers, Newark Museum

New York
Whitney Museum of American Art founded.

Winterthur, Delaware
Henry Francis DuPont Winterthur Museum founded.

1931 Paris
Deliberations of the First International Congress of Folk Art (Prague, 1928) published as *Art Populaire*. Henri Focillon's introduction identifies all the approaches to folk art that will be used over the next half century.

Chicago
James Johnson Sweeney organizes "Modern Primitives" for the Renaissance Society at the University of Chicago. Sweeney focuses upon plastic or structural design elements shared by "primitive" arts.

Newark
"American Folk Sculpture: The Work of 18th and 19th Century Craftsmen" exhibited at the Newark Museum. Holger Cahill again takes

a subjective, aesthetic approach to almost 200 objects. This exhibition establishes most of the categories accepted as folk sculpture today: figureheads, trade signs, cigar-store Indians, weather vanes, decoys, toys, various animal carvings, pottery and plaster ornaments, stone carving, and cast iron.

New York
Edith Halpert opens the American Folk Art Gallery, the first to deal exclusively with folk art. Objects are chosen "not because of . . . antiquity, historical association, utilitarian value, or the fame of the makers, but because of their definite relationship to vital elements in contemporary American art."

Social realism flourishes, characterized by pictures of downtrodden, socially and economically disadvantaged people.

Constance Rourke publishes *American Humor: A Study of the National Character*, a pioneering study dealing with the role of folklore in American culture, including the popular stage.

Poland Spring, Maine
The Shaker Museum founded.

Woodmere, New York
November issue of *Creative Art* devoted to a discussion on the possible existence of a discernible "American art." Some see folk art as evidence of a "native stamp," but no agreement is reached.

1932 **New York**
Holger Cahill becomes acting director of the Museum of Modern Art. In the first exhibition to cover both painting and sculpture extensively, Cahill sets the standard definition for folk art as an "expression of the common people, made by them and intended for their use and enjoyment." Although Cahill believes that folk art came from a craft rather than an academic or fine art tradition, his show codifies unstated aesthetic standards regarding folk art. These standards will be canonized through imitation in other exhibitions.

Allen Eaton publishes *Immigrant Gifts to American Life: Some Experiments in Appreciation of the Contributions of Our Foreign Born Citizens to American Culture*. The book chronicles his exhibitions of traditional crafts and culture, including costumes, music, and dance. Eaton sees folk art as an ongoing tradition, and he includes many twentieth-century items in his shows.

After lending pieces to early exhibitions of folk art, Isabel Carleton Wilde sells much of her collection.

Edith Halpert begins annual theme exhibitions of folk art, which are presented at her American Folk Art Gallery until 1967.

Joel Barber publishes *Wild Fowl Decoys*. Book is reissued in 1934.

Walter Rendell Storey, "Native Arts from Old Shaker Colonies. A Distinct Style of American Furniture Which Has Interest for Our Times," *New York Times Magazine* (23 October 1932).

Henry-Russell Hitchcock and Philip Johnson publish *The International Style: Architecture since 1922*.

Sheffield, Massachusetts
Inspired by Edward Duff Balken, J. Stuart Halladay and Herrel G. Thomas, co-owners of an antique shop, begin to collect folk portraits, landscapes, and genre scenes.

Winterthur, Delaware
Henry Francis DuPont is actively collecting Pennsylvania German materials.

1933 **Dessau**
Hitler closes Bauhaus.

Chicago
"Century of Progress Exposition."

New York
At the Museum of Modern Art, Holger Cahill organizes "American Sources of Modern Art," showing Mexican and Central and South American materials.

Philadelphia
"The Art of Soviet Russia" exhibited.

Springfield, Massachusetts
"Primitivism" as an art historical term first appears in *Webster's Dictionary*.

Washington, D.C.
Smithsonian's National Gallery of Art mounts "Exhibition of Work by Negro Artists," one of many such shows throughout the United States during the 1930s and 1940s.

Public Works of Art Project, through June 1934.

United States
Holger Cahill's "Art of the Common Man" circulated by the Museum of Modern Art to six cities, through 1934.

GENERAL
Washington, D.C.
Franklin Delano Roosevelt's first "fireside chat."

1934 **New York**
Museum of Modern Art exhibits "Religious Folk Art of the Southwest" and "Machine Art."

Washington, D.C.
Treasury Section of Fine Arts, dedicates 1% of each new federal building budget for art as embellishment. Program lasts through 1943.

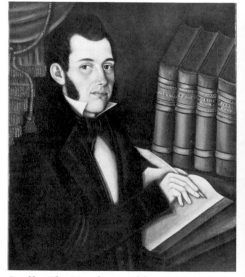

Crafft, *The Merchant*, Abby Aldrich Rockefeller Folk Art Center, Williamsburg

Southern United States
Holger Cahill goes south at Abby Aldrich Rockefeller's request, making the first regional folk art survey.

1935 **Boston**
Maxim Karolik begins assemblage of American decorative arts; his collection, which eventually includes non-academic paintings, will be donated to Museum of Fine Arts, Boston.

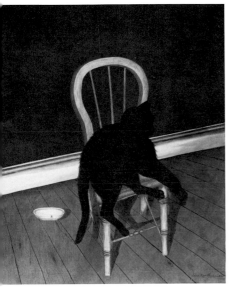

Belle of Bath, watercolor of figurehead, Index of American Design

von Wittkamp, *Black Cat on a Chair*, Karolik bequest, Museum of Fine Arts, Boston

Hartford
Abstract art shown at Wadsworth Atheneum.

New York
Whitney Museum of American Art exhibits Shaker furniture and spirit drawings.

Museum of Modern Art shows "African Negro Art," stressing the aesthetics of tribal art at a time when it was usually treated as ethnology.

Carrie A. Hall and Rose G. Kretsinger publish *The Romance of the Patchwork Quilt in America*.

Gershwin's *Porgy and Bess* unites "popular" and "serious" music.

Washington, D.C.
Federal Art Project established under Holger Cahill. The largest of the New Deal art programs, it was conducted between 1935 and 1941,

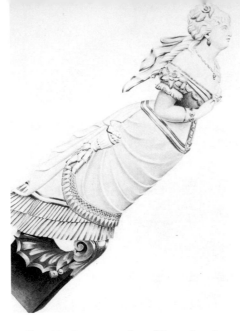

providing work for hundreds of artists. Also included the Index of American Design, which eventually compiled more than 17,000 watercolor illustrations, many of American folk art objects. Eventually these watercolors will be housed in the National Gallery of Art.

Williamsburg
Portion of Abby Aldrich Rockefeller folk art holdings lent to Colonial Williamsburg. Docent training emphasizes aesthetics.

1936 **London**
Nikolaus Pevsner publishes *Pioneers of Modern Design from William Morris to Walter Gropius*.

Brooklyn
Federal Art Project invited to do murals for lower-middle-income housing project.

New York
First American Artists' Congress. Meyer Schapiro gives address on "The Social Bases of Art."

Museum of Modern Art exhibits "Cubism and Abstract Art: painting, sculpture, constructions, photography, architecture, industrial art, theatre, films, posters, typography."

"Fantastic Art, Dada and Surrealism" at the Museum of Modern Art

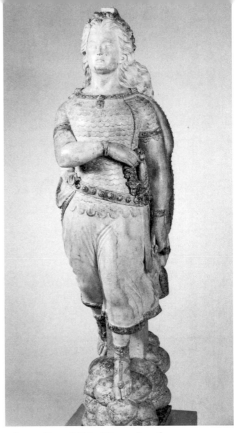

cat. 13, *Brunhilda Figurehead*

includes Joseph Cornell's small boxes containing Victorian bibelots and other snippets of popular art. Cornell will continue making such boxes into the 1960s.

GENERAL
Spanish Civil War breaks out; will engage the sympathies of many artists and writers.

1937 **Chicago**
New Bauhaus in America, led by Laszlo Moholy-Nagy, opens; it survives one year. Reopens in January 1939 as the School of Design. Affiliates with the Illinois Institute of Technology in 1949.

New York
Electra Havemeyer Webb becomes a client of Edith Halpert, purchasing folk art sometime in the late 1930s.

Museum of Modern Art presents "Prehistoric Rock Pictures in Europe and Africa"; will have subsequent impact on abstract painters.

American Abstract Artists, a group still existing today, holds its first exhibition at Squibb Galleries.

199

Edward and Faith Andrews publish *Shaker Furniture*. Georgiana Brown Harbeson publishes *American Needlework*.

Riverdale-on-Hudson, New York
Elie and Viola Nadelman dispose of their folk art collection. Many pieces are sold to Abby Aldrich Rockefeller and to the New-York Historical Society.

1938 **Los Angeles**
"Tail O' the Pup" appears on La Cienega Boulevard. This hotdog stand typifies a blend of architecture and popular culture in buildings shaped like objects that dot America's roadways during the 1920s, 1930s, and 1940s.

"Tail o' the Pup," Los Angeles

New York
Robert Goldwater publishes *Primitivism in Modern Painting*. Avoids unfounded connections between the efforts of modern artists and primitive arts, and sets "primitivism" within the context of modern Western art history.

Bauhaus exhibition at the Museum of Modern Art.

"Masters of Popular Painting: Modern Primitives in Europe and America" at the Museum of Modern Art completes a series of three shows intended to "present some of the major movements or divisions of modern art."

Sturbridge, Massachusetts
Old Sturbridge Village, an outdoor village museum, is founded.

United States
American Abstract Artists send survey exhibitions to several midwestern museums, and hold their second annual exhibition in New York.

1939 **Cambridge, Massachusetts**
Harvard University founds first American Studies program. Yale University, Boston University, and others will follow. During the next decades, academics will battle over the legitimate "territory" of this new discipline.

New York
Opening of the Museum of Non-Objective Art (eventually the Guggenheim Museum). Meanwhile, the outbreak of Second World War in Europe brings dozens of artists, writers, and other intellectuals to the United States. New York soon becomes a focus of artistic experiment and a magnet for young American artists.

Preoccupation with streamlining dominates the World's Fair, "The World of Tomorrow."

Williamsburg
Abby Aldrich Rockefeller Folk Art Center founded. Colonial Williamsburg receives principal part of her folk art collection; the rest is dispersed.

The Quilting Party, Abby Aldrich Rockefeller Folk Art Center, Williamsburg

1940 **Harvard, Massachusetts**
Clara Endicott Sears' collection of New England portraits, many of them in the folk tradition, exhibited at Fruitlands Museum.

New York
Pauline A. Pinckney publishes *American Figureheads and Their Carvers*, including over 800 names.

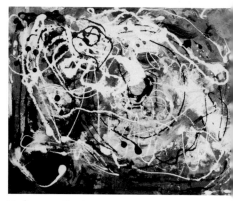

Hofmann, *Spring*

Piet Mondrian arrives. Hans Hofmann flings and drips pigments in his painting *Spring*, heralding the advent of "action painting."

1941 **Boston**
Clara Endicott Sears publishes *Some American Primitives: A Study of New England Faces and Folk Portraits*, the first book to study the signatures of little-known American primitive painters.

New Haven
Yale University accepts the collection of the Société Anonyme. The next year, Yale presents the first of many exhibitions of this material.

New York
"Indian Art of the United States" shown by the Museum of Modern Art.

In this year and the next, Edith Halpert's Downtown Gallery exhibits art by black Americans.

GENERAL
Pearl Harbor bombed by Japan; United States enters Second World War.

1942 Cooperstown, New York
The Farmer's Museum, an outdoor village, is founded.

New York
Sidney Janis caps a decade of searching for "naive" American equivalents to Henri Rousseau with the exhibition *They Taught Themselves*.

Jean Lipman publishes *American Primitive Painting*, judging the works on an aesthetic basis. During the 1930s and 1940s, Mrs. Lipman is a significant early collector as well as a writer. Many of her pieces will eventually go to the New York State Historical Association in Cooperstown.

Peggy Guggenheim opens her gallery, Art of This Century. Between 1943 and 1946, Jackson Pollock, Hans Hofmann, Robert Motherwell, Clifford Still, and William Baziotes are among the abstract expressionists exhibited.

1943 New York
James A. Porter publishes *Modern Negro Art*, pointing out contributions to American art by slave artists and craftsmen.

Philadelphia
Philadelphia Museum of Art accepts Gallatin collection of modern French painting.

1944 Pokety Farms, near Cambridge, Maryland
Edgar William and Bernice Chrysler Garbisch begin collecting folk art paintings.

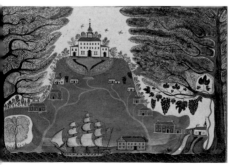

The Plantation, Garbisch gift to the Metropolitan Museum of Art

1946 New York
Museum of Modern Art exhibits "Arts of the South Seas," taking an aesthetic rather than ethnographic approach to the material, and sponsors a "Conference on Industrial Design, a New Profession."

1947 New York
Jackson Pollock pours paint on canvases spread out on the floor, beginning a long series of "drip" paintings. The first generation of abstract expressionists will be romanticized as cultural heroes.

Jackson Pollock

Shelburne, Vermont
Shelburne Museum established. Based on Electra Havemeyer Webb's collections, the museum combines the "outdoor village" with gallery exhibitions of folk art. By the mid-1950s, it comprises more than three dozen historic structures, all but seven of them moved to the site.

1948 Bloomington, Indiana
First American Folk Life program begins at Indiana University.

Cooperstown, New York
Louis C. Jones, the "folklorist of folk art," applies the methodologies of folklore to folk art when New York Historical Association begins seminars on American art and culture.

Newark
Catalogue published, *Quilts and Counterpanes in the Newark Museum*.

New York
Jean Lipman publishes *American Folk Art in Wood, Metal and Stone*.

John Kouwenhoven publishes *Made in America*, arguing for a distinctive American vernacular aesthetic as seen in native folk art.

1949 New York
The Museum of Modern Art organizes its first annual "Good Design" exhibition. These will continue until 1955.

Allen Eaton publishes *Handicrafts of New England*.

Life Magazine features Jackson Pollock, making the avant-garde artist a cultural hero.

1950 New York
Alice Winchester, editor of *The Magazine Antiques*, conducts forum, "What is American Folk Art?" No clear definition emerges.

Whitney Museum of American Art deaccessions many of the sixty-four folk art paintings from collection formed by Juliana Force, an early director of the museum.

Allen Eaton publishes *Handicrafts of the Southern Highlands*.

Washington, D.C.
National Gallery of Art publishes Erwin O. Christensen's *Index of American Design*, stimulating fresh interest in American folk art.

GENERAL
Korean War (through 1953).

1951 New York
The Museum of Modern Art exhibits "Abstract Painting and Sculpture in America," affirming abstract expressionism as the dominant movement in American art for the next decade.

Winterthur, Delaware
Henry Francis DuPont's Winterthur Museum opens to the public.

1952 Deerfield, Massachusetts
Historic Deerfield founded.

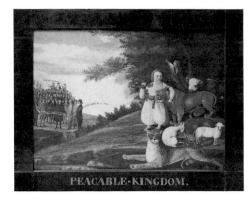

Hicks, *Peaceable Kingdom*

Philadelphia
Alice Ford publishes *Edward Hicks, Painter of the Peaceable Kingdom*.

Shelburne, Vermont
Electra Havemeyer Webb purchases approximately 1,000 decoys from Joel Barber estate.

Wilmington
Hagley Museum and Library founded.

1953 **Chicago**
A. W. Prendergast and W. Porter Ware publish *Cigar Store Figures in American Folk Art*.

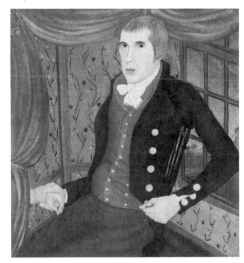

Dr. Philemon Tracy, Garbisch gift to the National Gallery of Art

1954 **Washington, D.C.**
National Gallery of Art mounts the first of two exhibitions of the Edgar William and Bernice Chrysler Garbisch collection. Mr. and Mrs.

Garbisch, with nine coauthors, discuss their collection of "American Primitive Painting" in a special issue of *Art in America* 42 (May 1954).

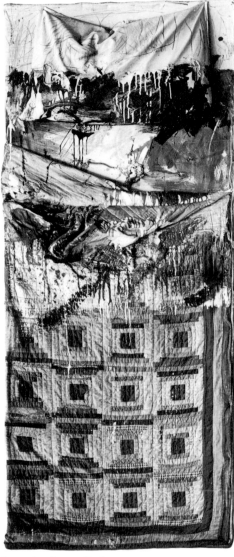

Rauschenberg, *Bed*

1955 **New York**
Robert Rauschenberg completes series of "combines" begun in 1953, paintings with three-dimensional objects attached to their surfaces. In *The Bed*, 1955, a real quilt and pillow are splashed with paint in the manner of abstract expressionism.

Shelburne, Vermont
Richard Moeller decoy collection acquired by Shelburne Museum; and a 220-foot steamboat, the

Ticonderoga, is moved almost two miles from Lake Champlain to its resting place on the lawn of Shelburne Museum.

1956 **London**
English artist Richard Hamilton, disciple of arch-dadaist Marcel Duchamp, creates a small collage, *Just What Is It That Makes Today's Home So Different, So Appealing?* An apartment is crammed with the products of mass culture, including a comic book cover framed as a painting and hung next to a nonacademic portrait. A body-builder hoists an outsize sucker labeled "pop." By 1957, critic Lawrence Alloway has coined the term "pop art" to refer to the products of the mass media.

New York
American Craft Museum founded.

1957 **Washington, D.C.**
National Gallery of Art's second installation of paintings from the Garbisch collection.

Williamsburg
Nina Fletcher Little publishes catalogue of Rockefeller folk art collection.

GENERAL
Russian satellite *Sputnik* orbits the earth.

1958 **Cooperstown, New York**
Dealer Mary Allis sells 175 pictures from the collection of Mrs. William J. Gunn, started in the mid-1930s, to the New York Historical Association.

Princeton
Edward Duff Balken presents his folk art collection to Princeton University.

Provincetown
Here and at Rutgers University in New Jersey, the first "happenings" are staged by Red Grooms and Alan Kaprow. By 1959, New York will become the center for this participatory art form, combining planned and spontaneous theatrical events, art objects, and everyday items.

San Francisco
Bruce Connor brings an assemblage aesthetic to filmmaking when he

releases *A Movie*, consisting of found footage taken from feature films, television commercials, and documentaries.

Shelburne, Vermont
Edward H. Mulliken decoy collection added to Shelburne Museum.

Williamsburg
Colonial Williamsburg buys the Halladay-Thomas collection of folk art. At a Colonial Williamsburg Antiques Forum, Electra Havemeyer Webb delivers a talk on the development of the Shelburne Museum.

1959 Portsmouth, New Hampshire
Strawbery Banke founded.

1961 New Haven
George Kubler publishes *The Shape of Time*, arguing for expansion of the concept of "art" to include all man-made objects.

New York
Museum of American Folk Art founded, firmly institutionalizing the aesthetic approach to folk art.

Alice Winchester compares folk art with contemporary modern art in "Antiques for the Avant Garde," *Art in America* 49 (April 1961), 64–73.

Pop art emerges as a movement during the winter exhibition season.

1963 Wuppertal, West Germany
In "Exposition of Music—Electronic Television," Nam June Paik appropriates a popular medium, TV, for fine art.

New York
Efforts to determine national characteristics of art continue as Jean Lipman edits *What Is American in American Art*. Nikolaus Pevsner had published *The Englishness of English Art* in 1956.

GENERAL
Dallas
Assassination of President John F. Kennedy.

Washington, D.C.
Freedom March draws 200,000 people in support of civil rights.

1964 GENERAL
Tonkin Gulf Resolution heralds full-scale involvement of the United States in the Viet Nam War.

1965 Cooperstown, New York
Graduate Programs in Museum Studies and American Folklore and Folklife begin.

New York
The Museum of Modern Art presents "The Responsive Eye," introducing "op art," whose dynamic visual devices were seen as a development of geometric abstraction. Textile scholars will make comparisons between op art and geometric quilts: for instance, Jonathan Holstein, "Abstract Design in American Quilts," organized for the Whitney Museum of American Art.

Vasarely, *Zebegen*

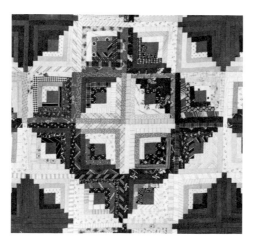

cat. 106, *Log Cabin Quilt*, detail

Washington, D.C.
"The Art and Spirit of a People," folk art from the Eleanor and Mabel Van Alstyne Collection, exhibited at the Smithsonian Institution's Museum of History and Technology, which acquires the collection.

1966 Austin
Norbert F. Riedl observes the European model for "folklife studies," and argues for a broader interpretation of "folklore" in "Folklore and the Study of Material Aspects of Folk Culture," *Journal of American Folklore* 79 (1966), 557–563.

New York
Mary Black and Jean Lipman publish *American Folk Painting*.

Minimalist sculptor Robert Morris advocates a "nonart" appearance for industrially fabricated art.

1968 Pokety Farms, near Cambridge, Maryland
Edgar William and Bernice Chrysler Garbisch choose "naive" as adjective for their collection, which eventually numbers 2,600 works. They deaccession their Fraktur paintings.

New York
"Country Furniture: A Symposium" attempts a definition in *The Magazine Antiques* 43 (March 1968), 342–371.

1969 New Haven
Robert Farris Thompson publishes "African Influence on the Art of the United States" in *Black Studies in the University*.

New York
"Harlem on My Mind, Cultural Capital of Black America, 1900–1968," an exhibition of photographs and ephemera at The Metropolitan Museum of Art, provokes stormy controversy.

Philadelphia
Henry Glassie publishes *Pattern in the Material Folk Culture of the Eastern United States*.

GENERAL
Americans walk on the moon.

Smithson, *Spiral Jetty*

1970 Great Salt Lake, Utah
Sculptor Robert Smithson completes the 1500-foot-long *Spiral Jetty*. His coil addresses primitivist tendencies in earthworks and minimal art.

New York
Superrealist painter John Baeder is collecting antique postcards. During the 1970s, he creates a long series of paintings of diners and other roadside stands, continuing his lifelong interest in vernacular architecture and mass culture.

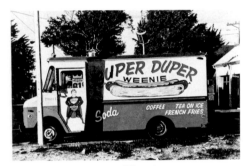

Baeder, *Super Duper Weenie*

1972 Kassel, West Germany
"Dokumenta 5" brings worldwide attention to superrealism, earthworks, and performance art.

Cambridge, Massachusetts
Robert Venturi, Denise Scott Brown, and Steven Izenour publish *Learning from Las Vegas*, a call for architects to be more receptive to tastes and values of "common" people. Advent of post-modernism.

New York
Museum of Modern Art displays "African Textiles and Decorative Arts."

Whitney Museum of American Art shows "Two Hundred Years of North American Indian Art."

Lady Madonna, by Audrey Flack, typifies a new wave of realist painting; folk objects, popular culture, and everyday scenes are favored subjects.

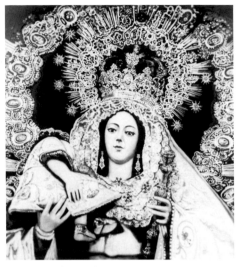

Flack, *Lady Madonna*

San Francisco
Center for Folk Art and Contemporary Crafts opens. Reorganized as San Francisco Crafts and Folk Art Museum in 1973.

Washington, D.C.
Smithsonian Institution opens the Renwick Gallery to display contemporary crafts.

1974 Minneapolis
"Naives and Visionaries" at the Walker Art Center features eccentric grass-roots artists of the twentieth century.

New York
The Flowering of American Folk Art exhibition at the Whitney Museum of American Art, with installation by Marcel Breuer, culminates decades of interest in northeastern folk art seen from an aesthetic viewpoint.

"American Pop Art" shown at the Whitney Museum of American Art.

Santa Fe
Elizabeth Boyd's *Popular Art of Spanish New Mexico* identifies *santeros* and dates some of their work.

GENERAL
Washington, D.C.
Resignation of President Richard M. Nixon.

1975 Berkeley
Michael Owen Jones publishes *The Hand Made Object and Its Maker*, questioning long-accepted assumptions about style, periodicity, cultural evolution, diffusion.

New York
Jean Lipman publishes *Provocative Parallels: Naive Early Americans/International Sophisticates*.

1976 Brooklyn
"American Folk Sculpture," organized by collector-curator Herbert Waide Hemphill, Jr., for the Brooklyn Museum. Helps popularize the concept of twentieth-century folk art. Daniel Robbins provides insightful historiography of the relationship between folk art and early twentieth-century modern art. According to historian Beatrix Rumford, this is just one of fifty significant exhibitions to be staged in the late 1970s and early 1980s.

Knoxville
Henry Glassie publishes *Folk Housing in Middle Virginia: A Structural Analysis of Historic Artifacts*.

New York
"200 Years of American Sculpture" at the Whitney Museum of American Art includes a large selection of folk art.

United States
America's Bicentennial encourages interest in regional folk art. Surveys (Michigan Folk Art Project) and exhibitions ("Folk Art in Oklahoma," 1981) document material culture.

1977 Chadds Ford, Pennsylvania
Brandywine River Museum exhibits "Beyond Necessity: Art in the Folk Tradition." Objects are drawn from the DuPont collection at Winterthur. Kenneth Ames' catalogue essay

shocks the folk art world by debunking long-cherished notions of an American folk art supposedly characterized by individuality, national uniqueness, and cultural innocence.

New Haven
Robert F. Trent, *Hearts and Crowns: Folk Chairs of the Connecticut Coast 1710–1840 as Viewed in the Light of Henri Foçillon's Introduction to 'Art Populaire.'* Retains a basis for art historical qualitative judgment without denying the relevance of anthropological structuralist theory in regard to pattern and system.

Winterthur, Delaware
Three-day conference on American folk art held at Winterthur Museum. Folklorists do battle with aestheticians. Members of the field are left in doubt whether folk "art" exists or not; many encounter the methodologics of folklorists for the first time. Folk art becomes a troubled area of study, divided by factions. Findings of the conference are published by the Winterthur Museum as *Perspectives on American Folk Art* in 1980.

1978 **Cleveland**
The Cleveland Museum of Art exhibits "The Afro-American Tradition in Decorative Arts," with a catalogue essay by John Michael Vlach.

1979 **Ithaca**
E. H. Gombrich publishes *The Sense of Order. A Study in the Psychology of Decorative Art.* Investigates the creation and function of formal, decorative orders or patterns, noting, "the theory of twentieth-century abstract painting owes more to the debates on design that arose in the nineteenth-century than is usually allowed."

1981 **New York**
First cablecast MTV video. Music videos rely heavily upon references to past movies, advertising, and popular culture.

1982 **Nashville**
Henry Glassie's "Folk Art" attempts a definition from the folklorist's point of view in Thomas J. Schlereth, ed., *Material Culture Studies in America* (Nashville), 1982.

New York
Museum of American Folk Art exhibits "American Folk Art: Expressions of a New Spirit." Selection and presentation of objects perpetuates aesthetic ideas of the 1930s.

Winterthur, Delaware
Art historian Jules Prown attempts to make the methodologies of material culture accessible to art historians in "Mind in Matter: An Introduction to Material Culture Theory and Methods," *Winterthur Portfolio* 17 (1982), 1–19.

1983 **Washington, D.C.**
The Washington Meeting on Folk Art, sponsored by Folklife Center, Library of Congress. Their findings published as *Folk Art and Art Worlds*, ed. John Michael Vlach and Simon J. Bronner, Washington, D.C., 1986.

1986 **Hartford**
Wadsworth Atheneum publishes *The Great River: Art and Society of the Connecticut River Valley, 1635–1820.* Exhibition catalogue includes items that have, in the past, fallen under the rubric of "folk art."

Los Angeles
Los Angeles Municipal Art Gallery organizes "The Art Quilt."

New York
Museum of American Folk Art presents "Young America: A Folk Art History." Categories of folk art acknowledged in the catalogue include photographs and native American art, but concepts of the 1930s and 1940s dominate the text.

"Shaker Design" shown at the Whitney Museum of American Art.

"Craft Today: Poetry of the Physical" inaugurates new American Craft Museum. Objects include contemporary quilts and weather vanes.

Washington, D.C.
National Museum of American Art acquires Hemphill folk art collection of 378 objects, many of them twentieth-century pieces.

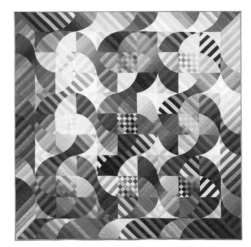

James, *Rhythm/Color: Bacchanal*

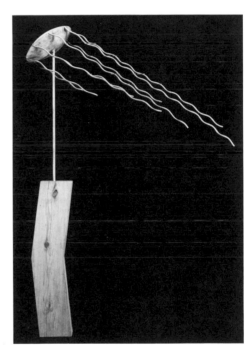

Bonner, *Weathervane #76*

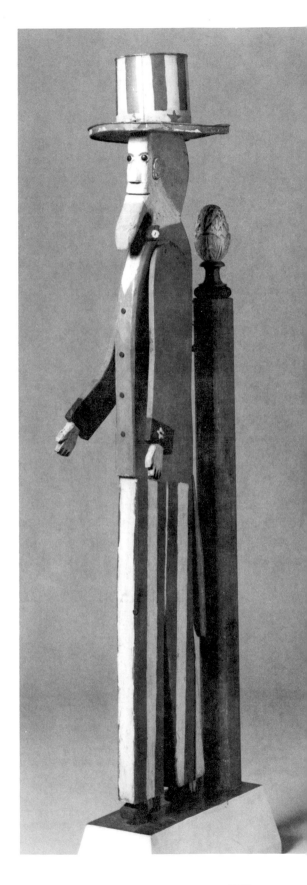

Uncle Sam, National Museum of American Art, from Hemphill Collection

Conservation Notes

RICHARD L. KERSCHNER

VALERIE J. REICH

DURING THE SUMMER OF 1985, a condition survey of the objects to be included in the exhibition was conducted by a student in the art conservation graduate training program at the State University of New York College at Buffalo. The survey established that many of the objects have painted or gilded surfaces. In addition, the objects share a multitude of conservation problems associated with deterioration of wood, metal, and paint. The treatment of these artifacts presented an excellent opportunity to study and conserve painted surfaces, research new conservation techniques, and develop an approach to the conservation of painted folk art in general. We approached several granting agencies with a proposal for a postgraduate internship in the conservation of objects with painted surfaces, and received funding from both the National Museum Act and the Samuel H. Kress Foundation. Additional funds were provided by the National Gallery of Art. Many of the artifacts included in this exhibition were conserved during this internship. The project yielded several new conservation techniques as well as material for future research.

At the Shelburne Museum, we have attempted to develop a flexible approach to folk art conservation that considers the artist's original intent as well as historically significant changes to the artifacts. A related aspect, the history of use, is also a major factor in determining a conservation treatment,
which is formulated through close examination of the object, technical research, curatorial assistance, and careful judgment. Folk art comprises decorative, functional, and even ethnographic artifacts, which fall into indistinct and often overlapping categories that may require different conservation approaches.

There is general agreement that structural consolidation to arrest deterioration and stabilize the object is the first priority of conservation treatment. This formed a major portion of the treatment of *Indian with Rifle* (cat. 51). The heavy, carved wooden figure was poorly attached to the metal-covered wooden base by iron rods that were weakened by extensive corrosion, and the figure was in danger of breaking off the base during even routine movement. Support strength for the heavy figure was improved by replacing the weakened iron rods with corrosion-resistant steel. Wood weakened by fungal attack was consolidated by impregnation with a synthetic resin. The right foot, a former restoration constructed of concrete, was replaced with a foot carved from wood. The figure was reattached to a strong base constructed from new materials. The original base completely covers the new support structure, but it no longer supports the weight of the figure. Although to this point in the treatment, the overall appearance of the figure was unchanged, its structural integrity was
greatly improved, allowing it to travel safely.

For years, many folk art objects have been viewed through films of grime or of varnish that has darkened through chemical change, resulting in colors that sometimes have been misinterpreted as authentic. With respect to the artist's original intent, it seems doubtful that colorful painted surfaces were meant to be obscured. The partially cleaned carousel *Goat* (fig. 1, and cat. 58) is from a demonstration model carousel made by Gustav Dentzel in 1902. As these figures were never used enough to require repainting, the paint is completely original. In a past effort to prevent the wood from drying out, linseed oil was applied to these carved animals. It is now known that linseed oil does little to prevent wood from drying and checking, but it does darken and chemically change with age, becoming very difficult to remove. In this case, the linseed oil treatment completely obscured the original bright, decorative colors, which were in excellent condition, and turned the subtly painted and shaded, highly individual animals into dark brown figures of similar appearance (fig. 2). Tests on the linseed oil film indicated that it could still be safely removed using solvent mixtures, so the decision to remove it completely was straightforward. The cleaned carousel goat (fig. 3) was coated with a synthetic varnish that does not darken, remains easily reversible, and protects the origi-

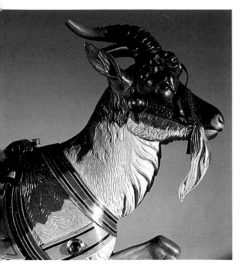

fig. 1 Detail of Dentzel carousel goat partially cleaned

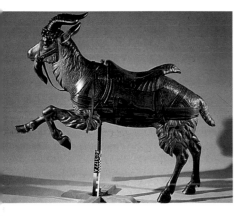

fig. 2 Dentzel carousel goat before cleaning

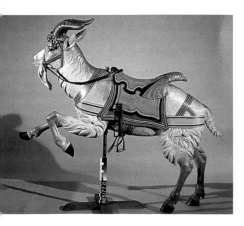

fig. 3 Dentzel carousel goat after cleaning

nal paint surface from deterioration due to abrasion and oxidation. The visible wear of the paint on the saddle and around the stirrups was considered part of the object's history of use and no retouching was deemed necessary.

Objects such as *George Washington on Horseback* (cat. 11) were treated by their owners as decorative, nonfunctional objects throughout their history. Such objects are usually conserved with careful regard for the artist's original intent. Here, the dark, greenish brown linseed oil film (fig. 4) was cleaned from the surface to reveal a colorful figure seated on a white horse (fig. 5). Close examination of the cleaned surface showed painted shadows outlining the pattern of a bridle and small fragments of leather attached to the horse's head and clenched in Washington's fist. Through research based on these traces of evidence, it was possible to determine the configuration of the original bridle. Without the bridle, the horse's head had appeared small and out of scale, and this distorted the overall appearance of the object. The addition of the bridle and reins allowed the horse's head to be reintegrated with the figure. Now that the proper visual balance between horse and rider has been reestablished, *George Washington on Horseback* more closely represents the artist's original intent.

An in-depth conservation treatment can offer an excellent opportunity for a thorough technical examination of an object. The x-radiograph of the *Spinning Woman Whirligig* (figs. 6 and 7, and see cat. 77) revealed construction techniques as well as old repairs. The figure was carved from blocks of wood that were doweled and glued together. The outdoor use of this object necessitated constant repairs with nails and

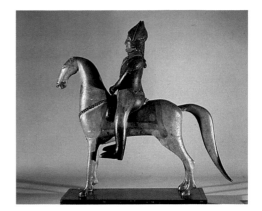

fig. 4 *George Washington on Horseback* before conservation

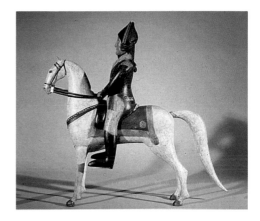

fig. 5 *George Washington on Horseback* after conservation

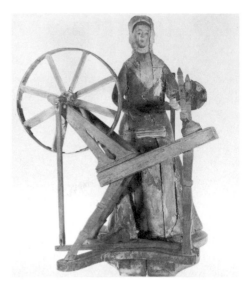

fig. 6 *Spinning Woman Whirligig* before treatment

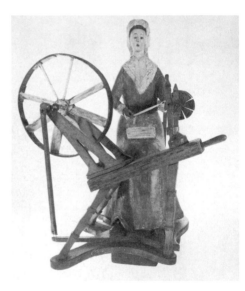

fig. 7 *Spinning Woman Whirligig* after treatment

screws. In addition, microscopic examination of a cross section of the paint indicated that the figure had been repainted twelve times. These layers are a valuable record of nineteenth-century paint (fig. 9). In the case of a trade sign, weather vane, or whirligig, the aged surface represents years of exposure to environmental factors such as sun, rain, wind, heat, and freezing temperatures. During conservation no effort was made to alter the weathered characteristics, which are considered historically significant. Instead, treatment of the *Spinning Woman Whirligig* focused on the structural stabilization of wooden parts, fabrication of missing structural elements, consolidation of the flaking paint layer, and minor surface cleaning.

Principles of conservation of ethnographic artifacts are often applicable to utilitarian folk art objects. For example, the painted surface of a decoy that was used in the field can contain valuable evidence of the object's history (fig. 10), in the form of gunshot holes, blood stains, or specific patterns of paint abrasion. Conservation treatment of working decoys focuses on structural stabilization and consolidation of flaking paint. Decisions concerning the removal of surface films and dirt are more difficult. If the dirt on the surface is the result of use in the field, it might not be removed. However, if the darkening surface is the result of aging oil or varnish applied by a collector or museum after the utilitarian life of the artifact has ended, removal is acceptable. In some cases, the appearance of an artifact coated with a darkened layer of oil or varnish may be aesthetically pleasing. However, as the coating ages, it may become darker and more difficult to remove, eventually completely obscuring the painted surface and detail. Such potentially harmful

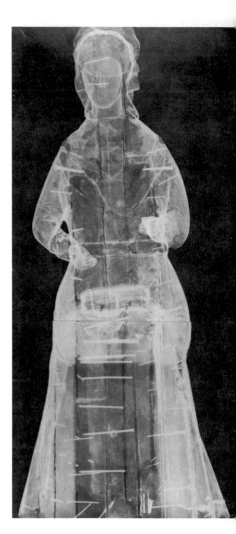

fig. 8 X-radiograph of *Spinning Woman Whirligig*. Photo courtesy of the Art Conservation Department, State University College at Buffalo, N.Y.

ig. 9 Photomacrograph showing various
paint layers

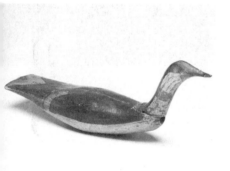

ig. 10 Red-throated loon decoy with sur-
ace worn from use in the field

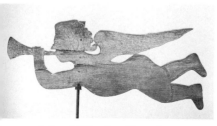

ig. 11 *Gabriel Weather Vane* showing
weathered surface

coatings should be cleaned before it becomes impossible to remove them safely. Benign coatings need not necessarily be removed.

The five examples just discussed present a range of conservation treatments encountered in preparing for this exhibition. While conservators seldom disagree about the importance of structural consolidation to prevent deterioration, the question of how a conserved artifact should appear is subject to various interpretations. Because the state of preservation of objects varies widely, no hard and fast rules can be made concerning the extent of conservation treatment. The parameters of the treatment are governed by the individual condition of each artifact. The folk art conservator and curator must guard against the tendency to strive for a consistent appearance among different artifacts, and preconceived notions of how an old artifact should appear should not influence the treatment. For example, although an old weather vane such as *Gabriel* (fig. 11, and cat. 63) may have a wonderful appearance, only traces of the original paint remain. Another artifact of similar age, such as the E. Noyes trade sign (fig. 12, and cat. 7), may be in excellent condition beneath the darkened linseed oil film. The weathered *Gabriel* should not be restored to match the bright, original paint on the cleaned E. Noyes (fig. 13) even though it originally appeared that way. Nor should the dark layer of obscuring oil on the E. Noyes be left simply to make its appearance more consistent with the naturally aged *Gabriel*.

Through analysis and examination of the artifact, the conservator provides technical information and offers conservation options. Curators refine their sense of how an artifact should appear based on historical knowledge and

experience. To design and implement a treatment that is best for a particular object, frequent and open communication between curators and conservators is essential. At the Shelburne Museum, we strive to maintain such communication. We would like to thank Polly Mitchell, Ingrid Neuman, Elizabeth Walmsley, Annette Rupprecht, Deborah Liebmann, and Eric Bessette for their assistance.

fig. 12 E. Noyes trade sign partially cleaned

fig. 13 E. Noyes trade sign after cleaning